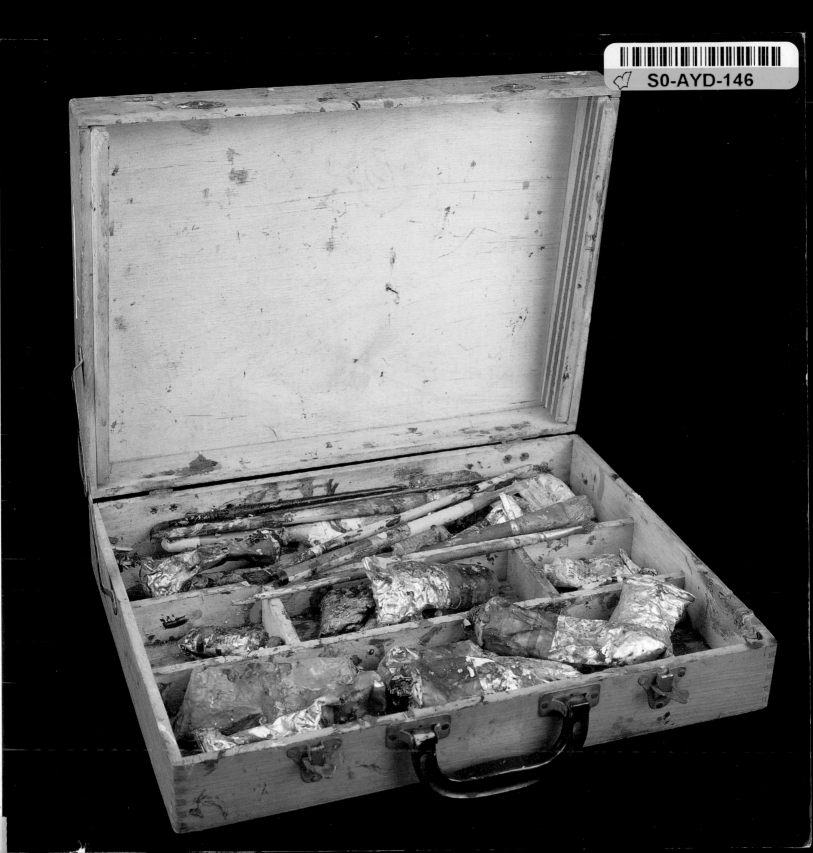

DEPARTED ANGELS
Jack Kerouac

TEXT BY ED ADLER

THUNDER'S MOUTH PRESS • NEW YORK

THE LOST PAINTINGS

My mother says it's not God's fault what happens I — if not, then who "created" the world in the first place? — If God is not <u>us</u>, then he is "something else" and "somewhere else" — and THIS CANNOT BE THE WORLD IN HIS HAND

I'm going to ask Dody to marry me

I stuck my head out the window & saw & breathe — in the Spring rain.

Fig.1 | Notebook page, 1959

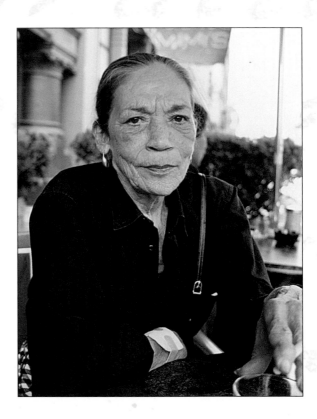

Fig.2 | Dody Muller, 1995. Photo Ed Adler

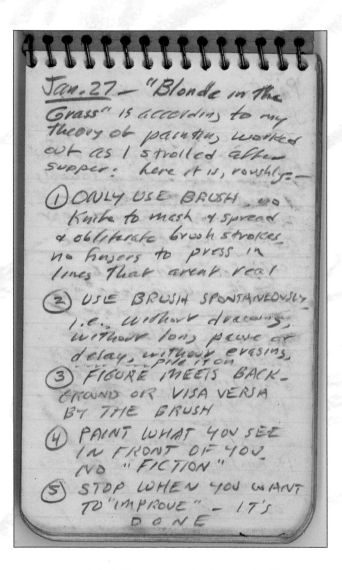

Jan. 27 — "Blonde in the Grass" is according to my theory of painting, worked out as I strolled after supper. here it is, roughly:—

1. ONLY USE BRUSH no knife to mesh & spread & obliterate brush strokes no erasers to press in lines that aren't real

2. USE BRUSH SPONTANEOUSLY i.e. without drawing, without long pause or delay, without erasing, no fiction

3. FIGURE MEETS BACK-GROUND OR VISA VERSA BY THE BRUSH

4. PAINT WHAT YOU SEE IN FRONT OF YOU. NO "FICTION"

5. STOP WHEN YOU WANT TO "IMPROVE" — IT'S DONE

Fig.3 | Jack Kerouac notebook page, 1959

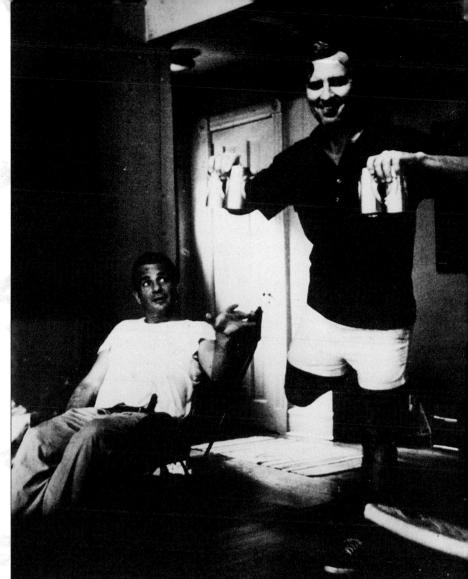

Fig.4 | Jack and Stanley Twardowicz

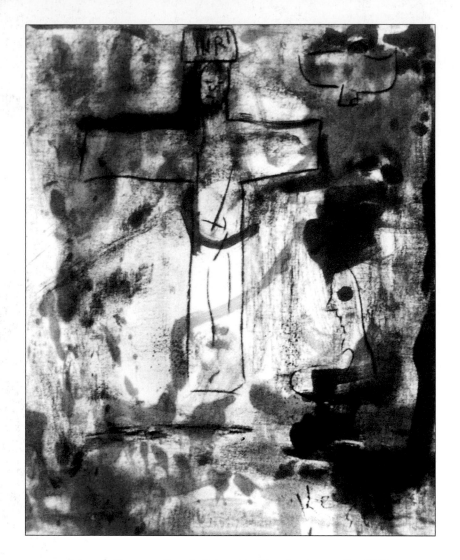

Fig.5 | Kerouac, *PIETÀ*. Painted in Twardowicz studio, 1962

The void is not concerned
about the birth & death
of birds & men,
and neither are the
principals thereof,
as we'll all see
in the end,
which is now, the beginning,
The Primordial Dawn
of Eleven OClock
Today

All these activities
are mindless ———

And so, walked 2 miles
to liquor store, bought booze,
painted THE EYE &
(in the Eagle) & completed
GIRL ——— & finished
typing up BOOK OF SKETCHES

Fig.6 | (from facsimile; original lost)

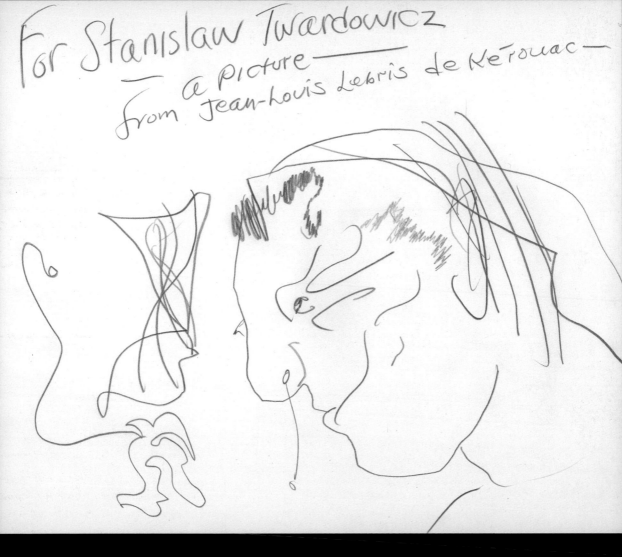

For Stanislaw Twardowicz

— a picture —

from Jean-Louis Lebris de Kerouac —

Fig.7 | Kerouac. Pencil, 8½" x 11"

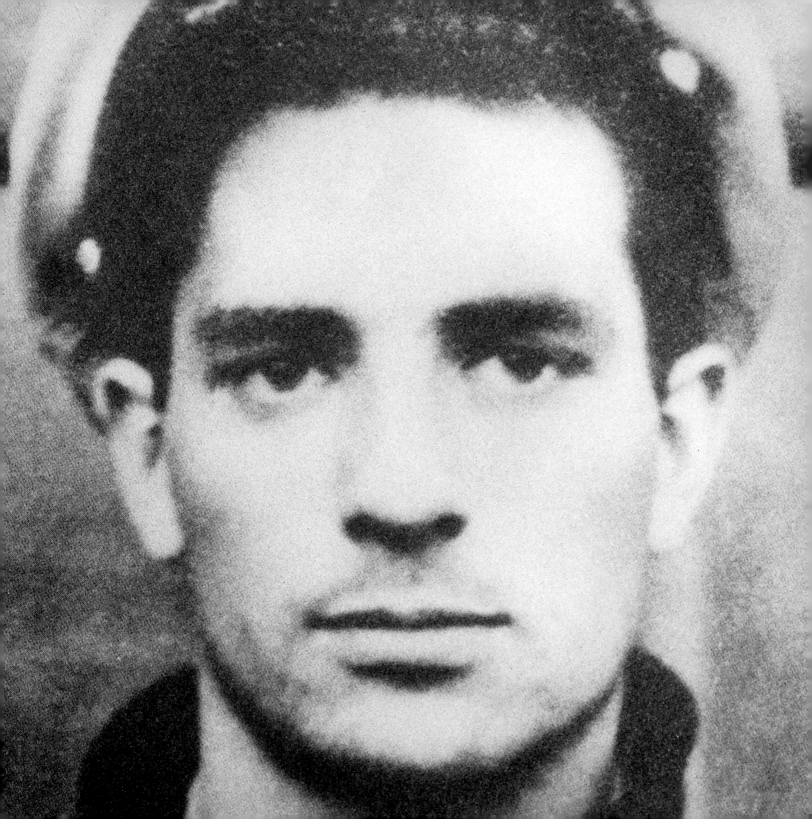

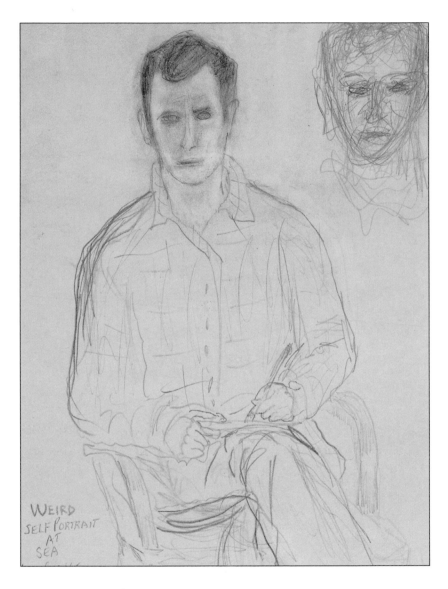

WEIRD
SELF PORTRAIT
AT
SEA

Fig.9 | Kerouac, *WEIRD SELF-PORTRAIT AT SEA*.
Pencil, 8 ¹⁄₂" x 11"

Fig.8 | Photograph of Jack during his merchant marine days. (Photo courtesy Frankie Edie Parker)

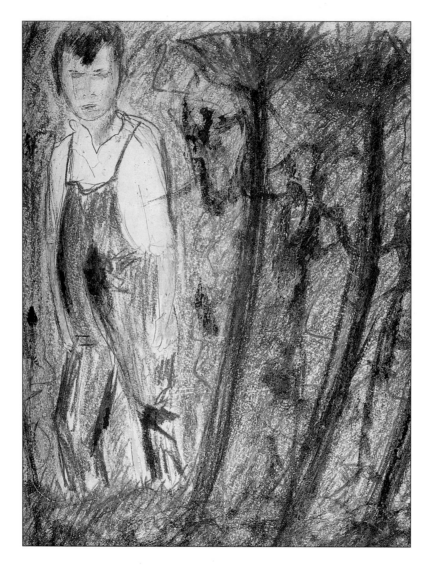

Fig.10 │ Kerouac, *SELF-PORTRAIT AS A BOY*. Oil, crayon, charcoal, pencil, and ink, 10 $\frac{1}{2}$" x 13"

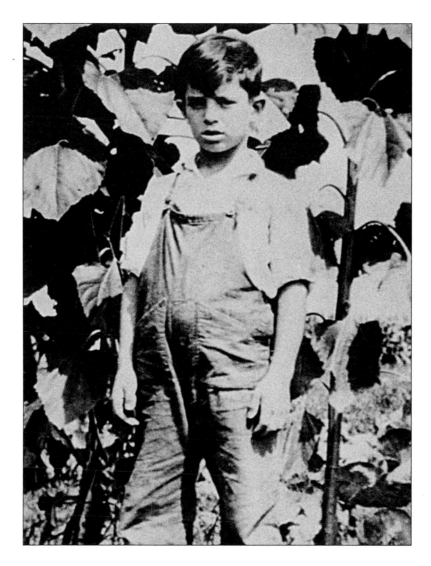

Fig.11 | Snapshot of Jack as a boy

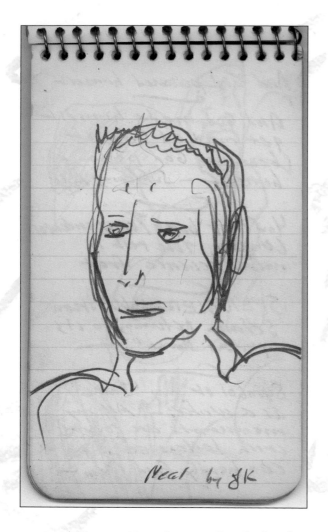

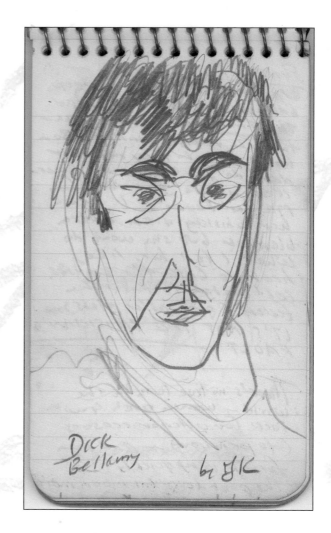

Fig.12 | Kerouac, *NEAL CASSADY*. Pencil, 3" x 5", notebook, January 1959. In a letter to Neal of October 6, 1950, Jack wrote: "Well did you get the picture I drew, and wasn't it a good picture?"

Fig.13 | Kerouac, *DICK BELLAMY*. Pencil, 3" x 5", notebook, January 1959

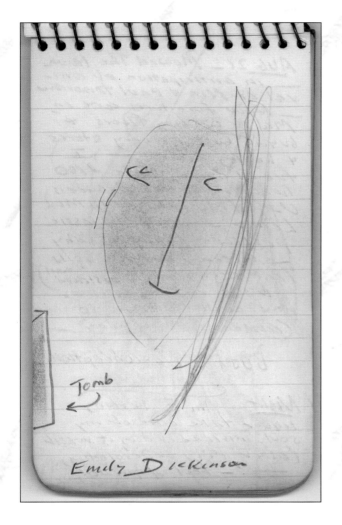

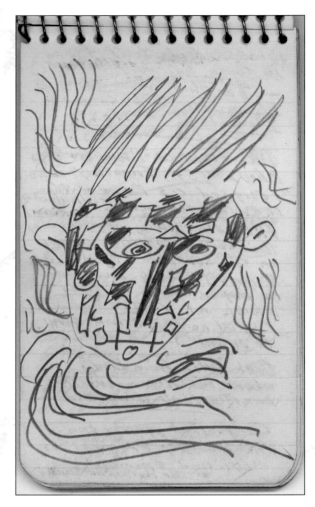

Fig.14 | Kerouac, *EMILY DICKINSON*. Pencil, 3" x 5", notebook, Summer 1958

Fig.15 | Kerouac, *MAN OF KAFKAEN HORRORS*. Pencil, 3" x 5", notebook, February-March, 1959

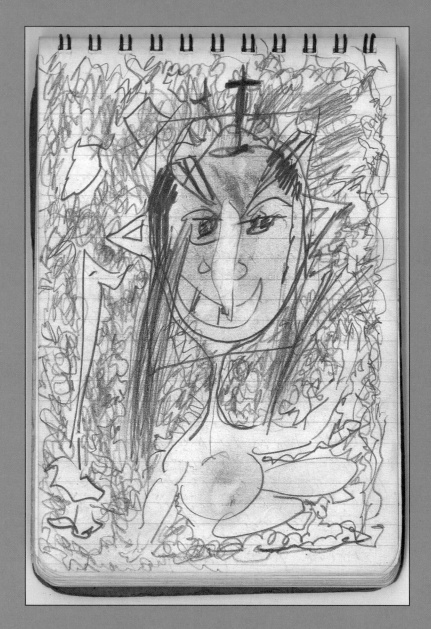

Fig.16 | Kerouac, *ANDROGYNOUS FIGURES*. Pencil,
4" x 6", notebook, Winter 1961

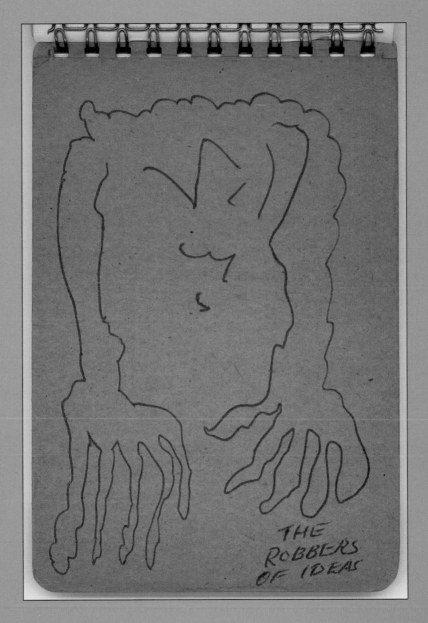

Fig.17 | Kerouac, *The Robbers of Ideas*. Pen and ink on inside of back cover of notebook, 1961

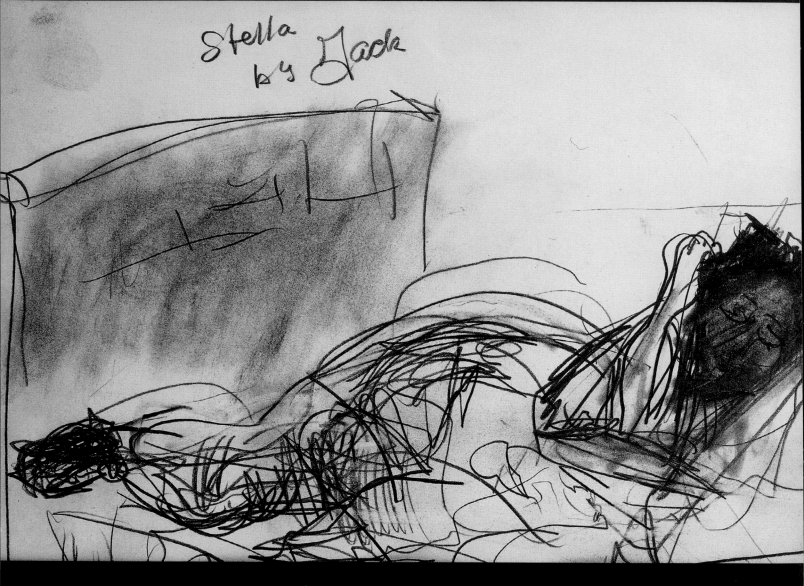

Fig.18 | Kerouac, *Stella by Jack*. Pencil, 9" x 12"

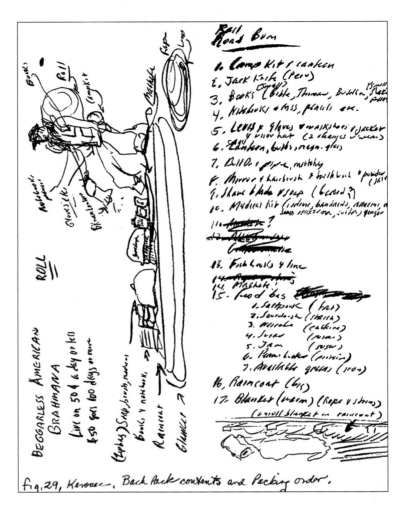

Fig.20 | Kerouac, backpack contents and packing order
(from facsimile; original lost)

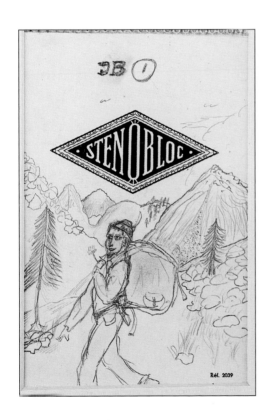

Fig.19 | Kerouac, *Stenobloc Dharma Bums*.
Pencil on notebook cover, 5" x 8"

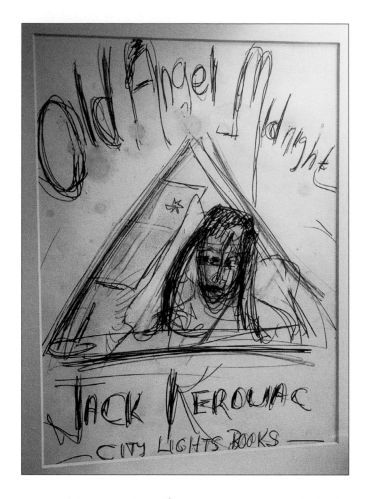

Fig.21 | Kerouac, *OLD ANGEL MIDNIGHT*, study for back cover of book. Pencil and ink, 9 ¼" x 12 ¼"

Fig.22 | Kerouac, *OLD ANGEL MIDNIGHT OVER LOWELL*. India ink and pastels, 10 ¾" x 15"

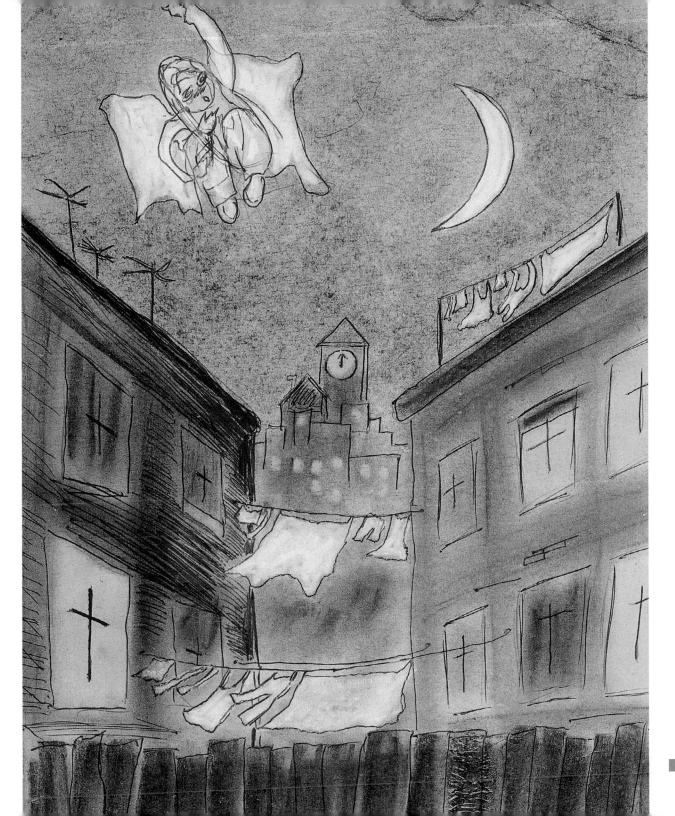

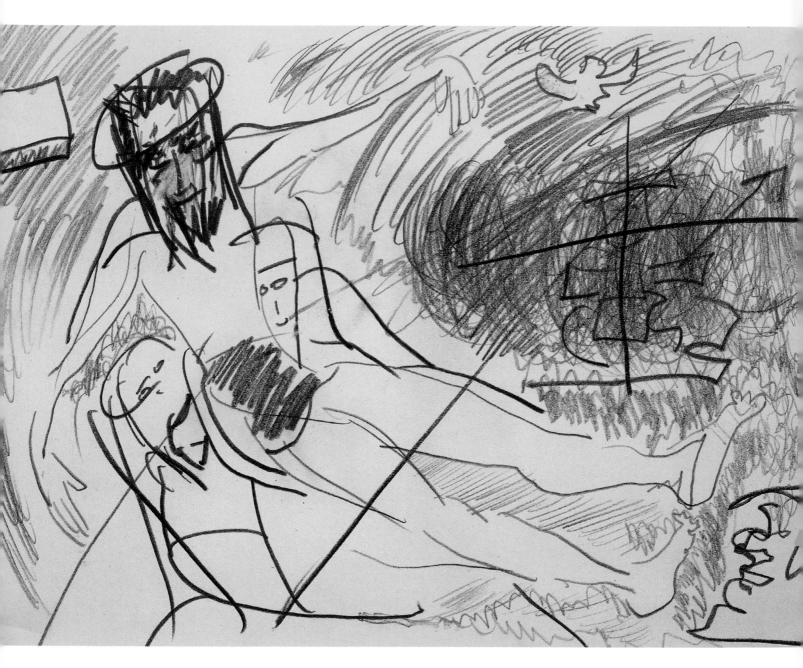

Fig.23 | Kerouac, ***Descent from the Cross***. Pencil, 9" x 12"

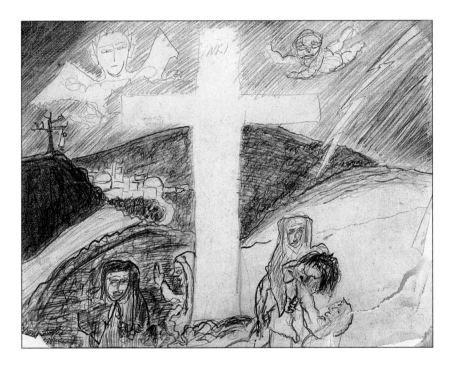

Fig.24 | Kerouac, *PIETÀ WITH BOLT OF LIGHTNING.*
Pencil with ink signature, 8 $\frac{1}{2}$" x 11"

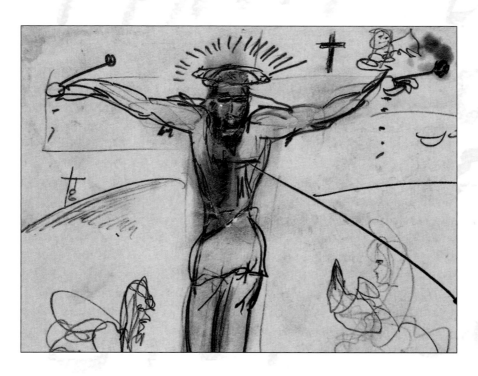

Fig.25 | Kerouac, *GOLGOTHA WITH BUDDHA EYES*.
Pencil, 5 ¼" x 7"

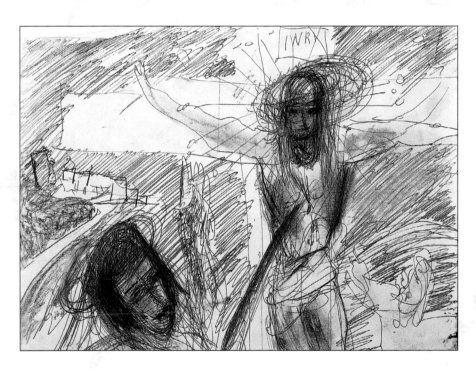

Fig.26 | Kerouac, *CRUCIFIXION DRAWING IN BLUE INK*.
Pencil and ink, 8 ½" x 11"

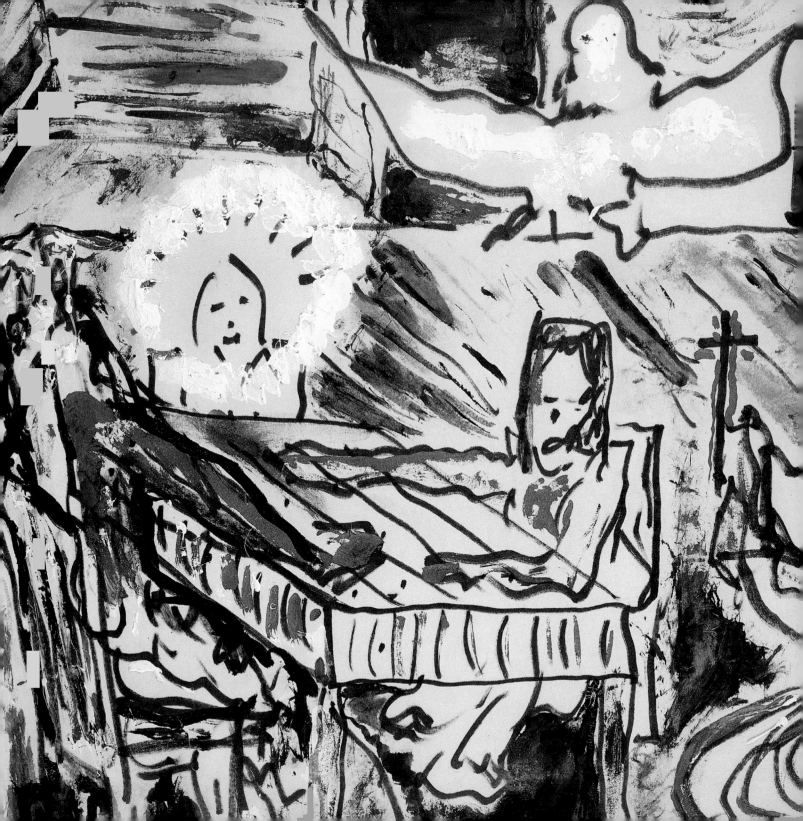

Fig.27 | Kerouac, *TOBIAS*. India ink, pastel, and gouache, 14" x 16 $\frac{1}{2}$"

Fig.28 | Kerouac, *TOBIAS WITH FISH*.
Ink and gouache, 8 ½" x 11"

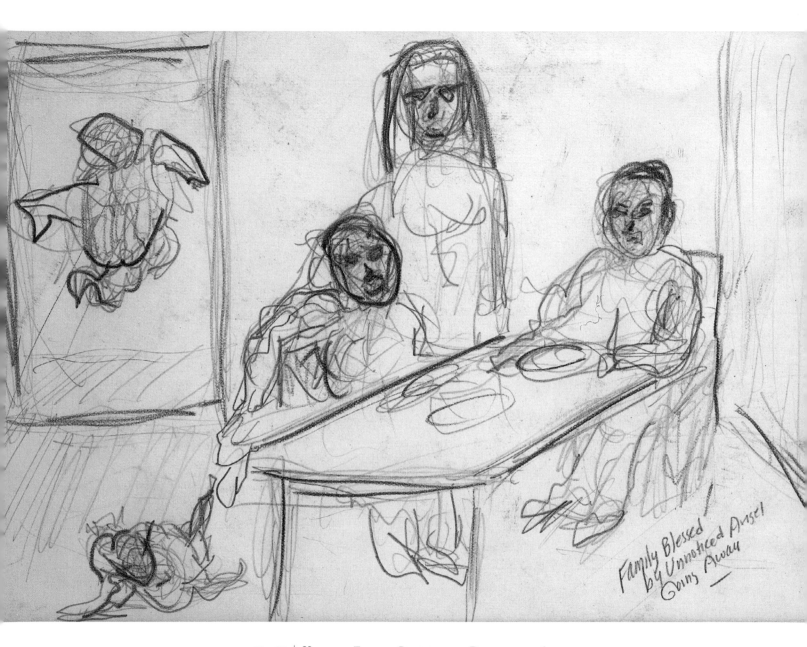

Within the drawing: *Family Blessed by Unnoticed Angel Going Away*

Fig.29 | Kerouac, *FAMILY BLESSED BY DEPARTING ANGEL.*
Pencil, 6 ¹⁄₂" x 9"

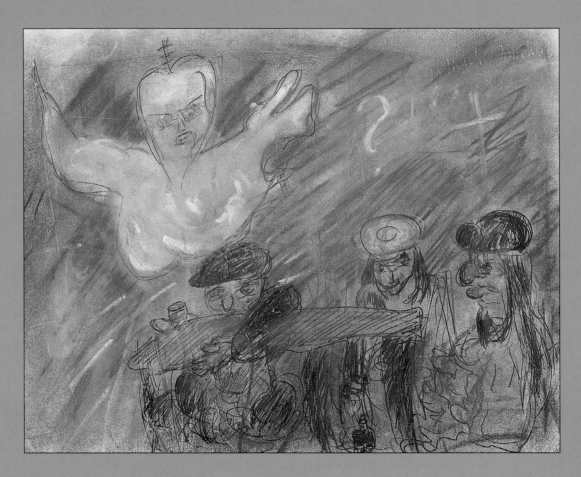

Fig.30 | Kerouac, *Saint Matthew Appearing to the Angels*.
Pastel and ink, 8 ½" x 11"

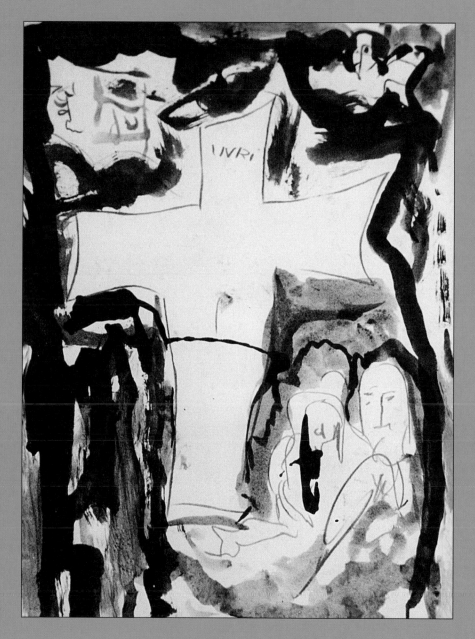

Fig.31 | Kerouac, *PIETÀ IN BLACK AND GRAY*. Ink
drawing and wash 12" x 9". Done in Stanley Twardowicz's studio

Fig.32 │ Kerouac, graffiti drawn on
Twardowicz studio door

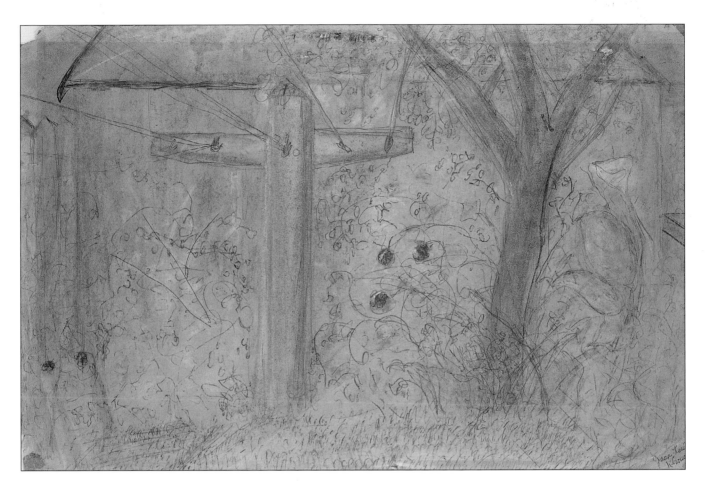

Fig.33 | Kerouac, *THE CRUCIFIX CLOTHESLINE*. Pastel, charcoal, and pencil. 11 ½" x 17 ½"

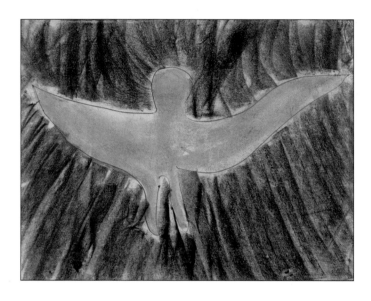

Fig.34 | Kerouac, *BLUE ANGEL*. Pastel and ink,
11" x 14"

Fig.35 | Kerouac, *ANGEL WITH TWO SMALL ANGELS AND PRAYING WOMAN*.
Pastel and ink. 8 ½" x 11"

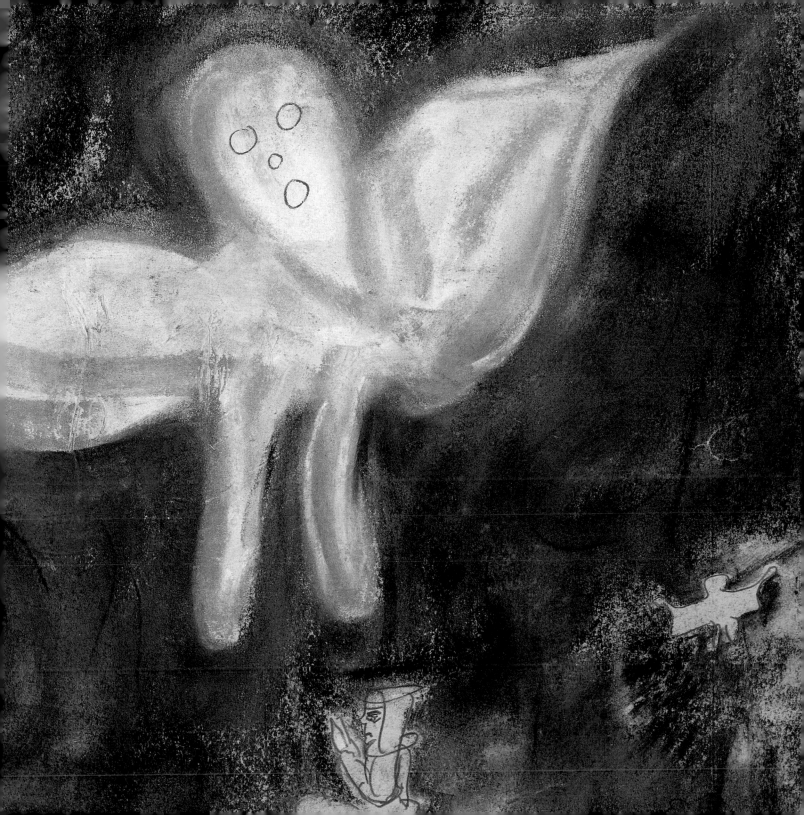

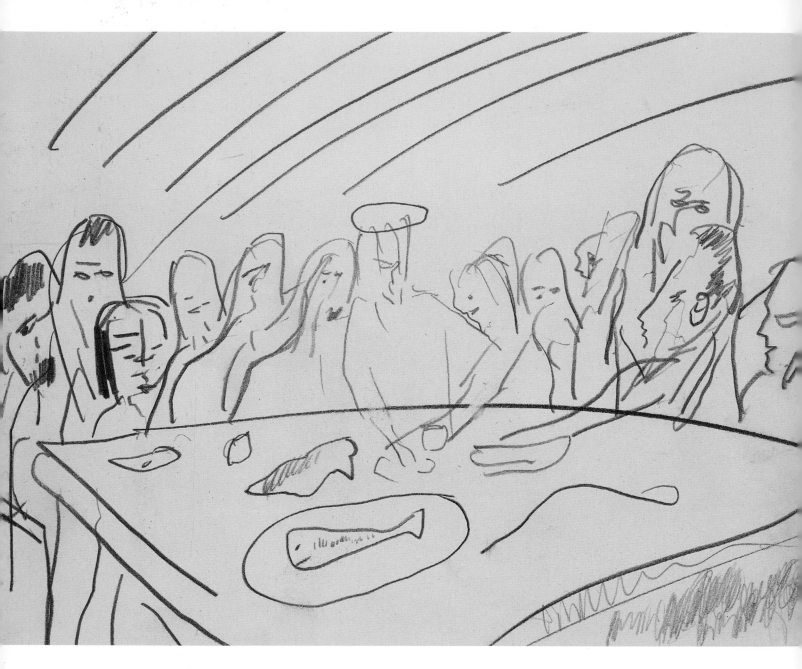

Fig.36 | Kerouac, *THE LAST SUPPER*. Pencil, 9" x 12"

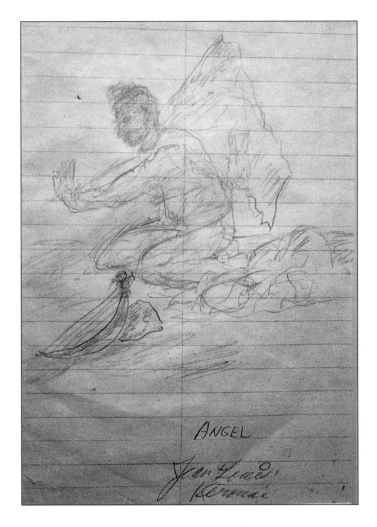

Fig.37 | Kerouac, *ANGEL AFTER LEONARDO*.
Pencil on red-lined notebook paper, 5" x 8"

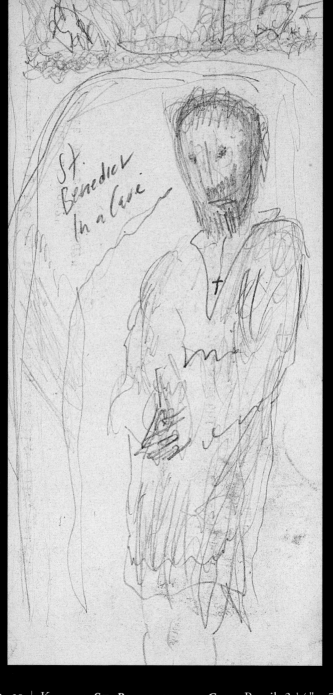

St.
Benedict
In a Cave

Fig.38 | Kerouac, *ST. BENEDICT IN A CAVE*. Pencil, 3 ¼" x 7

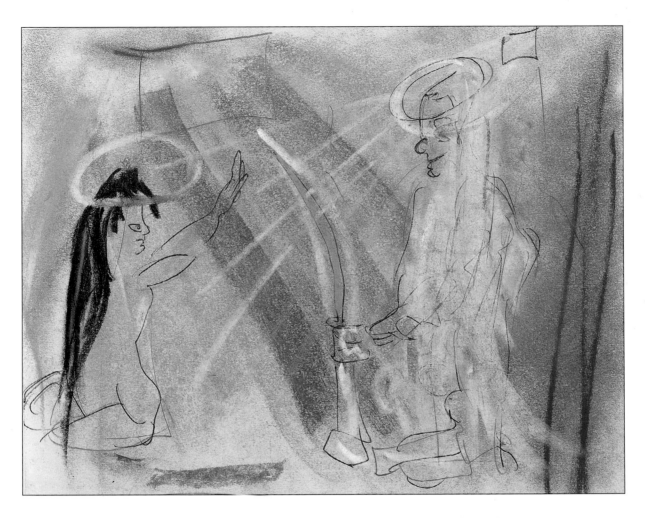

Fig.39 | Kerouac, *RED GLOW*. Pastel and India ink, 8 ½" x 11"

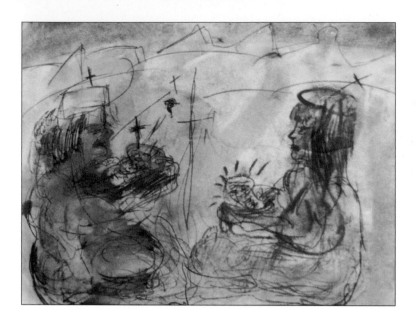

Fig.40 | Kerouac, *GOLDEN SANDS*. Pastel, ink, and pencil. 8 ½" x 11"

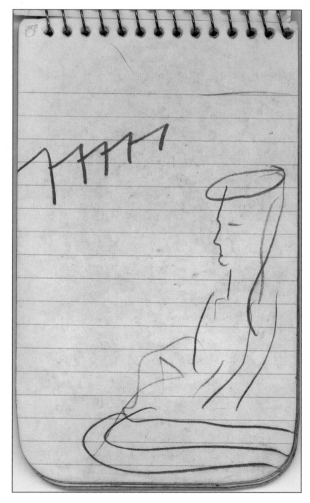

Fig.41 | Kerouac, sketch for *GOLDEN SANDS*. Pencil, notebook, 3" x 5"

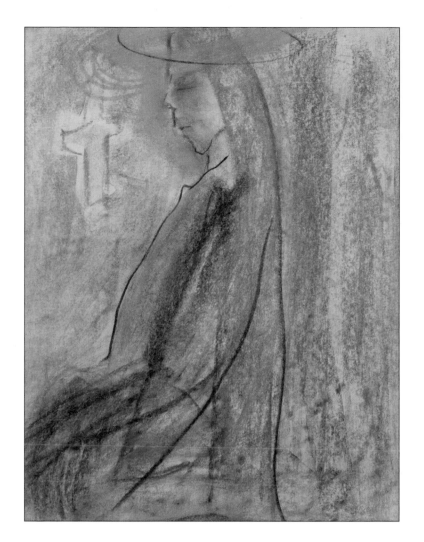

Fig.42 | Kerouac, *BLUE MADONNA WITH CROSS*.
Pastel and crayon, 14" x 17"

right: Fig.43 | Kerouac, *MADONNA AND CHILD*.
Pastel and pencil, 9" x 12"

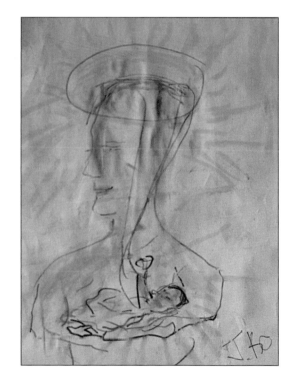

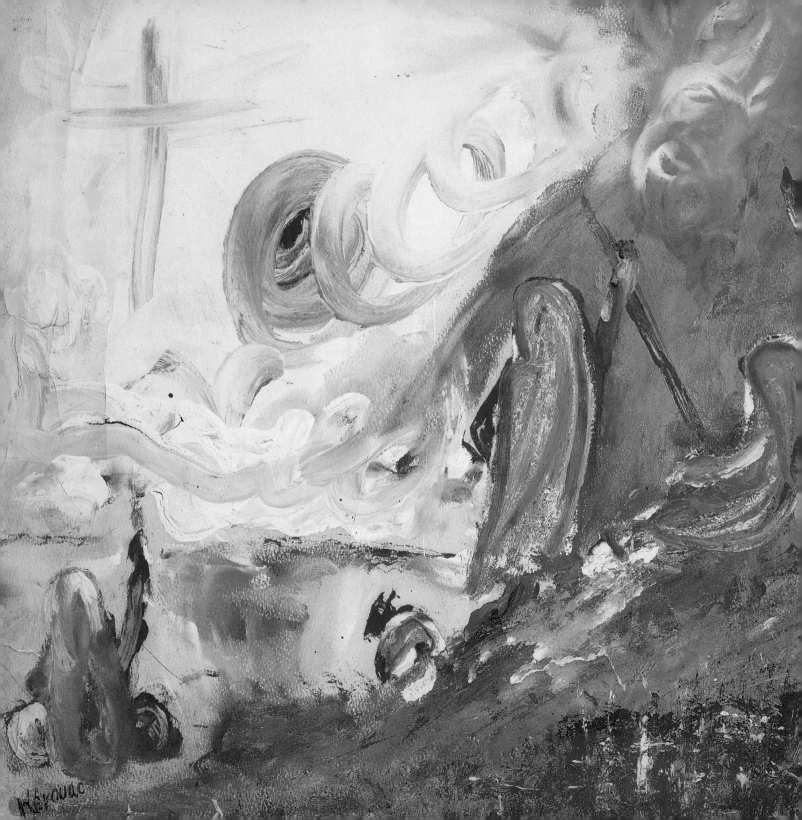

Fig.44 | Kerouac, *VISION OF THE GOATHERDS*. Oil on board, 14 ½" x 18"

Fig.45 | Kerouac, *GOLDEN ETERNITY*. Oil, 9" x 12"

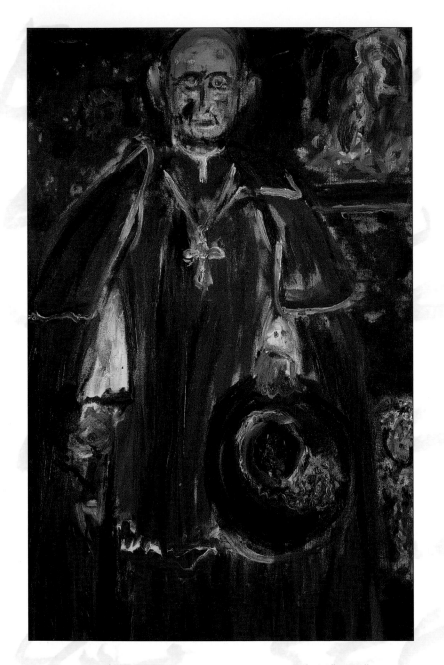

Fig.46 | Kerouac, *CARDINAL MONTINI*. Oil, 20" x 30"

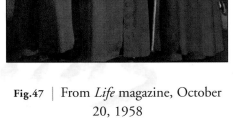

Fig.47 | From *Life* magazine, October 20, 1958

Fig.48 | Back of *MONTINI* canvas

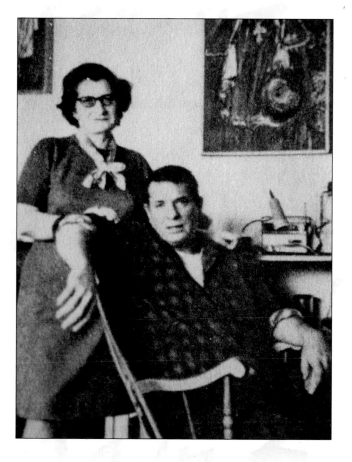

Fig.49 | Jack and Stella with *CARDINAL MONTINI*

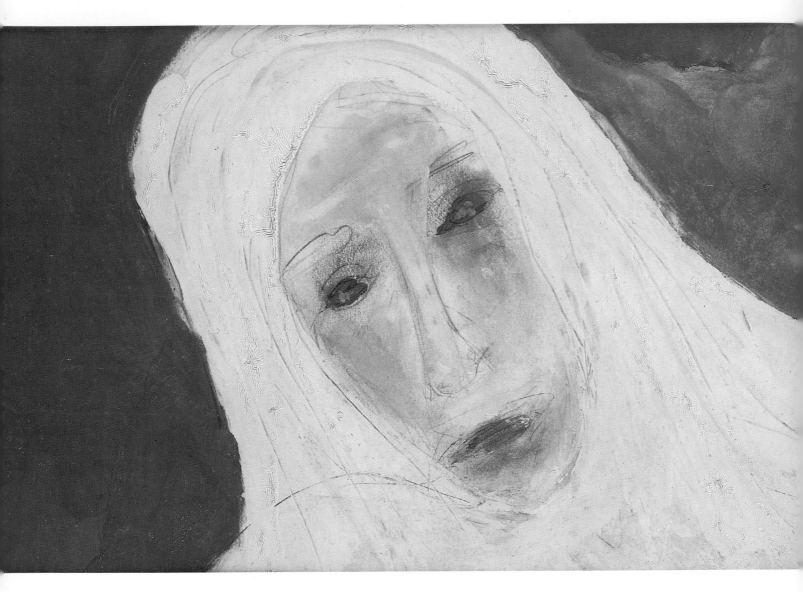

Fig.50 | Kerouac, *GOD*. Oil and pencil, 7 ³/₄" x 11 ³/₄"

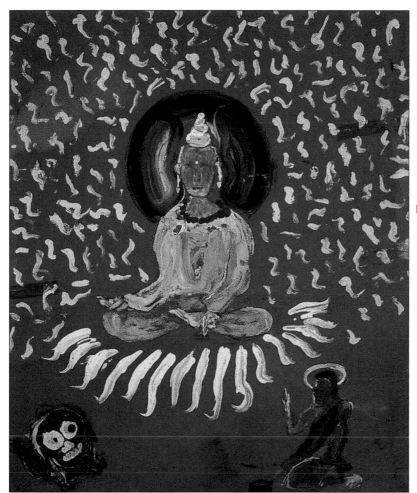

Fig.51 | Kerouac, *THE GARY BUDDHA*. Oil, 14" x 17"

Fig.52 | Kerouac, *THE VISION OF DIPANKARA/SOURCES OF IMAGINATION*. Oil and pencil on red-lined notebook paper, 5" x 8 ½"

Fig.53 | Kerouac, *FACE OF THE BUDDHA*. Pencil, 8" x 10"

Fig.54 | Kerouac, *ENLIGHTENMENT*. Pencil in sketchbook,
8 ½" x 11"

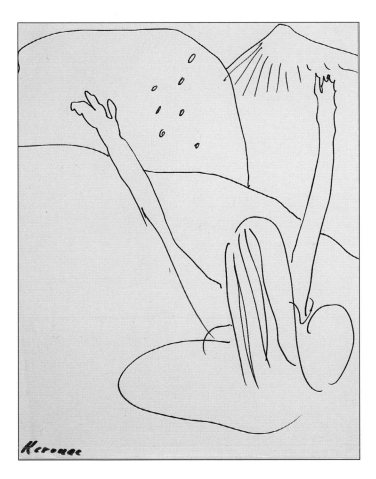

Fig.55 | Kerouac, *MT. HOZOMEEN*.
Pen and ink, 8 ½" x 11"

Fig.56 | Gary Snyder, *VIEW OF MT. HOZOMEEN*.
India ink with chop signature, 12" x 15 ½"

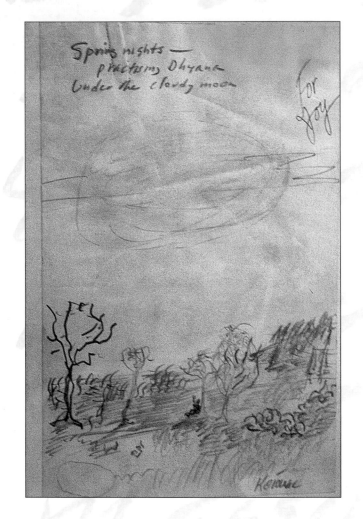

Spring nights —
practising Dhyana
under the cloudy moon

For
Joy

Fig.59 | Kerouac, *SPRING NIGHTS*. Pencil, "For Joy"
in ink, 5 ½" x 8 ½"

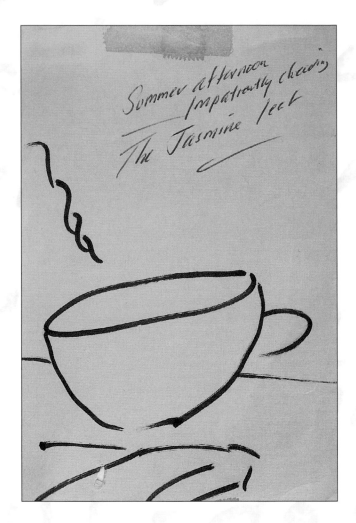

Summer afternoon
Impatiently checking
The Jasmine leaf

Fig.60 | Kerouac, *SUMMER AFTERNOON*. India ink
and writing in blue ink, 4" x 6"

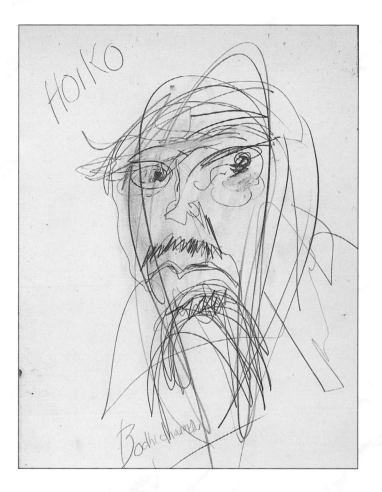

Fig.61 | Kerouac, *BODHIDHARMA HOIKO*.
Pencil, 9 ¼" x 12 ½"

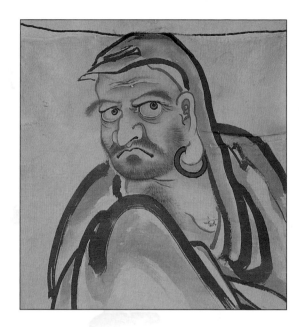

Fig.62 | Artist unknown, *BODHIDHARMA*.
Ink drawing found among Kerouac's
drawings.

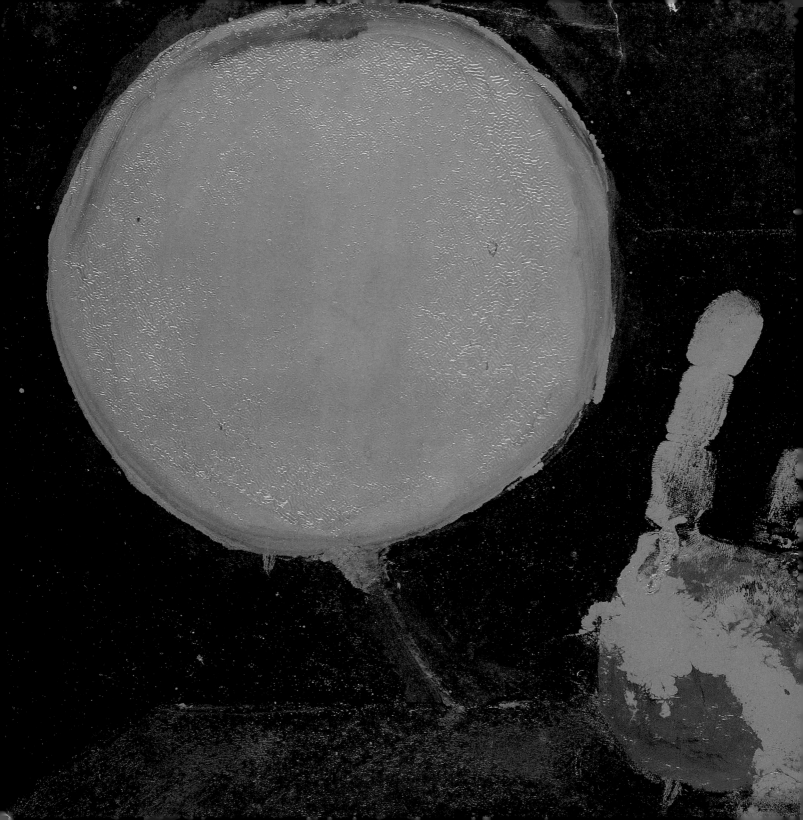

Fig.63 | Kerouac, *BLUE BALLOON*. Oil, 9 ¼" x 12 ½"

Fig.64 | Kerouac, *HEART AND HANDGUN*. Oil, 9" x 12"

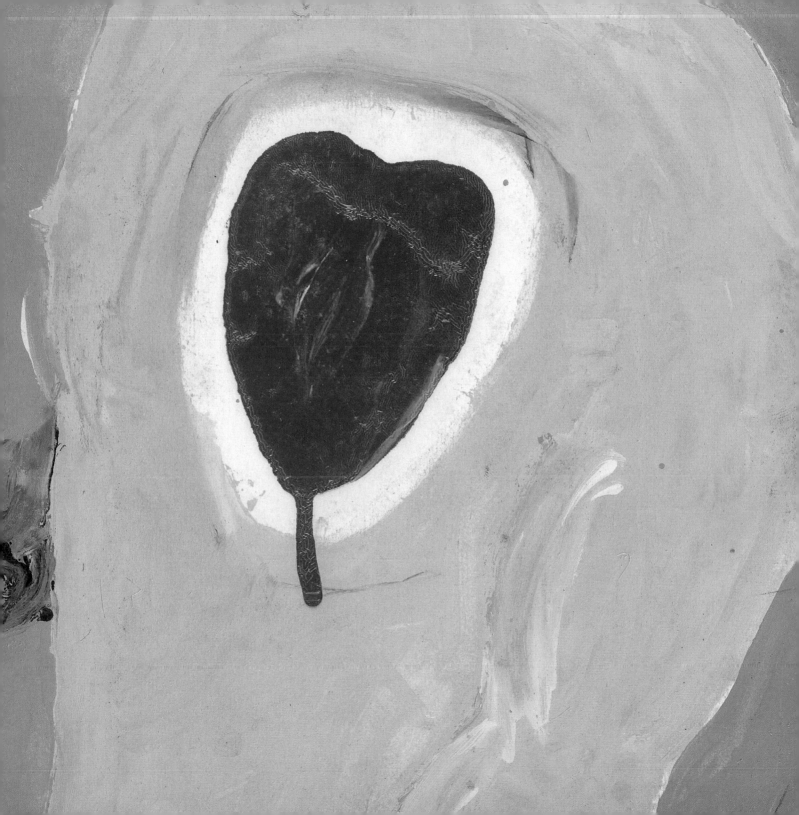

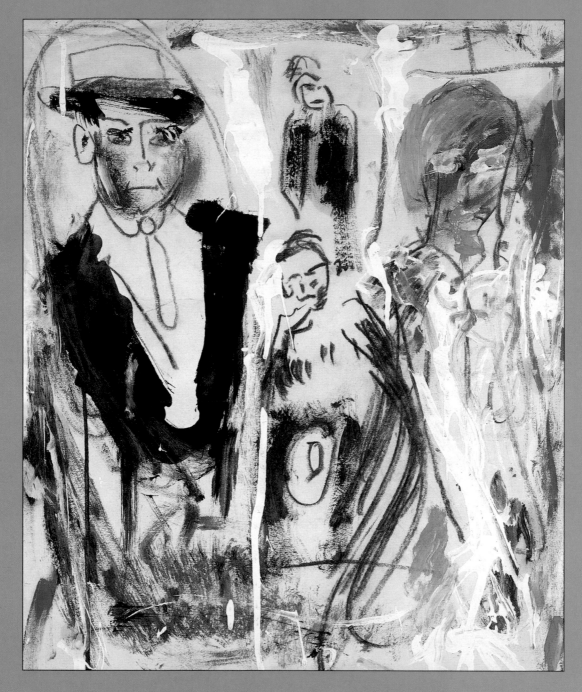

Fig.65 | Kerouac, *THE SLOUCH HAT*. Oil and charcoal, 14" x 17"

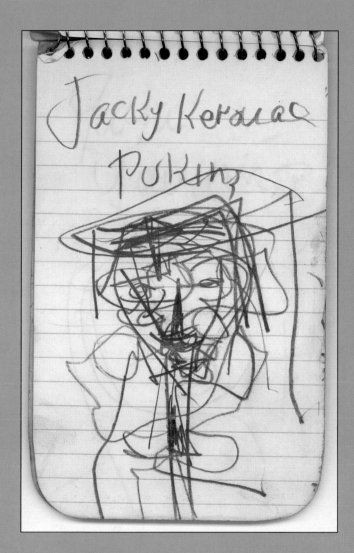

Fig. 66 | Kerouac, *Jacky Kerouac Puking*.
Pencil, notebook, 3" x 5"

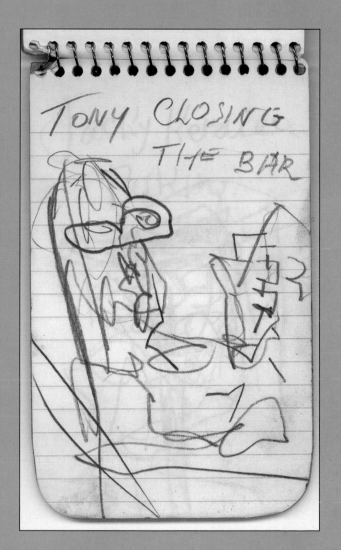

Fig. 67 | Kerouac, *Tony Closing the Bar*.
Pencil, notebook, 3" x 5"

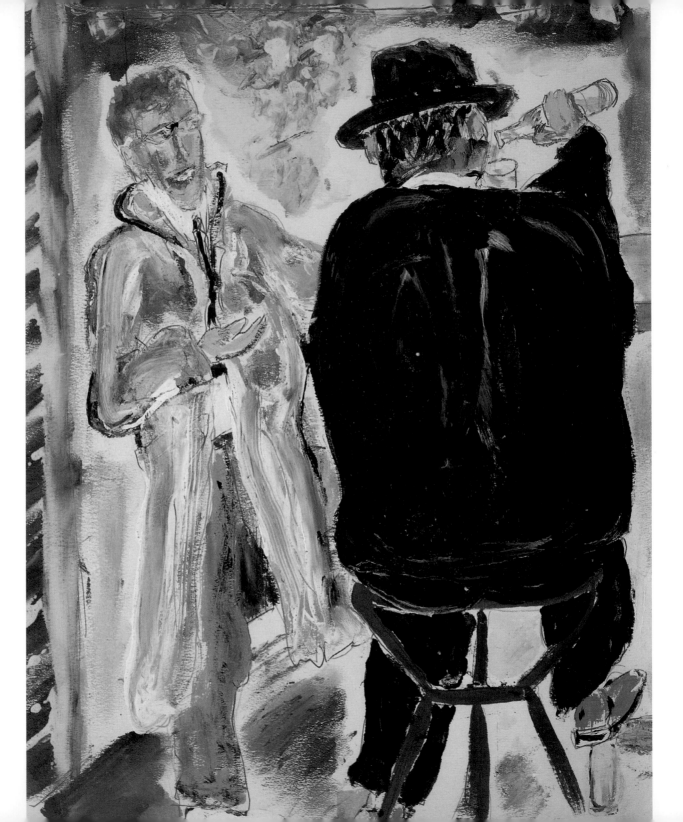

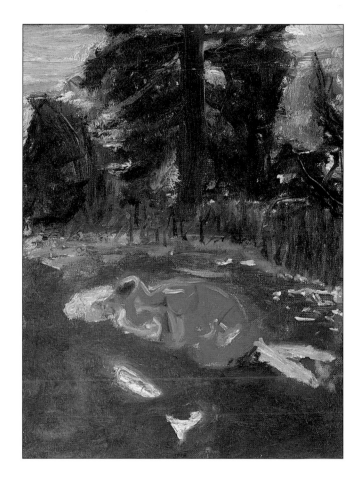

Fig.69 │ Kerouac, *BLONDE IN THE GRASS*. Oil, 9" x 12"

left: **Fig.68** │ Kerouac, *THE DRINKERS*. Oil and pencil, 9 $\frac{1}{4}$" X 12 $\frac{1}{2}$"

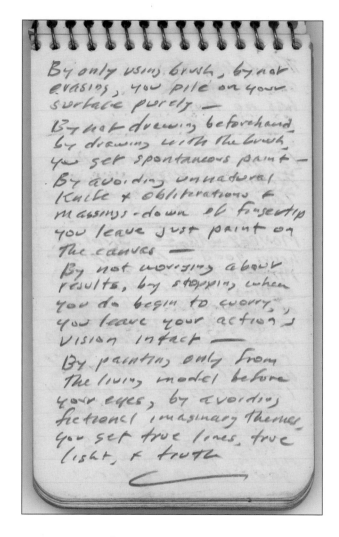

By only using brush, by not
erasing, you pile on your
surface purely —
By not drawing beforehand,
by drawing with the brush,
you get spontaneous paint —
By avoiding unnatural
knife & obliterations &
massings-down of fingertip
you leave just paint on
the canvas —
By not worrying about
results, by stopping when
you do begin to worry,
you leave your action's
vision intact —
By painting only from
the living model before
your eyes, by avoiding
fictional imaginary themes
you get true lines, true
light, & truth

Fig.70 | Kerouac, *NOTEBOOK*, 1959

right: **Fig.71** | Kerouac, *WOMAN WITH GUITAR.* Oil, 9" x 12"

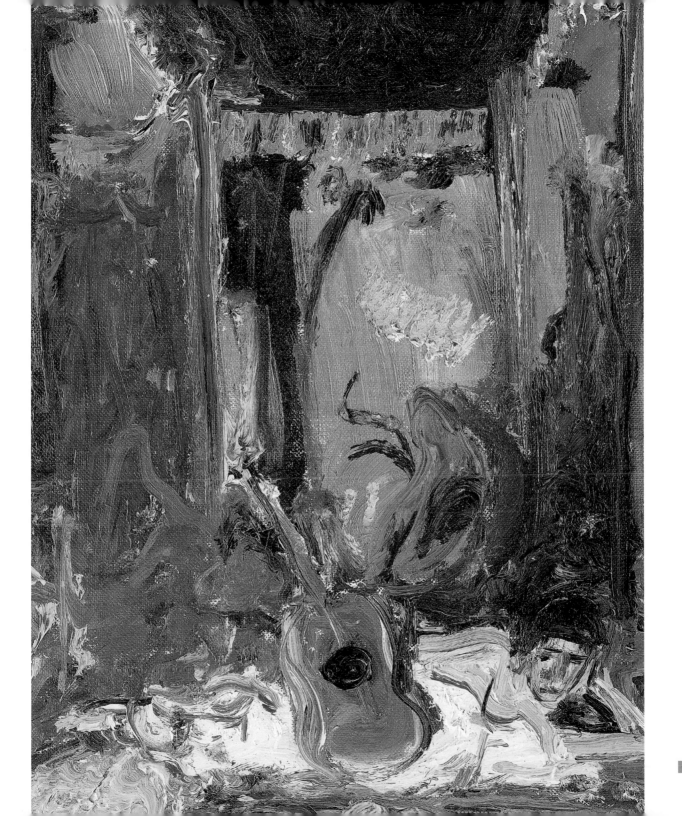

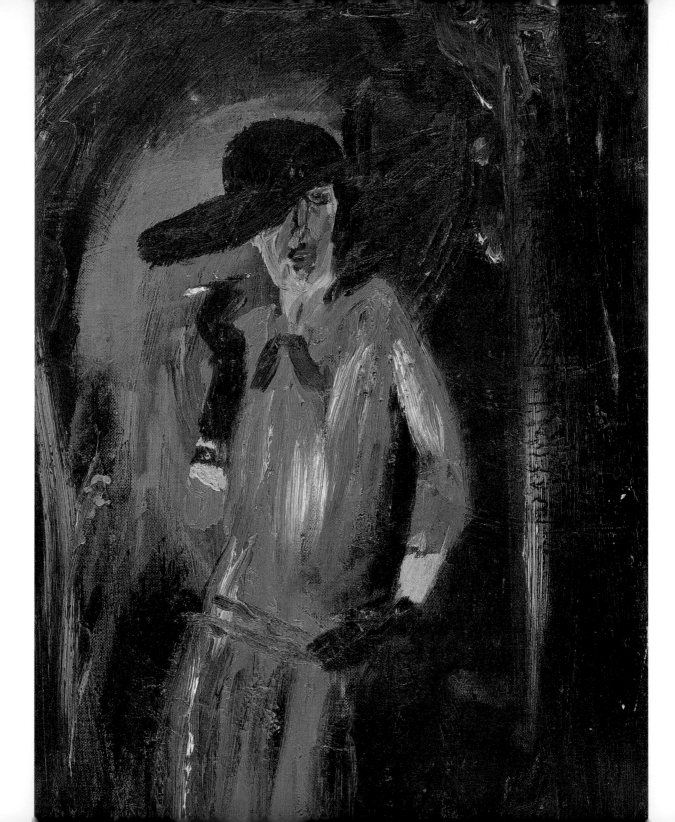

Fig.74 | Kerouac, *THE SILLY EYE*. Oil, 9" x 12"

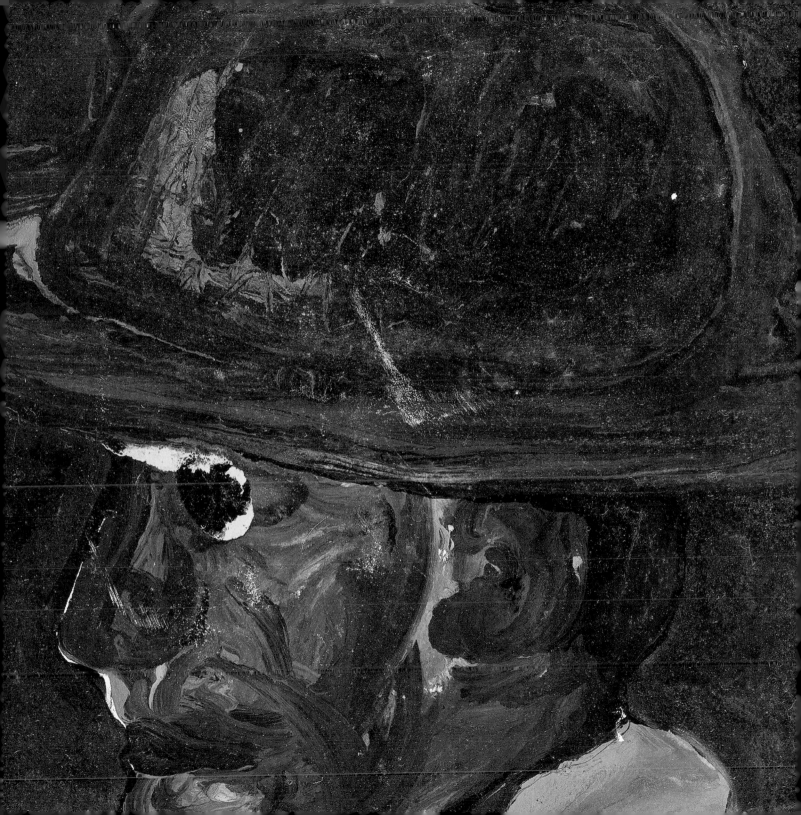

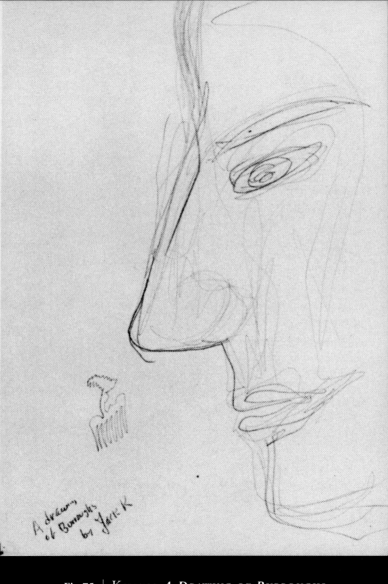

A drawing of Burroughs by Jack K

Fig.75 | Kerouac, *A Drawing of Burroughs*.
Pencil on drawing paper, 6 ¾" x 9 ½", 1957

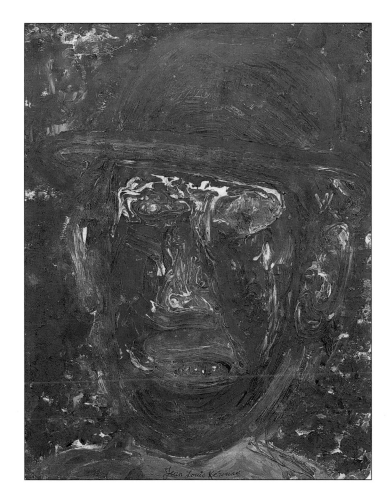

Fig.76 | Kerouac, *THE RED FACE*. Oil, 9 $\frac{1}{4}$" x 12 $\frac{1}{4}$"

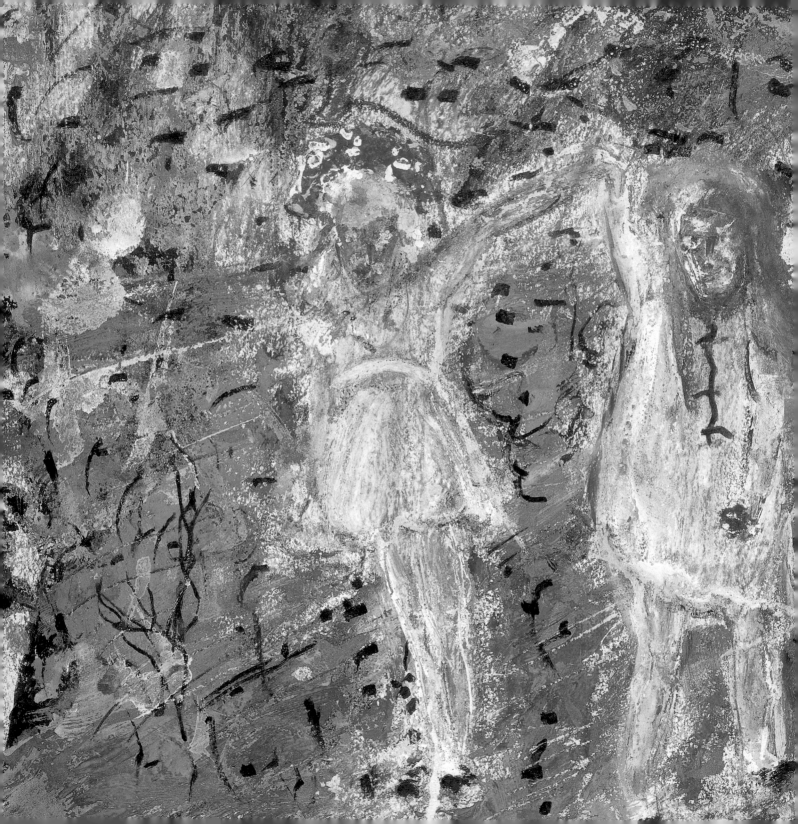

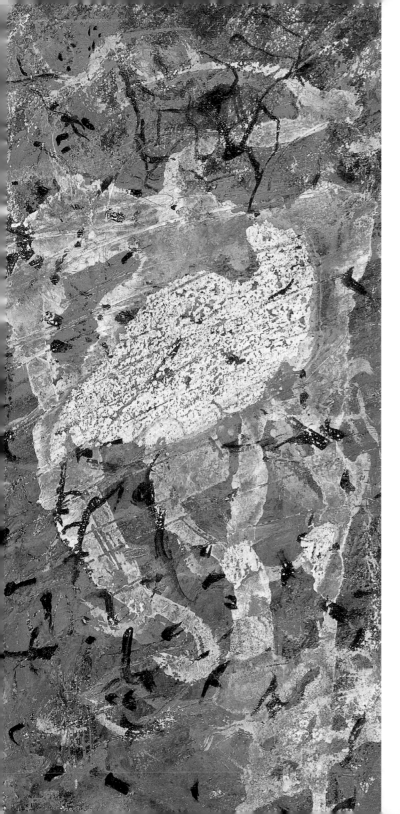

Fig.77 | Kerouac, *Two Figures in the Woods*. Oil, crayon, and ink, 9" x 13 ½"

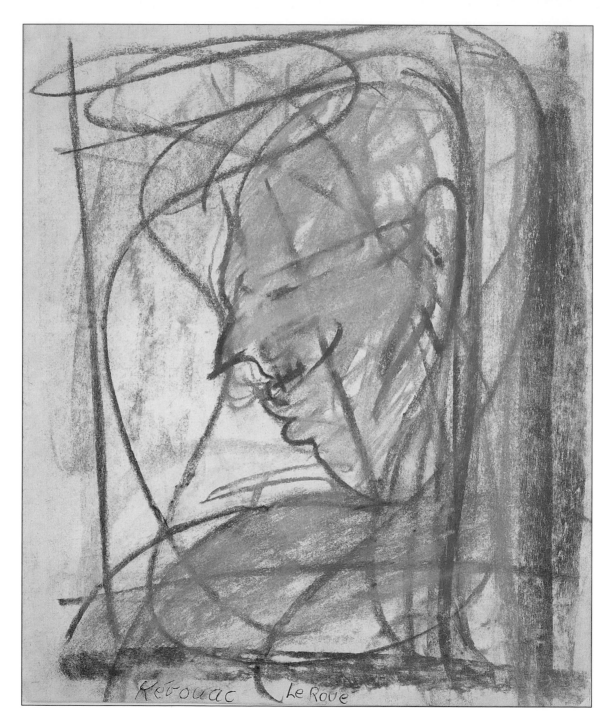

Fig.78 | Kerouac, *Le Roué*. Pastel, 14" x 17"

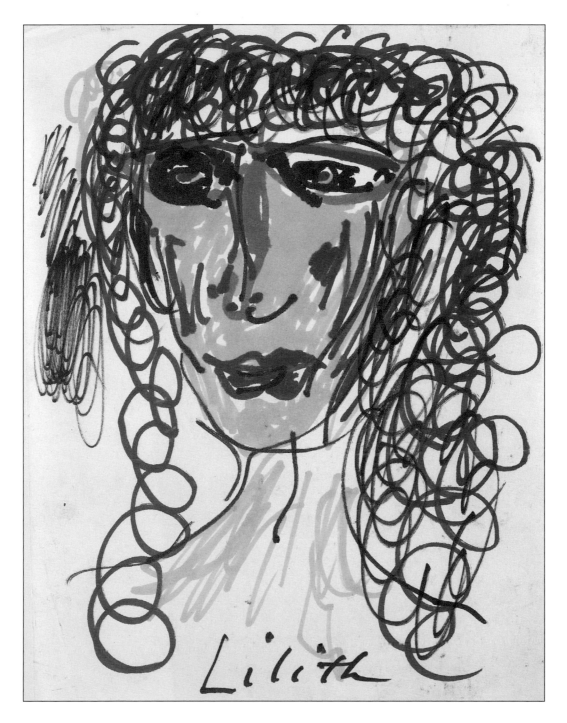

Fig.79 | Kerouac, *LILITH*. Marker pen, 8 ½" x 11"

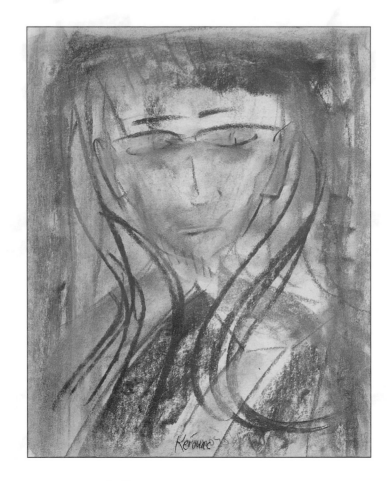

Fig.80 | Kerouac, *WOMAN WITH BLUE BOOK*.
Monoprint and pastel, 14" x 17"

Fig.81 | Kerouac, *NEW YEAR'S EVE INVITATION*. Pen, ink, and typewriter, 4 ¾" x 6 ¼"

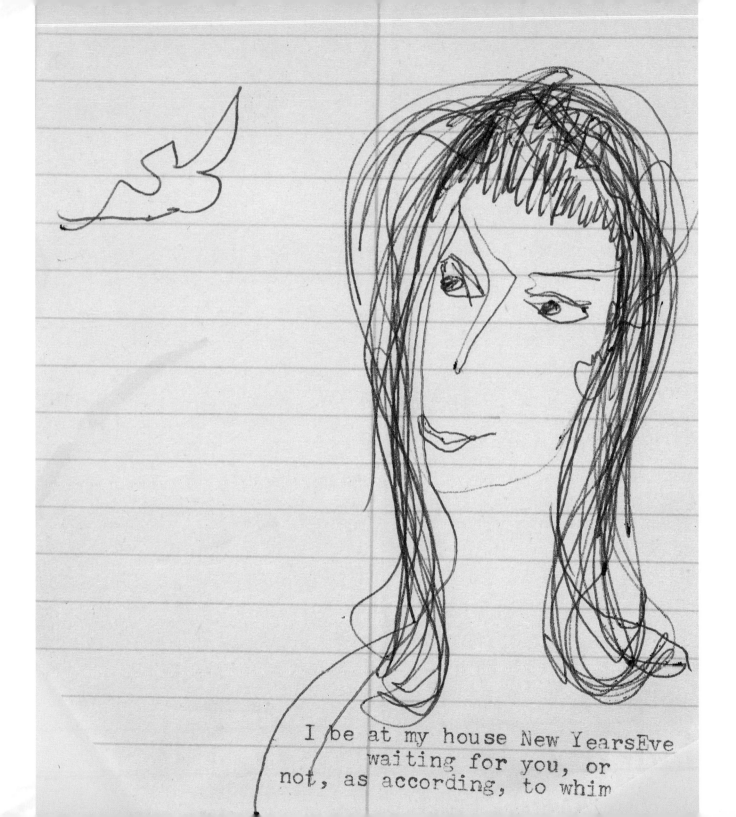

I be at my house New YearsEve
waiting for you, or
not, as according, to whim

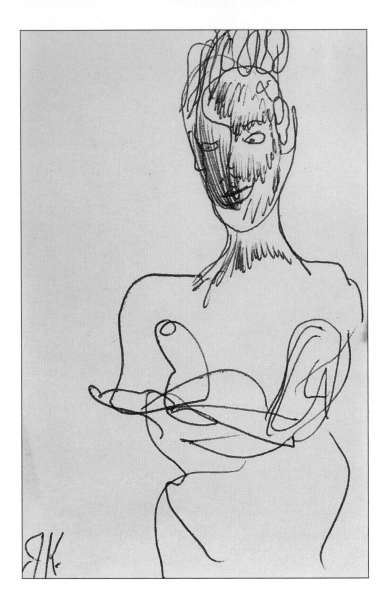

Fig.82 | Kerouac, *MOTHER AND CHILD*.
Ink on paper, 3" x 5"

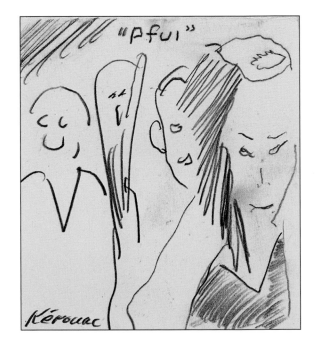

Fig.83 | Kerouac, *PFUI*. Pencil, 3 ¾" x 3 ¾"

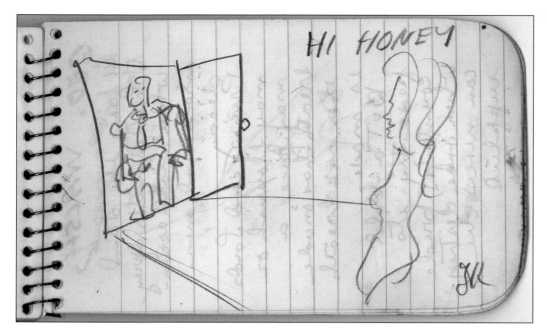

Fig.84 | Kerouac, *HI HONEY*. Pencil, notebook, 3" x 5", 1967

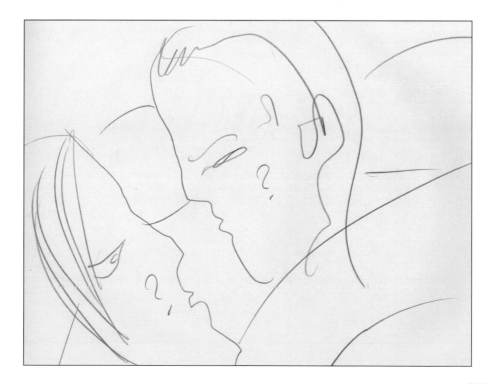

Fig.85 | Kerouac, *WHERE ARE WE GOING, WHO ARE WE?* Pencil, 8 ½" x 11"

LOVERS

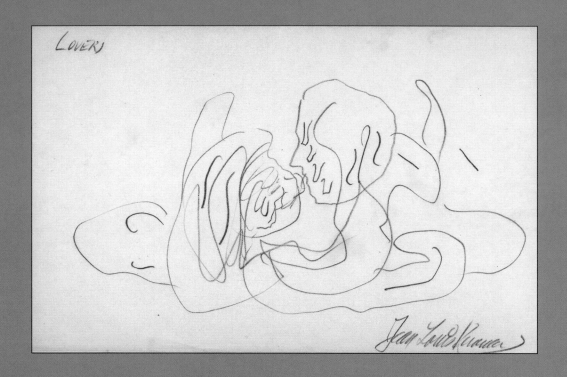

THE LAY

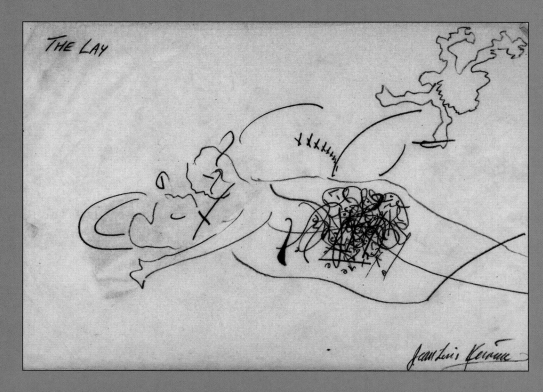

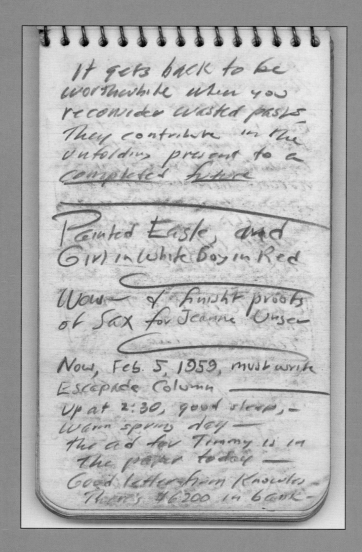

Fig.88 | Kerouac, notebook, February 1959

top, left: **Fig.86** | Kerouac, *LOVER, LOVER*. Pencil on onionskin paper, 5 ½" x 8 ½"

bottom, left: **Fig.87** | Kerouac, *THE LAY*. Pencil on onionskin paper, 5 ½" x 8 ½"

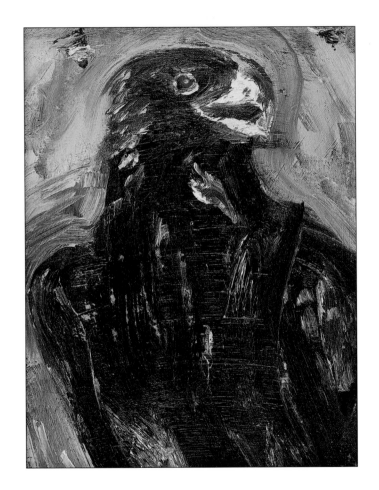

Fig.89 | Kerouac, *EAGLE*. Oil, 9" x 12"

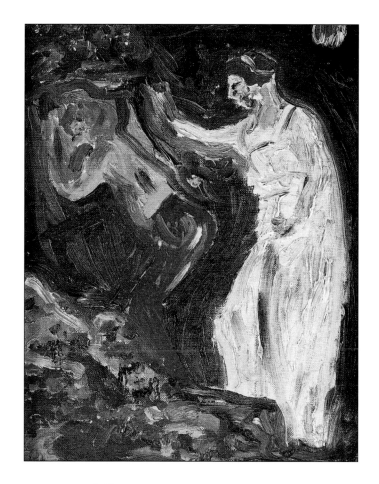

Fig.90 | Kerouac, *GIRL IN WHITE, BOY IN RED*.
Oil, 9" x 12"

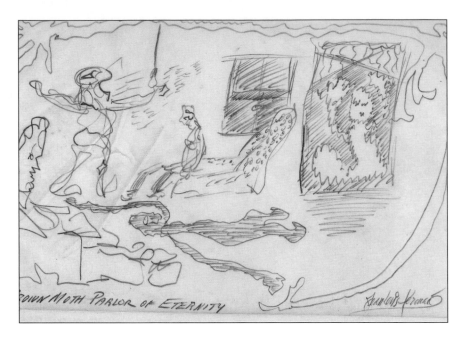

Fig.91 | Kerouac, *Brown Moth Parlor of Eternity.*
Pencil on onionskin paper, 5 ½" x 8 ½"

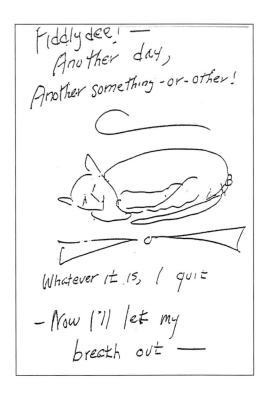

Fiddly dee! —
Another day,
Another something - or - other!

Whatever it is, I quit

— Now I'll let my
breath out —

Fig.92 | Kerouac, Ink drawing, 8 ½" x 11"

right: **Fig.93** | Kerouac, *Two Figures with Ying Yang Cat.* Blue ink and pencil signature
on back of letter from Henri Cru, 8 ½" x 11"

1958

by Jack K.

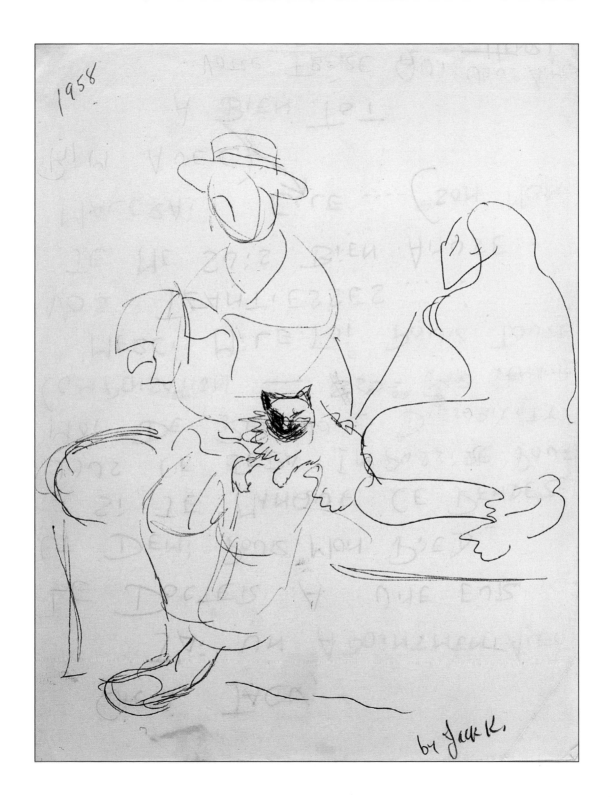

Fig.94 | Kerouac, *CAT HUNT I, FAT CAT*. Pencil, 9" x 12"

Fig.95 | Kerouac, *CAT HUNT II, LEAN CAT.*

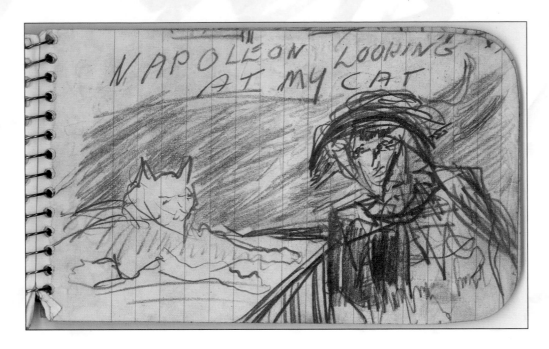

Fig.96 | Kerouac, *NAPOLEON LOOKING AT MY CAT.* Pencil in notebook, 3" x 5"

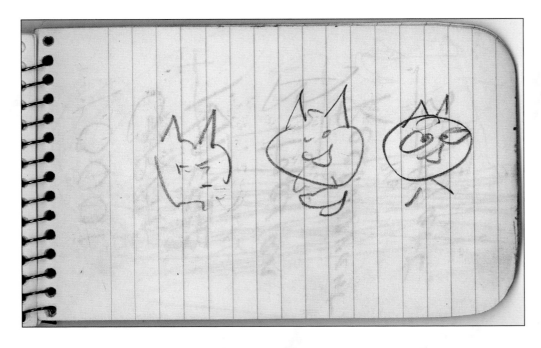

Fig.97 | Kerouac, *THREE CAT FACES.* Pencil in notebook, 3" x 5"

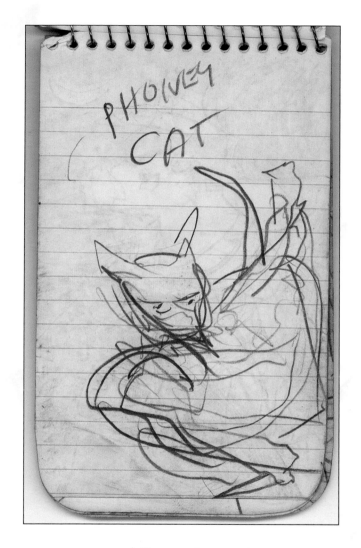

Fig.98 | Kerouac, *PHONEY CAT*.
Pencil in notebook, 3" x 5"

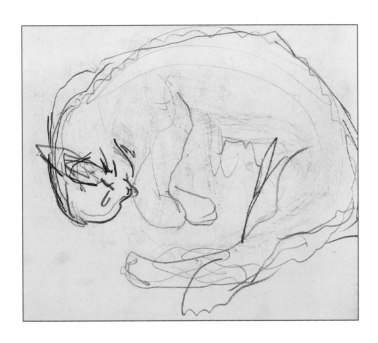

Fig.99 | Kerouac, *SLEEPING CAT.*
Pencil, 9 $\frac{1}{4}$" x 12 $\frac{1}{4}$"

Fig.100 | Kerouac, *SLEEPING CAT II*. Pencil, 9 $\frac{1}{4}$" x 12 $\frac{1}{4}$"

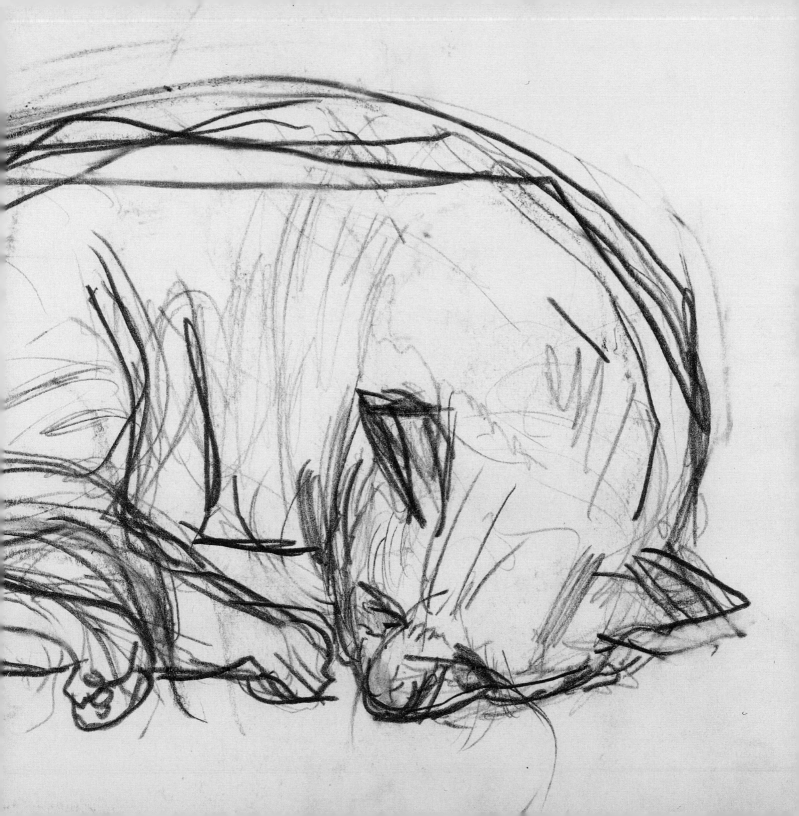

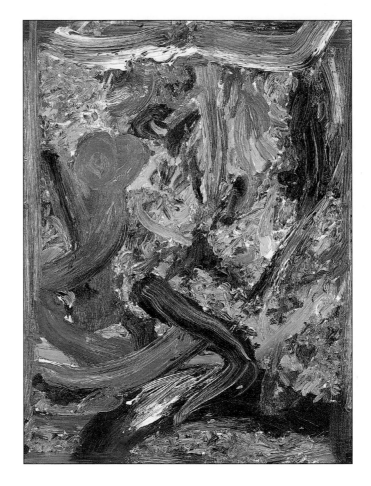

Fig.101 | Kerouac, *UNTITLED ABSTRACT I.* Oil, 16" x 20"

Fig.102 | Kerouac, *UNTITLED ABSTRACT II.* Oil, 16" x 20"

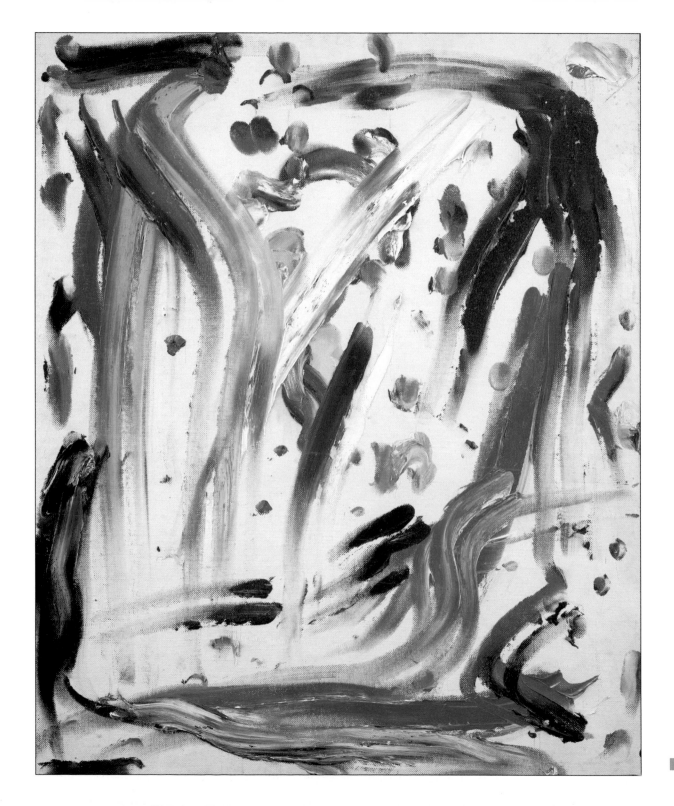

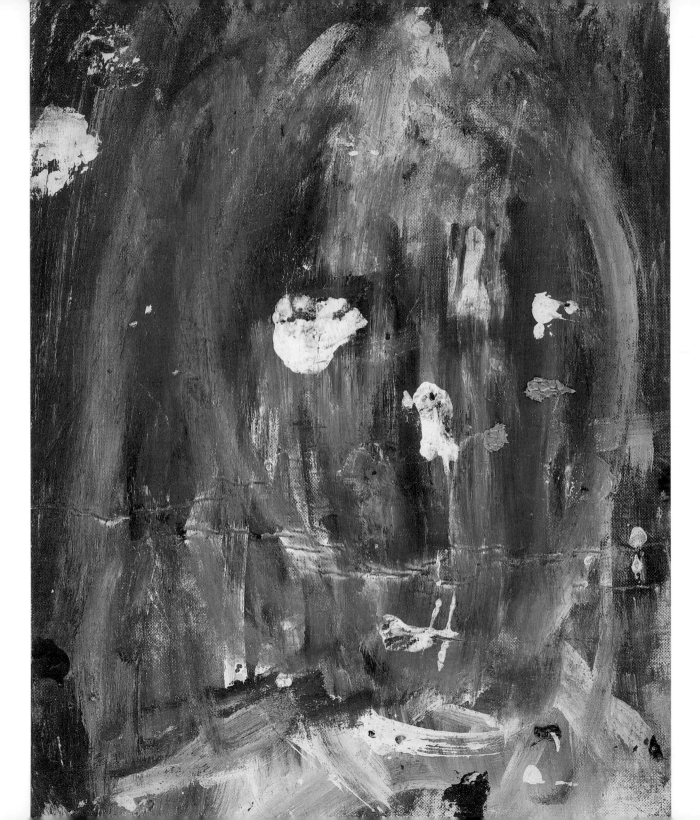

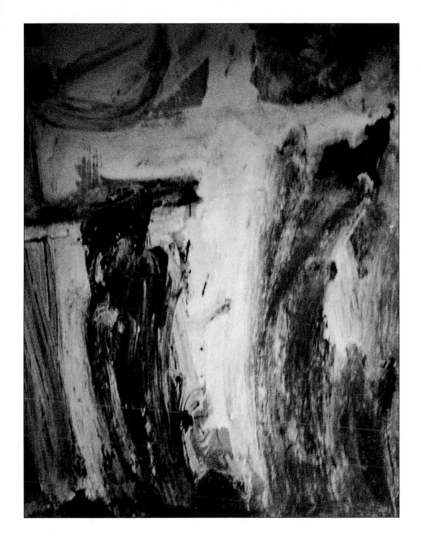

Fig.104 | Kerouac, *UNTITLED (CRUCIFIX).*
Oil, 12" x 16"

left: **Fig.103** | Kerouac, *BIG BLUE OVAL.*
Oil, 12" x 18"

Fig.105 | Kerouac, *UNTITLED 185.*
Ink. 8 ½" x 11"

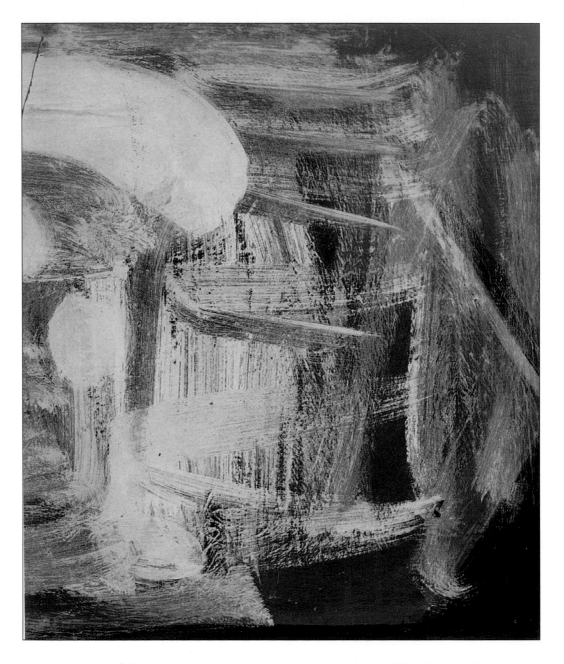

Fig.106 | Kerouac, *RED, WHITE, AND BLUE ABSTRACT*. Oil, 15 ¾" x 13"

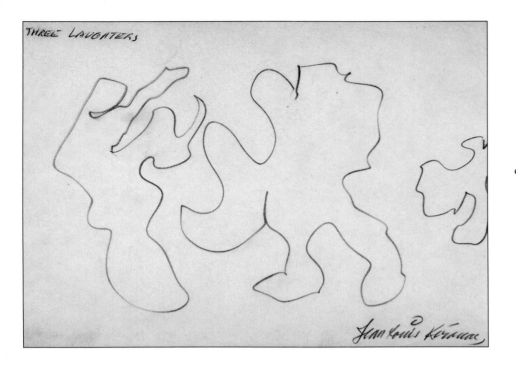

Fig.107 | Kerouac, *THREE LAUGHTERS*. Pencil on onionskin paper, 5 ½" x 8 ¼"

Fig.108 | Kerouac, *WHITE FIGHTERS WITH BLACK REFEREE*. Pencil on onionskin paper, 5 ½" x 8 ½"

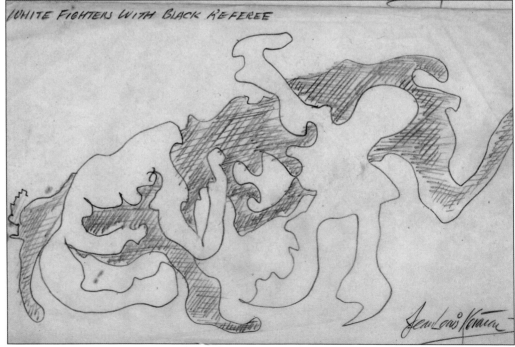

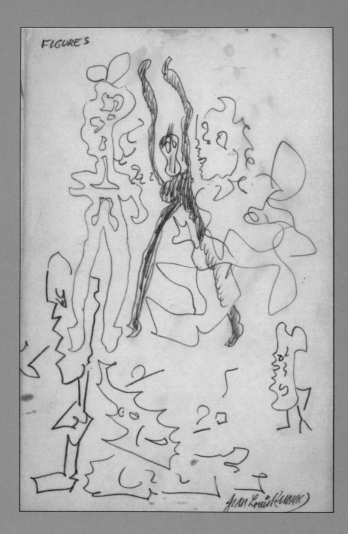

Fig.109 | Kerouac, *FIGURES*.
Pencil on onionskin paper, 5 ½" x 8 ½"

Fig.110 | Kerouac, *ABSTRACTION WITH TWO STARS*.
Pen and ink on paper, 5" x 8"

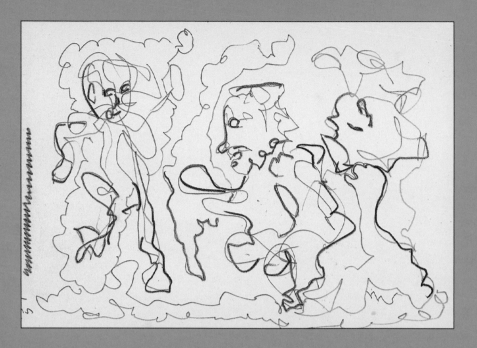

Fig.111. | Kerouac, *THREE DANCERS*. Pencil, 6 ¾" x 9 ½", 1957

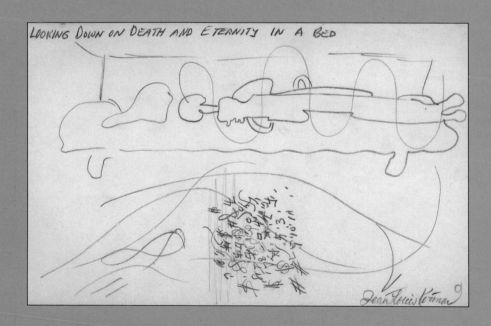

LOOKING DOWN ON DEATH AND ETERNITY IN A BED

Fig.112 | Kerouac, *LOOKING DOWN ON DEATH AND ETERNITY IN A BED*.
Pencil on onionskin paper, 5 ½" x 8 ½"

Fig.113 | Kerouac, *WATERLOO*.
Pencil, pastel, and charcoal, 5 ½" x 8 ½"

Fig.114 | Kerouac, *COSSACK*. Pencil, notebook, 3" x 5"

Fig.115 | Kerouac, *KNIGHT*. Pencil, notebook, 3" x 5"

Fig.116 | Kerouac, *RACEHORSE AND JOCKEY*. Pencil, notebook, 3" x 5"

Fig.117 | Kerouac, *THISAWAY*. Pencil, notebook, 3" x 5"

Fig.118 │ Kerouac, *HORSE WITH HARLEQUIN COLLAR*. Pencil, notebook, 3" x 5"

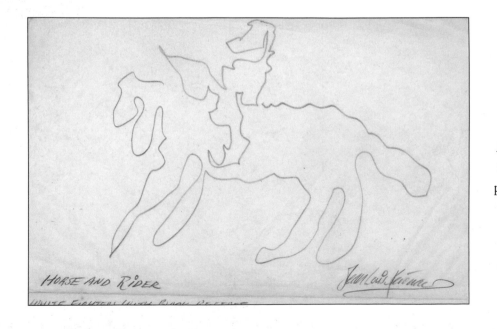

Fig.119 │ Kerouac, *HORSE AND RIDER*. Pencil on onionskin paper, 5 ½" x 8 ½"

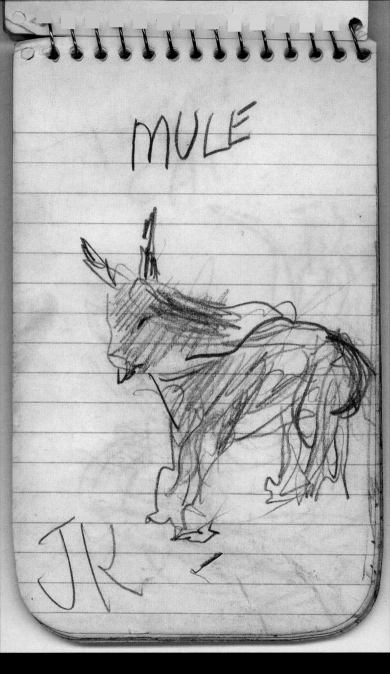

Fig.120 | Kerouac, *Mule*. Pencil, notebook, 3" x 5"

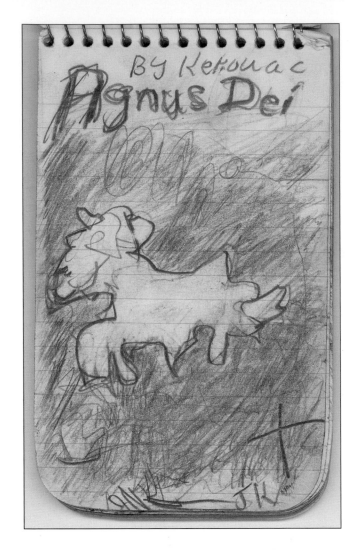

Fig.121 | Kerouac, *AGNUS DEI*. Pencil,
notebook, 3" x 5"

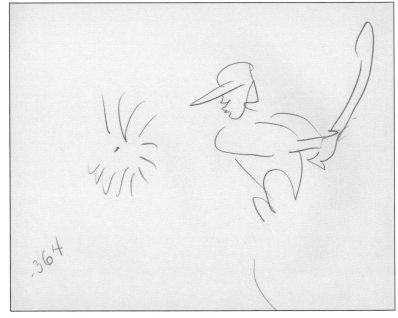

Fig.122 | Kerouac, *.364.* Pencil, 8 ½" x 11"

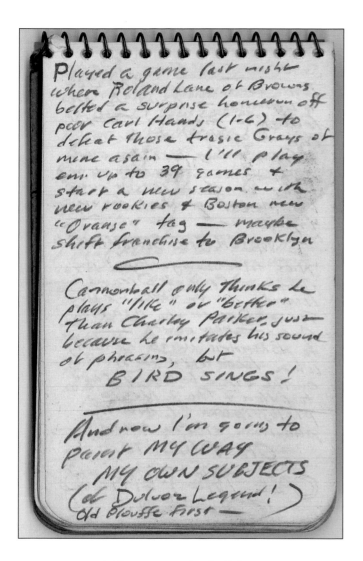

Played a game last night
when Roland Lane of Browns
belted a surprise homerun off
poor Carl Hands (1-6) to
defeat those tragic Grays of
mine again — I'll play
em up to 39 games &
start a new season with
new rookies & Boston new
"Orvaase" tag — maybe
shift franchise to Brooklyn

Cannonball only thinks he
plays "like" or "better"
than Charley Parker, just
because he imitates his sound
of phrasing, but
BIRD SINGS!

And now I'm going to
paint MY WAY
MY OWN SUBJECTS
(of Duluoz Legend!)
Old Blousse First —

Fig.123 | Kerouac, notebook, February 1959

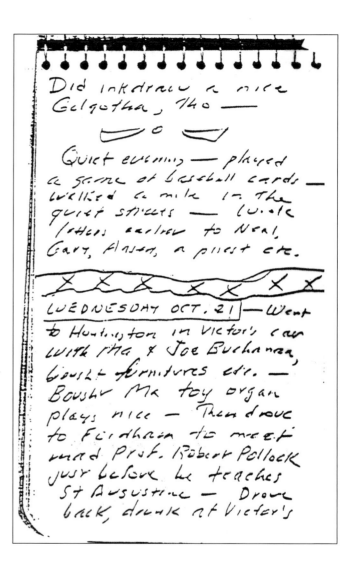

Did inkdraw a nice
Golgotha, 140 —

Quiet evening — played
a game of baseball cards —
walked a mile in the
quiet streets — Wrote
letters earlier to Neal,
Gary, Ansen, a priest etc.

XXXXXX

WEDNESDAY OCT. 21 — Went
to Huntington in Victor's car
with rita & Joe Buchanan,
bought furnitures etc. —
Bought Ma toy organ
plays nice — Then drove
to Fordham to meet
mad Prof. Robert Pollock
just before he teaches
St Augustine — Drove
back, drunk at Victor's

Fig.124

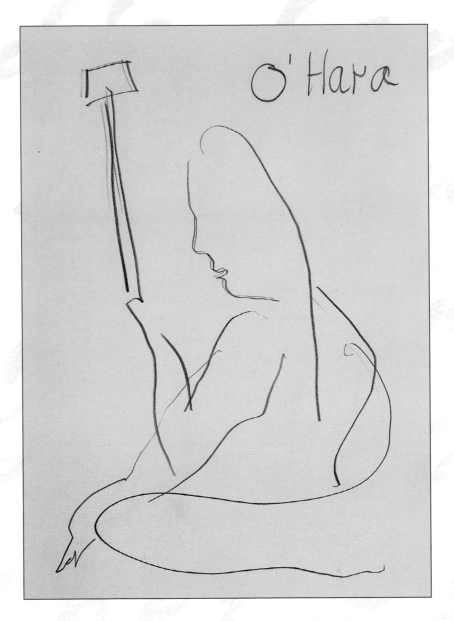

Fig.125 | Kerouac, *O'HARA*. Pencil, 9" x 12"

Fig.126 | Kerouac, *YAYA YAWNING*. Pencil, notebook, 3" x 5"

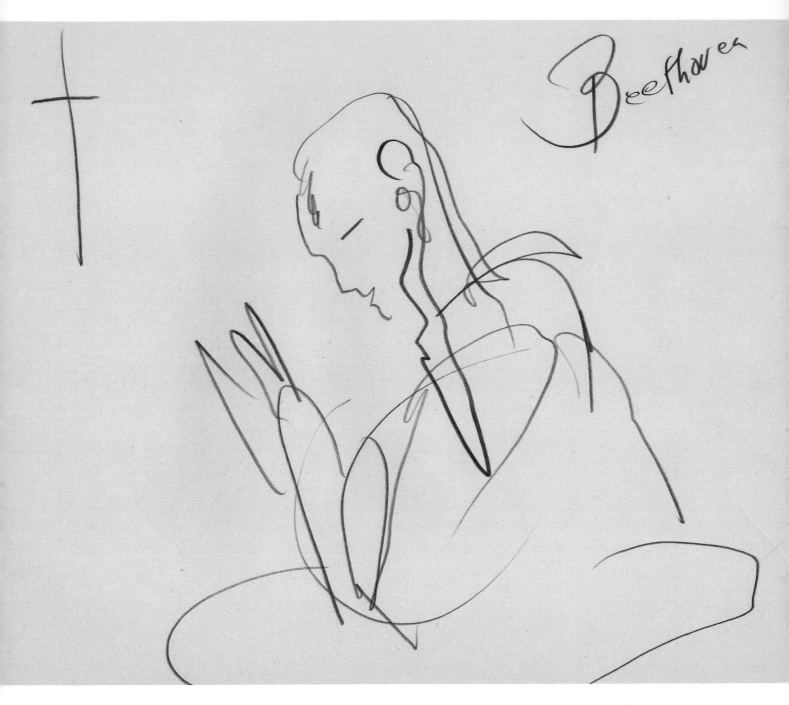

Fig.127 | Kerouac, *BEETHOVEN*. Pencil, 8 ½" x 11"

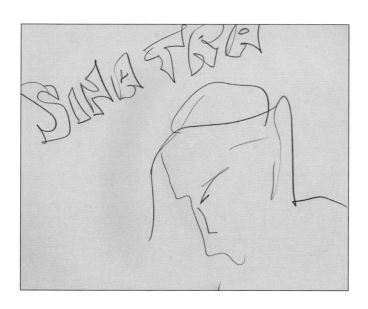

Fig.128 | Kerouac, *SINATRA*. Pencil, 8 ½" x 11"

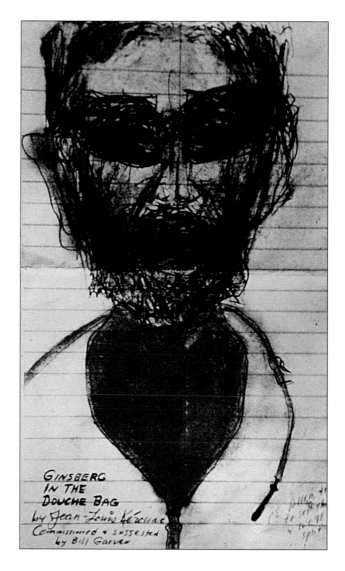

Fig.129 | Kerouac, *GINSBERG IN THE DOUCHE BAG*.
5" x 8", 1956

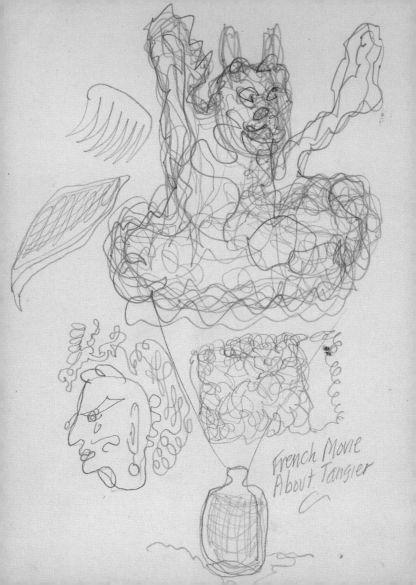

French Movie
About Tangier

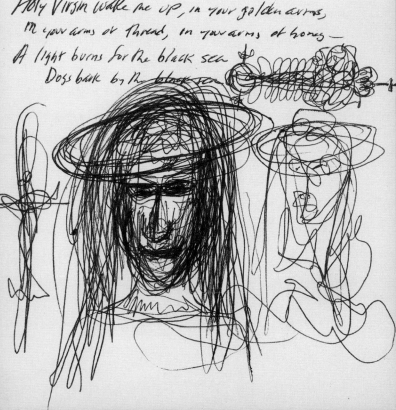

Star of Islam over roar of sea —
Dreaming sleeping Arabs believe—
 Poor bone in a bunk carried here to market hands!
 Poor Sheridan /vstre the ruby cook Prose crowing...
 Lons for thick pocket Prouse whip the Khatiß —

Holy Virgin wake me up, in your golden arms,
 in your arms of Thread, in your arms of honey—
A light burns for the black sea ⚓
 Dogs bark by the black sea

Fig.131 | Kerouac, *STAR OF ISLAM*. Pen and ink on drawing paper, 6 ¾" x 9 ½", 1957

The sighing of the sea near I might listen
Big sound have man are not ya for to be
Either I man ~~~~~~~~~~~~~~~~~~~~~~~~~
Hashi is depressant ~~~~~~~~
symptom is better all ares ~~~~~~~~~~~~~~~~~~~~~~~~
~~~~~~~~~~~~~~~~~~~~~~~~~~~~~~~~~~~~~~~~~~
~~~~~~~~~~~~~~~~~~~~~~~~~~~~~~

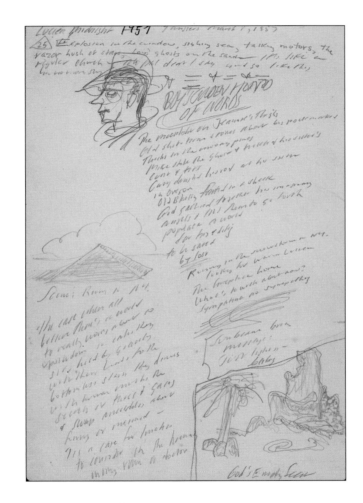

Fig.133 | Kerouac, *LUCIEN MIDNIGHT*.
Pencil, 6 ¾" x 9 ½", 1957

left: **Fig.132** | Kerouac, *THE SIGHING OF THE SEA*.
Pencil on drawing paper, 6 ¾" x 9 ½", 1957

1957

ZOCO CHICO — TANGIERS — a weird Sunday in Fellaheen Arabland with you'd expect mystery white windows & do see how he led the broad up there on white my veil is sitting & peering by a Red Cross, above a lil sign says PRACTICANTES Servicio Permanente
TFNO. ✠ 9766

The cross being red — This is now a tobacco shop with luggage & pictures, a little barelegged boy leans on counter with a Spaniard... Limey sailors from the submarines pass trying to get drunk & drunker yet quiet & lost in brown regret & two little Arabs repeats have a brief musical (boys of 10) & then part with a push of arms & whack of arm, the cat has a yellow skull...

I am now high on Mahoun

MAHOUN

Cakes or Kier boiled with spices & candies — eaten with hot tea — The black & white tiles of the outdoor café are soiled by lovely Tangiers time — A little bald cropped boy walks by, goes to men at table, says "..." then the waiter throws him out, "Yeg" — A brown ragged robe priest sits with me at table, but looks off with hands on lap at brilliant red scene & red girl sweater & red boy shirt span scene

(pencil sketch with handwritten notes: "& this is a pencil vision of it by which Arabs may be seen")

Fig.134 | Kerouac, *ZOCO CHICO*. Pencil, 6 ¾" x 9 ½"

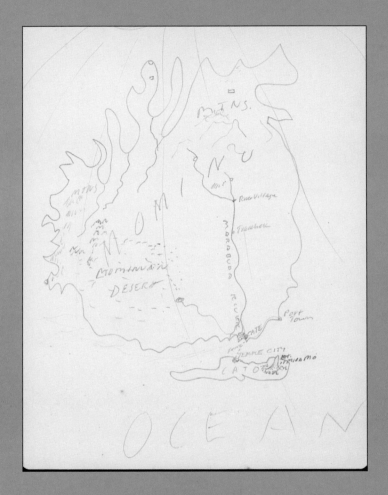

Fig.135 | Kerouac, *MAP OF MOMINU*. Pencil on drawing
paper, 6 ¾" x 9 ½", 1957

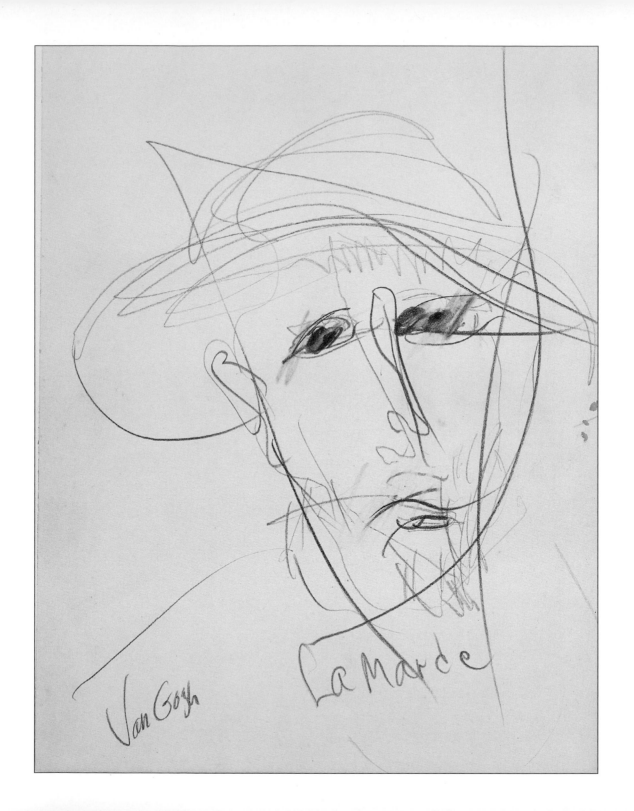

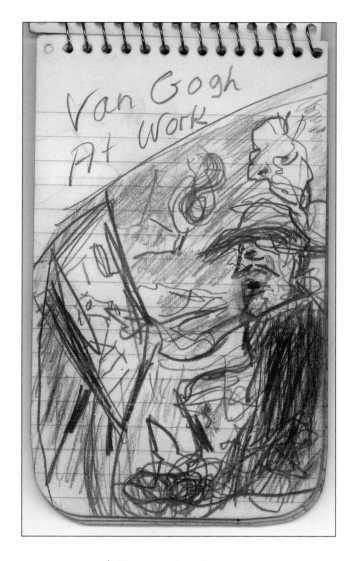

Fig.137 | Kerouac, *VAN GOGH AT WORK.*
Pencil, notebook, 3" x 5"

left: **Fig.136** | Kerouac, *VAN GOGH, LA MARDE.* Pencil, 9" x 12"

Fig.138 | Kerouac, *VAN GOGH THROUGH THE WINDOW.*
Pastel and pencil, 8 ½" x 11"

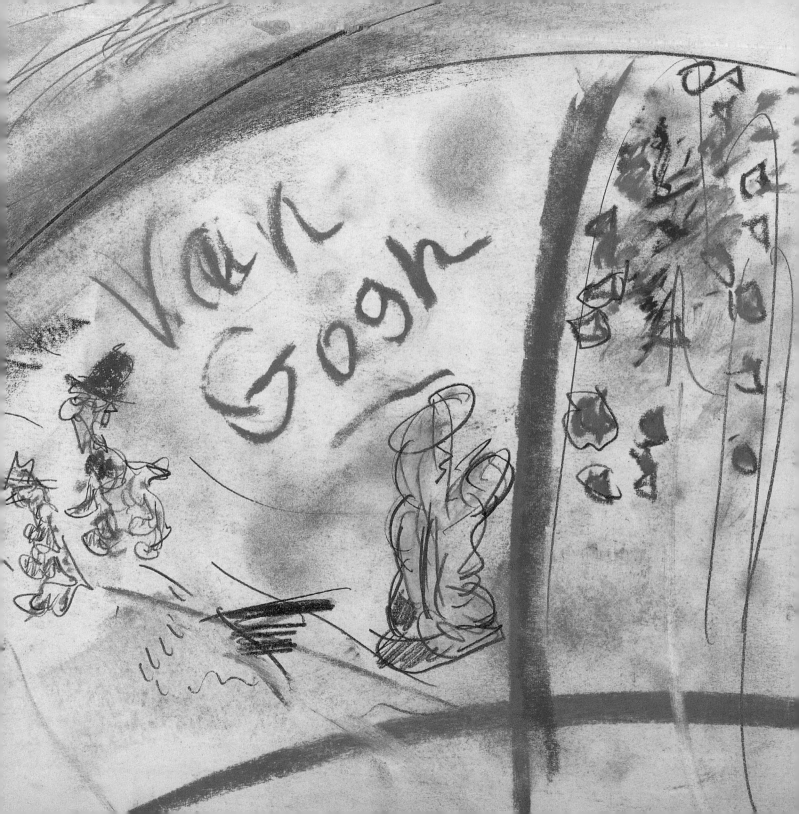

Fig.139 | Kerouac, *WINDOW WITH CAT*.
Charcoal on paper, 4" x 6"

Fig.140 | Kerouac, *NIGHT CANDLE.*
Watercolor and pencil, 9 ¹/₄" x 12 ¹/₂"

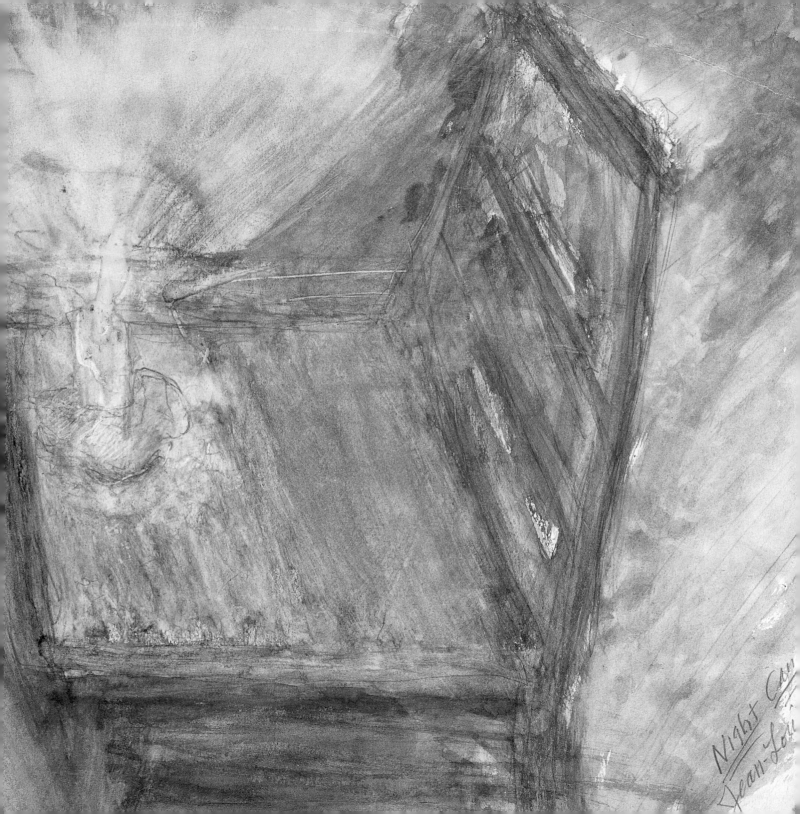

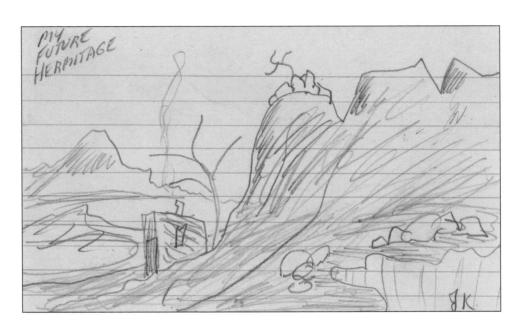

Fig.141 │ Kerouac, *MY FUTURE HERMITAGE*.
Pencil on filecard, 3" x 5"

right: **Fig.142** │ Kerouac, *WINTER EVENING*. Oil and enamel, 12 ¾" x 13"

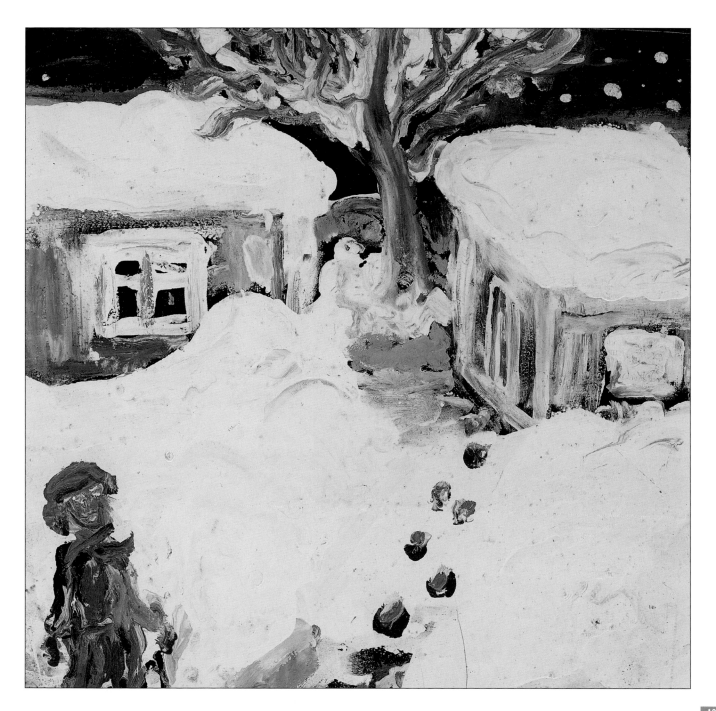

BEYOND WORDS

To Emily, Jake, Ethan, and Layla

preface

Jack Kerouac painted—and sketched—the way he wrote: with spontaneous bursts of raw imagination and little concern for what erudite critics thought of his creative output. Had he not been the celebrated author of *On the Road* and father of the Beat Generation, his brightly colored canvases would likely still qualify as fascinating examples of the alternative artwork of a great writer. Of course, Kerouac today is a literary legend whose stock keeps rising; Sotheby's and Christie's auction houses treasure his art as exquisite paeans to the cultivated primal instincts of an original American prose stylist.

As one learns when reading Ed Adler's *Departed Angels,* like many talented writers—including e.e. cummings, Henry Miller, and John Dos Passos—Kerouac relished the adventure of applying paint to canvas. Encouraged by Willem de Kooning whom Kerouac would visit at his East Hampton, New York studio, Kerouac found great joy in painting and drawing. Reading *Departed Angels,*

and studying the plates, is like peering into the kaleidoscope of Kerouac's mantic soul.

As a great admirer of Kerouac's fiction and poetry, I found this book irresistible. First off, Kerouac had an artistic style distinctly his own. It's hard not be impressed by *Two Figures in the Woods* or *Girl in White, Boy in Red,* and for good reasons. Each Cossack, knight, or eagle he drew emanated from his conviction in the power of art/literature to liberate. Zen-like haikus, bleeding hearts, religious seekers, and paint splattered like jazz notes are all Kerouac hallmarks. Then there are the pure white-black abstracts where Kerouac—influenced by Franz Kline—unlocked his overactive mind and set himself free. During the tense days of the Cold War, even when he was stone broke, Kerouac found time to paint. One can just picture him stirring around at midnight, listening to Coleman Hawkins play "Body and Soul," imagining he is the

masterful de Kooning for a few fanciful hours. It's as if his brush strokes were his redemption swords and the yawning dawn out his window the demon he raced against. His wooden paint box, with "Kerouac" scrawled on its top, is a direct extension of his prose. Once again he was embracing the "Lamb of God" through art.

One of my favorite Kerouac paintings reproduced in this volume is *Old Angel Midnight.* It showcases downtown Lowell as a lonesome town, where clotheslines are connected to redbrick buildings, and the white sheets float upward in the air like angels as the quarter-moon smiles on. All the murky secrets of the haunted Merrimack River seem to be swirling around under the dark sky. And, most notably, the window frames are drawn as crucifixes. The painting is a surreal scene straight out of Kerouac's novel *Dr. Sax.*

What I found most illuminating about Adler's prose in *Departed Angels* is his recounting how Kerouac loved the old masters like Rembrandt and van Gogh. Adler, himself a world-renowned painter and professor of art, informs the reader of the influences derived from Kerouac's friendships with the abstract expressionists of his era. Anecdotes abound about him drinking at the Cedar Tavern with Jackson Pollack, making an underground movie with Larry Rivers, and laughing all night long in Northport, Long Island with Stanley Twardowicz. He also fell deeply in love with gorgeous Dody Muller, hanging out with her at her Greenwich Village loft/studio discussing the mad genius of William Baziotes.

Often, however, when depressed, Kerouac would remember his poignant childhood in working-class Lowell, Massachusetts. He would paint iconographic Catholic symbols such as popes, saints, and crucifixes (pietás). In his unpublished journals, Kerouac talked about his high regard of William Blake, the eighteenth-century British poet who also was an astounding artist.

This brings us to the heart and soul of Kerouac's art: his Blakean association with angels. Kerouac believed that humans were constantly struggling between the Ego and the Holy Ghost (a.k.a. angels). Often, when he painted people, he was dismissing the ego, choosing only to see the angelic in his frenetic friends. All of Kerouac's paintings/sketches, therefore, are mediations tinged with the uplifting suffering of Christ and the Buddha.

So it is that *Departed Angels* is necessary reading for anyone wanting to understand the legacy of Jack Kerouac. It offers revealing "glimpses" into an American prose saint who never yawned, wrote, or painted a commonplace thing. He signed his work, "Jean Louis Kerouac," as if he were the New World's Cézanne, bringing into focus the windblown world in which he always traveled with opened eyes.

—DOUGLAS BRINKLEY

foreword

Thirty-seven years ago, my brother-in-law, Jack Kerouac, moved back to his boyhood home of Lowell, Massachusetts from Hyannis, Cape Cod, where not long before he had moved from St. Petersburg, Florida.

While in Lowell, he hired carpenter David Orr to build shelves in his basement to hold his framed and unframed paintings and his art supplies. It was then when I became aware of his passion for painting, a passion informed by the acquaintances and friends he had met at the Cedar Tavern in New York City in the early 1950s. Previous to the gestural painting he had adopted under their influence, Jack had been influenced primarily by van Gogh and Rembrandt, as can be seen in his Madonna and Crucifixion paintings, and especially in his painting *God,* the colors of which belong to van Gogh.

In 1968, Jack, Stella (his wife and my sister), and his mother Gabrielle moved to St. Petersburg, and took the paintings and drawings with them. The house was sold and a new house they had purchased directly from a contractor, who had built the house for himself, was ready to be occupied. I was at Jack's house one evening shortly before his move to Florida. I was leaving, getting into my car, when Jack came running out with his

arms full of paintings that he wanted me to have, as a gesture of his fondness for me. I gently refused to accept them at the time, saying I was in a rush and would pick them up on a later visit, which never occurred. They left for Florida.

After Jack died in October of 1969, Stella and Gabrielle planned to return to Lowell. Stella was concerned about the safety of Jack's papers, which were subject to the humidity and potential mold so common in St. Petersburg. There was another consideration: thievery. Even while Jack was alive, papers had been stolen from him. In early 1970, Stella and Gabrielle had Jack's paintings moved to Lowell, to a private, Sampas family house. Sometime in the '70s Stella gave me the paintings and drawings that Jack had wanted me to have. Jack's papers and the rest of his paintings remained locked in a room of their own until 1992 when I placed them all in the vault of a local bank here in Lowell. This book on the paintings of Jack Kerouac illuminates a side of his genius whose sensitivity to the nuances of his fellow painters is a revelation. Dr. Adler wonderfully illuminates the connections between Kerouac's paintings and writings that demonstrates the essential oneness of Jack's oeuvres.

—JOHN SAMPAS
Lowell, Massachusetts
April 6, 2004

introduction

The bell rang on the fax machine. I had just started the outline for this book. It was about a month after my first lecture on Jack's paintings and drawings at the NYU Kerouac Conference in May 1995, which was exactly a year after I had co-curated the first exhibit of Beat Generation Art at the 80 Washington Square Galleries as part of the big NYU Beat Conference, which I instigated and worked on in the spring of '94. I was knee-deep in the Beat Generation.

The fax chattered on. It was a letter from Jack, written thirty-eight years ago, apparently addressed to me and all about art.

Kerouac
de le
Village
de
Kerouac
en la
Bretagne
Okay

PS Dear Ed
With you I would very much
like to get drunk tonight!

April 28, 1957
Jack c/o Glassman
554 W. 113 St.
New York, NY

Ho Ed!

Yes my good friend I got your fine letter in Tangier, Morocco less than a month ago and wanted to write to you from Dr. Johnson's house in London when I got there but got too engrossed in the British Museum and staring at El Grecos in the National Gallery so here I am back in NY and leisure to write you. . . . Very interesting, your notes about Buddhist art, in fact in the Brutish [sic] Museum they have a Stupa from the Deccan south India showing empty places for the Buddha in the old sculpture. . . . En route from Tangier to Paris . . . well first, in Tangier are Bill Burroughs who has just written a great book WORD HOARD and Allen Ginsberg whose poem HOWL has just been banned in Frisco. There I had a room overlooking the straits, a patio, for 20 bucks a month, and went mountain climbing to isolated Berber villages, etc. and smoked tea out of pipes with shrouded Arabs in cafes. . . . Then, after Marseilles, I tried to hitchhike through Provence, outside Aix, where Cézanne painted, ended up hiking 20 miles but it was worth it . . . sat on side of hill and pencil sketched drawings of the Cézanne country, dull red rusty rooftops, blue hills, white stones, green fields, hasn't changed in all these years . . . mauve tan farm houses in quiet fertile farmer's valleys, rustic, with weathered pink powder roof tiles, a grey green mild warmness, voices of girl, gray stacks of baled hay, a fertilized chalky horseshit garden, a cherry tree in white bloom (April), a rooster crowing at mid day mildly, tall Cézanne trees in back . . . etc. just like Cézanne nein? Then a rattly old bus through Arles country, the restless afternoon trees of Van Gogh in the high mistral wind, the cypress rows tossing, yellow tulips in window boxes, a vast outdoor café with huge awning, and the gold sunlight. . . . I haven't had chance to tell you but I've begun to paint, hence all the excitement about painting, started in Mexico City last October, first with pencil, then chalks, then watercolor, then paint . . . my first painting: God.—So I went to Paris and in the Louvre stuck my nose up against Van Gogh and Rembrandt canvases and saw they are the same person. . . . I dug Pittoni first, as I walked in, expressive gestures . . . Tiepolo, *Last Supper,* perfect dog attitude at bone, the final white paint touches on Christ's face . . . Guardi, always the Doge, insane for detail and architecture but Canaletto is the master for that *(View of Venice)* splashing light on building and plazas and on corner, one thin line on corner edge (the Venetian 18th Century school) . . . and so on, and thru David, Girodet Trioson, Fragonard, Gros, and suddenly face to face staring at me, a Rubens! A big smoky Rubens *(La Mort de Dido)* which got better as I lookt, the muscles' tones in cream and pink, the rim shot luminous eyes, the dull purple velvet robe on the bed. . . . But ah, THEN, Goya's *Marquesa de la Solana,* could hardly be more modern, her little silver feet shoes pointed like fish crisscrossed, the immense diaphanous pink ribbons over a pink face, a woman a French workingwoman said "Ah c'est trop beau!" . . . but then, walking along thru Gentileschi's little Jesus and Castiglione who paints a raging Christ distantly in a blue robe scourging the vendors in the Temple, throatslit lambs on the floor, confusions of ducks, baskets, goats. . . . Ah then Brueghel! Wow! His *Battle of Arbelles* has at least 600 faces clearly defined in impossibly confused tight mad battle leading nowhere NOWHERE like real life, no wonder Céline loved him! Complete understanding of world madness, beyond which we see thousands of clearly defined figures and swords, above it all the calm mountains, trees on a hill,

clouds. . . . everyone LAUGHS when they see this insane masterpiece, they know what it means. . . .Then O Rembrandt! Dim Van Gogh like trees in the darkness of Crépuscule Château, the hanging beef completely modern with splash of blood paint . . . with Van Gogh swirls in face of Emmaeus Christ . . . the floor (in Sainte Famille) completely detail'd in color of planks, and nails, shafts of light on Virgin's tit. . . . St. Matthew being Inspired by the Angel is a MIRACLE, the rough strokes, so much so, the drip of red paint in the angel's lower lip making it so angelic and his own rough hands ready to write the Gospel (as I will be visited). . . . Also miraculous is the veil [of] mistaken angel smoke on Tobiah's departing angel's left arm. Finally, not least, Van Gogh . . . his crazy blue Chinese church, the hurrying women, the spontaneous brush stroke, the secret of it is Japanese, is what for instance makes the woman's back, white, because her back is unpainted canvas with a few black thick script strokes (so that I wasn't wrong when I started painting God last Fall in doing everything fast like I write and that's it). . . . Then the madness of blue running in the roof of the church where he had a ball, I can see the joy red mad gladness he rioted in that church heart. . . . I have a headache from all this. . . . His maddest pic is of those gardens Les Somethings, with insane trees whirling in the blue swirl sky, one tree finally exploding into just black lines, almost silly but divine, the thick curls and butter burls of color paint, beautiful rusts, glubs, creams, greens, a master madman, Rembrandt reincarnated to do the same thing without pestiferous detail. . . . HISTORY OF ART: from Egyptians & wall cavers to Meissonier-types (where was finally mastered exact imitation of nature) (of DeHooch, Treck, Van Velsen, Kalf and all the Dutchmen and Italians who could do exact silver spoons and hams) back to Van Gogh and Renoir and Degas and Cézanne (Gauguin really a cheap cartoonist compared to these masters), (via Goya, Greco, Velázquez and Tintoretto this movement back), to exact *painting* (not imitating) of nature. . . . So I will paint what I see, color and line, exactly FAST . . . Paint being the holy blood. . . . (St. Matthew's Angel with the smear red mouth MOVED when I lookt!!!)

And of course Ed I visited Notre Dame, Montmartre, etc. all that jive, And so, Ed, another letter later, write to me, and I'll tell you more about Paris than just museums. . . . I had a ball, it is greater than I thought it would be but now I'm going to California. . . . if you want to write to me care of this address pronto, do it by return mail as I am leaving in 8 days. . . . alas, won't pass thru Denver but thru El Paso.

Till I hear from you, as ever sir,
your humble servant
—Jack

Regards to your loved ones.
How's Justin?

By the way, you started whole new movement of American literature (spontaneous prose & poetry) when (1951) in that Chinese restaurant on 125th street one night you told me to start SKETCHING in the streets . . . tell you more later . . . this is big historical fact, you'll see . . . (weird sketches).

And how in Dickens did you know always I wd. become painter somehow?

1958

I didn't know anyone named Justin, couldn't recall being in a Chinese restaurant on 125th Street in 1951, and it wouldn't be fair to take the credit for telling Jack to start sketching in the streets.

And I didn't have the slightest idea that he would become a painter somehow.

The fax, it turned out, was being sent to me by John Sampas, Jack's brother-in-law and literary executor, in Lowell, Mass. The letter was originally sent to Jack's friend, the architect Ed White, back in 1956.

But let me tell you, there was a minute or two there. . . .

—ED ADLER
New York City
September 10, 1996

the northport years

Jack Kerouac took himself seriously as a visual artist and on a number of occasions told friends he would have been a painter if he wasn't a writer. His enthusiasm for art was omnivorous, he drew, he painted, he designed covers for his books, and as he sketched with words, so he sketched with images: organized and deliberate but spontaneous, and supported by typically Kerouac methodically detailed theory. Jack made reference to his drawing and painting when he wrote John Clellon Holmes from Denver:

> I am Reubens and this is my Netherlands.
> I've been drawing pictures of the scene.

and in a letter to Jack from Allen Ginsberg in 1952, Allen wrote:

> Your abstraction is shore superior.
> Save the pastels. I incidentally knew it was yours
> minute I laid eyes on it. Like a signature.

The art world likes neat categories, and among the most recently coined is "outsider art," but in the world of artists Jack was decidedly an "insider." His letter to Ed White illustrates his keen eye, art history background, and decisive critical judgment of the fine arts, and his own technical virtuosity is detailed in his notebook commentary of January 27, 1959 **(fig.3)**:

1. **ONLY USE BRUSH**, no knife to mash and spread and obliterate brush strokes, no fingers to press in lines that aren't real.
2. **USE BRUSH SPONTANEOUSLY**: i.e. without drawing; without long pause or delay, without erasing . . . pile it on.
3. **FIGURE MEETS BACKGROUND OR VISA VERSA (SIC) BY THE BRUSH.**
4. **PAINT WHAT YOU SEE IN FRONT OF YOU, NO "FICTION".**
5. **STOP WHEN YOU WANT TO "IMPROVE" —IT'S DONE.**

Those late 1950s years in Northport, a town on Long Island within easy reach of New York City, were Jack's most prolific as a painter. Kerouac

chronologies list 1958–60 as "writes sketches in Lonesome Traveler," but these were the second generation of Jack's New York years, the same years the Beats frequented the Cedar Tavern in Greenwich Village, also the gathering place of the abstract expressionist painters. Friendships developed between Jack and painters Willem de Kooning, Larry Rivers, Franz Kline and Stanley Twardowicz, who was his Northport neighbor. In those same years, Jack had a romantic relationship with the painter Dody Muller (**fig.2**), who had been widowed in 1958 from Jan Muller, a well-known expressionist painter with an impressive museum exhibition record.

A page in Jack's notebook of February 1959 (**fig.1**) emphatically states, "I'm going to ask Dody to marry me." Above this statement is a sad, questioning paragraph about the nature of God and the universe; written sideways within the dark border of the marriage intention is a lovely, perfect seventeen-syllable haiku:

> I stuck my head
> out the window
> and saw a freighter
> in the spring rain

Jack did ask Dody to marry him, but Dody turned him down. "I would have married him in a minute," she said, "but I didn't want to marry that damned mother of his."

The affair with Dody lasted about two years. It began when Jack broke up with Joyce Johnson, who reflected on her years with Jack in her book *Minor Characters,* and it may be that Dody was the cause of that breakup. Jack was enamored of painters, he held them in awe. Dody remembered, "He liked to sit in my studio and watch me paint." Jack describes the relationship in a letter to Allen Ginsberg of October 28, 1958:

Dody is a painter, a big Alene-Esperanza combination in looks (laughs exactly like Alene) but not frigid like Alene, not junkey like Espy, built better too, great woman, part Commanche Indian and French, a good painter (huge Al Leslie canvases of pink and blue women bathing) (also little tiny ones so big) and is regular barefoot Provincetown and Mexico City Helen Parker sophisticate also and fantastic cook and clean when does dishes, makes kitchen all beautiful with flowers and displays of vegetables and in the candlelight her face is holy and has black eyes and high cheekbones like I like and everybody likes her and is a young widow. And loves me. And I love her. Don't know what will happen. Used to draw pornographic pictures in her notebook which her mother threw into the sea weeping. In other words big Neal-favorite good doll and so fucking sensual I cant believe my good luck. She knows everybody, which is too bad. Altho good because I know everybody too. What a complicated scene is on now, wow, too much.

Al Aronowitz, writer and journalist and in 1958 a *New York Post* columnist who was assigned by his editor to do a hatchet job on the Beats—the editor felt they were a bad influence on his young son—interviewed Kerouac in Northport. Aronowitz found him to be gentle, erudite, a serious professional writer and not at all the menacing hipster his boss expected him to demean in his column. He went on to write the now historic first series of positive articles on the Beat Generation.

In this visit with Jack he was shown an inner sanctum, a room that had been set up as a painting studio, and Jack showed him his work, told him about Dody, and said she was teaching him to paint.

Dody didn't remember doing any teaching. She just remembered Jack spending lots of time at her studio.

The break-up came as a result of his drinking. He kept coming around and most of the time he was all right. He even did some paintings there. But then the drinking got out of hand. It actually got boring to be with him. It was the same thing day after day. Boring to be with Jack Kerouac! Imagine.

The final blow came when he brought a "Bowery bum" to Dody's loft one night. Dirty, in rags, smelly, drunk. When Dody complained, Jack stormed out, but left the bum behind. She didn't know how to get rid of him. It was the last straw. When Jack returned three days later, she "kicked him out for the last time."

What is perhaps one of the art and literary world's least known but histrionically outstanding examples of hyperactivist art criticism followed on the heels of the breakup. Dody had begun going out with Willem de Kooning. They were at a party when Jack and Lucien Carr showed up. Lucien, a friend of Jack and Allen Ginsberg and a charter member of the original Beats-to-be coterie at Columbia, was an admirer of de Kooning's work and asked Dody to introduce them. She told Lucien they were going out for a drink afterward and invited him to join them. He did and brought Jack, who had a "hang-dog look" around his old girlfriend. After a few drinks, they all went back to Dody's loft to cook some Mexican food. Dody was from Texas, and her parents would send her cartons of down-home components for tacos, tamales, and enchiladas. She had the best Tex-Mex kitchen in town.

They began a three-and-one-half day, Bloody Mary-fueled, art-talk marathon, "breaking only to take turns going out for vodka, and sleeping. All four in one bed, no sex, Jack on the end, and he kept falling off."

Halfway into the fourth day, in need of provisions and vodka to extend the party, the three men went shopping. On Hudson Street, they halted at the window of a dry cleaning store. The art work on the sign advertising the cleaning process, depicting a man in a suit, struck Bill de Kooning as so bad it was offensive. The three of them, fresh from three days of vodka and hot taco–inspired aesthetic aerobics, agreed the ugly had no right to exist, and Lucien righteously kicked in the window.

The owner of the store roared out, demanding payment and calling for the police. De Kooning explained that he was the famous painter, Jack, that he was the famous author, and Lucien, that he was the famous journalist. The cleaner said he never heard of any of them. They didn't have enough money between them to cover the cost of the large plate-glass window, but de Kooning had some traveler's checks in his wallet from a recent trip to Italy, which the cleaner took as payment. Jack never had any money on him; Dody remembered Mamere doled it out to him in small amounts. "Probably the one intelligent thing Mamere ever did," she added. She viewed Jack's mother as "the most miserable, wicked, nasty person" she had ever encountered and had some letters from her to prove it.

There is a punch-line postscript to this story. Lucien sent a check to Bill de Kooning shortly afterwards, to reimburse him for paying for the window, since he was the one who kicked it in. Bill didn't want to take

Lucien's money, as he felt he had instigated the inflammatory critique of the sign in the window. At Dody's suggestion, they tore up the check and collaged it back together in the shape of a heart. Then Bill wrote "Stick this up your ass," in the space beneath it. Ironically, when it arrived at Lucien's, the post office had postmarked the envelope with "Report any mailed obscenities to your post office," part of the ongoing censorship and obscenity program so frustrating to American writers in those years when "ass" was still an obscenity. Lucien framed the envelope together with the collage.

Dody recalled some good days with Jack in Northport, where Allen Ginsberg's companion Peter Orlovsky's family also lived. Jack had brought Lafcadio, Peter's brother, a set of paints and he wanted to do a painting of Jack, but the set came without black, a point of great frustration for Lafcadio. Dody explained how he could make a rich shade of black by mixing burnt umber and ultramarine blue. The youthful Lafcadio was amazed and became a great admirer of Dody from that moment on.

Dody, in a conversation in 1995, didn't recall just how much she and Jack talked about art.

He did paint quite a bit, and was serious about it. He was painting Popes—or that one Pope he liked.

His feeling about painting so far as she can remember, was that "he admired, envied, and was awed by the painters."

Dody was Jack's most direct link to the mainstream segment of the '50s art world which came to be known as the New York School. Its key painters were Jackson Pollock, Willem de Kooning, Franz Kline, Robert Motherwell, and William Baziotes; its key stylistic and philosophical theme: Abstract Expressionism. Yet, Jack didn't like or understand Abstract Expressionism, his Northport neighbor painter Stanley Twardowicz recalls.

Twardowicz's studio was one of the places where, as David Amram would say, Jack, when he wasn't writing, practiced the fine art of hangoutology. Another was Gunther's, a local blue-collar bar from where Jack and Stanley, who he called Stash—a Polish nickname— would stumble home after many a night of excessive celebration (fig. 4,5,7).

I would hear Jack out there calling me, 'Stash, Stash' and I'd be in the middle of painting. Then pebbles would start hitting the upstairs studio window—Jack knew I was in there, holding out. Finally, I'd open the window. He'd be out there grinning. "Let's go Stash, time for a couple of drinks." Often I held out, but then threw Jack a fiver—he was always broke—and met him at Gunther's later. There were these times when Jack was in the mood to paint. I remember a really fine Pieta he did at my place. He would draw the image first, then paint it. I tried getting him to work directly with the paint, but he felt better with the security of a drawing to work from. And he didn't like abstraction. I think he tried to understand it, but he had no interest in painting that way. He liked my work—he made one of the best comments I ever heard about it, said I painted with 'kissing colors.' Imagine some art critic coming up with something like that? And he really liked the painters, Franz Kline was his favorite, they were good friends. He did a woodcut at Franz's studio once, I remember him cutting himself carving the wood, his hand slipped. He joked about another inch and it could have altered his sex life. Sex was on Jack's mind a lot. Sometimes it was hard to tell

when he was kidding. There was a lot of good natured ribbing about homosexuality in those days. Once Jack told my wife of that time he would have married her if she wasn't married to me. She said maybe he would be happier if he married both of us. Sometime later, in my studio Jack tried to get me to show him my penis. "Come on Stash," he kept urging, "Take it out, let's see what you've got." "No Jack," I said, "Not until we're married." He liked that, laughed his head off and dropped the subject. That's all you needed with Jack, a good line. He was a writer to the core. He fell asleep in a chair once, and his mouth never stopped mumbling words the whole time he napped. He was writing in his sleep.

It was in those same years that the classic underground Beat film *Pull My Daisy* was made, one of the most enduring examples of a painter/poet/musician/filmmaker collaboration. It was in the spring of 1959. Painter Alfred Leslie was the director and Robert Frank, who had gone on the road with Jack to photograph and publish *The Americans,* was the cameraman. It was all based on a play Jack had written, and the title song was a collaboration with lyrics by Jack, Allen Ginsberg, and Neal Cassady and music by David Amram. The actors were Ginsberg, Amram, Gregory Corso, Peter Orlovsky, art dealer Dick Bellamy, and painter Larry Rivers. Jack did not appear in the film, but his brilliant narration, which

he improvised to Amram's music, was one of the finest parts of the film. He spoke in the personalized, lyrical, improvisational manner he had adapted for the poetry and jazz readings they had begun doing in those years. It was a spontaneous, extraordinary performance on Jack's part. The film had been shot without sound. The music, today a jazz classic, was recorded with Anita Ellis singing the title song. They recorded at the studio of an old friend of Jack's, Jerry Newman. The film was projected, Jack listened to Amram's music on a headset, and in only two spontaneous takes produced a remarkable twenty-five-minute piece of improvisational theater. He refused to go beyond the second take so as not to lose the spontaneity, but at the all-night party that followed, celebrating the end of filming, he jammed into the late hours singing, improvising, and even playing the piano. The filming had been done at painter Alfred Leslie's Bowery loft and ownership of the film still remains in contention. The film is available at a few libraries and film archives, and screenings tend to attract large audiences, spanning several generations.

Photographer John Cohen documented the filming and among the photographs is one of Jack with Rivers, Amram, Ginsberg, and Corso at a Third Avenue coffee shop. After the film they became known as the Third Avenue All Stars, their cinematic legerdemain assured.

the new york school

The poetry and painting of William Blake, the journals of Delacroix, Van Gogh's letters, Gauguin's *Noa Noa,* the paintings of Lawrence Durrell, Henry Miller, Winston Churchill, Bob Dylan, Frank Sinatra, Jerry Garcia. There is rarely an element of surprise at the discovery of paintings, sketches, photographs, prints or other artworks that have been made by writers and poets. The precedent reaches far back into art and literary history. Benvenuto Cellini's autobiography is a grand record of the daily activities, lifestyles, philosophies, passions, and frustrations of the artists of the Italian renaissance. Cellini, in his time, was known as the goldsmith of Florence. Today, he is as often remembered for his first-rate works of literature as for his elegant works of art.

The "discovery" of Jack as a painter has a noteworthy parallel in the story of Vincent van Gogh, who painted for most of his adult life, but was unable to garner any interest in his work and had only one sale to his credit when he came to his untimely end at the age of thirty-six. There were occasional trades of a picture for a drink or a meal at local cafés, but for the most part he was known in Arles, the city in south central France he made his home, as the crazy artist who painted pictures of his shoes and his chair.

Vincent's brother, Theo, led a far more bourgeois life as an art dealer. As much as he tried championing his brother, he could never convince the art establishment that Vincent was the genius he believed him to be. Theo's home in Amsterdam was filled with Vincent's paintings and Theo continued to support his brother, much to the chagrin of his wife, Joanna, who saw Vincent as the hopeless, somewhat mad brother-in-law living off the charity of her hardworking husband. Then Vincent died, and six months later, Theo died. Shortly thereafter, Joanna, Theo's wife of eighteen months, in sorting out Theo's belongings, came upon the big box of letters from Vincent to Theo. Looking through them, she was overwhelmed by the beauty and sensitivity of the prose, the extraordinary perspicacity Vincent had for the world about him, the awesome respect, at times approaching fear, with which the artist viewed nature and the elements, and the great love he had for his brother. Somewhat beyond her ken

was another dimension of the letters, the detailed descriptions of the paintings in progress and of the methods by which he went about painting them. Beautifully rendered sketches were often in the pages of the letters, illustrating the work or places he was describing or planning to paint.

Joanna van Gogh had friends who taught at the university. She showed them the letters and they agreed that they were wonderful and should be published. But where are these paintings he writes about? They should be used as illustrations for the book. The rest is legend.

It does not take a great deal of semantic acrobatics to draw an analogy between Vincent's tale and Jack's. Vincent's paintings were discovered, as it turned out, as a result of his writing. So were Jack's. Now this leads us to a whole other issue : If Jack Kerouac, famous author, had not been the painter of these pictures would we be reading this book? The honest answer is probably no. When we view Jack's art, the question is not whether he is a great painter, but how these paintings and drawings complement and complete Jack's oeuvre

Some people have referred to them as illustrations. If we think of the books as autobiographies, I suppose we could think of the paintings as illustrations for certain events in his life. Jack wanted to be an artist some of the time.

In fact, the Tenth Street galleries, where the first abstract expressionist paintings were exhibited—the Hansa, the Bratta, the Tanager—were where Jack first read his poems to the jazz accompaniment of David Amram in 1957. He wanted to be like his friends at the Cedar Tavern, go into the studio, and make art.

And he did.

So what were these friends at the Cedar Tavern up to? Often, they were arguing about the value of figurative imagery versus the abstract and surrealist. The cultural and political background for these schools of thought in the visual arts grew out of two dissident but not entirely unrelated, highly traumatic world events: the U.S. stock market crash and resultant Depression of 1929, and simultaneous rise of the Nazi party in Germany. The second, indirectly a result of the world depression, was heightened by the battered egos and emotional depression of the German populace over their defeat in World War I, just a decade before.

In the United States, the work of the "Eight," a group of painters in New York and Philadelphia, including John Sloan, Reginald Marsh, and Robert Henri, painted images of the down-and-out visage of an economically depressed America that earned them the nickname "The Ashcan School." In Germany, various movements evolved into "German Expressionism."

While the Ashcan painters focused on lower-class urban cityscapes, evoking the morbid tone arising predominantly from the poverty, unemployment, and general sadness of the scene, the German art focused on the people. Images by painters such as Beckman, Kirchner, and Grosz display the battered psyche of the German citizen in those years. It was the same self-effacing mood that opened the door to the insane, inhumane ideas and wildly ideologized promises of the Nazis and allowed them to become acceptable to a sophisticated, well-educated, and generally moral German population.

Antithetically, in France in those same years between the world wars, artists were producing some of the most beautiful artwork the world had yet seen: it was the time of Picasso, Matisse, and Chagall, whose bright, effervescent paintings were clearly reflective of the glories of Paris and the Cote d'Azur. France was among

the victorious nations of World War I and the frequent use of the tricolor in art by Picasso, Marie Laurencin and others in those postwar years clearly celebrates that fact.

Meanwhile, the French surrealist painters had been delving into the theories of Sigmund Freud, popularized throughout Europe in the 1930s, concerning the workings of the unconsciousness mind. André Breton, a leading French poet, wrote the *Manifesto of Surrealism,* outlining a regimen to adopt the Freudian theories to the arts. After Germany's invasion of France, it wasn't long before stringent wartime censorship and propaganda extended to the arts, to the unprecedented point where modern art was labeled "degenerate" and paintings and books were burned in the streets by the Nazi occupation forces.

An exodus from Europe began. Poets, painters, teachers, intellectuals, all endangered under Nazi rule, fled, and most came to New York City. A few had arrived earlier and settled in the Greenwich Village bohemian enclave. Marcel Duchamp came to New York from Paris at the peak of the Dada movement in 1916. A precursor to Surrealism, Dada evolved from the anger of poets and painters to the loss of life in World War I. It was a calculated art of nihilism and farce, the only art form the artists felt was appropriate for a world insane enough to wage war on itself with the devastating weaponry of the modern age. Reacting to this "insanity," Dada was directed at making absolutely no sense. When Duchamp got to New York, he wrote his friends in Paris, "Dada could never exist in New York, for all New York is Dada," and shortly thereafter submitted a urinal as a work of art to an otherwise conservative exhibition of American painting.

The Bauhaus, too, contributed to an increase in the U.S. artist population. This great Munich-based school of art, where painting, drawing, architecture and commercial design were all integrated, shut its doors when the Nazis took it under their wing. Its faculty included Wassily Kandinsky, who had fled there from the Russian Revolution, and Paul Klee, who taught textile design. Its well-known director, Joseph Albers, emigrated to the United States and became the head of Black Mountain College, the arts-oriented "alternative" avant-garde school located in North Carolina, where experimentation in the arts was born in America. Robert Rauschenberg, Kenneth Noland and John Chamberlain were among the students. De Kooning, Kline, Motherwell, John Cage and Clement Greenberg were on its faculty at one time or another. There were so many European intellectuals teaching at the school, the local townsfolk reported to the government that it was an enclave of German spies.

And to New York from Paris came André Breton and his *Manifesto,* and a formidable group of surrealists would follow: Marc Chagall, Salvador Dali, Max Ernst, Fernand Léger, Jacques Lipchitz, André Masson, Roberto Matta, Piet Mondrian, Amédée Ozenfant, Yves Tanguy, and Pavel Tchelitchew. By the end of 1939, almost every important painter had abandoned Europe, with the very noticeable exception of Matisse, who remained cloistered in the south of France, and Picasso who would not budge from Paris. They both calculated that the German army would leave them alone and they were correct. There is the story of a German officer who, visiting Picasso's studio on the Rue des Grandes Augustins and seeing the painter working in gloves and a scarf, offered him an additional ration of coal, which Picasso refused. Then the

soldier saw a reproduction on the wall of *Guernica,* the well-known painting Picasso did for the Spanish Pavilion of the 1937 World's Fair. It depicted the horrific slaughter of civilians when the Germans bombed the town of Guernica, a nonmilitary target in northern Spain, at the height of the market day. It is considered one of the world's most important antifascist, antiwar paintings. The German looked at it and said, "You did this?" "No," Picasso replied, "you did."

His paintings during the war years were noticeably different. Grim, angular, dreary, they depict skeletons, black cats, morbid still lifes, nightmarish visions. "Art should be like a machine gun," he said, "to shoot down fascists . . . But, you don't have to paint a gun to make an antiwar statement, an apple can do as well."

Meanwhile, America was in the throes of the Great Depression. President Franklin Delano Roosevelt had established the Works Progress Administration, the WPA, to provide jobs. Included in this program were the Easel Project and the Mural Project. An artist would be paid $38.00 a week to either paint murals on public buildings as part of a team, or work independently and bring one painting a month to a government office. Just about all of the artists who would become known as the New York School the abstract expressionists—worked in the program. An ironic epilogue was that when it was all over, the thousands of WPA paintings were sold to a plumbing contractor who used them to insulate pipes. An element of aesthetic revenge manifested itself when the heat from the pipes caused the oil paint on the canvases to give off noxious odors. The remainder were sold from a surplus store on Canal Street for twenty-five cents each. Among them were paintings by Kline, Gottlieb, Motherwell, Pollock, and the like.

It was into this cultural climate that Breton and company arrived. American painters had formed a community centered around the WPA office, where one went to drop off paintings and pick up checks, a few local bars, and the Artists Club, where Friday night forums and panel discussions were held. Hans Hofmann's school, too, was a popular gathering place for artists where, after hours, many a heady discussion of modern art would take place. Hofmann had come from Munich and opened his school near Sheridan Square in the Village where he would expound upon his complex theories of abstraction and color. In the summer the school would relocate to Provincetown, Massachusetts, a small art colony on Cape Cod.

Most significant, perhaps, is the fact that these painters had no market for their work. There were virtually no customers for paintings in those hard times except the government bureau, which made no judgmental determination, merely accepted what was brought. And so the artists had no immediate financial pressure or need to produce salable work. There was rent money and food money, so they could afford to experiment. Breton's manifesto determined that the Freudian link to the unconscious for both artists and writers was best achieved through the process of Psychic Automatism: automatic painting or automatic writing, based on the Freudian method of free association. In painting, one lets the hand and arm move of its own unconsciously guided volition, rather than by cerebral calculation. In writing, this was the origin of stream of consciousness: let the words fall as they may. The operational word was "spontaneity." We begin to see here a more than close parallel to Kerouac's spontaneous prose, and the defining characteristics of Jack's painting and drawing in relation to his writing.

To see how painters experimenting with the psychic-automatic methodology would lead to the nonfigurative, free flowing, action painting nature of Abstract Expressionism requires no great stretch of the imagination. Pollock is the perfect case in point; however, there is in Pollock's background a secondary influence that at first seems to contradict the Breton theory, but on further examination, reinforces it.

Pollock studied at the Art Students League in New York with Thomas Hart Benton, among the greatest of American mural painters. Like Pollock, he was a rugged individualist capable of hard work and hard play, quick to pick a fight in a bar, and dedicated to art. Hailing from Missouri—where his grandfather was the state's first senator—he shared Pollock's western gunfighter personality. Benton painted figurative depictions of American folklore and legends. Those who studied with him, like Pollock, learned to paint Benton-like realism, but there was an element in the Benton process that reflected back directly to the surrealists, to Breton, to Psychic Automatism. The flowing, rhythmic composition of Benton's style was established in the first moments of the painting's genesis. Benton, as his initial step in a painting, would allow his brush or charcoal to freely roam about the canvas, forming large and small elliptical spaces. One could link them to the subtle complexities of Cubism but what they did was to establish an elementary framework for Benton's muralistic tales of American life. With this infrastructure as a foundation into which he drew the elements of the story, the work was assured a cohesive, rhythmic composition. The activity was pure Psychic Automatism and the result was a harbinger of the Abstract Expressionism to follow. Pollock, after following a long trail of figurative art,

ultimately would return to Benton's first step in establishing the individual iconography with which we associate his name. Of course, Pollock took this image to another level, by ladling multiple layers of swirling, dripping paint upon each other, enhancing, enriching and synthesizing the simple Benton presketch idea with the Freud-based psychologized surrealism of the Benton manifesto.

In Bernice Rose's book on Pollock is a poetic notation of Pollock's outlining his theory of painting:

Technic is the result of a need - -
new needs demand new technics - - - - - - - - - -
total control - - - - - denial of
the accident - - - - - - - - - - - - - - - - - -
states of order - - - - - -
organic intensity - - - - - - - - -
energy and motion
made visible - - - - - - - - - - - - - - - - -
memories arrested in space
human needs and motives - - - - - - - - - -
acceptance - - - - -

In Dennis McNally's biography of Kerouac, he sees Jack as a "close brother" to Pollock, "who shared a virtually identical aesthetic" with less concern for the formal aspect of the work than for the emotional and sensual. McNally describes the parallels in their lives, and includes Jack's musician hero Charlie Parker as part of their revolutionary coterie.

All three men were working class sons of matrifocal families who refused to "adjust" to the conformist society of mid-century or the accepted styles of their disciplines, and for their efforts were labeled psychopaths and falsely associated with violence. Each

ignored the critical authorities in their field and stood emotionally naked before their audiences, spewing words, notes, or paintdrops that were like the fiery rain of a volcano: The rain captured the passing moment in a luminous veil of particulars that depicted the universal as an expression of the artist's own self.

Robert Motherwell, a close friend of Pollock, is credited with prodding Pollock to experiment with the automatic painting technique, thereby setting off what would become the first significant change in pictorial space since Cubism: overall composition. In later years Motherwell became a prolific writer and editor on art and for many years a member of the art faculty at Yale. He saw automatism not far removed from doodling but with the maintenance of some degree of control. His own resistance to giving over entirely to the unconscious, instead preferring to combine creative freedom with some rules of order, manifested itself in his paintings, which clearly denote a balance between chance and control.

Even the most definitive art movements have a way of dividing in two aesthetically theoretical directions. They can be generally classified as "classic" and "romantic." In modern art history, Gauguin personifies the classic and van Gogh the romantic. In antiquity: Apollo, the classic, and Dionysus, the romantic; and the abstract expressionists could divide their ranks at the same fork in the road. The classic model was fulfilled by the controlled work of the color field painters: Barnet Newman, Mark Rothko, Adolph Gottlieb, Morris Louis, and Helen Frankenthaler; the romantic, by the "action painters," the gestural artists, Pollock, Kline, de Kooning, and Guston. But there are some painters like Motherwell and Still that simply do not fit neatly into either category, they fall somewhere between. There are theories that analyze these differences and account, too, for the "in-between" category, by attributing the characteristics of the painting styles with the workings of the dual hemispheres of the brain: the bicameral mind. In this psychologizing of the process, the classic painters are those with dominant left hemispheres—the side that governs logic, reading, writing, and arithmetic. The romantic are those governed by the right side: sensuality and spiritualism. Those in the center, like Motherwell, have a well-developed "bridge" between the hemispheres so that both sides can act simultaneously—not uncommon, but still a significant minority. Kerouac was without doubt in this gifted group, as demonstrated in so many of his writings, which alternate between genuinely free-wheeling spontaneity and masterful control.

Another Cedar Tavern painter, soundly ensconced in the gestural, action-romantic group, Willem de Kooning, focused on the theme of "woman" throughout his long career. His nervous, highly energized lines and zags define the concept of Abstract Expressionism while looking back to the very best of Surrealism, as the image of a woman created of pure sexual energy emerges from the frenzy of the paint: order out of chaos. Apollo rules over Dionysus, but it is the Dionysian image that dominates the work,

On the other hand, another painter from the Cedar group, Mark Rothko, leaves no recognizable sensual object on the canvas. His works evolved into a highly personal language based on rectangles of hazy-edged blocks of colors. They deal with space, contemplation, equilibrium, perhaps meditation. In 1948, he stated he wanted to isolate his work from associating with "any particular visual experience" and he wanted to

eliminate "all obstacles between the idea and the observer." Adolph Gottlieb said of the painter's life in the Depression years: "The situation was so bad that I know I felt free to try anything, no matter how absurd it seemed. What was there to lose?"

His early pictograph paintings aimed to be "tragic and timeless," yet evolved from ancient mythology and American Indian art into the image with which Gottlieb has become identified: the blazing circle of a red sun above, and a black, irregular, sometimes jagged oval of an earth below.

Barnet Newman met great resistance, even among his peers, with his large, flatly painted canvases, interjected with an occasional contrasting color vertical line. The overall nature of the vast field of color on the work has been related to Pollock's overall handling of space, but the limited imagery opened the work to limitless critical interpretation. Artists in those days talked of achieving the "zero" in painting, in a sense, the "last" painting. Harold Rosenberg saw Newman "pushing painting as near as possible to extinction." He believed that art would survive "as an act of faith rather than as a normal attribute of modern culture." Newman brushed off much of the rejection within the art world with the explanation that they simply didn't take him seriously because he wasn't on the artists' WPA project as he had worked in his family's clothing business during the Depression years.

Larry Rivers, who knew Jack well and played a starring role in *Pull My Daisy,* fulfills the model renaissance-man requirements quite well. A musician who played jazz and wrote poetry, Rivers studied with Hofmann and then, during a period in Europe, moved to a figurative style. When he returned, New York was in the heyday of Abstract Expressionism and Rivers successfully synthesized the two aesthetics. A close friend of poets and writers Kenneth Koch, John Ashbery, and particularly Frank O'Hara, with whom Rivers collaborated on several works, the Cedar Tavern was his hangout. He reflects upon those days in a chapter of his book *Drawings and Digressions*:

By the early fifties American painting had suddenly become an international commodity. There was burgeoning art activity. . . . Culture no longer had to be found in Europe. And one little microcosm that represented that whole thing was the Cedar Tavern on University Place. When you went to the bar de Kooning was there and Franz Kline, and Milton Resnick, and every writer who wrote about art . . . everybody would come down. That was the place to go—it was a scene. It was absolutely fantastic in that way.

the beat poets

The Beat poets were quite different from Frank and John and Kenneth [O'Hara, Ashbery, Koch] who, probably without saying it, considered themselves aristocrats. These poets considered themselves the poets of the people, or the poets of the lost souls of the world. They identified more with the junkies or the poets who had hard times. . . . But at the same time so much attention was paid to them that the others were forced to acknowledge their existence.

Larry Rivers, *Drawings and Digressions*

Whether it was triggered by the close association with the painters, or a vast creative appetite that couldn't be satisfied in one dimension, the Beat writers and poets almost unanimously took a serious approach to drawing and painting and, in Allen Ginsberg's case, photography. Allen's photographs have now been published in several books and exhibited widely in America and Europe, including the American pavilion at the 1995 Venice Bienale and major exhibitions in the fall of '95 and '97 at New York's Tibor de Nagy and Howard Greenberg galleries. His collection of photographs of the personalities that crossed his life are professionally catalogued and organized and number in the tens of thousands. It begins with the "drug store" snapshots of the 1940s and grows more professional in later years as it changed from a matter of just "taking pictures of his friends" to an art form incremental to his poetry. Allen spoke of photography recording the sacred friendships and sacred places of his life and of incorporating Buddhism into his photography. It is a means of "keeping things alive beyond their moment." His attitude toward photography was the same as towards his poetry: "seriousness, sincerity and affection" and to achieve "a melancholy but delighted sense of the moment. From the Buddhist view, everyone has the quality of sensitivity and generosity so the function of the artist in the role of Bodhisattva is to help other people recognize their own mind and heart."

He cited the first 120 pages of Kerouac's *Visions of Cody* as "pictorial quick flash sketches" and talked of "open form free style imagist aesthetics in poetry coinciding with the photographs, like in Robert Frank's *The Americans*." He credited Frank with being his

photography teacher and described his own work as "urban imagery, discontinuous, nonlinear but still coherent . . . as photographer you have the opportunity of presenting the pattern of your own consciousness."

William Burroughs painted for many years, has won general acceptance as an artist, and has had numerous shows at the prestigious Gagosian Gallery in New York. His friendships with artist Bryon Gysen led to "cut-ups," which were intended as "writing" experiments but effectively lean toward a Dada-like collage imagery. He would later adopt a shotgun as a painting tool. A can of paint would be placed on a bench in front of a wood panel. When the can was hit by the shotgun pellets, it splattered the paint onto the wood, blowing a pattern of holes along with the color. It was unique as art and uniquely Burroughs. His interest in firearms led to the small Hanuman book *Painting and Guns*. Quite in tune with contemporary art, Burroughs's last paintings were made with a variety of materials.

Most of the painting I've been doing now is on paper. It's got to be slick paper, I want the colors to run around. I've done a lot of painting with my hands. Then I did a whole mushroom series. Taking a mushroom, a toadstool, sticking it in color and using it as a paintbrush. I hate the limitation that says, "You can only do it with a brush." I say, "What's this shit?" There's so many ways: spattering, marbling, strips of paper, rollers, Pollock's drip can device, the Rorschack method . . . all these randomizing techniques. I got some good mileage out of them mushrooms.

Lawrence Ferlinghetti was a painter before he became a writer. His master's thesis at Columbia was about J. M. W. Turner and he later studied art at the Sorbonne, where he earned a Ph.D. With twelve books of poetry and four novels, his City Lights Publishing Company (a heroic venture and a great success) and his City Lights Bookstore, one of the inner sanctums of the San Francisco intellectual community, Ferlinghetti has long been a legend of the literary world. And the legerdemain has extended to the fine arts. With numerous gallery exhibitions behind him, Lawrence has had one-man shows at the Baltimore Museum of Art, the Palazzo delle Esposigoni in Rome, the Museum of Fine Arts in Boston, and continues to paint and exhibit.

It was hard to find anyone who looked "beat" at the last great Beat revival meeting, the NYU conference in 1994. The speakers and the audience were generally traditional in clothing and hairstyles and one could hardly see a beret or black turtleneck in the crowd. But with Gregory Corso, born on the corner of Bleecker and Macdougal Streets and then still firmly ensconced in the heart of Greenwich Village, the spirit and the image and the volatile, unsettled lifestyle of the Beat poet endured. Not necessarily, however, that of the performer. As he told me follwing that event,

You write from someplace deep in the heart and people expect you to get up and just read it. So before I read I have a few drinks, then I get up and clown around a little and everyone thinks, isn't Gregory funny?

And often he was, adding a light but very profound touch, a bright, eyebrow-raised smile to some very serious events. There is never a question as to the deadly, head-on earnestness of Corso's work, and so it is evident on first happening upon a Corso painting: There is joy and there is a solid take on reality, a *joie de vivre* in the *raison d'être*. His work in color takes full breadth of the medium. Brilliant, and owing maybe a bit to

Matisse and Dufy, Gregory takes it his own way and into his own ever–Beat territory. Some have been used as illustrations or covers for his books, many are in the collection of his publisher and his friends, sold, borrowed, or given as gifts. In the nineties, he was using pastels, studying the work of Redon, with an eye on Paris where this kind of romantic visionary art finds space readily in the small galleries of the Left Bank.

The first major exhibition of the art of the Beat poets was at the 80 Washington Square East Gallery of New York University in May 1994. Along with the paintings of Kerouac, Burroughs, Ferlinghetti, and Corso were works by Ted Joans, who has lived for many years in Paris, Jack Hirschman, Jack Micheline, Peter Le Blanc, Kristin Wetterhan, Stephanie Peek, Harry Smith, Charles Gill, Stanley Twardowicz (Jack Kerouac's good friend and painting buddy), and Michael McClure. McClure, a major figure in the San Francisco poetry establishment, pursues a second career as a painter. His paintings generally synthesize abstract and natural forms and, in so doing, connect humanity to a larger, more universal aesthetic. There is a strong, not easily expressed relationship between his poetry and his painting, and he has articulated his views on painting and drawing in his book *Lighting the Corners.*

Kerouac had learned from his tradition-laden orthodox French-Canadian Roman Catholic religious background that he could expect plenty of suffering and misery on the road ahead. The nuns at St. Louis de France in Lowell, Massachusetts, had reinforced this dark side of life, and the loss of his brother when he was a child, his best friend Sammy Sampas in the war, and his own problems with health and rejection upheld the prophecy through a good part of his life and work. Later, in Buddhism, he would find the ways to deal with the suffering. He wrote, "Jesus should have traveled to Asia and learned Buddhism, then his ego would never have allowed him to be crucified and we all wouldn't have to suffer so much." Despite Mamere's wrath at Jack's adoption of these "pagan ways," he would pursue the study of Buddhism, write his *Life of the Buddah, Dharma Bums,* and *The Scripture of the Golden Eternity* as well as numerous articles, and as he celebrated Christianity in his drawings and paintings so would many of his artworks reflect the images of the Buddha. Picasso has been quoted as saying, "What do they mean by religious art? It's an absurdity. How can you make religious art one day and another kind the next?" With Jack the question might be, how do you paint Christian art one day and Buddhist the next? The fact is Buddhism

works well as a philosophic, focused orientation to everyday life. If Christianity is providing the "whys," Buddhism leads to the "why nots" Christianity preaches of sacred rituals and laws. Buddhism reaches out to sacred friendships and sacred places.

It was the stuff of which the Beat Generation was made. Allen Ginsberg once spoke of Yeats making "little portraits of people in their sacred places . . . portraits of people in little corners where they do their work." What makes this image so filled with rich sentiment is our attention to it. Allen explained, "The most boring part of this room can become interesting, take the corner of the ceiling. If we really concentrate on it, examine it, think about it, study its angles and its shadows and the play of light . . . even boredom can be interesting," he concluded, "if we examine it thoroughly."

In one of the small pocket notebooks that Jack always carried, he commented on the empty moments in life (fig.6):

The void is not concerned
about the birth and death
of birds and men
and neither are the

principals thereof,
as we'll all see
in the end,
which is now, the beginning,

The Primordial Dawn
of Eleven O Clock
Today

All these activities
are mindless ————-
And so, walked 2 miles
to liquor store, bought booze
painted THE EYE *
(in the Eagle) * completed *
G I R L ——— * finished
typing up BOOK of SKETCHES

In one 3" x 5" pocket notebook page, Jack has taken us through a categorical rejection of Western religion. Then, with an existential vault, he enters the pragmatic arena of Buddhist mindlessness and, thus empowered, it is on to the real stuff of life: booze, painting, and the culminating moment for the writer: typing up the book.

self portraits

It is not a question of good painters and bad painters, he [Picasso] loves all painters——or almost all: and he respects them even in their errors. Because in this vocation, he says, there is a kind of madness that deserves to be taken into consideration. . . .

Jack's artwork reflects a wide range of art history all the way from Renaissance angels to de Kooning's women. This in no way infers that his work was overly derivative or lacked originality or creativity. The genesis of most artistic creativity is rooted in precedent, tradition, and influence. Then, through the idiosyncratic catalysts of environment, education, and personality and any number of ineffable qualities, it is molded into a personal iconography: the "style" of the artist.

Picasso expressed this aspect of art well:

What does it mean for a painter to paint
in the manner of so and so or to actually imitate
someone else? What's wrong with that?
On the contrary, it's a good idea. You should
constantly try to paint like someone else.

But the key is, you can't. You would like to.
You try. But it turns out to be a botch. . . .
And it's at the very moment you make a
botch of it that you're yourself.

Picasso was aware that just about every painter in Europe and the United States was following his lead in the 1930s, 1940s, and 1950s, until Abstract Expressionism broke the hold he had in setting world art trends. Picasso knew of what he spoke, having evolved through Post-Impressionism to African masks, classical figuration and, late in life, studies from Valasquez.

But Jack's work shows evidence of a number of influences that have little bearing on the art world. Like his writing, we have every reason to believe the paintings and drawings have autobiographical connections and, as his "rules of painting" dictate, his belief in spontaneity also extended to the visual arts.

"Paint what you see in front of you, no fiction" is his rule number four. And in a sketch that Jack did while serving in the merchant marines (fig.8,9), we see Jack drawing himself, in the mirror no doubt, as it pictures

him drawing with his left hand and the shirt is buttoned in the wrong direction. The deep, thoughtful dark eyes, the athletic shoulders and neck, the ubiquitous plaid shirt, are all Kerouac trademarks. At the upper right is a lightly rendered sketch of what is very likely Jack's face. There is historical precedent for a small sketch, often in the border of a picture, as a "quick study" of the features, and left in the finished work as an example of "process." This may also explain why Jack thought of this drawing as "weird." At the bottom right is written in Jack's hand, "weird self-portrait at sea," and signed Jean Louis Kerouac. One is reminded of a description of Jack aboard a merchant marine ship in "Slobs of the Kitchen Sea," a chapter in *Lonesome Traveler.*

In another self-portrait, Jack works from a boyhood photo of himself (**fig.11**), at about seven years old, from the family album. The oil pastel drawing (**fig. 10**) is true to the photograph and captures the spirit of a young boy asked to pose for a snapshot. There is a great deal of self-assurance in the draftsmanship and a confident, rhythmic pattern to the diagonal staccato application of the oil crayon strokes—particularly noticeable in the hair, the grass, and the voraciously applied darks on the body and immediate foreground—that unify the work and amplify the energy inherent in some of these natural forms. Equally self-assured are the painterly gestures in the sweep of the plant stems, which Jack positions in the right half of the work and which appear decidedly anthropomorphic, with arm-like branches and hairy-headed tops, and which counterpoise the concave curve of young Jack's overalls.

Although the two works are undated, and although they represent Kerouac at the space of about fifteen years, there is a clear relationship between the face in this self-portrait and the face in "weird self-portrait at sea." The forelock in the younger portrait becomes a pompadour in the older. Even the sweep of the shirt collar is identical, as is the shape of the head, nose, cheekbones, and the expression of the eyes and mouth. Interesting to note is that in "weird self-portrait," Jack is holding a brush in his hand, depicting himself as the artist, not the writer at work. The eyes, too, are both drawn with what appears to be a deliberate ambiguity as to where they are focused. At first look, both faces seem to be looking downward, in the "at sea" painting seemingly at the pad on his lap, and in the younger portrait, toward the ground and not at anything in particular; but a closer examination of the eyes in both works shows vaguely sketched pupils that stare directly at the viewer—a synthesis of Jack's innate shyness and the writer's necessary perspicacious confrontation.

Among the notebooks of Kerouac are a number of small, spiral pads in which Jack jotted notations throughout the day. From time to time, sketches appear in the books. On a page dated January 1959, is a sketch of Neal Cassady (**fig.12**). It is made up of a few lines—like a Chinese calligraphic word—but with some lines drawn with certainty, others sketchy and tentative. The resemblance to Neal is clear. It is as though Jack had "written" the image in a pictographic language in his own handwriting. The quick Z stroke that forms the eye is drawn with confidence and fine draftsmanship. The long curve of the cheek is unmistakably Neal. Jack has captured the essence of his dear friend's features. In the sensitivity of the few lines it took to encapsulate the aura of the Cassady persona, we can read the familiarity that can come only from an extraordinary bond, like the love Jack

felt for Neal, who he saw as his brother Gerard returned to him. On December 18, 1950, Jack wrote a letter to Neal in which he recalls that Gerard, too, was motivated to draw:

> He spoke frequently of angels and drew pictures of them. As he neared his death a tremendous drawing technique began to come to him. He was so good, one day he drew a picture of a ship after a drawing in *The Saturday Evening Post* magazine, and when my father came home he laughed to hear Gerard had done it. There was another man with my father, he laughed too. Gerard drew still another picture to convince them and wore himself out all pale sweat to do so. Then my father did not laugh anymore; it was too late to laugh. Everybody in the family must have sensed his impending death.

In another letter to Neal dated "before April 15, 1955," he wrote:

> The point of my letter is, I want you and I to be big buddies again, not that we're not big buddies anyhow; in thinking about Reincarnation and Cayceism I'm not too sure that maybe you arent my brother Gerard reborn, because he died in the summer of 1926 and you were born . . . when? in 1927. Sometimes I explain it to myself that way, what is all the holy feeling I have for holy Neal, maybe he's my brother at that; it was you first said we were blood brothers, remember?

The abstract expressionist painters found the first opportunities to exhibit their then-outrageous work at a group of small galleries on East 10th Street in the part of Manhattan that later would be known as the East Village. In Beat culture, that small cluster of brownstone galleries was the site of their first poetry and jazz readings in New York in December 1957. David Amram, then a close friend of Jack's, and today a world-renowned composer, jazz musician, and

conductor who has accompanied the poets, recalled the event in a tribute he wrote for Jack in *Evergreen Review* on October 24, 1969, two days after Jack's passing.

Poets Howard Hart and Philip Lamantia came by my place with Jack. They had decided to read their poetry with music, and Jack said he would join in, reading, improvising, rapping with the audience, and singing along. Our first performance was in December of 1957 at the Brata Art Gallery on East 10th Street. . . . There was no advertising and it was raining, but the place was packed. Jack had become the most important figure of the time. His name was magic.

He was suddenly being billed as the "King of the Beatniks," and manufactured against his will, into some kind of public guru for a movement that never existed.

In the cluster of East 10th Street brownstones was the Hansa Gallery, whose directors were Dick Bellamy and Ivan Karp. Bellamy had a role in *Pull My Daisy* and so knew Jack from the Greenwich Village poet and painter community. In January 1959, Jack did a portrait sketch of Bellamy in his notebook and marked it "Dick Bellamy by JK" **(fig.13)**. We need no further proof of Jack's self-confidence as an artist than that he would draw that most intimidating of all possible subjects: an art dealer.

The sketch itself is typical of Kerouac's drawing, with some tentative lines to mark off the territory, followed by bold, decisive, long lines that carry off the personality of the sitter and the spontaneous regimen emphasized by Jack as so salient to all forms of art. The subject sits bolt upright and stares directly at the viewer. Some signs of dissipation in the eyes, which appear to be wide open, and a crease in the right cheek, make the young art dealer look a bit stressed, and the diagonal lines across the mouth reinforce this with the illusion that the lips are tightly compressed. The bushy eyebrows and dishevelled hair lend a bohemian look.

drawing the blues

Jack's notebook, dated summer, 1958, has a titled but otherwise unexplained or annotated sketch of Emily Dickinson **(fig.14)**. It is one of Jack's most sparingly calligraphic drawings, yet he achieves a cryptic likeness and symbolic essence of the poet in less than a dozen lines. One eye is drawn in an ambiguously open-or-shut style that lends a touch of animation to the picture, and the long straight line of the nose brings an ethereal but regal expression to the face. There is no mouth or suggestion of ears, perhaps alluding to the reclusive Dickinson as a silent figure in the poet world, whose work was seldom spoken or heard. A few wispy lines account for long straight hair and a single curve shapes the cheek. An enigmatic element in the drawing is a rectangle set at bottom left which is demarked as "tomb." This could have been motivated by a visit to her gravesite, as she was born and resided throughout her life in Amherst, Massachusetts, and so was a not-too-distant neighbor of Jack's. This tomb reference also appears in the forty-seventh chorus of *Orizaba 210 Blues,* which Jack wrote on a rooftop adobe cell in Mexico City in 1956. "Said, Emily Dickinson is as

great / as Shakespeare sometimes; / said T.S. Eliot's editor / Robert Giroux, swell fellow- / Her attic divine / her antic, / -her / sang in the blue hill / her larks and mimes / and died all a silent / in her prophecy tomb."

In a letter to Allen Ginsberg of July 14, 1955, Jack lists Dickinson as one of his favorite poets, along with Blake and Thoreau. Although in 1958, when he drew this sketch, Jack was a published author, he must have sympathized with Dickinson who, withdrawn and hermetic, remained largely unpublished at her death in 1886 at the age of fifty-six. In the tenth chorus of *Orlanda Blues,* which Jack wrote in Florida in 1957–58, the same years as the sketch of Dickinson is dated, he wrote:

> "Maybe Eden aint so
> lonesome as New England
> used to be," said Emily
> Dickinson sitting with
> a tangerine in her hand

Emily's work would emerge from obscurity through the dedication and determination of her sister when her entire oeuvre of 1,775 poems and many volumes of

letters were published in the 1920s, nearly forty years after her death. She would go on to become one of America's most beloved poets, and still another fifty years later, Jack would celebrate her in this poem:

EMILY DICKINSON

Ere so sober Emily
Did New England sow
with brooms of activity
I'd the tree-rock spoken to.
But it only said to me
"This sleet's crack
you hear cracking my hide
Is the voice of olden poets
Nor far from rocks of here
Did their olden eyes
On nature bestow blue

—"I said
"Ah Oh How So Sad
I said—"And graves?"
And I said "Darling
Supposing it should
To nature
Suddenly occur
To make unending poet
Unendingly Blow"

Nature Said : "Mean,
I don't know what you
Mean"—
"Ah Nature, Ah Rock,"
I cried, "Nobody's Bone
Has so suffused been,
No burden of boredom
Greater

No love colder
No love life less
No grave nearer
Always
Than "ye Bard"

A drawing in the notebook of February 1959 demonstrates a decidedly antithetic view of the Kerouac personality and also how well artwork can function as an extension or barometer of frustration. On Wednesday, February 11, Jack wrote: "went to Huntington for typewriter business, bought 3 spring binders etc.—got haircut—walked exhausted thru Kafkean horrors—(couldn't find a newspaper office near a cemetery). . . ."

On the following notebook page is the sketch of a checkerboarded face with squares and circles, hair and ears flailing in the air, eyes with varying pupils bulging and a mouth like a football goal post (fig.15). The writhing lines that curve across the body contribute further to the nervous, discombobulated aura of the disturbing portrait: Kafka in the castle or Jack among the suburban traumata of Huntington, Long Island. The artist Francis Bacon, the godfather of British Pop Art and one of the most revered of twentieth-century figurative painters, believed that the distortions he manifested upon the figures in his paintings were the result of his efforts to make the artwork "come across directly on the nervous system," and so he avoided "boring and illustrational work which appeals to the brain." And we can make the connection here to Jack's often-quoted statement from *On The Road* as equally appropriate for his *Man of Kafkaen Horrors*:

The only people for me are the mad ones . . .
mad to live, mad to talk, mad to be saved,
desirous of everything at the same time,
The ones who never yawn or say a
commonplace thing, but burn, burn, burn . . .

Another sketch—done sometime later, in notebook #26—depicts a strange phallic-nosed, devil-eared, broadly grinning dervish of a face, enclosed in an outlined rectangle and crowned atop its bald pointed head with a black crucifix, which appears to be anchored in a tiny fish **(fig.16)**. The eyes of the figure, comprised of circles and angular lines, have a glistening, unfocused, stoned effect and the eyebrows are a pair of pointed rods that dart into the long bridge of the nose. The nude body of the androgynous figure has a sensual protruding abdomen and seems quite at ease as it rests comfortably on the ground, leaning on its right arm and waving the left at the spectator. A lot of time went into this drawing; the background is completely covered with small, abstract geometric and biomorphic shapes related to the psychic automatism of the surrealists. As for the figure itself, whether it is man or woman, devil or nun is difficult to determine. Even the two halves of the face have completely different expressions. The right possesses a degree of humor and compassion while the left evokes an expression that is quintessentially evil. A fine example of bicameral physiognomy.

In the same notebook, there is a sketch where Jack completes the entire main body of the work with one continuous, emotionally charged line, adding just six additional small marks to suggest a scowling face as the chest anatomy of this humanoid monster. The creature is all hands, no head, no genitalia, no sign that this represents a sentient being. It is devoid of Christian or Buddhist truth. It is that which takes all, in those oversized claws, and gives nothing. It is the writer's nemesis, anathema to all who value the creative act: it is Jack's depiction of "The Robbers of Ideas" **(fig.17)**.

There is no annotation to explain this very definitive drawing, but there are a few examples of Jack exhibiting anger at plagiarism or at more than an acceptable level of influence of his or his friends' ideas or work. He does make a statement in a notebook (February '59) in defense of his greatest of musical icons:

Cannonball only thinks he
plays "like" or "better"
than Charlie Parker, just
because he immitates his sound
or phrases, but
 BIRD SINGS !

Orizaba 210 Blues offers some explanation of this sketch in its second chorus: "I almost called these poems / pickpocket blues because they are the repetition / by memory / of earlier poems / stolen from me / by twelve thieves" and again, on the robbery in the 26th chorus of *Orizaba 210 Blues*:

My poems were stolen
 by Fellaheen Thieves
In the city of the midnight

The title was "Fellaheen Blues"
And justice is done to Rome

I'll never see them again
Learn what sweet development

I'd harbored up to meditate
All's left now
 is these hateful
New Fellaheen Blues
which mean nothing
and I hate them

In the other book I cried
Ah - da Ah - da
 the parturient spinsters
 that prate i the dining hall
Are having blue venison
To goose their old hyms
 Og

But these were not abstract ideas that are referred to in these poems. John Sampas, Jack's brother-in-law and literary executor of the estate, recalls moments when Jack's near-paranoid outbursts castigated poets, many of them Jack's colleagues in the Beat movement, for getting just a bit too close to him in their work.

In a flurry of linear spontaneity, Jack exemplifies the joys of drawing in an endearing sketch of his wife Stella **(fig.18)**. She is wrapped in a blanket lying in bed, her head raised on a pillow, hands clasped, and forearms resting against her cheek. Although it is obviously a quick study, there is a great deal of sophistication in the draftsmanship. The slashing, looping lines that create the figure, perfectly describe a sense of the solid form under the blanket's folds, and there is a pleasing line quality to the work, a good example of "gesture drawing," elementary to basic studio art schooling that Kerouac never had. This in itself is not that unusual in the visual arts, where so many are self-taught and where the value of a formal studio art education as opposed to dedicated self-teaching, determination and experimentation, is difficult to determine.

> I see . . . a great rucksack revolution, thousands or even millions of young Americans wandering around with rucksacks, going up to mountains to pray, making children laugh, and old men glad, making young girls happy, and old girls happier, all of 'em Zen lunatics who go about writing poems that happen to appear in their heads for no reason . . . wild gangs of pure holy men getting together to drink and talk and pray.
>
> Jack Kerouac—*The Dharma Bums*

Eugene Herrigal, in *The Method of Zen,* refers to Chinese landscape painting as "picture writing" and states that those who learn to read the language of this writing will feel

> the mighty tension of the world process, of things rising up and sinking away, appearing and vanishing; how everything that has become vibrates in the flux of Becoming and Unbecoming—evanescent yet absolute.

Jack's own Zen studies included the Diamond Sutra and resulted in his writing *The Dharma Bums*. It may then be a private joke or a Dada symbol that when Jack did a drawing which he intended for a cover for *The Dharma Bums,* he used the cover of a stenography pad with the trademark diamond design dominantly in the sky. The other elements in *Stenobloc Dharma Bums* **(fig. 19)** are carefully drawn and shaded with varying degrees of skill and attention. There is little spontaneity in this work. It is controlled and traditionally drawn to clearly delineate its meaning and includes details like the

pocket and hanging straps of the backpack, the boulders on the mountainside, and even the cuffs on the pants.

The figure could be Jack, Neal Cassady, or Gary Snyder or simply a figure symbolizing the dharma bum on the open road. The big, bulging rucksack can be explained by another drawing of Jack's in which he itemizes and illustrates its contents and packing order **(fig.20).** There is a well-known van Gogh painting titled *On the Road to Tarascon* in which the artist walks alone on the cobblestone road. Like the figure in Jack's work, he is right between the two trees. He carries his paint box in his hand, and a yellow canvas under his arm. Everything is vigorous; tall straight trees, a bounce in Vincent's step not unlike the stride in Jack's, and even the strong shadow demonstrates the vigor of the light itself.

Whether Jack was influenced by the Van Gogh or was even aware of it, is not nearly as intriguing as is the attribution of a Kerouac link to the pantheon of visual art history.

Friday afternoon in THE UNIVERSE, in all directions in & out you got your men, women dogs children horses pones tics perts parts pans pools palls pails parturiences and petty Thieveries that turn into heavenly Buddah—. . . I made the world & and when I made it no lie & had old Angel Midnight for my name and concocted up a world so *nothing* you had forever thereafter make believe its real—but that's alright because now everything'll be alright & we'll sooth the forever . . .

So begins *Old Angel Midnight,* and as he so often wrote of angels so, too, did Jack draw and paint them as an element in many of his artworks. There are a number of drawings he made specifically as covers for the book. One features a triangle at the center with a very rough sketch of the head and shoulders of the angel, as

though the triangle was a window. The angel's wings are highlighted with a bit of white chalk and rays of light shine from two candles on a plate off in the left corner. Jack has even designated the typeface to be used on the cover (fig.21).

In a postcard to Lawrence Ferlinghetti, in this case his publisher at City Lights, Jack wrote,

> **Dear Larry—have 5000 additional new words for your edition *Old Angel Midnight,* plus the cover finished in ink and pastel depicting a white angel in a blue sky by a white saucer moon hovering over tenement rooftops with ghostly white wash and some windows lit, some dark.**

It's an unusual subject for Jack, an urban landscape, elegantly drawn and colored and animated by the angle of the clothes blowing about on the washlines. A white angel and saucered moon hover over the cityscape as described in Jack's card to Ferlinghetti (fig.22).

The architecture of the Industrial Revolution is in Lowell, Massachusetts, Jack's hometown and the setting for much of his life and many of his books. Lowell has changed a lot since Jack's days there. Some of the old mill buildings have been renovated, there's a new park commemorating Kerouac and his work, a modern Sheraton hotel, and the textile school Jack often mentions in his books has grown to become UMass-Lowell. Moody Street, Lowell's old Pigalle, has been swallowed up by a housing development, but much of downtown and the adjacent residential areas, like Chelmsford and the Highlands, are right out of *The Town and the City* and *Maggie Cassidy*. The Pawtucketville Social Club, which Jack's father managed, is still just across the street from the Kerouacs' last tenement apartment and on the corner is the wrinkly tar sidewalk that Jack writes of in *Doctor Sax*. The painting of Old Angel Midnight does more than illustrate the poem; it celebrates the warming *gemutlichkeit* of Jack's hometown of Lowell in an October dusk.

sunday school painter

JK: **Paint! Bring out the canvas, I'm gonna show Dave how to paint!**

ST: **Oh, oh, you're going to do a pietà again.**

JK: **And I mean it, a pietà. I'm going to do you a picture of Christ being taken down from the cross by Mary and St. Peter, and St. John, and Martha with Judas hanging in the background.**

The powerful association between Jack's spiritual life and his art is evidenced in the frequent appearance of angels in his work. They played an impressionable role in the traumas and psychodramas of his childhood and remained a part of the continuum of vacillating religious epiphanies that occurred throughout his life. It is no wonder, then, that *Old Angel Midnight*, written in 1956, includes some of Jack's finest examples of spontaneous prose. What safer place could Jack find than among the angels to experiment with literary abstraction, to use words for sounds, without meanings and to turn words into the jazz and bop prosody of Charlie Parker and Thelonius Monk and the abstract expressionist intellectualized modality of Pollock and his friends at the Cedar Tavern.

The angels are often represented in varying stages of abstraction: Their very presence, in pictorial form, suggests that the scenario is beyond our ken, not of logical literal consciousness but raised from the more sensuous depths of the mind. It was a step back to Freud, half a step forward to Surrealism, and then just a shuffle toward the then controversial abstract art movement that Kerouac found himself in the midst of in New York.

Jack drew his angels in a variety of ways, from Renaissance cherubs to comic batshapes. Most are contour drawings that grasp the essence of "angel" and relate somewhat in their elegance and preciseness of line to the style of Matisse. There are others that have the frivolous cartoon sensibility of Casper the Friendly Ghost.

Among the most intriguing of the angels are those in *Pieta with Bolt of Lightning* **(fig.24)**. The pencil drawing, carefully executed with much attention to detail, depicts a crucifix with INRI written at its top and with five figures beneath. One of the figures, in a white nun's habit, holds an undersized fragile Jesus in her arms, another hooded woman lends her support from

below. Still another kneels in prayer, while the fifth figure, dressed in what appears to be a dark cloak, is difficult to comprehend. In the background is the city of Jerusalem and on a hill overlooking it we find Judas, the hanged man. The road, a Kerouac trademark, curves up the hill and on to Jerusalem. Overhead, in a sky darkened by closely sketched diagonal lines, are two angel figures. One, the most cherubic of all of Jack's angels, is well proportioned and well drawn with complicated anatomical perspective, although the head and face seem out of character, like that of an older bespectacled man with a peculiar resemblance to the baby-faced former FBI director J. Edgar Hoover.

The second angel too has a number of strange features. It is angular, has a sphinx-like demeanor, with wings that could be likened to a bat and the face to a Batmanesque superhero. But the pointed ears and narrowed, glaring eyes lend a devil-like countenance to this character, who hovers to the left of the cross. We may be witnessing here a visitation by Lucifer, former head of the angels, now the devil himself, announced from the upper right corner of the picture by a long slashing bolt of lightning.

In a most expressionistic drawing, Jack again depicts the *Descent from the Cross* **(fig.23),** but here the elements are virtually dashed onto the paper with charcoal pencil in bold, decisive lines. The limp figure of Jesus extends diagonally across the paper; the delicate drawing of his body in strong contrast to the surging, twisting gesture drawing of the background or the heavy marks that define the face. The two women carrying him, the intruding arm of the cross and other details of the scene are drawn as equally definitive statements. The

delicate lost humanity of the recumbent Jesus is emphasized in the hands and feet, which Jack gently delineates to reflect the consummate debility of the enervated body.

The faces, for all their spareness of detail, are rich in emotional substance. The face of Jesus, composed in what appears to be a burst of religious fervor, displays an extraordinary tranquillity, one of restful peace rather than mortality. The halo encircles his forehead like a crown of light. The women holding him are created of pure line. There are no earthly distractions. The merest ellipse of an eye, a dash for the nose, a line for the mouth, a single stroke for the supporting arms. Yet, the action is clear and the emotional impact of the work gains from its diminutive detail.

While a prototypical Kerouac angel, drawn with two continuous lines, hovers in the sky, another figure looms in the background. Drawn over a tornado-like rush of pencil marks, it rests within a large contiguous cross, quartering the entire figure. A clue to its identity lies in the long, pointed line of a spear in the figure's hand. It is the same symbolic element Jack uses in his crucifixion drawings. The spear that pierces the heart of the crucified Christ. The figure then is a Roman soldier, now marked with the Sign of the Cross.

A rather strange figure is drawn at the bottom right corner of the work: a head, with a toothful grin, sideburns, and a lock of hair over its forehead, which lies on the ground like a bust, fallen from its pedestal. The linear motion of the drawing resembles that of the angel at the upper right. A fallen angel perhaps?

"Did inkdraw a nice Golgotha—." Anomalies haunt many of the Kerouac artworks, as in the seemingly classic example of a Golgotha. Here the crucified Jesus,

first lightly sketched and then approached again with more aggressive strokes of the drawing pencil, appears animated, unflustered, looks directly at the viewer as though unaware of the torture to which he is being subjected **(fig.25)**. Looking closely one sees that the shining halo is in fact a crown of thorns. This drawing spares no details. The nails hammered into each hand are exaggerated as is the piercing thrust to the heart. The two figures at the foot of the cross are fine examples of Jack's spontaneous sketching but offer little hint as to their position in the bible story. The squatting figure on the left, drawn with one continuous line, appears to be half human and half animal, a sphinx-like being, its identity a riddle. The clearly feminine figure on the right seems to be sitting on the ground, wearing a headcovering which Jack gesticulates as a sweeping figure-eight loop. The woman is holding an object that may be the shroud in which to wrap Jesus when he is brought down from the cross.

The figure of Judas hanging on the hill is extremely simplified in this work, not much more than a shorthand notation. Four lines comprise the entire image, yet there is an unquestionable essence of a body swinging from the rope. Then there is the angel, an almost signature example; but like all of Jack's heavenly messengers it has its unique personality—in this case an elliptical face with the simplest of features, a curlicue of hair and two lines coming down both cheeks forming perhaps a cowl or a religious headdress. Next to the angel, to remove any doubt as to the nature of the work, is a carefully denoted cross.

The most enigmatic aspect of the work is an image, on the right side just under the angel, which appears to be the symbol for the eyes of the Buddha. It is a symbol common throughout Tibet and Nepal, seen on shop fronts as well as temples. The Buddha eyes are considered the windows to the spiritual world, representing peace, prosperity and good will to all. Jack has drawn this same image in his notebook just below his comment about drawing Golgotha, and it appears elsewhere in his notes with no explanation.

It is likely what we see here is a manifestation of Jack's Catholic Buddhism. In *Tristessa* he wrote, "The Buddha and the Virgin Mary have given him proof that everything is alright." It was a return to the uncomplicated religious philosophy of Gerard, Jack's deceased younger brother, "All is well, practice kindness, Heaven is nigh."

In *Crucifixion Drawing in Blue Ink* **(fig.26),** we see a continuation of the bold gesture drawing that coincides so well with Jack's ideas of spontaneous prose. The faces are modeled with swirling lines and ovals that evolve into features. Denser areas delineate hair and deeper space and are used here and there for emphasis, as on the faces, the groin, and the weapon that pierces the heart.

There is a peculiar raised hand that seems to be wearing a long fingerless glove. It belongs to the figure at the lower left of whose identity we have no hint other than that it appears to be a woman who has earned a halo. A second person, depicted as a series of long, continuous, meandering lines, seems distraught at seeing the crucified Christ and although this figure has only the vaguest suggestion of arms and hands, they are expressive in their upward gesture. This is combined with an inkblot of an open mouth and grief-stricken eyes that, for all their simplicity, reveal an important role for this character in the story: from the

tentative detail and volatile physiognomy he appears cast as the ever-present Kerouac angel. As in most of Jack's Golgotha drawings, the crucifix remains white while the entire background and foreground are covered with rhythmic, diagonal strokes of the pen. The hillside and roadside are sketched in charcoal and then dissolve into the picture. This same treatment adds dramatic quality to the body of Jesus and the face of the foreground figure.

Particularly effective is the face of Jesus. The matrix of lines that evolve into the hair and beard form a fine frame for the face, where within the hirsute oval we find very defined and sensitive features: piercing eyes, an aquiline nose and a misty aura of purple which, although it may be an accidentally blotted area of the blue ink, adds a subtle beauty to the majesty of the face. An energy field around the head, created by the myriad concentric circles that are the crown of thorns, emerges as a halo and endows the features with a mystical aura appropriate to the biblical moment. This awesome sense of bible history is further enhanced by the heavenly rays that emanate from the head, lines with small circles at their ends, like little popping epiphanies. On the left, curving around the hill, the hanged Judas swings as a warning for all those on the road. It is the road to Jerusalem, as we determine from the familiar rooftop minarets on the horizon.

For a man of many words, Kerouac the artist left few titles or written information about his paintings or drawings. An exception was *Tobias* (**fig.27**). It is painted in Jack's most typical of styles, beginning with a light pencil sketch to establish the composition, gradually shading and filling in the various elements and then finally launching an aggressive attack on the work with a black that is very likely a mixture of ultramarine blue and burnt umber, a lively vibratory shade of black, as would have been taught to Jack by Dody Muller. In this work, Jack added some cerulean blue, some purplish whites and some dark burnt umber to the walls of the room, and then some thick impasto whites to the angel, the halo around the person at the head of the table, and on sections of the walls and floor. The most difficult figure to comprehend is seated at the left side of the table, a long brown arm stiffly extended, the rest of the face and body ambiguous, androgynous and just barely anthropomorphic.

The legend, a biblical tale which appears in the Apocrypha, tells of Tobit, a devout Jew who has led a life of good deeds and is suddenly struck blind. Rather than be a burden to those around him, he asks God to end his life. Meanwhile, in a nearby village, a woman named Sara has just had her seventh consecutive husband killed on their wedding day by the demon Asmodeus, who for his own demonic designs seems to prefer that she remained unmarried. Wanting to end this reign of terror, Sara too asks God to kill her. God instead enlists the archangel Raphael to pay a visit to Earth and help both Tobit and Sara. Posing as a mortal and dressed in civilian clothes, Raphael accompanies Tobias, the young son of Tobit, on a business trip to the city of Ecbatana, where Sara lives. Tobias and Sara meet, fall in love, and marry. With directions from Raphael, Tobias successfully exorcises the jealous, evil demon before he can carry out his mission of the post-nuptial widowing of poor Sara for the eighth time. Full of the power of God and the support of his amazing new friend Raphael, on their return home, Tobias manages to cure his father's blindness and the

story ends happily with Tobias's prophesy that Jerusalem shall arise one day as the great holy city of the Bible.

Now that's a story Jack would certainly have remembered from his days as a boy in Catholic school. And assigning roles in the story to the characters in Jack's painting is not difficult. The expressionistically painted person at left, largest- and oldest-appearing of the assembled group, would be Tobit, the father. The fellow with the impressive halo is, of course, Tobias and the young woman opposite him at the table, his new wife, Sara. The angel is Raphael in his heavenly form, while the nun, Jack's original source of the Bible story, kneels and extends the crucifix, celebrating the miracle. Jack effectively draws the interior of the Tobias home-in-exile as humble, made of logs or roughly hewn wooden boards. The table too seems crudely constructed and very old and the distinct imbalance in perspective adds a surrealist, otherworldly note to the tableau. This kind of distortion, along with the soaring nature of the Tobit figure and the saint-like glowing figure of Tobias, associates the images with the Mannerist painting of the sixteenth century, when the Catholic Church, responding to the challenge of the Protestant Reformation, called upon its artists to increase the drama and mystique in their paintings and render the saintly heroes of the Church even more saintly and heroic by making them look like they were soaring toward heaven. This was generally accomplished by exaggerated, distorted perspective. Some of the best examples of this are among the works of El Greco.

Eugéne Delacroix observed that in studying drawing, perspective should be thoroughly learned, and then as thoroughly forgotten. Jack Kerouac's advice to readers of his *Scripture of the Golden Eternity* was "when you've understood this scripture, throw it away

. . . I insist on your freedom." One hundred and twenty years later in France, Picasso would scramble the rules of perspective to a very different end. After a period of experimentation during his popular blue and rose periods, in 1908 with his painting *Les Demoiselles d'Avignon,* Cubism was born. There are a number of stories that relate to the origin of this strange and very radical painting for its time, with its most obvious roots in African and Iberian masks, but one of the most significant aspects of the *Demoiselles* is its variegated perspective. Each element in the work is seen from a different point of view; it is as though the painting was being looked at from many different positions in the room simultaneously.

Kerouac used distorted perspective in a more spontaneous version of what is very likely the Tobias myth, *Tobias with Fish* (**fig.28**). The angel and the halo are both highlighted with white paint. The three figures seated at the table are the heroic Tobias emitting the blessed glow, his wife, Sara, at right, with a flower in her hair, and the father, Tobit, looking here rather like an old bear, raising his arm in salute to the angel Raphael, who smiles at the happy conclusion of the story. On the table is a fish, an ancient Christian symbol of Christ and of life. Tobit, now cured of his blindness, lives on to prophecize the restoration of Jerusalem; and as for Tobias and Sara, at whom the fish is pointed, they will be fruitful and multiply. It is notable that the one element in the work that requires perspective drawing, the table, is distorted about as far as one could go without losing its identity as a table.

One mysterious element that resists interpretation is the elliptical shape hovering at the upper right. Jagged

lines emanate from its left half and a series of bumpy cloud-like shapes from its right. The ellipse is divided in half by a single, graceful, vertical sweep and the whole segment is encompassed in a rectangular shape. It could represent the door to the room and the natural world without; but if that is the case the breach of perspective is so great as to render it untenable to the perceptive senses. Also open to speculation is the scrawling penmanship-like border along the right edge. At first it appears to be no more than a rhythmic fill-in of a deep space along that edge; but it engages the picture directly with the intrusion that hangs like a black penis and scrotum shaped cloud, right over Sara's head. This could be a symbol of the demon who had plagued Sara through her previous seven violently interrupted marriages. Then the ellipse that rises in this area may be Jack's symbol for the exorcism of the demon, smoke and fumes rising into a hole in the sky.

Family Blessed by Departing Angel (**fig.29**) is Jack's title for another drawing of a family at the table. Two boys are seated; the mother stands over them, her arms protectively over one of the boy's shoulders. The other boy sits poised with a spoon waiting for the meal to begin. On the floor a small child crawls about. The angel is leaving through the doorway. The drawing style here is typical of Kerouac. He begins with a rapidly moving gestural pencil line that roughs out the shape, action and position of the objects in the work. Then he draws the most expressive of the lines in strong contrast to the light sketch, which now reverts to a foundation for the work. This dark line drawing on top of a sketch becomes the most important and most noticeable of any of the elements in the work. It is particularly well done in the drawing of the angel, where with few lines he captures the angle of the head, the motion of the wings and the tucked up knees and legs in an airborne position. The meaning behind this painting could be construed as Mamere and her two sons Jack and Gerard, or they could be Gerard and his father at the table with his mother, and Jack as a baby on the floor. Still another possibility would be Jack and his father at the table in the years after Gerard's passing. In any event, the angel was "unwanted" because its visit could relate to the taking away of Gerard or their father.

The scene is sedate; things are in place with realistically acceptable perspective drawing. And Jack has written the title on the front of the work, very rare for him. He wanted to direct the viewer toward the meaning of the work, but with a title that still allows for a bit of equivocality. Although primarily a literary person, he lets the drawing tell the story.

A controversy over titles became part of the Stanley Twardowicz, Jack Kerouac, Northport Library interview, when Stanley told Jack he assigned numbers to his paintings rather than titles. Dave Roberts, of the Library staff, participated in the conversation.

JK: **Numbers?**
ST: **Numbers, yes. For some reason I don't want to give them titles . . . The most beautiful titles I've seen on paintings have nothing to do with the painting . . .**
JK: **Like for instance . . .**
ST: **Like Paul Klee or de Kooning. They're beautiful titles in themselves but have nothing to do with the painting.**
JK: **de Kooning's, ah, what's the thing called, *Landing*?**
ST: ***Bolton Landing*.**
JK: **That's the name of the place where he was.**

ST: That's it exactly.

JK: So what?

ST: So what, yeah.

JK: He could have called it Number Eight.

DR: Don't you think it's kind of like, a number is a little cold?

ST: Yeah, I think they are. As long as my paintings are not cold, then I'm not worried.

DR: Numbers are just too cold. That's alright for Mondrian.

ST: Okay, Mark Rothko gives titles for instance *Blue and Red* or Yellow and Ochre . . . Then you have Picasso, who does it very simply, *A Seated Woman, A Boy Standing, Still Life.* They are not really titles. They're just a very descriptive overall . . .

JK: I'll get 'em for you. For instance, give me five bucks and I'll get 'em for you.

ST: Yeah, yeah, then if you try to be very literary with your paintings, then the titles have nothing to do with the painting. They're beautiful titles, I agree with you, like Paul Klee especially. In fact, the story goes that every time he finished, say for instance, ten or twelve canvases he used to have a christening party. He would invite friends, give them a meal and liquor and then they would sit around all evening and give titles to the paintings. . . . It was beautiful.

JK: I could have done that.

ST: Yes, yes. Oh you have! He gives better. . . like what he said describing my painting . . . kissing colors. For him to be aware that colors kiss. The word kiss gives a connotation of what the painting almost is, you know, it's not like fighting colors, see?

Jack had a keen awareness of color, and although many of his drawings were in pencil or pen and ink, there are many paintings where color is used innovatively as in his counterpoising of red against green in

the perplexing painting of three figures with an angel that has the face of a Buddha (**fig.30**). A question mark and a cross float in the air over their heads. Just barely readable, at the top right corner, Jack has written "St. Matthew Appearing to the Angels." The figure at left, the youngest looking of the three, has his arm thrown around an object that appears to be a table. He holds a wine glass in his right hand. Like the others he wears a cap, but unlike the others, who are ambivalent and androgynous, this person appears young and struggling to hang on to the table for dear life. His grasp of the wine glass is as determined as is the clutch of his legs around the base that supports him. This central figure could be Jack, in the company of St. Matthew, beset by questions of spirituality, with an angel of confusing origins. The long-haired person at right has two very different faces, one a hook-nosed disgruntled hag and the other a smiling, goateed, possibly Asian, philosopher. The second could be holding a plant-like object, or flowers, represented by the blue-green coloration sketched over an area drawn as Jack might draw organic plant life. Just off the right of center, at the bottom edge of the work, is a bottle. It's full, and the white-capped figure seems to be reaching for it.

It is a picture with multiple lives. It has its unsolvable mysteries: double images, a strange angel—what is that triple cross on its head? Unidentified objects: a guitar case? It also has a buoyant, aesthetic side: expressive dashes of red over a blended-in rusty-rosy background, a subtle splash of yellow balances, a burst of turquoise-green, slashing white highlights, and the drawn and redrawn object outlines energize and activate the figures. All the lines are in Jack's "handwriting" and even the single-directioned diagonal flourishes do not unbalance the work. The strength of the verticals and the solidness of the angel maintain the stability of the space.

lighting candles to the madonna

"And it will say *INRI,*" said Jack to Stanley Twardowicz, describing a pietà he was going to paint in Stanley's Northport studio. "Iesus Nazarenus, Rex Iudaeorum, Jesus of Nazareth, King of the Jews." And with grand flourishes of brush and India ink, Jack, in a burst of calligraphic painterly penmanship, once again translated his favorite subject into a striking work of art. Drawing directly with the brush, with no initial pencil or charcoal sketch, *Pietà in Black and Grey* (**fig.31**) has an appealing clarity and simplicity and adds a new monochromatic painterly dimension to the Kerouac oeuvre. The figures in white advance from a shadowy background. The shades of black and grey—water diluted ink—are likely a Twardowicz influence, as the painting was done in the same time period as the Northport interview in which Jack and Stanley discussed black-on-black painting.

ST: **But this was one period of my life for about a year. This was exactly what I was doing. Black on black and that's exactly the way I felt.**

JK: **Black on black?**

ST: **This one here I did right after Franz Kline died. I did this one in his memory. . . . There is some purple in the background, I put one wash over the other. The black is very direct. . . . It's quite beautiful.**

JK: **Dullness against dullness. It's very subtle. . . . It's a key. Yeah, a minor key.**

Yet Jack's *Pietà* emerges in a major key. It tells the story with confident broad gestures that cleave their way through the Calvary landscape, carving each of the elements into independent, solid white, sculptured icons. The angel and the other figurative objects in the work are more abstract than in most Kerouac paintings. Stanley had tried to win Jack over to Abstract Expressionism, then in its heyday, and as *Pietà in Black and Grey* demonstrates, Stanley had made some progress. It is as though Jack sketched his cast of characters, whom he designated as Christ, Mary, St. Peter, St. John, and Martha, with Judas hanging, and of course the angel, and then went on to do an abstract expressionist painting all around them.

The ongoing dispute between Jack and Stanley over abstraction was not without humor, and Jack left a

permanent document of his position in a graffiti sketch he did on Twardowicz's studio door **(fig.32)**. The long, thin ink drawing depicts a canvas on an easel in the foreground, with a vertical swirl drawn down its center. Next to the easel stands the "swirl" itself, posing for the picture, and through a cartoon-like voice balloon, it is saying, "All that Abstract Art." Jack's "road" curves upward over the easel, along which is a large crucifix, and off in the distance are the skyscrapers of Manhattan, home of the Cedar Tavern, the San Remo, and "all that abstract art." "The problem," says Stanley, "is now I can never move!"

Whether out of whimsy or the conviction that God is everywhere, Jack did a pencil drawing, with some added color, of the backyard clothesline in the shape of a crucifix **(fig.33)**. The drawing demonstrates that Jack was capable of reasonable perspective. There is heavy greenery in the yard, a feeling of thick, vine-covered, unmanicured, natural shrubs. Some flowers, maybe the last roses of summer, very poetic, like the old O. Henry story about the last leaf, or maybe just a Corot-like device of putting a little red in every painting. The swirling surrealism of the tangled branches and vines sends one searching for hidden images, like Tchelichew's well-known *Hide and Seek* painting, with children painted into the bark and leaves of his tree of life—or the symbolist painter Odilon Redon, who eerily secreted faces in his flowers.

And sure enough, as we meander through Jack's overgrown yard, just to the right of the tree—which stands toe-to-toe with the quasi-crucifix, probably symbolizing the power of God and in fact looking very crucifix-like itself, but with "arms" raised in release or prayer—we find, highlighted in white, the figure of a woman. She appears to be sitting on a small stone wall, so ubiquitous in Massachusetts. Her hair is white and swept back. This could very well be Mamere in her yard, the washline a monument to her domestic diligence. Subtle though it may be, there exists a Buddhist spirit in this work: the meditating image of the figure, and the animism associated with the tree, the post, the drawing of the individual blades of grass and so many individual leaves. It was, after all, from Thoreau's *Walden* that Jack first learned of the *Bhagavad Gita,* which led to his interest in Buddhism. We can see *The Crucifix Clothesline* as a sutra, winding its way through its contradictions of Zen koans:

What does it mean that the clothesline is a crucifix? It means that the clothesline is a crucifix. What does it mean that the clothesline is not a crucifix but just a clothesline? It means that the clothesline is not a crucifix but just a clothesline.

From the 8th chorus *Cerrada Medellin Blues* written July 1961 at 37-A Cerrada Medellin, Mexico:

My hand is moved
by holy angels
The life we are in
is invisible
Holy Ghost

Angels. When Jack picked up a pencil to doodle, it was likely to turn out as a sketchy little holy seraph. Then there was *Old Angel Midnight* and *Desolation Angels.* There are angels all over his drawings and paintings. In "The First Word," a rewrite of Jack's first

article in *Escapade Magazine* (June 1959) that he wrote in January 1967, he talks of "wrestling with this angelic problem with at least as much discipline as Jacob." The angelic problem stated in the article stems from Mark 13:11: ". . . it is not ye that speak, but the Holy Ghost." Jack then explains that Mozart and Blake too "felt they weren't pushing their own pens, 'twas the 'muse' singing and pushing." Jack aligns this thinking with an ancient Buddhist spontaneous mental process, "The Seven Streams of Swiftness." It all adds up to spontaneous prose emanating from a metaphysical source, i.e.: the angel. Jack's angel, as an agent of the Holy Ghost, is ever-present. He guides Jack's pen, forms his words, and like Jacob, Jack must wrestle to keep from going over the "edges of language where the babble of the subconscious begins." He writes of being concerned that in *Old Angel Midnight,* his "ultimate lit'ry experiment," he became "unclear and dull" by becoming "ravingly enslaved to sounds . . . There's a delicate balance between bombast and babble," Jack notes. And one is reminded of Aldous Huxley's concern about the danger of mind-expanding experience: "Suppose you couldn't get back out of the chaos," he warns. But all of this is secondary to the real danger, which according to Jack is this laborious and dreary thing called craft and revision by writers.

There was a sound of slapping
when the angel stole come
And the angel that had lost
Lay back satisfied
. . . raving rabid
angels drooling happily
among the funny fat
cherubim

Jack's angel in this context can be likened to Elwood P. Dowd's "Harvey," in the play and movie of the same name. He is a guiding spirit, a literary collaborator, the secret pal of childhood, the personal god that was once in every human consciousness but has been lost these three thousand years, if we are to believe some theories of pale-ontological psychiatry. Harvey was an invisible white rabbit that went drinking with Jimmy Stewart. Jack never mentioned drinking with his angel, but he does manifest him spiritually in his writing and physically in his art. In two unique paintings, *Blue Angel* (**fig.34**) and *Angel with Two Small Angels and Praying Woman* (**fig.35**), Jack presents close-up portraits of his angel, in a form which could quite easily be taken for the Holy Ghost. In *Blue Angel,* we confront one of Jack's most minimal works. A simple, uncomplicated, single line drawing delineates the angel. It is then filled in with turquoise blue pastel, applied with a few sweeps of the chalk, and blended into the paper. The powerful effect of this work is the result not so much of the spare drawing and color-ing of the angel, but of the dynamism of the black high energy field of the background. Here a stick of black pas-tel chalk was methodically pulled across the work from the central figure to the paper's edge, working around the image and, following Jack's rule of "just left alone: no craft, no revision." The result is perfect. Jagged white space around the figure creates an inner glow, a heavenly presence against the blackened void from which light radiates. The figure hovers. Powerful. Ready. Is this Jack's personal angel or the Holy Ghost itself?

maybe that bird that floats
hill belly on the wind up there,
 and that cat
 that pats

in the grass,
is the same
Infinite
World wide
Angel

Far more complicated is *Angel with Two Small Angels and Praying Women*. Palpably the companion painting to *Blue Angel*, the most striking dissimilarity is in the face, where little circles delineate the eyes, nose, and mouth. This comic touch so alters the otherwise ecclesiastical tone of the work that it is difficult to take it as seriously as one might, had these four perfect little circles not been added. Why Jack added these graffiti-like features is an intriguing question. But they were added on, after the white paint had been applied to the angel, otherwise they would have become partially obscured by its opacity.

Examine the painting without the facial features, blocking them out with a finger and note the sudden sobriety of the image as a religious work, as well as its similarities and differences from *Blue Angel*. Here, the background is deep space. No radiant celestial beams of light project from this angel. The heavens are stormy, the dark air is choppy, like the sea in a hurricane. There are barely visible indeterminate objects in the darkness and three ovals, one a deep alizarin crimson with a face just barely discernible within it. There is also perhaps a momento of an earlier drawing on this sheet of paper—in art terminology this is called "pentimento"—appropriate, too, as representative of the past-life experiences of the angel, a subject of some interest to Jack.

An angel at the upper left seems to be engaged in some physical activity. A bit of a Rorschach test, the actions of the angel can be read in several ways: as two angels, embracing or embroiled in combat, or merely conversing. The dark storm about them seems to fulminate and rage onward from a deep disturbing hole in the blackened sky. At the lower right, another angel, more traditionally Kerouacian, squares itself away in a space bursting with disrupted paint. It hovers in the corner, as the black space around it dissolves in its holy presence. At bottom center is one of the most intriguing characters to appear in a Kerouac painting: a woman sitting in the full lotus position, her hands together in prayer or Buddhist greeting. The woman bears some resemblance to the figure in *Golgotha with Buddha Eyes* in the way they both seem so naturally rooted to the ground, as though a part of the earth. But where the more gesturally sketched woman is a swirl of continuous line, and although whatever activity her arms are engaged in is unclear, this figure is very decisively drawn, the most distinctly focused part of the painting. What is most extraordinary is that it is eminently Mayan in its appearance. It is a dead ringer for the hieroglyph of the Mayan merchant god, which would explain the object the figure has on its back, a ruck sack with a kernel of corn at its top.

Now Jack was no stranger to Mayan hieroglyphics. Travels in Mexico had exposed him to the mysterious lost civilization with its orgiastic and sacrificial rituals and undeciphered hieroglyphic language, where corn was the staff of life, and where the glyph for corn, in the shape of a kernel, is among the most ubiquitous in the carvings that exist throughout the Mayan ruins. The tradition of worshipping the corn god is so ensconced, that today in the Dominican Church in Antigua, Guatemala, there is a larger-than-lifesize icon of Jesus on the cross, hanging over the tabernacle sculptured of compressed cobs of corn, carved and

beautifully finished, painted and patined. On the floor of the church, beautiful mosaics are arranged by the local descendants of the Maya. The designs celebrate Christian legends with just a touch of Mayan mythology. They are formed of brilliantly dyed kernels of corn.

So, if Jack was combining Christian angels with a Mayan god, there existed a long historical precedent; but the question remains as to why the comic-book facial features were added to this angel.

 It might be worth considering that Jack found this picture in its original form so overwhelming, so disturbing, that after it was completed and tacked up on his wall, he felt compelled to "graffiti" the cartoon features onto the face of the angel and transmogrify this otherwise spiritually provocative work from the sublime to the ridiculous, from the Holy Ghost to Casper the Friendly Ghost.

Disregarding the red-ruled lines on the small pocket notebook page, Jack did a pencil sketch of another angel, this time in anatomically correct human form (**fig.37**). The figure is male and seems to be clothed in indeterminate fashion. The head is somewhat carelessly shadowed, more "filled in" than with any concern for light and shade; the cut of the hair is short, and the facial features are too general to associate with Jack or any of the people in his literary or social entourage. The angel has a large pair of wings rising from sturdy shoulders, and a small harp leans on a stone at his side. He kneels among rocks and stones, and his hands are drawn in an awkward clasping position, ostensibly in prayer. Lest there be even the slightest doubt, the word "angel" is written at bottom,

just above Jack's most official of signatures, "Jean Louis Kerouac."

But there is a familiar note to this angel, it brings to mind an angel in a painting by Leonardo da Vinci that hangs in the Uffizi in Florence. The painting is titled *The Annunciation* and it plays an influential role in modern art history. It is a fine example of Leonardo's work and one that stands up to frequent close examination by the multitudes of eager art students who daily swarm the Uffizi. One of those was the young Robert Rauschenberg, before he talked of working in the "gap between art and life" and before the detritus of the streets, found in the morning walk around the block, went into the paintings. His work was very different then, in the early 1950s: small, somewhat witty assemblages and constructions, black paintings, white paintings, red paintings, severe criticism, and little encouragement from Joseph Albers, his teacher at Black Mountain College. He had no real direction. Then he saw *The Annunciation* and everything changed. What he perceived in the painting was that every element in the work was painted as sharply, as detailed, and with the same sense of urgency and importance as every other element. The face of the angel received no greater attention from the artist than did each leaf, each blade of grass, each stone on the ground. It changed Rauschenberg's perception of art. Art was everywhere now, in everything. He threw his old work into the Arno River and became the Robert Rauschenberg of modern art.

Thoreau could well have added to his observation that some people can account for a change in their lives from the reading of a book, that others can find a like catalyst in the experiencing of a painting. Jack, too, traveled in Italy, visited the Uffizi, and saw the Leonardo.

He may have done the sketch right there, in that little notebook, a quick notation for a painting-to-be perhaps; or he may have done it later, from memory, or even much later, no longer consciously considering *The Annunciation* but withdrawing the image from the recesses of his memory as he sat back to bring another Kerouac angel into the world.

In the drawing *The Last Supper* (**fig.36**), we find Jack at his most spontaneous. Clearly comfortable with his subject, he virtually "writes" the picture down. You can sense the sweep of his hand, the joy he found in drawing the phalanx of apostles crowding about, reaching out, looking here and there. Jesus in the center, busy with something at the table, Peter, his best friend, at his right. Facial expressions flicker about as quickly as the hand that recorded them. But that intense fellow on the far right, Judas maybe, will soon turn on Jesus. Jack will get his revenge by hanging him from a tree on each and every Golgotha he draws. And working within the accepted glossary of sacramental symbols, on the table, among a few unidentifiable objects, Jack places a fish. Now, as it happens, fish wasn't served at the last supper, just bread and wine (Mark 14:22–25), but early Christian New Testament gospels were written in Greek, the official language of the Roman empire, and the word for fish in that language is *ichtus* which was noted to be an acrostic of the initials of the Greek words "Jesus Christ, Son of God, Savior." It would become an emblem of Christianity, biblically connected to the miracle of loaves and fishes and the idea of the apostles as "fishers of men." It would make a fine title for the work. The boss in the middle, flanked by his twelve fishermen, about to embark on a world history-altering mission. Jack's drawing of the seven parallel arcs that constitute the ceiling, or sky, generates an up-and-away high energy space, and this same spirit of elevation permeates every figure in the drawing. They are a dedicated group, determined, obsessed. Each apostle representing one of the twelve tribes of Israel. There is Jesus, the Messiah who had been foretold by the prophets—the invisible God suddenly made visible: teaching, blessing, healing, forgiving.

In *St. Benedict In a Cave.* (**fig.38**), Jack not only gives us the title and theme behind the work, but writes about the saint in the 6th chorus of *Cerrada Medellin Blues.*

Alone with my Guardian Angel
Alone in Innisfree
Alone in Mexico
 City
Alone with Benedict
 Cave is free
Alone is Alone
 Thou only one -
Alone and Alone
The song of the pree
(Pree means prayer
in English & Frenchie)
Choose yr words lightly,
 shit on the world
Merton'll die
 When he reads
 this from me

The pencil drawing, on a small 3 1/4" x 7" strip of paper, conforms to Jack's regimen of instinct-driven

automatic draftsmanship and the image gracefully occupies the long vertical space. Saint Benedict stands in a rather shy pose in front of, or inside, the cave. The sketchy pencil strokes are contained by more assured contour lines that clarify the artist's intended image; only in the abstracted drawing at the top is there any visual ambiguity. The head of the saint is formed largely by the hair, beard and slanted, slightly beady, browless eyes and by a well-formed mouth, which puts the final touch on the facial expression. The position of the arms and clasped hands, the monk's collar and dangling crucifix, slight angle of the body and tilt of the head are an excellent example of the sensual and decisive "body language" we find in many Kerouac subjects.

Jack's selection of St. Benedict could well have been based on the avant-garde position the saint adopted in the sixth century, when, having felt the need of fellowship, he left the isolation of the cave to found the monastic order of Benedictines. In his order, he did away with the extreme austerity and asceticism normally associated with monastic life and shifted its focus toward the arts, education and utilitarian pursuits. Renunciation of the world was not the way of life in his monastery. Other orders would follow his lead, and literature, art, music (such as the Gregorian Chants), and the world-renowned liqueur given his name and still made at the Benedictine monastery, would be part of the great legacy of his rule. This too, is celebrated by Jack in the 4th chorus of the 1st solo of *Cerrada Medellin Blues.*

When I drink Benedictine
I drink what the Holy
 Father
 Blessed
I drink the blood of Christ?
 Naw !

I drink Christ hisself -
I say "Thank ye, God"
 and drink
and kiss the bottle
with the cross on it
And D . O . M.
 the director of drinkers
 the Heavenly Daiquiri ?
 the troublesome Innisfree.

In *Red Glow* (**fig.39**), with broad, slashing, expressive movements of a red pastel crayon, held on its side and pulled with strokes of varying degrees of intensity, Jack creates an effect reminiscent of Rayonism, best recalled in the work of Robert and Sonia Delaunay in Paris, in the early years of the twentieth century. Jack draws these rays of light over a background he has already colored with blended red and golden yellow pastel. At the extreme right are three long vertical lines in the same red crayon, partially blended into the paper. At the bottom of the work, just left of center, is an ultramarine blue, rectangular shape for which there is no explanation other than as an element of the abstract pattern that exists within the work, formed largely by the areas of color. The two slightly irregular, outlined rectangles at the top also contribute to the abstract background and have as their precedent in Kerouac art the three-sided shape marked "tomb" in Jack's drawing of Emily Dickinson. Neither analysis nor intuition sheds much light on the meaning behind the two figures in *Red Glow,* but one can examine them existentially, exactly as they appear. The naked kneeling person at left, arms raised in prayer or salute, has the left hand quite accurately drawn, but the right one is inexplicably

missing. From the anatomy, one is unable to determine the gender of the figure, nor is the long hair any real indication of its sex. Very disconcerting is the lower body area, where the knee appears to be seriously dislocated, and then there is that object curling up right where a tail would be. The face, though, is entirely human, pleasant in its demeanor, and bright-eyed with a high intellectual-looking forehead. It is encircled by a formidable eraser-generated halo.

The second figure, clerically garbed in angelic white, has a long shock of hair around its smiling, button-nosed face. On its back are golden wings and from the halo around its head, white rays shine down upon the kneeling person opposite. The subtle blending of white pastel on this figure and around it enhances the aura of religiosity with an ecclesiastical halation. The entire work is infused with this holy glow, largely through the effects of the open white space as well as the blending of the white chalk.

The action of the figures, particularly the angel at right, centers around the object in its hand. There is also the question of whether the orange streak along the cup is a stream of liquid pouring into the cup and filling it, or is it flying upwards out of the cup, possibly fueled by the mysterious object beneath the cup.

Both the aesthetic and the mystery of *Red Glow* are again apparent in *Golden Sands* **(fig.40),** a painting based on a sketch in Jack's notebook #54 **(fig.41),** in which two women sit on the ground, facing one another, with tiny infants in their arms. The pyramids and minaret in the distance, and the rolling sand dunes locate the scene in Egypt. There are five crosses in the painting: two small ones over the heads of the women; one reinforced and darkened cross over the head of one of the children; another that emanates from the mouth of the woman on the left, as though she were speaking of Christianity; and one larger cross at the exact center of the painting. The child with the woman at the right has no cross, but it does glow with a heavenly light. The rainbow sky, a wide, texturally varied area of yellow, and the dusky color wash in the figures are contrasted by the free-wheeling red ink drawing, which unites the elements of the work. Even the watercolor effects in those places where the colors ran adds textural tonality. The colors are gorgeous. Yellow is difficult to work with and while many artists avoid it, some, like van Gogh, Gauguin, and Matisse, took it on as a challenge, working it with greens, purples, and blues. Jack handled it extremely well, keeping the yellow from overwhelming the work through his largely intuitive handling of the tertiary rosy reds and complementary turquoise blues. *Golden Sands* has great energy; it brings to mind the fifth-century Chinese aesthetician Hsieh Ho's first principle of art: For a painting to affect its audience, it must possess "rhythmic vitality." Jack has so infused *Golden Sands* with vitality it seems to glow from some internal power source. Its rhythms, beginning with the baton-like motion of the pen in drawing the background, undulating pyramids, and rolling dunes, are a prelude to an ever-accelerating symphonic spirit, the *andante cantabile* of the two figures.

"I'll go light candles to the Madonna, I'll paint the Madonna, and eat ice cream, benny and bread—" writes Jack in the closing lines of *Tristessa*. And he did go on to paint the Madonna, many times and in many ways. Two of them which reflect both the pleasure Jack

found in their making and the religious fervor from which they evolved, *Blue Madonna with Cross* (**fig.42**) and *Madonna and Child* (**fig.43**), generate such a sense of godliness that one recalls Jacques Barzun, who, in his famed series of lectures "The Use and Abuse of Art," spoke of the painter, poet, and musician as having assumed a priest-like role in our society. Barzun, in an attempt to equate art and religion in a politically and ecumenically correct light, quoted George Santayana, an avowed atheist:

Religion is a kind of poetry whose dogmas are symbols of truth imaginatively enforced. Religion and poetry are identical in essence and differ only in their practical links with daily life.

Van Gogh, too, believed that God had a hand in art, and the way to the understanding of God could be through comprehension of creative works. This is an indirect but clear parallel to the Kerouac belief that the Holy Ghost was directing his pen. Jack's guardian angel just may have been guiding his hand in drawing these two very pious and sacred profiles of the Madonna.

Jack left a legacy of several hundred drawings. Some are witty, some sad, most are expressionistic in style, but in these Madonnas we find a unique sensitivity of line, color, and texture. They can be described as poet Ray Bremser described Jack's writing: "soft and sweet and hard and blunt."

Looking at the elements that comprise the *Blue Madonna*, we find two harmonious yet quite different images. One is the "soft . . . sweet" cosmic universe of the fluidity of the paint—a blend of color and misty line that forms the bodily structure of the work, gently running off at the edges. The other, "hard and blunt"

decisive lines, that grow even harder and blunter as one tracks them along their discursive route, where they broaden as the artist's hand holds firm, certain of its intention. Worthy of note, too, are the few lines that trace a course to designate the meditative facial expression and the swift oval of the halo. The somewhat lopsided, off-balance look of the crucifix on the wall is not without some meaning; it adds a theologically correct anthropomorphic sensibility, which one finds in so many of Kerouac's crosses. It's just Jack putting the Christ image back on the cross. *Madonna and Child* brings us a pleasant smiling image of Mary and the baby Jesus with some rather suspicious resemblance to Mamere. And the quickly dashed-off baby could certainly be Jack. The features are ambiguous enough to read many ways, and the baby seems to be reaching up and grasping a cup-shaped object. But whether this is a portrait of Mamere as the Virgin Mary with Jack playing Jesus is not the point. After all, most works of religious art were done from living models, and Jack would surely not have been the first to see his mother as the Virgin. Nor, I suppose, himself as Jesus. The fact is, it is a lovely work of art, showing Jack on his softer and sweeter side in the gentle line drawing and pastel pinks, blues, and yellows of the Madonna—and see how she shines like the sun.

There is a harder, blunter side to this work, however, and inexplicably it is focused on the baby, who is drawn quickly, gesturally, with only enough marks of the pen to capture the essence of a small person cradled in the Madonna's arms. Why the face is clouded in a blue wash and what object is at the end of the thrust-upward arm remains a mystery. But the picture has subtlety, charm and sincere religious conviction, once you get past the adult face of the child. Is this

Jack placing himself in the arms of the Madonna? Is the cup then truly a cup?

Jack's period of Christian iconography was concentrated largely in the late 1950s, but continued into the 1960s with his many drawings and notebook sketches. Among the most effective of these works are those done in the gestural expressionist style: free and spontaneous strokes of the brush and a fluidity of paint throughout the work that conforms both to the Kerouac rules of painting and the aesthetic principles of the German expressionists and the American abstract expressionists. The common denominator: The work was a direct expression of the artist's emotional state. The German movement in the 1920s and '30s reflected the plight of Germany following their defeat in World War I. A decade later abstract expressionists built the American movement on the foundation of Existentialism and Surrealism, both French imports quickly assimilated into the search for a new artistic truth. At the center of the group were Willem de Kooning and Franz Kline, who often held court at the Cedar Tavern and the Artists Club. Both were drinking companions of Kerouac's and it is believed by Jack's close friend Helen Elliot, that de Kooning gave Jack some lessons and advice on painting, and by Stanley Twardowicz, that Jack also spent time at Kline's studio. The extent of the influences is subtle, as Jack continued to experiment with his own ways of using form, line and color throughout his years of making art.

In a letter that Jack wrote from Spain on June 7, 1957, to Allen Ginsberg, Peter Orlovsky, William Burroughs, and Alan Ansen, he states:

"I painted *The Vision of the Goatherds,* which is red shepherds looking at a creamy cross in the heavens, with swirling blue clouds around . . . "

The Vision of the Goatherds (**fig.44**) is a classic example of expressionist painting technique and quintessentially Kerouac in its dramatic content: Christian mythology with a twist. It has among its inspired, dashing brushwork some of Jack's finest moments as an artist. The application of paint is itself remarkable for its deftness and for a rhythmic, textural configuration that at first appears amorphous and convoluted, but with a longer look establishes itself as the carefully choreographed superstructure of the biblical drama unfolding on the canvas.

The blue swirling energy mass of a sky brings to mind some works of Van Gogh in which that artist's intention was to project the powerful natural dynamic of the universe. This could have been Jack's intention as well. That bold, triangular space that dominates the work is a classic of Renaissance compositional methodology, but what is unique as art and unique for Jack is the painting of this entire segment in red. As for the draftsmanship, the figures are accomplished skillfully so that each is firmly planted on the slope of the hillside. Jack had an intuitive sense of posture, of how bodies moved and shifted their weight. The people in his work always appear comfortably ensconced in their environment, like the powerful figure at right, who sits lordly on the top of the hill, one arm raised, the other clutching a staff. The seated person on the hillside leans on one arm, the legs are drawn up at the knees and the left arm rests along the top of the thigh. The curve of the hooded standing figure, right arm raised and holding a staff, left hand on the hip, animates this

figure as well. At the base of the hill, a fourth figure sits on the ground, leaning on a white object. Here, too, an arm is raised, but possibly as a shield against the bright light, of which we see reflected highlights on the hand and arm.

At the bottom of the slope is an animal, a sheep or goat, and a fine example of how an artist can capture the essence of a difficult subject with a minimum of brushstrokes. Jack was skilled at drawing animals, he often sketched his cats and did a fine drawing of a donkey. Although there is no clear meaning as to the subject of this work, it is worth noting that it depicts the days of animal sacrifice, and the obvious religiosity of the painting could suggest that the goat or sheep was there to participate in the ritual. It could also merely have been part of the flock.

Everyone in the painting is focused on the surreal golden apparition that appears overhead in a splintering dispersal of blue sky and twisted clouds. There is the large cross, beside it a bold swirl of paint that begins in a nucleus of deep red and twists about itself in a widening circle, then spirals off to slowly fade into the pale gold of the "hole" in the sky. These may be the goatherds to whom the angel Gabriel is appearing, to announce that Christ is born in Bethlehem. A literary rather than biblical connection may be that the swirling energy mass emanating from the deep hole in space is "the golden swarming peace of Heaven" that Jack falls asleep to at the end of his long vigil in the last pages of *Big Sur*.

In the December 1980 issue of *Art in America* magazine, Linda Nochlin did an analysis of Picasso's use of color. The study turned up a number of paintings where the colors of the French flag (blue, white, and red) were emphasized and noted that these paintings were done during a period (1921) when Picasso was celebrating the victory of France in World War I.

Jack was known for his patriotism, for his staunch support of the government, and his anger, angst, and frustration at the hippies and their protests during the sixties. The late '50s, when *The Vision of the Goatherds* was painted, was a period of extreme superpatriotism in America. It was the age of Senator Joseph McCarthy and the House Un-American Activities Committee hearings to search for and fire Communist sympathizers in the schools, the arts, and the government itself. It was the time of Jasper Johns's flag paintings; Tom Wesselmann's red, white, and blue Great American Nudes series; and just a few years before Abbie Hoffman would be arrested for wearing a shirt made from the flag. Red, white, and blue was a big political issue then, so we shouldn't overlook the possibility that it is a painting Jack did "for God and country."

They say there's a mighty force no one of us know about . . . especially tonight when the Invisible Power of the Universe is supposed to be nigh—we don't know any more than the Sun what the Snake will do—and can't know what the Golden Being of Immortality can do, or will do, or what, or where—

Doctor Sax, p.191

Looking at a most unusual painting of Jack's, *Golden Eternity* **(fig.45)**, one is drawn to the painter-poet consciousness of which Picasso spoke; to the William Blake poet-painter sensibility; and to wondering if Jack had really incorporated Christian and Buddhist imagery on one canvas. It depicts a person in the nude, with waist-long, golden-orange hair, seen from a

three-quarter rear view. The soft contours of the body and smoothness of the skin, the long hair and general demeanor, make the figure appear to be a woman. The space around the figure is aglow with a soft radiance of the same hue as the hair, a void which echoes into the distance, where it blends with a muted yellow-, mauve-, and green-streaked cosmos. It has a mystic radiance reminiscent of Blake.

Jack left no title and no clues to the meaning of this work, but a number of ambiguous elements can be variously understood, like that hill off to the left, composed of just a few gray-green sweeps of the brush. At its top is a fading, misty image of an elongated crucifix with a standing dark figure silhouetted beside it. Directly behind this, and gloriously illuminating it, is a vast circular expanse of bright burning yellow, as though a huge sun lay beyond the soft violet and murky green streaks of sky. An elegant spruce tree, in rich tones of blue-green, whips about in the heady atmosphere of the void, its branches bending this way and that, as though being blown about by unnatural currents in the air. In that corner of the painting alone, there seems to be a symbolic drama in progress as lemon yellow rays of the sun illuminate the cross while the great symbol of nature, the mighty spruce, leans into the wind, struggling for survival.

Then there is the squatting figure who watches this scene from center stage,—Buddha-like, tranquil—and that narrow whirl of wind that reaches out to envelop the figure like an Indian dust devil. Half way into the picture is a face with a high forehead, yellow eyes, a red mouth, and a green beard. No one ever said Jack lacked a sense of humor. Jack had no trouble incorporating Buddhism into his Christianity. In the closing lines of *Big Sur*, we find words that express the mood of this painting: "St. Carolyn by the Sea will go on being golden one way or the other." He also writes of a "Simple golden eternity blessing all," and that "a golden wash of goodness has spread over all and over all my body and mind."

> —On soft Spring nights I'll stand in the yard under the stars—Something good will come out of all things yet—And it will be golden and eternal just like that—There's no need to say another word.

Northport, Long Island, New York, 1964:

Miklos Zsedley, the art director of the Northport Public Library, suggested to Jack's friend, painter Stanley Twardowicz, that they do a taped interview with Jack, who was living in Northport at the time and had given the original manuscript of *The Town and the City* to the library. He at first declined, but after a brief visit to Gunther's, their favorite bar, just across from the library, Stanley managed to convince him, and a three-day session followed. The interviewers were Zsedley and three staff members: Joan Roberts, Dave Roberts, and James Schwarner. Stanley was also at the table and played a key role in the dialogue. An excerpt:

ST: **You know Jack paints, too.**

MZ: **He paints, too?**

ST: **He's been painting on and off, yeah.**

MZ: **[to Jack] You're a painter too?**

JK: **Oh yeah, I painted an oil portrait of the Pope.**

MZ: **Which one?**

JK: **Pope Paul.**

ST: **The previous Paul, yeah, yeah.**

JS: Pope Paul the Second.

JK: While he was still a cardinal.

MZ: Mhmm.

JK: Archbishop of Milano. See the picture in . . .

MZ: Milano.

JK: See the picture in *Time-Life* magazine.

MZ: Mhmm, mhmm.

JK: Hung it up with nails [JK makes three knocking sounds with his mouth] had my girl [Dody Muller] stretch a canvas, was in my shorts, took a big pot of paint. Took some charcoal first and drew him.

MZ: Mhmm.

JK: Then I painted it. While I was trying to do that, two mover friends of mine say, "What's Jack doing there standing there with a pot of paint in his hand, trying to paint a picture?" She says, "Get out of here! He's working." She calls it working. Today the picture's hanging, haangg ging. Ha ha . . .

JS: In the bathroom.

JK: In a Central Park West penthouse.

ST: Yeah, your agent's house.

JK: Yeah.

ST: Naturally.

JK: I'll sell it. It's beautiful, it really looks like him.

ST: Jim, but . . .

JK: What's his name, Paul? What's his real name?

MZ: Montagne.

JK: Mon - taigne!

JK: Real mean. He's mean.

ST: You know this is the funny part about Jack, you know, he was talking about writing, you know, he says no plot.

JK: However, that was luck. Now this man has worked at painting.

MZ: Yes.

ST: No, but to add to this thing, this is very strange . . .

JK: I'm an, I'm an instinctive painter like Wyndham, Wyndham Lewis or D.H. Lawrence. I'm not a real painter.

JS: Will you shut up already?

ST: Yeah let me, let me finish this. I think this is in relation to you anyway. He was talking about his writing, his structure and so on. He can write a novel in three weeks sort of a continuous sentence, you know, going on like you were talking. In a sense no structure at all to speak of except what it is, you know.

JK: (garbled)

ST: But then he's been to my studio, he's been to my studio, and every time he says, "I want to do a painting, I want to do a pietà." I say fine, I give him the canvas . . .

JK: I'll do it right now! Paint.

ST: I give him the paint, and all of a sudden, he says, "Give me a charcoal." I said, "What do you want a charcoal for? Get the brush! " You know this is what I use. He has to draw first and then fill it in. Structurally in painting he's very traditional.

MZ: Yes.

ST: Most writers are, this is very strange, you know.

MZ: Ah, by the way, with this ah . . .

ST: They have lousy taste in paintings.

MZ: With this ah, three weeks writing . . .

JK: However, my favorite painter is Hieronymus Bosch.

ST: Oh yeah, good thing he's dead.

JK: My favorite painter is Van Gogh.

ST: And he's dead, too.

MZ: Mhmm, yeah.

JK: Yeah, but who's your favorite painter, number one?

ST: Number one?

JK: Delete Van Gogh.

ST: Paul Klee. If I had to choose one.

JK: I've never even seen his paintings, just his drawings! He has, he has lousy drawings.

ST: If I had to choose one it would be him. My second would be Franz Kline.

JK: No kidding! Why?!

ST: Because I like him. Yeah.

JK: [Be] serious.

ST: But I think what he had to say and the way he said it, a kind of directness. I think he was a terrific painter, very direct and to the point. What I first saw in Pollock or Kline or, de Kooning. I think de Kooning in a sense is a French painter, he's very tasty. You know?

JK: [to DR, JR, and JS] He had great big beautiful whites, reds, there with red splashes. I didn't know what the hell it is, it's just something . . . I don't know . . . Why is he beautiful? Why is Franz Kline beautiful?

ST: I know, most people don't see that, that's true.

JK: Why? I can't understand why.

ST: I think maybe bec . . .

JK: Do you think maybe because of his spontaneity?

ST: Yeah, exactly what you were talking about, his very direct . . .

JK: Yeah, but he doesn't go as far as I do. I have to go on all night. He just goes ftch ftch ftch finished . . .

"Cardinal Montini," Jack wrote on the back of the canvas, "by Jack Kerouac '59." Then he signed it again with a flourish "Jean-Louis Kerouac," his special signature **(fig.48)**. Clearly, this is a painting of which he was proud. Over three feet high, it is a large painting for Jack, and its subject, too, is big as life, not biblical or mythological, but a living being of our time **(fig.46)**. When Jack painted the future Pope Paul VI, he was in his second year as cardinal. As archbishop of Milan from 1954 to 1963, his attention had been focused on social problems, labor relations, and some significant reforms regarding abstinence and intermarriage. After he was elected Pope in 1963 he made church history by being the first to hold that office and travel out of Italy in 150 years. His ultimate internationalization of the Vatican did a lot to improve its relations with the communist countries still hostile in those Cold War years. As modern as his outlook appeared, he upheld the church's traditionally conservative position regarding such critical issues as the ban on contraception, priestly celibacy, divorce, and the role of women in the church.

The magazine article in which Jack found the photo of the cardinal, which he used as his model for the painting, appeared in the October 20, 1958, issue of *Life* about candidates for the next pope **(fig.47)**. The caption beneath the photo described Giovanni Battista Montini as "only an archbishop" and said that the chances of him becoming pope were slim, because for 580 years the new pope had been chosen from the cardinals. Shortly thereafter Montini was appointed a cardinal, and five years later elected pope. There is no way of knowing whether Jack selected Montini as his model because he was awed by his heroic rise to ecclesiastical fame or because of the physical and aesthetic dynamics of the cardinal's pose: his regal bearing, elegant cape, the broad-brimmed decorated hat in hand, the reflected light on his face, steady all-seeing look in the eyes, and the silver crucifix hanging authoritatively from his neck.

Jack's painting of the cardinal, and his spirited interpretation of the photograph, is quintessentially

expressionistic. The paint is applied with urgency, the thick, wet-on-wet colors streak, blend, and curl about at the edges. The deep burning reds of the cardinal's holy vestments dominate the composition, with a dome of golden yellow light shaping his high forehead as it absorbs a broadside of tinted sunlight, likely beaming through a stained glass window overhead. Hollow black voids and dark blue interstices drop back behind the image, deep into the canvas, but the swirl of the doffed black hat highlights itself onto the frontal plane of the work and rests against the future pontiff's elegant robe.

Jack uses white in this painting as many artists use black: as a note of emphasis and outline. There is a rhythmic design in the placement of the white that runs in counterpoint to the red painterly mass surrounding it. The white paint skirts across the surface emblazing the crucifix, the sleeves, and the border of the cape; it then floods the lower half of the face in rectangular strokes of light, as though His Holiness is standing before a large array of votive candles. The ears, too, are inextricably alight in this reflected glow, but it is in the penetrating eyes that we find an intensity peculiar to Jack's style. Large, concentric, white and then blue circles are placed, with a twist of the brush, on top of the eye socket and then left untouched without painting

the eyelids. The effect is hypnotic. Surrounded by the complements of yellow and red, the transparent blue irises lock the viewer in their liturgical grip.

In the background, we can see the capabilities Jack had of becoming a first-rate abstract painter. In his depiction and diffusion of the spaces behind the cardinal, he created four independent nonobjective paintings. Jack's intention was an abstracted rendering of the church environment. His use of the same passionate palette of colors in this contiguous area, as in the figure, amplifies the spiritual connection of the main subject to his station: the cardinal as an all-embracing, integrally ensconced element of the Church.

—POSTSCRIPT—

October 4, 1962—letter to Allen Ginsberg from Jack

. . . Sterling's wife wanted to buy jejeune oil painting of mine of Cardinal Montini done in oil at Dodie's [sic] studio in 1959. Ma said no so she's borrowing it for a year. I'm mailing it . . . when I'm old and grey money for me in paint like Van Rembrandt. Who shall I choose to be my model for the Pietà? Kingsly, Orlovsky, Lafcadio or Peter, you, who . . .

the face of god

POEM
I am God
HAIKU
came down from my / ivory tower
and found no world

ORIZABA 210 Blues, 46th Chorus
And What is God ?
The unspeakable, the untellable,—
Rejoice in the Lamb, sang
 Christopher Smart, who
 drives my crazy, because
 he's so smart, and I'm
 so smart, and both of us
 are crazy No,—what is God ?
The impossible, the impeachable
Unimpeachable Prezi - dent
of the Pepsodent Universe
but with no body & no brain
no business and no tie
no candle and no high
no wise and no smart guy

no nothing, no no nothing,
no anything, no -word, yes word,
everything, anything, God,
the guy that aint a guy,
the thing that can't be
and can
and is
and isnt

I am waiting for God to show me his face" Jack told America on the John Wingate *Nightbeat* show on WOR-TV. He ruminated on the essence of God in the 46th chorus of *Orizaba 210 Blues,* and he painted the face he had been waiting to see and wrote, at the lower right, "God" **(fig.50)**.

The surface of the work is transparent with pigment applied in a scumbled, scrubbed-in manner, allowing the original pencil sketch to show through the thin veil of color. The spectral image appears tentative and unfinished and has little physical substance. Consider, too, the angle at which the face slips into view, as though it suddenly arrived in this space and was surprised to find a staring audience. It never becomes comfortably

ensconced in the picture; it is as though one is allowed only a momentary glimpse of the face of God.

Of note is that strange expression in the triangulate of the eyes and mouth. Set in dark hollows, squinting and heavily lashed, the eyes simply do not focus. They have deep black corners and dilated dark pupils that seem to be looking upward and somewhere to the right; gray, sunken, misty, they remain distant and ambivalent. Did Jack intend God, like Justice, to be blind? Or is this an inner-directed, all-seeing being, who observes the universe through an inner second-sight.

Complementing the blue-black hollows and shadows encircling the eyes is a sensuous crimson mouth. A touch of light reflects off the lower lip which is parted ever so slightly from the upper. A dash of gray shadow is at the top of the chin. The highlight below the nose and the dark touch of the brush at the right edge of the lips bring the mouth to a contemplative pout.

The long bridge of the nose, just slightly askew at the nostrils, lends a concave note to the face and contributes to the pensive expression; but it is the paint quality on the cheeks, resembling over-applied rouge, that defines the sweeping curve of its bone structure. Whether the "black cye" on the left side is intentional is indeterminate, but there is the appearance of tear-driven, running mascara. In fact, on close examination, one can see what could well be a teardrop on each cheek, one trailing through the darkened area beneath the left eye.

One way of contemplating the baffling ambiguity of the facial expression is to consider each side of the face independently. The left half appears to be a bit sad, but meditative and thoughtful. The eye looks up at the viewer, the mouth slightly open but pleasant enough. The right side, however appears to be completely devastated: the open mouth down at the corner, and the cheek swollen as though uncontrollably sobbing while the black-laced eye looks away to the side in a terrifying, pitiful expression of grief. Jack has painted God in the image of human suffering so ubiquitous in both his Catholic upbringing and the sad realities of everyday life; but he paints the forgiving, hopeful side of God, and of life, as well.

In the *Vanity of Duluoz,* Jack examined the two faces of this God

. . . who will pat you kindly on the head and say now you're being good, when you pray, but when your begging for mercy anyway say like a soldier hung by one leg from a tree trunk in today's Vietnam, when Yahweh's really got you out in the back of the barn . . . he wont listen, he will whack away at your lil behind with the long stick of what they call "original sin" in the Theological Christian dogmatic sects but what I call "Original Sacrifice."

Then there is the accessible, "regular guy" God of the *Doctor Sax* novel, with whom Jack Duluoz, just recovering from a serious bout with the flu, commiserates while pondering his cure:

I lay reading The Shadow magazine, or feebly listening to the radio downstairs in my bathrobe . . . the last few days were blissful contemplations of the heaven in the ceiling . . . I had conquered death and stored up new life. Beautiful music, regale me not in my bier heap—please knock my coffin over in a fist fight beer dance bust, God—

Still another Kerouac version of God is the pragmatic, politically connected ruler of the universe, who is called upon by Emil, in the role of Jack's father, as he

walks "along the redbrick walls of commercial Lowell," in a blizzard, looking for a job, on page 74 of *Maggie Cassidy:*

> **God, tell me if anything goes wrong and you dont want me to go on that way. I'm just tryna please. If I can't please the lion and the angel and the lamb all at the same time neither. Thank you God, and get those Democrats outa there before this country goes to hell!**

There are two elements in the painting of God which, although peripheral to the dynamics of the face, cannot be overlooked. One is the red and green atmospheric background, the other is the sweeping mass that encircles the face and that Jack in his letter of October 11, 1956, to Peter Orlovsky describes as "snow white hair."

The transparent, crimson-red and mottled, earthy blue-green of the background are the stuff of which art criticism is made. "Confrontational colors," said Stanley Twardowicz of these symbolic, most quintessential of complementaries: heaven and earth; fire and water; hot and cold; love and war; man and woman; Eros and Thanatos. Jack had come to a similar conclusion as van Gogh, who a century earlier had written Theo that through his juxtapositioning of red and green he sought to express the "terrible human passions."

Jack's painting of God, then, is a study in contrasts. The painting can be quartered as well as halved: as the face divides into the light and dark moods, so the background does the same. Its visual ambiguity is summarized and amplified in the 7th chorus of *Cerra Medellin Blues:*

> I see the face of Christ
> in the door
> after it has been the face
> of the Dog, the Owl,
> the Lamb, the Lion
> Christ, the Dog again,
> the Collie then suddenly
> My God the Colleen!

Her soft brown eyes,
 esperanza morena,
Then it's Christ again,
 this time in profile
— This I just saw.

Jack again addresses the idea of God in Scripture #14 of *The Scripture of the Golden Eternity:*

Both the word "God" and the essence of the word, are emptiness. The form of emptiness which is emptiness having taken the form of form, is what you see and hear and feel right now, and what you taste and smell and think as you read this. Wait awhile, close your eyes, let your breathing stop 3 seconds or so, listen to the inside silence in the womb of the world, let your hands and nerve-ends drop, re-recognize the bliss you forgot, the emptiness and essence and ecstasy of ever having been and ever to be the golden eternity. This is the lesson you forgot.

<div align="right">Scripture #14 p.27–28</div>

And finally, there's Jack's own focus on the work, described in a letter to Peter Orlovsky—October 11, 1956—from Jack, from Mexico City.

My most recent painting now is an oil painting called "God"—it shows his sad + beautiful face in the sky—the sky is deep red with blue clouds, his hairs flows snow-white down both sides of his compassionate cheeks, his eyes are blue and beautiful and eternally tearful almost—his mouth is a marvel of expression, as if he's saying "Aw, poor Peter—poor Allen—poor Gregory—poor Laff in the dishpans—poor Jack on the roof—poor Gui in the dress—"—I'm going to try to add a little boy in a white wagon drawn by two white lambs, when the red paint dries—Tell Gregory to let me know when he gets Lucien Midnight in the mail—Tell Neal I'll write to him + Carolyn soon—Tell Allen I painted "The Holy Folded-Arm Buddha sitting on the Red Poppy of Re Awakening" which I'll send to Gary in Japan

<div align="right">Jack</div>

painting the buddha

TRISTESSA, **page 19: "I know everything's alright but I want proof and the Buddhas and the Virgin Marys are there reminding me of the solemn pledge of faith in this harsh and stupid earth where we rage our so-called lives in a sea of worry. . . . "**

MEXICO CITY BLUES, **page 14: "I believe in the sweetness of Jesus / And Buddha / I believe in St. Francis / avaloki / Tesvara / The Saints of First Century / India AD . . . "**

LETTER TO CAROLYN CASSADY, July 2, 1954: "I'm sure Christ never trekked to the Orient, only wish he had, one dab of Buddhism would have wiped clean his mind that egomaniacal Messiah complex that got him crucified and made Christianity the dualistic greed-and-sorrow monster that it is, should say greed-and-piety . . . Buddha never claimed to be God . . . he only said he was a man who had gotten contact with the Buddhas of old, which everybody will do eventually anyway. . . ."

Against a deep Chinese red backdrop, Jack paints *The Gary Buddha*, legs crossed, in the asana sym-bolic pose of dhyanasana, the lotus posture of meditation (**fig.51**). As all Buddhist divinities, the Buddha is seated upon a lotus throne. Expressionistic brushstrokes, in turquoise blues, lemon yellow, and white, delineate the priestly robes, and a crimson neck piece borders the collar. The head and neck are painted with a thin glaze of lemon yellow that blends with the red underpainting to lend a rich golden-orange transparency to the skintones. The symbolic position of the hands, *mudra,* shows the right hand palm up, a gesture of giving while the left points downward in the bhumisparsamudra, a connection to the earth, the source of all gifts.

Jack has simplified the facial features: delicately drawn eyes, defined with an inquisitive curve to the upper lid, and soft green pupils with blended gray shadows at the outer edges that lend a dimensional roundness. An opaque white dot is placed between the ever-so-lightly sketched eyebrows, depicting the *Urna,* that raised spot from which emanates rays of light to illuminate the world. The nose is divided vertically across its bridge by a fine line that bisects the face and at the forehead it forms a cross with the horizontal of the eyebrows. An

elongated triangle on either side of the vertical is the geometric basis for the construction of the nose. Atop the Buddha's head is a yellow-and-white spiraling *Usnisa,* the bump on top of the head which accommodates the superior wisdom which the Buddhas achieve upon their attaining years of enlightenment. The lengthened earlobes are clearly visible and dangling along the ears, not quite to the shoulders, are golden yellow braids, one with a pale blue object that seems to cup the ear. Surrounding the Buddha's head is a large circle, carefully outlined in turquoise blue and comprised chiefly of sweeping brushstrokes of black, yellow, and red, forming a kinetically charged field of energized paint that meanders into a familiar round organic shape. One recalls the popular mantra "*Om mani padme hum*": "power is in the eye of the lotus," as one begins to sense the shape of the encircled Buddha who is, in fact, the eye of the lotus flower.

"Existence was like the light of a candle," Siddhartha muses, in "Wake Up," Jack Kerouac's life of the Buddha published in *Triangle,* The Buddhist Review. (Vol. II, No. 4 and Vol. III, No. 1, 1993) The publication used this painting as an illustration for the story and in February 1993 for the cover of the magazine. So one must consider this quote as a possible influence in analyzing the background patterning of yellow variegated shapes—an important part of the "overall" design of this work. In Jack's mention of this painting in the letter of June 7, 1957, to Peter Orlovsky, he talks of these shapes as yellow gold electrons and the effects of a "Jackson Pollock THIS SIDE UP madhouse . . . I just shot paint all over the page and the floor." The resultant image relates, too, to the multi-figuration common in traditional Buddhist Tanka paintings where the artists take great pride in the inclusion of record-breaking members of little Bodhisattvas going about their ritual activities. But not having the saintlike patience of the Tanka artists, who work for months on a single painting, and influenced by friends like Pollock, Twardowicz, de Kooning, Kline and Dody Muller, and the pace of 1950s America, Jack may have succumbed to the basic precepts of the New York School painters and expressed the phalanx of a Tanka's hundred-plus little Buddhas in an abstract expressionist's instant-gratification aesthetic of golden-yellow squiggles.

Jack completed the essential composition of the Buddha with a series of gesticulating painterly white marks that signify the lotus throne on which the Buddha is seated; but phenomenologically they seem to project a bleached and purified white radiant energy in a curving sunburst sweep around the meditative body. Truth perhaps: purity of thought, dispersion of karma, teaching of dharma. At bottom left is a figure Jack describes as a "sentient crazy being," but it does resemble a dharma lion sitting at an odd angle as though cocking its head enquiringly. One round, cartoon-style eye in extreme dilation heightens this quizzical expression. Just below this figure is Jack's signature.

The kneeling person at bottom right is described by Jack as a Subhuti. His green robe is draped over the left shoulder, the other is bare, and his right hand is raised in the Buddhist sign for absence of fear. The palm of the left hand is open in a gesture of giving. The source of light on the figure emanates from the Buddha. A yellow reflection highlights the right side of the figure, most noticeably on its face, right arm, shoulder, and knee. The facial details are sketchy but definitive and the overall demeanor of this Bhikku appears to be quite fit—even muscular, and the face, with its

Buddhist-styled, close-cropped black hair and square-ness of chin is youthful, rugged, and sturdy. What is most enigmatic about this clearly Buddhist figure is the halo hovering about its head. Jack writes of Buddhist "saints"; here we have a depiction of one.

If one considers the possible aspect of this work as Mandala or Tanka art, the details of this Buddha's biography are rendered in quickly-noted shorthand brush-strokes. In this scenario, too, the young man, at lower right, represents the Buddha in his youth, at the beginning of the long road to enlightenment. Here he begs for food, is half clad in a simple robe, but is protected by his saintly vows, manifested in the halo that encircles his head. The golden rays of light that warm and beckon him on to the "simple golden eternity blessing all" (of the final paragraph of *Big Sur*), issues from the source of his own ultimate destiny—from all those golden symbols that are his story yet to be lived, and from the Buddha in the eye of the lotus, the ultimate source of all power.

Jack's enigmatic painting *The Vision of Dipankara / Sources of Imagination* (**fig.52**) reaches deep into Buddhist history. Dipankara was the first of the twenty-four Buddhas. There are a number of references to him in Jack's work: one toward the end of *The Dharma Bums,* where Japhy (Gary Snyder) is getting ready to leave for Japan and he and Ray (Jack) "sat crosslegged and chomped away as on so many nights":

just the wind furying in the ocean of trees and our teeth going chomp chomp over good simple mournful Bhikku food. "Just think, Ray, what it was like right here on this spot where our shack stands thirty thousand years ago in the time of the Neanderthal Man. And

do you realize that they say in the Sutras there was a Buddha of that time, Dipankara?" "The one who never said anything." "Can't you just see all those enlightened monkey men sitting around a roaring woodfire around their Buddha saying nothing and knowing everything!" "The stars were the same then as they are tonight."

This is a stirring passage and it sheds some light on the painting in extending our knowledge of Dipankara: that he was the Buddha who never spoke and that he existed in the age of the Neanderthal Man. In the last pages of *The Dharma Bums*, as Jack reaches the end of his mountaintop summer vigil, Dipankara appears again:

I called Han Shan in the mountains: there was no answer, I called Han Shan as the morning fog: silence, it said. I called: Dipankara instructed me by saying nothing. Mists blew by, I closed my eyes, the stove did the talking. "Woo!" I yelled, and the bird of perfect balance on the fir point just moved his tail; then he was gone and distance grew immensely white. Dark wild nights with hint of bears: down in my garbage pit old soured solidified cans of evaporated milk bitten into and torn apart by mighty behemoth paws: Avalokitesvara the Bear. Wild cold fogs with awesome holes On my calendar I ringed off the fifty-fifth day.

It should be noted that *The Dharma Bums* was published in 1958, one of the years that Jack was most prolific in his output of drawings and paintings. One should consider then, that any coinciding relationship between the written and visual works in these years can be assumed to be intentional.

Jack's introduction of Avalokitesvara the Bear throws

considerable suspicion on the nature of the beast-like creature at the center of this work. But this dark figure has Buddha eyes—and the Neanderthal Man is generally described as heavily built and powerful.

Which character in the work is Dipankara? Is it the figure behind the pyramid who makes a Buddhist two-finger gesture with his right hand and whose "vision" is the central figure, which could then be Avalokitesvara? Or is Dipankara the Paleolithic Neanderthal version of hirsute early man, at center, whose "vision" is that he is being observed from behind a white triangle—or pyramid—by a bald man in a dusty rose shirt, who is pointing two fingers at him?

Sources of Imagination remains a mystery, unless Jack is directing us to silence as a way of tapping our creative, imaginative forces. But yet another scenario is suggested in the last stanza of the 43rd chorus of *Orizaba 210 Blues:*

We haven't got the diamond tho
That freed Dipankara Buddha
In the Paleolithic morning
and made him make faces
In samapattis at me
Let's free

The large, white, heavily-painted, triangular shape in this context can be interpreted as a diamond, seated on its flat side, encompassing the full breadth of the Neanderthal Dipankara as it is described in *The Diamond Sutra,* Jack's favorite Buddhist scripture. Dipankara is mentioned in this work, and in Jack's translation of it, he classifies him philologically as the "Awakened One Dipankara." In Jack's *Scripture of the Golden Eternity,* he writes of "The Awakened Buddha to show the way," and later in that koan prose poem:

why he selfly and
unfree, Man God, in your dream? Wake up,
thou'rt selfless and free. "Even and upright your
mind abides nowhere," . . .
We're all in Heaven now.

This poem furthers the references to "awakeness" and "free," and these last words being in essence the last words of Gerard, who had counseled young Jack in kindness and in his belief that we are all living in heaven now. Jack compounds several of these factors in the 62nd canto:

awake is not really awake because the golden eternity never went to sleep: you can tell by the constant sound of Silence which cuts through this world like a magic diamond through the trick of your not realizing that your mind caused the world.

But all other conceptions fade with the discovering of a passage in Jack's *Some of the Dharma* which reads:

C O L D N I G H T March 8 1956 (1922 it says in my notebook!) Amazing Samadri—Flowers, pink worlds of walls of them, salmon pink - - -Obtaining Nirvana is like- - - Saw ancient vision of Dipankara Buddha as vast snowy Pyramid Buddha with bushy wild black eyebrows and stare - - - old location - Emptiness Samapattie - - - Dhyana and Blah blah blah, might as well Dhyana, for, go ask the silence to do something else - - - saw the wonderful happiness within and had no qualms about the poor lil world of UNHAPPINESS to which "I" had to return - - - no difference - - - *Obtaining Nirvana is like locating silence* because 1, there is no obtaining of Nirvana because it is the realm of no thing-ness, 2, there is no self to obtain it - - -

And then, Jack adds on,

2 weeks later 'Locating silence,' - - - it is everywhere - - - like Nirvana - - - here, now, every- where - - - The Pyramid Buddha made my hair rise - - - it was an ancient snow field like Alban - - -

In his *Introduction to Metaphysics,* philosopher Henri Bergson describes the two ways that one can grasp the essence of a "thing." One way is to "enter into it," wan- der about there: Alice through the looking glass— an intuitive Zen approach. Profoundly different, the other way is to simply "turn about it." This is a physical rather than metaphysical analogy, and although it seems the methodologically simpler of the two, it is in practice far more complex. For here one can rely less on intuition and must adopt a concept, learn a partic- ular set of rules, and the language skills needed to grasp the essence of the object.

In painting *The Vision of Dipankara,* Jack entered into the infinite Buddhist world and, ascribing to Bergson's first thesis, emerged with an image that transports the viewer back to the Paleolithic age, to the Neanderthal Buddha, "vast snowy pyramid" and all.

Far more traditional a work is *Face of the Buddha* **(fig.53)**. Here Jack subscribes to Bergson's second model of "turning about" the subject. And to accomplish this work of figurative realism, Jack had to adapt to the rules of drawing, anatomy, perspective, and light and shade. Although no photograph of this Buddha head was found in the Kerouac archive, it is likely that one of the Sukhodaya heads was used as the subject of the drawing.

The chiaroscuro—the darks and lights—of the work is quite effective, and the technique that Jack uses of sketching lines that parallel the outline of the subject and then break away into spontaneous rhythms is a quality that distinguishes other of Jack's drawings; it can be viewed as "spontaneous bop prosody" sketching.

There are a number of errors in the anatomy—the left eye, the angle of the mouth, the curve and breadth of the forehead, the penciled, added-on look of the eyebrows, are all a bit off-key. But Jack has achieved here, either consciously or intuitively, a drawing that in the best fine-art tradition exists on more than one level. In the curvilinear symmetry of the black-and- white segments of the Buddha's face, one perceives a metaphorical visage of the Taoist "Perfect Circle of Wholeness," the ancient symbol for the Yin and the Yang. The elements are all there: the circular shape, the inverted *S* curve separating the light and shadow, and the round "eye" in each half of the face, like the nucleus dot that brings light to the darkness and dark- ness to the light—much as the *urna* spot between the eyebrows radiates a light to brighten the world.

These interactions of the opposites in the Yin Yang symbol are believed to influence the destinies of all things and all creatures. The visual metaphor is placed with hope and optimism in the gentle face of Jack's Buddha, whose road toward the attainment of highest perfect wisdom is routed in the practice of kindness. It is written on the face of this Buddha: We are aware of five classifications of smiles on Buddhas—hidden, implicit, explicit, sublime, and stereotype. The shape of the mouth changes from a *U* to a *V.* The smile of this Buddha is blissful, beatific, subtle. It has the sound of a smile I once heard Gregory Corso describe. He had seen it on the face of Jack Kerouac after Jack had been badly beaten up in a fistfight in front of the San Remo Bar at the corner of Bleecker and Macdougal

Streets in Greenwich Village. As Gregory dragged Jack's opponent off him—he had been pounding Jack's head on the sidewalk—he saw that Jack, who had offered little resistance in the fight, had this blissful pacifistic smile on his battered, bloody face. The Buddhist persona had overwhelmed that of the football hero. The smile, Gregory said, was "beatific," and it was Jack just a few years earlier who had said that "beat" meant "beatific" and not "battered by society."

Although Jack did adopt the first of the four noble truths of Buddhism, "All life is sorrowful," which paralleled his Catholic teachings as the basic premise in much of his writing, in the other three noble truths Jack would find the ways to deal with the sorrow, ways he could not find in his Christianity: the cause of suffering is ignorant craving; the suppression of suffering can be achieved; and the "way" is the noble eight-fold path. The eight-fold path: knowledge, aspiration, speech, conduct, labor, endeavor mindfulness, and meditation.

The life of Zen begins with the opening of *Satori*. Satori may be defined as intuitive looking into, in contradistinction to intellectual and logical understanding. Whatever the definition, satori means the unfolding of a new world hitherto unperceived.
 D. T. SUZUKI—in *An Introduction to Zen Buddhism*

Jack cuts detail to the bone in *Enlightenment* (**fig.54**), an elegant line drawing of a figure: beaming, radiant with joy, ecstasy, passion, excitement. The legs positioned in a full lotus. The arms extended, open, receptive. The vibrant inner body as spiritual experience that takes place while the outer body falls into the "deadstop trance" of Jack's directions for meditation.

HOW TO MEDITATE
by Jack Kerouac

----- lights out -----
fall, hands a - clasped , into instantaneous
ecstasy like a shot of heroin or morphine,
the gland inside of my brain discharging
the good glod fluid (Holy Fluid) as
I hap down and hold all my body parts
down to a deadstop trance --- Healing
all my sicknesses -- erasing all -- not
even the shred of a "I - hope - you" or a
Loony Balloon left in it, but the mind
blank, serene, thoughtless, when a thought
comes a - springing from afar with its held --
forth figure of an image, you spoof it out,
you spoof it off, you fake it, and
it fades, and thought never comes -- and
with joy, you realize for the first time
"Thinking's just not like thinking ---
So I dont have to think
 any
 more"

And in Scripture #4 of *The Scripture of the Golden Eternity* Jack writes:

. . . meditate outdoors. The dark trees at night are not really the dark trees at night, it's only the golden eternity. Meditate outdoors. The dark trees at night are not really the dark trees at night, its only the golden eternity.

In another stingy-line pen-and-ink drawing, *Mt. Hozomeen* (**fig.55**), Jack depicts a figure from the rear, the arms extended and exaggerated in length, the hands

crudely drawn, index fingers pointing at the sky. There is an indication of breasts in the two curved shapes just visible at mid-body, while the sweep of the thighs and buttocks suggests the full lotus position. Long straight hair cascades down the back of the figure who appears to be nude, female, and engaged in some form of post-meditational euphoria. There is a distant, snow-capped mountain peak on the right and at left a massive mound, possibly the peak of another closer mountain. There is a strong possibility that these mountains were part of the view from the cabin on Desolation Peak where Jack spent the summer of 1956 as a fire lookout, and which Gary Snyder depicts in his Japanese brush drawing, signed with his signatory "chop." The picture is in Jack's personal collection (**fig.56**). There may be meaning attached to the series of small, ovular marks, first three and then four, that appear against the wall of the large mound or are floating in the air in front of it. The numerical progression suggests an *I Ching*–like pattern, but from a Freudian point of view they may represent seeds, falling randomly into the receptacle shape formed by the raised arms. The entire figure, from this perspective, takes on a sense of female genitalia.

The overall lack of detail in the drawing and the flexibility of analysis brings to mind the focused, uncluttered frugality of Buddhism, as well as a line written by Henry David Thoreau, whose work Jack admired and who was his original source of Buddhism. (It was a Hindu reference in *Walden* that sent Jack off to the library for elucidation, where he mistakenly took the reference as Buddhist.) Thoreau said: "Our life is frittered away by detail . . . simplify, simplify." In *The Dharma Bums*, there is the description of Jack's own elation at his first real look at the mountains facing his summer cabin, as the "marshmallow roof of clouds blew away."

Then my first sunset came and it was unbelievable. The mountains are covered with pink snow, the clouds were distant and frilly and like ancient remote cities of Buddhaland splendor, the wind worked incessantly whish, whish, booming at times . . . Sharp jags popped up from behind slopes, like childhood mountains I grayly drew. Somewhere, it seemed, a golden festival of rejoicement was taking place; In my diary I wrote, "Oh I'm happy!" In the late day peaks I saw the hope. Japhy had been right.

In the book *Painters on Painting,* in a segment titled "Painting and Zen Archery," Alan Davie, a British Pop artist, highlights an essential element of the creative act that ultimately comes to every artist struggling to find their aesthetic identity:

"The more obstinately one tries to learn how to shoot for the sake of hitting the target, the less one will succeed. In the same way, as long as I am aware of my inability to paint exactly as I desire, I am paralyzed by that very desire and only when I succeed in abolishing completely that desire can I create anything.

In the same spirit is the advice Pablo Picasso gave to Henry Miller, another American writer who seriously pursued painting. Miller had asked, "Pablo, how do you do it, how do you paint?" Picasso, predating Nike by many years, replied, "Don't think about it, Henry, *just do it.*" Picasso could have followed that up with another of his frequently quoted observations: "Painting is stronger than I am. It makes me do what it wishes."

There are all very Zen-associated, ego-free creative modalities. There are Kerouac drawings in which his

pen uninhibitedly explores the surface, guided by intuition, with figures appearing here and there among the largely abstract imagery. In one of these, *Buddha Surrounded by His Monks* (**fig.57**), drawn, with some irony, on an ordinary business file folder, the Buddha sits in the lotus position at the top of the work. Immediately to the left is a head that resembles Ganesh, the elephantine Hindu god, and just beyond this looms a walking skeletal figure. Between the two, a small, ghost-like personage rises out of a series of serpentine lines that continue to the bottom of the page. Here a group of figures, drawn at varying degrees of realism, sweep across the lower part of the drawing. One of these, the head of a woman with bulging, baggy eyes and long, dark hair, has two curved, wing-like objects that rise up from her shoulders and suggest that the amorphous lumpy shape continuing along the bottom edge of the work must be the body that belongs to the more clearly delineated head.

The most complex aspect of this work is the image of two intertwined shapes at the bottom center. They are decidedly anthropomorphic, the feminine-looking of the two positioned above the male, her back fitted like a piece of a jigsaw puzzle tightly against his. It is a nonsexual position but does have an innate sensuality. The male, with the weight of the woman on his back, leans a muscled arm on the reclining body beneath him, whose passive expression shows no concern for the burden. The globular aspect of the work, which is derived from the circular composition surrounding the Buddha and resembling a map of the world, brings to this view of the action the aspect that the male figure represents the legendary Atlas supporting not only the woman, but the weight of the whole world on his back. This Atlas, however, unlike the classic model,

balances on the body of a woman, who rests easily along the lower edge unfettered by the weight of the world being passed on to her by the man.

At the lower half of the composition is a bird-like creature with a long beak, and from the position of the tail and legs it seems to be jumping. Directly above this is a human figure, simply drawn with a large head, eyes wide and turned-down mouth, and a few quick notations of the pen to represent the body, arms, and legs. An elongated cartoon balloon swirls upwards from the mouth but encloses no words. Just above this figure is a more realistic rendering of a woman. It is a small sketch, cramped into a niche. Long hair falls to her shoulders, facial features are spare but expressive, and her breasts, covered by tight fitting clothing, are drawn, somewhat out of context, with anatomical correctness.

At the lower right of the blue circle formed by the wash effect, among a maze of quickly-sketched, partially-obscured, biomorphic images, stands a whimsical, Dr. Seuss-like animal. It is hairy, with tail extended, a hump on its back and an almost human face nested between the curly cowl formed by the top of the head and the jaw. It takes just a moment to recognize it as the dharma lion.

In the upper-right-hand corner of the work is a single figure. It has a large head, narrow ellipses for eyes, then lines for the eyebrows and nose, and a full-lipped, tightly-closed, smiling mouth. Two darkened areas at the sides of the head suggest a short hairstyle, in the 1950s likely to be that of a man. But swirling downwards from the top of the head are what appear to be long, wavy locks of hair that in 1958 one would have associated with a woman, and unique among the figures in this drawing is a halo that circles about this head. Adding to the ambiguities, in what may have

been a moment of whimsy for Jack, is a concealed face among the curvilinear patterns below the head. It looks inward, smiling, with a Buddha-like eye and an impossibly upswept banana nose. The shape was very likely never intended to be a face, but Jack, spotting the possibility of adding another monk to this freewheeling mandala, graffitied in the eye and mouth.

There is a characteristic Kerouac element common to most of the figures in *Buddha Surrounded by His Monks:* rays of light, or radiant energy, emanate from their heads—semicircular arcs of little vertical lines that are drawn around each, which in traditional cartoonology denotes sainthood, enlightenment, or beatitude. The Buddha seems to emanate his own light, as does Ganesh and the many little, just barely human anthropomorphs that inhabit the work. There is even an unexplainable burst of enlightenment that goes off on its own, in the bottom right segment. A sudden little epiphany that is gone in a moment. Jack's source of these halos is likely in the circles or lotus petals, often depicted in Buddhist art, framing the heads of Buddhist divinities, as he united them with the parallel Catholic iconographic symbols.

If one is to categorize the Kerouac paintings to find Jack's archetypal style as an artist, it would clearly be in Expressionism, where form is exaggerated and distorted, contrasts are sharp, colors are vivid, heavy outlines are often used as emphasis, and subject matter is thematic and symbolic. A perfect example of Jack's work as quintessential expressionist painting is seen in *Figures on a Red Ground* (**fig.58**). It has every prerequisite for the classification and no small degree of influence from Jan Muller's paintings, which Jack would likely have seen

during the period of his relationship with Dody Muller, after the death of her husband in 1958.

There are Kerouac works that are serious essays on religion, and there are those which are as avowedly secular. Although the mask-like features, general grotesqueness, vivid color, and black outlines instantly define this painting as expressionistic, it is in the central figures that we sense the religious spirit of the work. "The Buddhist Saints are the incomparable saints . . ." Jack wrote, and it would be difficult to find a group more incomparable than these.

That dark brown fellow atop the large, central animal-shape could well be the paleolithic Buddha Dipankara, here on his feet, eyes aglow, arms swinging. It could as well represent Avalokitesvera the bear, with that furry brown coat, tan belly, and eyes reflecting the light of a haiku moon or oncoming headlight.

Signs of the Buddha are everywhere: eyes graffittied into the red paint at upper right; facial features—eyes-nose—mouth, incised below the brown Dipankara's arm; a roly-poly Buddha in the red hourglass shape just to the left of the Dipankara-Avalokitesvera figure.

The large face at the upper left, comprised, as is this entire work, of vigorous, loaded-down-with-paint, expressionist brushstrokes, presents another lexicon of interpretive possibilities. The placement of the features suggests the possibility of a human face, a mask perhaps. The large segments rising from the side of the head are like long ears raised in alert or the still-fuzzy, developing horns of a bull. The white and gold paint surrounding the head thrust it forward from the fiery background. White areas define the body and fill the central space of the work—a large parallelogram, front legs just beneath the head, rear legs at a 45-degree angle, a long black tail growing wider at its end, swishing

in the action-painted space at its rear. From between the hind legs, a long, fiery red phallus curves upward. He stands poised for sexual activity. The ears are up, on the alert, the tail down, protecting the rear. The facial expression, as well, is fully focused. The eyes, wide open, confront the viewer, searching for the sexual partner. The body language, too, conforms to this view, poised on the backswing, coiled for the first conjugal thrust.

Another figure hovers just over the tail. Painted freely, but with enough defined characteristics to identify the image as a vulture. The sweeping neck, the small beak-defining gold line, and the red dot of an eye, clearly mark its head; the blur of the body and legs as though in motion, and the sharp right angle of the wing complete the shape.

The flamboyant brushwork in the painting and generous use of red and black set up some visually ambiguous conflicts. The great teacher Hans Hofmann taught that red advanced toward the viewer from the flat plane of the picture, while blues and the cooler tones receded into the deeper spaces "inside" the painting. Although in this work Jack did use the red, along with orange and a bit of yellow, in the initial stages of sketching the large figure, he applied the red amply and vigorously in a later stage as emphasis and highlight and in a large area of "negative" background space surrounding the figurative elements. The aggressive nature of the red, as Hofmann predicted, does surge optically forward from the canvas, setting up a massive perceptual dichotomy. The empty, negative spaces that we know as distant, as background, register in the perceptive senses as existing on a closer plane than the figures themselves—the background in front of the foreground—just the kind of juxtapositioning that stimulates the senses by challenging logic. One must debrief what one knows about foreground and background, object and space, and view this work in a new way, letting the intuitive senses ramble about its surface and into its depth for clues as to its meaning.

Serenely seated in the balcony of the painting is the little red Buddha. He is part of the visual interplay as he advances forward while simultaneously hovering in a neutral space. He is an observer of the scene, but as evidenced by the knitted brows and coiled body, a particularly engrossed observer. His presence in the work is large. Like the two figures that flank him, he confronts the viewer—the author awaiting an audience response. We can hear Jack's voice questioning his very being:

> . . . At present, the
> 100,000,000 th
> myriad of Multimillionth
> Buddha is
> myself
> my - not - self . . .

"Go to the pine if you want to learn about the pine, or to the bamboo if you want to learn about the bamboo." So Matsuo Basho, Japan's greatest poet, taught his students three centuries ago. And as Jack advises readers of his book *The Scriptures of the Golden Eternity,* "When you've understood this scripture, throw it away." Basho instructed his students to learn the rules well, and then forget them, to focus on becoming one with the object of their writing. His obsessive concentration on the most minute details of nature which he integrated, along with the precepts of Zen and Tao, led to his elevating

the traditional Japanese poetic form, the haiku, into the mainstream of world literature.

Kerouac, along with Gary Snyder, Allen Ginsberg and other Beat writers, was enamored of the haiku. As a prelude to the twenty-six of them he wrote and published in *Scattered Poems,* Jack writes the following explanatory note:

> The "Haiku" was invented and developed over hundreds of years in Japan to be a complete poem in seventeen syllables and to pack in a whole vision of life in three short lines. A "Western Haiku" need not concern itself with the seventeen syllables since Western languages cannot adapt themselves to the fluid syllabillic Japanese. I propose that the "Western Haiku" simply say a lot in three short lines in any Western language.
>
> Above all, a Haiku must be very simple and free of all poetic trickery and make a little picture and yet be as airy and graceful as a Vivaldi Pastorella. Here is a great Japanese Haiku that is simpler and prettier than any Haiku I could ever write in any language:

> a day of quiet gladness,—
> Mount Fuji is veiled
> in misty rain
> (Basho) (1644–1694)

> **Here is another:**

> Nesetsukeshi ko no
> Sentaku ya natsu
> No tsuki

> She has put the child to sleep,
> And now washes the clothes;
> The summer moon.
> (ISSA) (1763–1827)

And another, by Buson (1715–1783)

> The nightingale is singing,
> Its small mouth
> open.

Perhaps the best-known of haikus is one by Basho, so simple it is sometimes interpreted as a koan—a question or riddle presented to a student of Zen as a catalyst to meditation and the disclosure of the meaning of reality:

> old pond,
> frog jumps in—
> plop.

Among Kerouac's "western haikus" are those that integrate contemporary imagery:

> Missing a kick
> at the icebox door
> It closed anyway

> The bottoms of my shoes
> are wet
> from walking in the rain

> In my medicine cabinet
> the winter fly
> has died of old age

And there are those that deal with timeless natural forms:

> A big fat flake
> of snow
> Falling all alone

> Birds singing
> in the dark
> -Rainy dawn.

And one which Jack has written at the top of a drawing (**fig.59**):

Spring nights—
 practicing Dhyana
Under the cloudy moon

Dhyana, meditation upon a single object, is the subject of a pencil sketch of a hillside, fairly well covered with knarled, twisting trees reminiscent of those drawn by Van Gogh. A lone figure sits at the center, arms raised, head straight up, darkly silhouetted in what the haiku tells us is the spring night. In the opening stanza of Jack's poem "Buddha" we find the perfect caption for this drawing:

I used to sit under trees and meditate
on the diamond bright silence of darkness
and the bright look of diamonds in space
and space that was stiff with lights
and diamonds shot through, and silence

And a Zen saying, too, captures the mood:

Sitting quietly, doing nothing
Spring comes, and the grass
Grows by itself

At the top of the drawing, a pencil-shaded cloud traverses the sky. It is superimposed with the kind of irregular ellipse that Jack uses to describe an energy field. At the very center of this is the source of a bright light, drawn with an eraser—a circle within the long, narrow cloud, and then erased lines radiate from it. It is moonlight, according to the haiku written on the work—bright enough, even through the cloudy haze, to illuminate the restless spring landscape.

The hilly scene, with the hint of a mountain on the horizon, gives no real information as to its location, although the partially leafless tree would suggest an area where trees defoliate in the autumn. Jack refers in his writings to sitting in the woods in back of his sister's house in North Carolina and meditating. This could be such a moment. The small oval shape at lower left, a pond perhaps, possibly in deference to Basho's "Old Pond" haiku.

"For Joy" written at upper right, may refer to Joyce Glassman (Johnson), who Jack was living with in 1957 and 1958, or simply to "Joy" in the emotional sense. In any case he never gave the drawing away, and it remained a part of his own collection.

Cha - no - Yu, The Zen Art of Tea:

| | |
|---|---|
| The first sip is | JOY |
| The second sip is | GLADNESS |
| The third sip is | SERENITY |
| The fourth sip is | MADNESS |
| The fifth sip is | ECSTASY |

In *Big Sur,* Jack, on his fourth day of his stay on the rugged coast of California, returns to the cabin after an evening walk down the trail, with notebook, pencil and lamp, where he would "sit there like an idiot in the dark writing down the sound of the waves. . . ."

Always so wonderful . . . to come to the cabin where the
fire's still red and you can see the Bodhisattva's lamp,
the glass of ferns on the table the box of Jasmine tea
nearby, all so gentle and human . . . I think of the mar-
velous belongings in my rucksack . . . I go back to the
beach . . . I go back to make a pot of tea

Summer afternoon
Impatiently chewing
The Jasmine leaf

It is the same haiku that Jack has written on his line drawing of a steaming cup of tea. It is a drawing as lean and simplified as the haiku itself, and whether by conscious intention or not, the drawing is composed of seventeen lines (**fig.60**). Jack has excused the "Western" haiku from the regimen of seventeen syllables; but where the universal language of the image is concerned, he may have felt motivated to adhere to the challenge of the ancient tradition.

The drawing is a good example of the Zen of art: clear sharp lines, calligraphic, asymmetrical, the imbalance energizing the work; and ample negative spaces providing the uncluttered, silent Kharma of the meditative spirit associated with the Buddhist drinking of tea. The ritual of the tea ceremony, although founded on the simple process of the mere boiling of water, is one of the most formal of Buddhist curriculums. Its traditions dictate that it take place in an "Abode of Vacancy," ideally a primitive thatched hut, empty of everything other than the necessary utensils, and these too should be of simple design and without pretension; a vase of flowers, or one painting on the wall, is all that is permitted by way of decoration. No more than five people are permitted in the room. The regimen for the preparation and serving of the tea is governed equally by stringent custom and tradition. Even the sound of the boiling water, as its vapors pass through the spout of the teapot, has a requisite: It must suggest the whisper of the wind in the pines and the rush of a distant waterfall.

In his Buddhist scriptures, Jack wrote of the "secret God—grin in the trees and in the teapot . . . Dharmakaya, the body of the truth law, the universal Thisness." And a well-known Zen saying by Bankei stresses the aura of veneration accorded to the tea implements:

When someone tosses you a tea bowl
-catch it!
Catch it nimbly with soft cotton
With the cotton of your skillful mind!

Bodhidharma, who became the twenty-eighth Buddha and the last of the Indian Buddhas, was an Indian monk credited with bringing meditative Buddhism to China during the late fifth century. He is considered to be the founder of Zen Buddhism in its eastern Asian form (Ch'an), still popular in Japan today. His teachings direct followers to obtain insight into the nature of truth, rather than put their trust

blindly into the hands of an all-powerful being. Meditation and self-discipline are the primary tools; freedom from worldly concerns and detachment from worldly goods are its goals.

Among the legends that surround this colorful Zen patriarch is one that explains the glaring expression with which he is always depicted in the many portraits of him that exist. Once, when he was deep in meditation, his eyes closed and he fell asleep. Angered at what he considered this inexcusable breach of discipline, he cut off his eyelids and flung them to the ground. They took root and grew into the first tea plant. The tea leaves, which contain caffeine, would be used as a remedy for sleepiness and to prevent drowsing off during meditation.

In the Kerouac archives is an ink and wash drawing of Bodhidharma (fig.62) that is extremely accurate in detail and very well drawn. Jack also drew the Bodhidharma, very likely using the picture in his collection as the model (fig.61). The lidless, staring, almost demonic power in the eyes is exaggerated in Jack's version. It is a gestural study that magnifies both the eyes and the too-wide, tragic mouth, with its turned-down corners paralleled in the mustache and beard underlining the intensity of the mood. The Bodhidharma's nose is a mere suggestion of cartilage and nostril, and his robes are accomplished with a few brisk lines. At bottom, near the center, is written "Bodhidharma," at the top is written "HOIKO."

The connection between Bodhidharma and Hoiko (generally spelled Hui-Ko) is told in another Buddhist legend. During Bodhidharma's reign, Hui-Ko, as a young man in China, disappointed with Confucian and Taoist philosophy, left home to become a Buddhist monk. At the Shao-lin monastery on Sung Mountain he practiced a demanding wall-gazing meditation technique under the instruction of Bodhidharma, who offered little encouragement, often ignoring him entirely. To demonstrate the level of his commitment, Hui-ko cut off his own left arm. The act most certainly got the attention of the living Buddha; Hui-ko became his successor, the twenty-ninth Buddha, and the first of the Chinese Buddhas. For his thirty years as living Buddha, Hui-ko, with identity concealed, lived among the people. He performed laborious and unpleasant tasks, jobs like cleaning public restrooms, and finally, after conferring his robe and bowl on his successor, Hui-ko was executed for heretical teaching by a maliciously misinformed government official. Jack had very likely read of the moving saga of Hui-ko and of the words of Dogen Zenji. "This is the moment when the one called you is actually Buddha Ancestor Hui-Ko."

the blue balloon

A vast perwigillar balloon exploded over my head, it was a blue balloon that had risen out of the blue powders in the forge, and so suddenly everything was blue. "The Blue Era!" cried Doctor Sax . . . The fire was blue, the blue cane roof was blue, everything, shadow was blue my shoes were blue —- . . .

> All Lowell was bathed in a blue light.
> The usually blue windows of Boott Mills in the night

are now piercing, heartbreaking with a blue that's never been seen before—terrible how that blue shines like a lost star in the blue city lights of Lowell—yet even as I look, slowly the night turns red, at first a horrible red suede red with evil shitty river and then a regular deep profound night red that bathed everything in dim soft restful glow but very death-like,—Doctor Sax's vacuumed powders had created an Ikon for the void.

The enigma of Jack's painting *The Blue Balloon* **(fig.63)** is lessened after one reads the passage in *Doctor Sax;* and although the symbolism of the blue balloon remains surrealistically challenging, the issue becomes substantially more compounded by other balloons in the Kerouac literature.

Some are relatively uncomplicated scenarios, like when Jack dances with Maggie for the first time: "I put my hard arm around her soft waist and took her dancing awkward dumb steps under the balloons and crinkly pop funhats of New Year's Eve America . . ."

In Jack's "How to Meditate":

I hop - down and hold all my body parts
down to a deadstop trance—Healing
all my sicknesses—erasing all—not
even the shred of a "I hope-you" or a
Loony Balloon left in it, but the mind
blank, serene, thoughtless. . . .

"Macdougal Street Blues" has a "Sea Blue Moon," and then a few paragraphs later "balloon atoms."

No Sound Still
 s s s s t t
 see the

Of Sea Blue Moon
Holy X - Jack
 Miracle
 Night —-
Instead, yank & yuck
For pits & pops . . .

.

 comma
The game begins
 But hidden Buddha
Nowhere to be seen
 But everywhere
 In air atoms
 In balloon atoms
 In imaginary sight atoms
 In people atoms

And in *Orizaba 210 Blues,* balloons abound. In the 12th Chorus:

Soft - pie tailed bird - dog
Sing Song Charley the Poet
From High Masquerade
Is about to shake the rain
From his empty head
And deliver a blurbery statement
About bubbles and balloons

Balloons O balloons
BALLOONS BALLOONS
BALLOONS O BALLOONS
BAL
LOONS
B A L L O O N S

In the 20th Chorus:

 And you, blue moon, what you doon

Shining in the sky
 With a glass of port wine
 In your eye
—Ladies, let fall your drapes
And we'll have an evening
of interesting rapes
 inneresting rapes

Ork, song of Nova Scotia,
 Silly, any, songs,
 Floating in the Open Blue,
 Balancing on Balloons,
 Balloons, BALLOONS,
 BALLOONS of Rose Hope,
 balloons Balloons BALLOONS
 the Vast Integral Crap
 a
 Balloons

BALLOONS is your time
B a l l o o n s is the ending
THAT'S THE SCENE

Finally, the rarely specified link between painter and poet makes its appearance in the 43rd chorus:

Well & well well so that is
the ancient fainter, the painter
who tied up blue balloons
—Globus azul—and threw
Them asunder in the thunder
Of the ul - Ur - Obi - Ob -
Fuscate me no more travails,
Pardy hard, this rock mine
we're workin'll yield up diamond
 hard

The hand of the painter that tied up the blue balloons and "threw them asunder in the thunder" has been pressed into the blue paint, and its image carefully superimposed upon an elliptical red object, which has been painted on what appears to be a tabletop. Is there some meaning to the missing thumb? Freudians could certainly evolve a few, but that was not Jack's way, and it is likely the four fingers suited his feelings about the composition; or he simply didn't press his thumb into the paint.

The red oval object presents a bit more of a challenge. There is, on closer inspection, a small, irregular triangular shape, painted in brown and ochre, near its top. In purely representative terms it looks very much like a robust ripe tomato and although the painting has a surreal tone, it is in fact comprised of real objects: a blue balloon, complete with knotted end and a string, and a hand that couldn't be more representational.

It is the juxtaposition of these seemingly unrelated elements that affords, to what could be seen as a traditional still-life work, the status of surrealism. The hand releases the balloon and reaches for the tomato. An allegory for the rejection of romantic youthful fantasy for the pragmatic. The volatile tentative balloon for the edible tomato.

In another of Jack's paintings, clearly related stylistically to *The Blue Balloon*, another hand plays a dramatic role. The first two fingers are extended, the next two folded into the palm, the thumb poised in what seems unmistakably the hand sign for a gun. And resembling in different ways both the blue balloon and the red tomato is a large blood-red heart shape, at the very center of the work. A deep red trail running out from the bottom of the heart suggests that this is no ordinary heart: This is a bleeding heart. The large, flesh-colored area that dominates the space can be seen as a human

torso. Although brushed-in quite freely in tones of pink, orange, and gold, there is ample detail in the curve of the left shoulder, the blue outline and white highlight of the bicep, and the subtle curve and nipple of the right pectoral to determine that the body is masculine.

In *Heart and Handgun* (**fig.64**), the bleeding heart is positioned over the left breast and is outlined with a broadly painted, soft white outer edge. The resultant halation is similar to that in Jack's paintings *The Red Buddha* and *Cardinal Montini*. The ambiguity of the image is such that we cannot sense whether we are seeing the heart within the body or placed visibly on the surface. If Jack had in mind the depiction of a "bleeding heart" persona—that is, of one who makes an exaggerated display of sympathy toward the exploited or underprivileged—then placing the heart ostentatiously on the outside would be the better choice.

Any reference to guns, in the context of the Beat Generation, brings to mind William Burroughs, whose connection extends from his lifelong interest in firearms, to his accidental shooting of his wife, to his book *Painting and Guns,* and to the artworks he creates by placing cans of paint against a wooden board, blasting them with a shotgun, and exhibiting the wooden boards as paintings. It is conceivable that *Heart and Handgun* was construed as a portrait of Burroughs, and that, at the time Jack painted it, something in their relationship might have motivated the "bleeding heart" symbol. It may have been intended as a cliché on excessive pity or a symbol of the walking wounded.

In this same context one can also consider the similarity in the style of this work to several of Burroughs's self-portraits in which the slouch-hatted subject is set aglow by a halation, much like that around Jack's heart. It may have tickled Jack's fancy, that in portraying a fellow painter he could deepen the game by doing so in Burroughs's own idiosyncratic style.

friends and fellaheen

Oswald Spengler, in his *The Decline of the West,* described the fellaheen as that great mass of down-and-out, disenfranchised, naively pious inhabitants of the earth. The very population that Herbert Huncke was thinking about when he said his generation was "beat." Kerouac and Ginsberg read Spengler while at Columbia.

Jack would later embrace the fellaheen. He saw their "beat" condition as a blessed saintliness. He wrote about them and he drew and painted them, as has been the way of artists from the models for Michelangelo's Sistine Chapel ceiling to the coal mining potato eaters of van Gogh. The dictionary defines the fellaheen as Egyptian peasants and laborers; it was Spengler and the Beats who elevated them to *objets d'art.*

When Jack spoke at Hunter College in 1958 on the topic "Is There a Beat Generation?" his analysis of its roots included the comedian Harpo Marx, who is the subject of one of Jack's poems; Lamont Cranston, who was "The Shadow," Jack's childhood pulp fiction hero and the inspiration for Doctor Sax; comic-book cartoon heroes Popeye and Krazy Kat; and jazz musician Lester Young. He also praised and credited "the glee of

America, the honesty of America, and America's wild, self-believing individuality." A harbinger of things to come in the 1960s, when the fellaheen of America would take to the barricades for civil rights, gay rights, women's rights, and to end the Vietnam War. In the sixties the country was returned to the people and it was "the people" that Jack had in mind when he wrote "Now I'm going to paint my way, the Duluoz legend" in his notebook in 1959.

Sketches, drawings, and paintings proliferated. Like the sacred friendships and sacred places in Allen Ginsberg's life that resulted in over 30,000 photographs, Jack, too, was preserving the moments in visual art as well as with words.

Desolation Angels concludes, "A peaceful sorrow at home is the best I'll ever be able to offer the world, in the end . . . and so I told my desolation angels goodbye. A new life for me." Jack is back from the road, at home with his mother, surrounded by old faces and filled with recollections of the new ones. One after another they appear as drawings, sketches, paintings. Not as pietàs, no saints, no Buddhas, just the fellaheen, the faces from Jack's life.

THE SLOUCH HAT

I had a slouch hat too one time
 The old slouch hat
 I just keep walkin' around
 And he keeps walkin around with me
 Around and round that necktie
 counter we went
 When it rained I wore my old
 slouch hat

This introduces a new character in the Duluoz legend, Bill Garver, a "tall, pale, sunken-eyed junky," who stole coats from restaurants for a living and is considered to be a major inspirational force behind Jack's writing *Mexico City Blues*. Jack's painting of *The Slouch Hat* (**fig.65**), shows a lot of influence of the painters with whom he socialized. It broaches, too, the ongoing problem of many artists in the 1940s and 50s, of integrating the figure into abstract art. The juxtaposing and rendering of the figures and then reinforcing them with abstract expressionist-like patches of freely applied paint corresponds to what Larry Rivers and others were doing in those years, just as the figure of a woman on the right and the small figure at top center are painted with the controlled abandon of Willem de Kooning.

It was a good felt hat
 I had to carry through many
 rainy day, late fall
 and the early spring

"Jack liked to draw with charcoal and then go at the drawing with paint. I tried to get him to draw directly with paint but that just wasn't his way," Stanley Twardowicz recalls. And in *The Slouch Hat* we see the perfect example of a charcoal sketch which details the four figures and the surrounding spatial segments. Red ochre was then applied to the woman's face at right, its value modified by varying amounts of white. In this face alone there are at least four shades of ochre. The brightest value was then spotted about the picture field, a dash or two around the opposite head, a slashing broadside in a corner, several lines along the right edge, and a singular, fully filled-in background segment off to the right of the head.

The black paint Jack made of burnt umber and ultramarine was then brought into play, with dense applications on Jack's coat, the brim of the slouch hat, against the body of the small top center figure, and along the lower left section of the painting, dashed in at the lower right, and a whisk of five o'clock shadow is added on the side of the face.

The dripping white paint then freely orchestrates its own composition across the right half of the work, counterpoising the dense black rhythms at the left and bringing the picture into a kinetic yin and yang balance. The white paint continues in the wet and juicy, *Z*-stroked depiction of the eyes, to which are added earth-red dots as pupils. This has become one of Jack's unique painterly trademarks.

The slouch hat I got at Harvard
 club, Yale Club, Princeton Club
 one or the other
 Dartmouth Club
 University Club

Always barred the Yatch Club
 because it was a little over
 my kin

The figurative elements in the work: Garver, presumably wearing the slouch hat of his poem and the

dark jacket, the much too thin, too short, Times Square hipster tie—Slim Jims, those skinny ones were called in the '50s, and you tied them on with a bulky "Windsor" knot.

> Not only a member of Who's
>
> Who but a Who's Who
>
> also have to be a member
>
> of Who's Who in New York
>
> in the special clique of Who's
>
> HOO———-slouch hat !
>
> I get in the Athletic Club
> many time

The woman in white with reddish-blond hair. A quizzical expression—the big wide eyes—mouth pursed. The gesture of the brushwork results in a gesture of the head turning suddenly to confront the viewer. She is dressed in pure white, framed in a rectangle, topped by a cross: Mamere? Just opposite, the man in the slouch hat is framed in an oval, familiar in Christian art as a halo and in Buddhist art as a lotus leaf. Coming between Jack and the central figure that may be Mamere are a couple of the women in Jack's life. In those years, one would be Dody Muller, who Mamere openly disapproved of.

The center strip of the painting functions somewhat cinematically, with the top figure in the distance, the figure beneath it somewhat closer, and then, almost lost in what seems to be a mass of abstract rendering, but filling the entire bottom left quarter of the painting, a grotesquely sepulchral creature, almost a death's-head, with a wave of hair,

a hollow sunken eye and a skeletal mouth—the ultimate virago.

The images and ideas that surface in the unscrambling of this work are much in the spirit of Beat writing. Like Jack's extended multipage sentences, and the long line poetry that Whitman passed down to Ginsberg, they invite the viewer to a slow cross-country trot, rather than a quick sprint. Instant gratification is not a Kerouac strongpoint.

> "Tell me about the old slouch
> hat"
>
> One of my numerous trips
> to one of the numerous clubs
> in New York City
>
> The hat finally was left
> in the hotel
> which I had to leave
> rather hurriedly one night
> never to return
> so the hat was given
> to the castoffs of the hotel
> which they collect
> and rummage sells
>
> May now be worn by one
> Of the members of Skid Row
>
> New York City—the Bowery
>
> "I seen that hat
> by moonlight"

TWO DRINKERS

Although the bar was a familiar backdrop in Jack's

life, it was one he rarely depicted in his painting or in his writing. He did, however, do some sketching in the bars: friends, passing thoughts, notations to be used later for a painting. On one occasion, he was blatantly existential with *Jacky Kerouac Puking* (**fig.66**), a quick, candid sketch, and *Tony Closing the Bar* (**fig.67**), a spontaneous bop study of Tony Sampas, Stella's brother who owned a bar in Lowell. A favorite Kerouac story among Lowell's tavern dwellers is how, one evening, Jack fell asleep in a dark corner of Tony's bar and went unnoticed at closing time. When Tony reopened the next afternoon, there was Jack just waking up and ready to begin the day at his favorite corner table. Jack appreciated that kind of tragicomic situation, and the drawing of Tony closing the bar may likely commemorate the sleepover.

There is one painting, *Two Drinkers* (**fig.68**), that is clearly set in a bar. Two men, one standing, one sitting, each with a leg on the rail, are engaged in conversation. The standing figure is wearing an off-white raincoat, white shirt, black tie, and blue-green trousers. He has curly red hair, a long narrow face, is wearing glasses, and has a toothsome smile. He gesticulates with his right arm to the seated man, who is seen from the rear, and who is dressed completely in black, including a black fedora and what looks like a black cape. He pours a drink from a bottle into a glass that is held by his companion.

The space above the figures swirls with shades of red, brown, and black against a mustard yellow background which, along with the bright smile, lends a cheery note to the work and creates the distinct atmosphere of a smoky, highly charged and gregarious pub. It is a painterly piece, the brushstrokes are deliberate and drawn to enhance the shapes they describe. They follow Jack's "Rules of Painting" in remaining untouched once they are applied; however, Jack's first rule, of working directly with the paint and not drawing with charcoal, does not apply here. You can still see the original line drawing at the edge of each shape.

The drinking pair are linked by a hazy, white aureole that outlines and interlocks the central portion of the painting. It begins at the lower left, at the bottom of the raincoat, follows the contour of the standing figure, then lightens the whole space around the seated figure's head and the arm that's pouring the drink. It is a technique Jack used in *Heart and Handgun* and *Red Buddha* and an effective way of isolating the figurative elements from the background while adding a note of spatial ambiguity to the work.

As in *The Slouch Hat*, the drama of *Two Drinkers* is heightened by the colors black and white that divide the central space. Jack admired the sole use of these colors in the paintings of Franz Kline and the "final white paint touches" on a Tiepolo, possibly the source of Jack's frequent use of white as emphasis and outline. Who are the two drinkers, the red-headed man in the white coat and the man in black? On page one of *The Subterraneans* is Allen Ginsberg's description of the hipsters who inhabit Kerouac's novels (Allen's identity in this novel is Adam Moorad):

> **The subterraneans is a name invented by Adam Moorad who is a poet and friend of mine who said "They are hip without being slick, they are intelligent without being corny, they are intellectual as hell and know all about Pound without being pretentious or talking too much about it, they are very quiet, they are very Christlike."**

And Jack's own description is most effectively rendered when he, as Peter Martin in *The Town and the City*, wanders into New York's Times Square and looks out upon

—the same people he had seen so many times in other American cities on similar streets: soldiers, sailors, the panhandlers and drifters, the zoot-suiters, the hoodlums, the young men who washed dishes in cafeterias from coast to coast, the hitch-hikers, the hustlers, the drunks, the battered lonely young Negroes, the twinkling little Chinese, the dark Puerto Ricans, and the varieties of dungareed young Americans in leather jackets who were seamen and mechanics and garagemen everywhere.

But there is a familiarity to the figures in *Two Drinkers* and Jack did write that he was painting the people in his life. The figure in black registers as William Burroughs, because of the well-known photograph of him in a black derby hat. A second candidate for the behatted one who "wears a shroud for a cape" and "appears out of the night when Duluoz first becomes aware of sexuality and evil in the world," The Shadow reincarnate, Jack's favorite character in his favorite book, the mythic Doctor Sax. The full notebook statement about painting the Duluoz legend that Jack wrote was: "and now I'm going to paint my way, my own subjects (of Duluoz legend! Old Plouffe first -)."

It is a rainy night, on the Moody Street Bridge there's poor old millhand Joe Plouffe bent against cold March rainwinds—and he looks across the wide dark towards Snake Hill behind the wet shrouds—nothing, a wall of darkness, not even a dull brown lamp suddenly you see a faint brown light come on far in the

night of the bridge, slouching, dark, emitting a high laugh, "Mwee hee ha ha ha," fading choking, mad, maniac, caped, green-faced (a disease of the night, Visagus Nightsoil) glides Doctor Sax—along by the rocks . . . in one movement removing the rubber boat from his slouched hat. . . .

An extraordinary description of Doctor Sax follows the discovery of him by the bohemian socialite Polly Ryan at a party:

. . . Doctor Sax was at the window. His eyes were emerald green, and they flashed at the sight of her. They lit with delight at her scream. When she fainted to the floor, Doctor Sax hurled his cape around his shoulder and glided swiftly to the front entrance. He wore a large slouch hat the very color of the night. . . .

Soon after, in the Doctor Sax boyhood fantasy world of Jack Duluoz, growing up, like the author himself, in Lowell, Massachusetts, the connection deepens:

Doctor Sax was like The Shadow when I was young, I saw him leap over the last bush on the sandbank one night, cape a-flying . . . I didn't know his name then. He didn't frighten me, either. I sensed he was my friend . . . my old, old friend . . . my ghost, personal angel, private shadow, secret lover.

Jack wrote the greater part of *Doctor Sax* when he was in Mexico City in 1952, while staying at William Burroughs's house. Burroughs has a small role in the *Doctor Sax* novel, as Old Bull Balloon of

Butte, who came once a year for a poker game with Doctor Sax. But just as Jack's living within the boundaries of Burroughs's hyperintellectualism and brilliant half-erudite-half-criminal lifestyle must have partially informed the Doctor Sax character, so too is it likely the man in the black slouched hat in the painting is a synthesis of both the real Burroughs, The Shadow, and Doctor Sax.

Other than a brief statement in *Book of Dreams* in which a red-headed person makes a cameo appearance, and a line in *Doctor Sax* describing himself with red hair and red eyebrows, there are no references to red-headed men in the Kerouac literature. The *Book of Dreams* statement mentions a somnambulistic dislike for red hair, with no further elucidation; Doctor Sax's mention of his own red hair was in the midst of the encounter with Polly Ryan, described above, and a part of the surrealistic, chameleon-like nature of the character.

There is a letter in which Jack writes of a musician named Sonny Red to Lorenzo Monsanto:

Dear Lorenzo,

I am writing on behalf of Sonny Red, the greatest alto Jazz saxophonist in my estimation playing today in the straight lyric tradition and one of the best phrasists since Parker . . .

Now this man has offers to play at commercial jazz clubs at good pay but surprisingly wanted me to inform him how he could somehow get to play with POETS he also happens to be an intellectual nut of some kind from Detroit His real name is Sonny Kiner but I guess they called him "Red" as a kid . . . He is called SONNY RED

Believe me, John Clellon Holmes and I have listened to him and find him the most exciting alto thinker since Bird, as I say, and since Sunny Stitt. . . .

Then follows a long list of people Jack feels Lorenzo should put Sonny Red in touch with, and it ends as follows:

But anyway this here Sonny Red who can make scads of money playing in the Blackhawk and elsewhere simply wants to play with the poets. And please don't tell Rexroth.

Incidentally got a rave review of *Book of Dreams* from Ottawa. Write.

copain
Jean Louis

Why Jack was looking to do no favors for Kenneth Rexroth might have been due to certain comments the elder poet of the San Francisco poetry renaissance and West Coast Beat movement had made about his work. Reviewing *Doctor Sax,* he said it "sounds like it was written on pot. The sentences are always diffuse, as if he were wandering, not driving forward to the point of the book. I know it's great writing. I just have the feeling he's gone astray somehow, on the wrong track. Now you take Burroughs, he'll never amount to anything, like Kerouac, but he knows how to write. . . ."

It didn't take more than that to get you on Jack's "list."

blonde in the grass

A page in Jack's pocket notebook of January 27, 1959, begins with the comment: "Blonde in the Grass is according to my theory of painting worked out as I strolled after supper. . . ." Jack's painting of a woman with blond hair lying on a grassy knoll does ascribe to the five-step outline that Jack lists on that same page (**fig.69**). The first step, to use only a brush and not mash, spread, obliterate, or press in the brush-strokes, is evident from the texture of the painterly surface. Each stroke is decisive, and exemplary of this are the rhythmic, gestural marks that highlight the upper edge of the woman's dress. They relate as well to the lemon-yellow crown of hair and to the formless legs of the same color that protrude from the bottom of her dress. The face is a pleasant flesh tone with light brown dashes for the eyes and eyebrows and a minute, smiling red curve of a mouth. There are a few highlight dashes of white on the cheeks and forehead. The hand and forearm are mere gestures, with no detail.

The woman's dress is almost the same shade as the green grass which surrounds it. However, the application of paint on the dress is decidedly thicker and has been mixed with white to add an opacity and to contrast with the transparency of the grass. The field has been painted according to Kerouac's five points (**fig.70**). It also subscribes to some very traditional basic rules of art, as seen in the darker shade and greater density of the grass in the foreground and its gradual lightening, in both color and thickness, as it moves into the distance. Throughout the field in back of the figure are spots, dashes, and curlicues of white and orange paint. Despite the fact that the sky is overcast, these painted marks appear to be reflections of incidental light. In the extreme foreground are a pair of white shoes, kicked off by the blonde, which accounts in part for the shapeless feet.

All according to the "rules": The brush was used spontaneously, there was no preliminary drawing, and the figure does meet the background "by the brush." No pen or pencil outlines here, and Jack apparently was painting what he saw in front of him: no "fiction." Finally, knowing when to stop—a critical point—and with his cautionary note against going too far and risking the danger of muddy colors and convoluted composition, Jack stops right on time.

There is a Magritte-like surrealistic dichotomy between the green grass of summer in the bottom half of the picture and the brown, wintry landscape of the upper half. The woman lying on the grass in a short-sleeved dress confirms the warmth of the season, yet the trees seem colorless, even lifeless, and whatever else is in that top segment appears to be in winter.

But Kerouac's surrealism did not extend to the witty, teasing style of Magritte—who would delight in a landscape depicting two seasons—and it is unlikely that Jack ever intended that contradiction to be the effect of the work. The impressionistic quality of the background was achieved by a very traditional painting process. Jack first covered the entire area with a transparent wash of burnt umber oil paint. Then, with a fairly wide brush he drew into this surface the large tree trunk that bisects the work and another, less distinct, to its right. Using the back of the brush as a tool, he drew lines into the wet, tacky paint surface to shape the branches of the trees. A dash here and there of black-brown color, and even small amounts of orange, dot the landscape, from areas of the trees and sky to the grass itself. A dark evergreen tree stands to the left, transparently painted and then dry brush-scumbled with a soft pine-green color. A few umber brushstrokes add shadows and a sense of depth.

Finally, the shapes of the trees were defined by painting what would normally be considered the "negative space" of the background, the sky. This was done with a mixture of white tinted with the burnt umber of the original overall wash. This opaque color, applied as sky in horizontal strokes, formed the soft shapes of the trees. Passages of paint between the branches allowed light from the sky to shimmer through, and with the addition of a few dabs of dark umber browns, orange

siennas, and a touch or two of green, the result is an effective rendering of a forest.

WOMAN WITH GUITAR

Working in his best expressionist manner, Jack painted another reclining woman, this time quite at ease in the decor of an eclectic interior space that echoes the annals of art history—from the romantic eighteenth-century, pastel-colored delicacies of Fragonard and Boucher to the Casbah of Matisse in North Africa, with a sidelong glance at the intimate and often overdecorated rooms of Vuillard and Bonnard (**fig.71**).

Kerouac's woman lies on her side on a gray-and-black striped rug that has a design of gold braid. Her hair is black, she has dark eyes, a broad nose, a puckered mouth, and a short red line denotes a square, determined chin. She rests her head on her elbow, and there seem to be dangling earrings; an elegant white dress has been partially removed, her arms and shoulders bare, her right breast exposed. The dress, which is trimmed along its edges with a dusty shade of sienna orange, reaches to her ankles and in the complicated array of fabric folds one cannot clearly identify the protruding legs and feet. Her look is head-on confrontational, her wide-set black eyes are focused directly at the spectator. Leaning at a slight angle across her mid-section, its black shadow falling against her body, is a full-size, olive drab acoustic guitar.

A woman with a guitar is one of the most popular of artists' subjects. It is no wonder that this picture looks so familiar. The fascination for combining the two subjects ranges from artists recognizing the purely visual relationship between the human physiognomy and the graceful curvilinear nature of the musical instrument,

to the psychosexual metaphoric notion of the guitar as an object that responds with sweet chordance to affectionate stroking. It is the harp of the modern-day muse, and in Jack's day, the instrument of choice of the fifties folk song renaissance—a required presence in every Beat Generation hip pad or party.

But there is so much more to this painting: blue sky, or are they mirrors? A vast green wall; or is it a wardrobe? A pot-bellied coal stove, or a lamp? A tree or an arch? A woman in the shadows or an angel? Jack has pitched a nearly perfect game here. An example of nearly total visual ambiguity, in a setting which at first look actually appears familiar. It is a model in a studio, a woman in the boudoir, a scene in the south of France, Northport, Long Island, Greenwich Village . . . but on close examination virtually none of the seemingly familiar elements that comprise the interior are indentifiable. There is a wise old Sanscrit maxim coined in response to the frustration of efforts at clarifications such as this: "He who knows he doesn't know, knows." It reduces, or expands the analytical function to an intuitive level which, when combined with Samuel Taylor Coleridge's "willing suspension of disbelief for the moment," constitutes the artistic and poetic faith one need muster to reckon with the subtler, more abstract of the arts.

JOAN RAWSHANKS

"Joan Rawshanks, with her long pinched tragic face with its remaining hints of wild Twenties dissolution, a flapper girl then, then the writhey girl of the Thirties, under a ramp. . . ."

On an evening stroll through San Francisco's Russian Hill neighborhood, Jack encountered the crowd-drawing, kleig-lighted spectacle of a Hollywood movie being filmed on location. The picture was *Sudden Fear,* its star was a favorite of Jack's: Joan Crawford. Joining the neck-craning throng of onlookers, Jack absorbed every detail of the extravagant panorama: the star, the director, the film crew, the action, the technology, the equipment, and the audience, from the elated teenagers on the street to the elderly wealthy tenants of the apartment house in front of which the filming took place, who stood in their windows wringing their hands.

The result was Jack's "Joan Rawshanks in the Fog," which appears as a chapter in *Visions of Cody.* Jack sets the mood with a hybrid of the cinematic and poetic: a mix of the concurrent images of a movie film strip and reiterative rhythms reminiscent of Gertrude Stein.

Joan Rawshanks stands all alone in the fog. Her name is Joan Rawshanks and she knows it, just as anybody knows his name, and she knows who she is, same way, Joan Rawshanks stands alone in the fog and a thousand eyes are fixed on her in all kinds of ways. . . .

Jack then gives a description of the young director of the film:

Crazy type in floppy stylish bought-at-Brooks-Brothers-deliberately clothes who talks his way entirely into his careers and stands there, gesticulating, ducking to see, measuring with his eyes, hand over brow to estimate just right, darting up, shadowing himself, looking furtively over his shoulder, long director's coat flying, hang-jawed sullen face, long Semitic ears, curly handsome hair, face with the Hollywood tan which is the most successful and beautiful tan in the world. . . .

Jack was appalled at his discovery of the contrived mechanization of Hollywood filmmaking—the repeated

over-rehearsed takes: shoot it with tears, shoot it again without tears. There was no interest in the spontaneity he believed was so essential to the divine function of art. He was surprised, too, and felt sorry for the star when the young director, holding the scarf around her neck like a noose, pulled her head toward him to "really make her listen to his pithy best instruction." In the midst of Jack's detailed description of the action on the set, he takes the Joan Crawford name on an unexplained semantic metamorphosis: from Joan Rawshanks it evolves to Joan Ashplant, then to Joan Clawthighs, and finally to Joan Crawfish.

Jack's one encounter with the actress reflects his distress with the big studio methods:

Joan Rawshanks stood in the fog . . . I said to her "Blow, baby, blow!" When I saw that thousands' eyes were fixed on her . . . all these people are going to see you muster up a falsehood for money . . .

But in the end he rationalized the Hollywood style.

. . . like sitting by swimming pools on drizzly nights in Beverly Hills in a topcoat, with a drink, to brood. As for poor Joan Rawshanks in the fog . . . I guess they'd raise a glass of champagne to her lips tonight in some warmly lit room atop the roof of a hilltop hotel roof garden swank arrangement somehere in town. At dawn when Joan Rawshanks sees the first hints of great light over Oakland, and there swoops the bird of the desert, the fog will be gone.

Jack's painting of Joan Crawford (**fig.72**) exemplifies both the emotionally driven expressionist style and the haughty Hollywood star posture of the story. The paint is applied with gusto and conviction and the drawing is done with the brush. He simply "piled it on." Yet, there is nothing careless in the execution, every brush stroke is calculated and as a result the body language is masterful. The angle of the head, the tilt of the hat, the position of the arms and hands—even the angle of the cigarette in the gloved hand are all in perfect balance with the swing of the hips and the single raised shoulder. There is a gesture here that exclaims "Star," and that is underlined by the golden spotlight that half-encircles the figure.

The setting is dark, night perhaps. The background elements are too abstractly denoted to determine any details, although there is a sense of the outdoors in the reflections throughout the black void. It has all the requisite drama, choreographed posture, and histrionic lighting of a Hollywood movie.

The face conforms to the best traditions of Expressionism, where psychological impact outstrips aesthetic pleasantries, although a bit more painting has gone into its construction than is evident at first look. The end result is the aging, tragic face described by Jack in "Joan Rawshanks in the Fog:"

I feel a twinge of sorriness for Joan, either because all this time she'd been suffering real horrors nevertheless as movie queen that I had no idea about, or, in the general materialism of Hollywood she is being maltreated as a star "on the way out"; . . . all the teenage girls were quick to say, in loud voices for everyone to hear, that her makeup was very heavy, she'd probably have to stagger under it, and leaving it up to us to determine how saggy and baggy her face.

THE SILLY EYE

On October 20, 1959, Jack wrote in his pocket notebook (**fig.73**):

"Yes Got cockeyed + painted high huge silly 'Eye'
in golden mess—Man, so drunk, a fifth of bourbon
almost—but had fun—But I want to paint more carefully
from now on, representational scenes done interiorly —
An insult to paint & to civilization

The eye that Jack refers to as "high" and "huge" and "silly" is in fact rather large and could be called "silly" in terms of its shape and color, but allowing for the near fifth of bourbon, we can attribute the "high" as much to Jack as to the look in the eye, and this may explain as well the confusing closing phrase of the journal entry about the insult to paint and civilization. Since there was never any discernible change in Jack's painting technique toward the "more carefully" done or more "representational scenes done interiorly," one can attribute this commitment as well to the temporary, fifth-of-bourbon-inspired state of mind (**fig.74**).

The brushwork is swift, decisive, and emotionally directed. The construction of the face is of half a dozen shades of yellow ochre and gold in brush strokes that are more concerned with a sense of variegated energy than with light and shadow. The orange-red ear exaggerates the aspect of the subject as a "listener" and echoes that yellow and black hook of an eye—a real Kerouacian punch line. Yet the mouth is shut tight, lips pressed together. That electric little white line down the bridge of the nose and above the mouth emphasizes the tight compression of the lips. The subject is all eyes and ears; nothing to say. He sees, he listens, but doesn't speak.

An area of subtle, tertiary colors surrounds the golden aura of the face, while every other aspect of the work is painted in varying tones of multi-hued grays and bluish blacks, with a touch here and there of the gold and reds of the face and some pale blue highlights. The paint-loaded brushwork is dazzling. Pure bravura: long-sweeping continuums of wet-on-wet painted lines circumnavigate the head to describe the broad brim of the hat. A similarly aggressive, more scrubbed-in technique, makes up its crown. In the background, where the murky grays darken into blacks, soft-edged, runny brush strokes follow the contour of the figure, adding depth and distance to the space behind the image.

The golden mess may look like a hasty pudding of a painting, but it is in fact calculated and deliberate. One is reminded of Cezanne's description of his working method, where he talked of loading his brush with paint and sometimes concentrating for several minutes before he found exactly the right spot to place it on the canvas.

The unique cropping of the face and hat, where all are cut off at the four sides of the painting, endows the work with the psychological impact of a movie closeup. Filmmakers have long known that the most effective way to achieve audience response is by closing in on the human face, and to close in to the point of losing peripheral detail is to bring the audience into intimate contact with the subject—in so tight you can't see the top of the hat or the point of the chin. It is as though you are standing just inches away from the subject.

As to who is the subject of this odd portrait, based on the clues of a deathly pallor and a derby hat, one suspects that it is once again William Burroughs—the palest member of the Kerouac legend and the only one known to wear this style of hat. There is a sketch on

which Jack has written, "A drawing of Burroughs by Jack K" that is among the Kerouac archives (**fig.75**). The profile in the sketch is almost identical to that in the painting, even to the angle at which the face is positioned; similar, too, are the curve and shading of the nostril, and the crisscross markings on the cheek. The mouth on the drawing remains relaxed; on the painting the expression changes as the lips draw inwards. As one studies the features, the resemblance to the William Burroughs of the 1950s becomes apparent, and Burroughs certainly played a major role in the Duluoz legend.

William Butler Yeats wrote of his own legend on seeing the many faces of the people in his life on the walls of the National Portrait Gallery:

Think where man's glory most begins and ends
And say my glory was
I had such friends

Among Jack's comments on the Beat poets with whom he found his glory was:

And, said I to the Angel
that *shall* certainly do,
and the angel said :
 Do you remember Gregory ?
Corso, the Way of Poetry ?
 Orlovsky too ?
 And Ginsberg O Shay ?
 And Burroughs the Master
 speaks thru his teeth ?
 And the writer of story
 the generous Huncke
And Lafcadio the Holy
 Innocent of Russia,

the Patriarch, & Sebastian ?
And Lucien ?
 And Neal Cassady

THE RED FACE

The original expressionist movement reflected the agonized and sullen social climate that engulfed Germany as a consequence of the First World War. The havoc and disaster on the German people, the defeat of the famed German army, and the psychological and economic national depression that followed became the point of departure for an art that was both visually grotesque and subliminally hysterical.

The artform would establish a track of romanticism that has reverberated through modern art history as a counterpoint to the more rigid classical iconography which evolved from Malevich and Mondrian and metamorphosed into geometric, hard-edge abstraction. Expressionism, whose major figures included Kandinsky, Kirchner, Nolde, and Kokoshka, and expanded to Soutine, Vlaminc, Matisse, Derain, and Roualt in France, would reincarnate with the Second World War in an abstract form in America with de Kooning, Pollock, and Kline and then undergo a third renaissance in the 1980s in the movement best known for its art-world hype and instantaneous though sometimes fleeting fame: Neo Expressionism.

It was in the mid-1950s, at the heyday of the first American expressionist movement, that Jack Kerouac entered the field. It was a style that best paralleled the spontaneity and prodigal cascadence of words that exemplified Jack's writing. It was open to continuous experimentation, free of inhibiting rules, and copacetic

with Jack's aesthetic, technical theories, and eclectic painterly influences.

"By not worrying about results, by stopping when you do begin to worry, you leave your action and vision intact," he wrote. Jack never referred to himself as an expressionist painter, but few artists have identified with the categories assigned to them by art history. In one painting in particular, *The Red Face* (**fig.76**), he approaches the look of one of the forerunners and greatest painters of the expressionist genre: Chaim Soutine. There is no way of knowing whether Jack was aware of Soutine's painting but the similarities are extraordinary.

For a more literary connotation, there is a passage in *Doctor Sax* for which these eyes seem remarkably appropriate:

> "The Wizard !" . . . his white eyes now shone
> like mad dots of fury . . . they were black
> and had snowstorms in them.

Finally, there is the painting itself, which stands on its own aesthetic merits and which is more about painting than it is about the sitter of the portrait. It is about the greens and deep turquoise blues that vibrate against the red background; about the open mouth, the streaky multicolored parted lips, the four teeth gleaming from the lower gum; the sweeping arch of a dark spectrum that forms the derby and the impressionistic speckling of the bottom of the derby brim; the *J*-shaped turquoise and red sweep that surrounds the left ear and a white sketchy mass that constitutes the right; and all those long, soft, violet swipes of color under the chin, dabbed throughout the hat and in the small segment of a shirt. And the odd, mini-Jackson Pollock–like veining of the nose, with gold, white, and green intersecting thin, curlicued skeins of paint.

The painting touches, too, on another, more esoteric, aspect of expressionist art: *Art Brut,* a French style of the late 1940s and '50s whose best-known artist was Jean Dubuffet and whose images were inspired by the works of Paul Klee. In Dubuffet's *Two Mechanists* are the red faces, wide-eyed engagement between subject and viewer, large dominant faces and hats, and a distinct feeling that the work was done with a sense of urgency. The Kerouac appears to have been painted, as Picasso once remarked, "out of necessity," and the Dubuffet looks like it was purposefully graffittied onto a wall of an urban alley.

There were some friends that had roles in the Kerouac legend but were never immortalized in the literary Duluoz version. Perhaps they were wait-listed for the books yet to come, when both legends came to an untimely end in 1969. One such unwritten character of heroic stature in Jack's life was Willem de Kooning, whose reputation as a world-class painter and leading figure in the abstract expressionist movement had already been established when Jack and Bill crossed paths at the Cedar Tavern and in Easthampton, Long Island, and later, as mutual friends of Dody Müller. De Kooning's first one-man show was in 1948 and his stature as an artist was second only to Jackson Pollock, who had exhibited his first "drip" paintings in that same year. But Jackson died in 1956, and in the years that Kerouac was most prolific as an artist, de Kooning had already worked his way through his famed "women" series, was painting abstractly, and was generally accepted as the leading painter of his generation.

By the late 1950s, the image of "women" once again dominated De Kooning's paintings. The fluctuations in his work, of figurative to abstract, were representative of the then-ongoing conflict between figurative and nonfigurative subject matter among the abstract expressionist painters. De Kooning believed the best way to apprehend the experience of life in art was through "glimpses" into the moment: gestural Abstract Expressionism done with passion, dedication and spontaneity.

He was the most influential of the artists: and was clearly an influence on Kerouac's painting. Helen Elliot, a close friend of Jack's from 1949 to 1969, told of the probability of painting lessons that Bill gave to Jack:

When I was alone in East Hampton, Bill would bicycle down for a visit. When Jack came into town he made me run with him, he lumbered along like a football player but he covered a lot of territory. He would lumber out to East Hampton to spend time with de Kooning. Bill urged him on with art, he was really helpful—I'm sure he showed him things about his painting, gave him some lessons

If there are to be "masterpieces" among the Kerouac works, one would most assuredly be *Two Figures in the Woods* (**fig.77**). In this bright and buoyant oil, we see a number of the idiosyncratic elements familiar in Jack's art, along with an undeniable sense of de Kooning in the aura of the figure in abstract space, that perspicacious "glimpse" of a single point in time and of the *joie de vivre* in the dance of daily life. Kerouac's two figures have their hands clasped together. The forest explodes all about them in shapes and rhythms and an all-over patterning pays homage to the then-recently-celebrated works of Pollock. The season could be autumn, Jack's favorite, with the undertone of rusty browns tinting the spectral variety of greens that overwhelm the background; or it could be a moment in a restless spring afternoon as a renaissance of newly verdant greens decorate the thawing, golden browns of the retreating winter.

Jack's use of white paint to define and highlight the dancing figures adds an ethereal note to the work. The bodies become wraith-like, transparent, in the dense bespeckled woods. There are the whites of the eyes, and white reflections on the face, white outlines follow the contours of both flesh and clothing, and a pattern of transparent, white, somewhat biomorphic forms hover like a creeping surrealistic haze through the background undergrowth of the scene.

In some minimally painted segments of the work, we can reconstruct the Kerouac working process. He begins with a charcoal sketch, which is sprayed with fixative, and then the entire canvas is covered with a transparent "underpainting" of greens, browns, and lustrous golds. Small sections of the original sketch can be seen in the legs of the figure on the right and in the face and arm of the figure at left, where blended charcoal seems to be the medium and the rite of nature that is burgeoning across the backdrop of the painting is achieved with a dry-brushed scumble of a rusty sienna applied somewhat randomly and then covered for the most part with a variety of greens.

In what may be an attempt to relate the figure at left to a specific person, a bright patch of cadmium yellow, denoting the hair, picks up a touch of the green and fades into the glowing background above this now clearly feminine person, whose outfit, a short belted dress, flares into a hoop as we view her from a ground-level perspective. Atop her head is a large, red, broad-brimmed hat, trimmed with white markings and a rising red plume.

The same electrifying, vibrant red reappears in a number of places on the painting: in the rose-like object in the hand of the figure at right and in the lines at the upper and lower right corners and along the left edge. These reds are all placed to bring both balance to the composition and a resonance to the work that is not possible with any other color. The eighteenth-century French landscape artist Camille Corot is known to have included, in all of his paintings, one or two small, red objects, often a flower or a chimney or most typically an article of clothing on the figure of a person walking off in the distance. If one blocks the often minuscule red elements from view when looking at these paintings, the diminishment of the aesthetic response is shocking. Jack's painting of *Two Figures in the Woods* reacts similarly to this visual experiment.

De Kooning's influence is noticeable in the eyes: oversized, staring, no details, no lashes or eyebrows or the subtleties of shape or reflection or shadow that artists utilize to generate emotional response. The broad, tempestuous slashes of white that delineate much of the de Kooning figures become more controlled in Jack's interpretation. The white does flow freely into strange, transparent, mythic bird-like shapes in the symphonic surrealism of the background. Jack has done away almost completely with the drawn black lines leaving the depiction of the figures to the white paint occasionally mottled with blues, greens, and grays. Where he does come in with the black is in the background and in that jagged line down the chest of the right figure.

Most notable among the differences is that Jack has clothed his figures, while de Kooning's icons remain nude. Jack is painting the people of his life, and when they dance in the woods they are dressed. De Kooning is painting the earth-mother goddesses, who, uninhibited by society's customs and mores, are free to run naked in the forest. Jack tries, too, for a sense of the essence of the forest, and is quite successful in his abstracting of that feeling in color and sensuousness.

From the Freudian perspective it is noteworthy that Surrealism, the movement in painting that was concerned with the unconscious mind, was an outgrowth of a literary movement. In fact, a number of writers took exception to the idea of surrealist painting, seeing it as a bastardizing of the poetic concept. In an article titled "Poets and Painters," Stephen Spender analyzes this juncture of the visual versus written art:

Visual art is not things speaking through the artist, but the artist telling us, by the marks he makes on the material, how he sees the outside world. I think that painters often write out of an envy of writers, because they would prefer to be interpreters of experiences and not commentators on them.

Jack Kerouac, then, a writer who paints, reverses the process, shifting from the interpretive to the commentary mode. Although considering the theories of spontaneous prose and sketching with words practiced by Jack and other Beat writers, it appears that they work in what was previously a gap between interpretation and commentary, between thinking and feeling.

To those who think, life is a comedy;
to those who feel, a tragedy.

Balzac

And in that gap fomented the great literary tragi-comedies of Kerouac and Ginsberg, and beyond *On the Road* and *Doctor Sax* and *Howl* and *Kaddish*, there are Jack's inspired paintings and drawings and Allen's prodigious body of photographs. Not unexpectedly, there is the aesthetic overlap. Techniques described for writing are interpreted into drawing and painting; Buddhist teachings evolved into imagery.

From Jack's "Belief and Technique for Modern Prose":

—**The unspeakable visions of the individual**
—**In tranced fixation dreaming upon object before you**
—**Struggle to sketch the flow that already exists intact in mind**
—**Composing wild, undisciplined, pure, coming in from under, crazier the better**

And from Jack's "Essentials of Spontaneous Prose," a description which, if one substitutes "draw" for "write," one finds an accurate description of his visual art techniques:

If possible write [draw] "without consciousness" in semi-trance (as Yeats' later "trance writing") allowing subconscious to admit in own uninhibited interesting necessary and so "modern" language what conscious art would censor, and write [draw] excitedly, swiftly, with writing-or-typing-cramps, in accordance (as from center to periphery) with laws of orgasm, Reich's "be-clouding of consciousness," Come from within, out - to relaxed and said.

Jack's pastel drawing *Le Roué* (**fig.78**) is a work that hovers in that gap between his art and his life, between reality and abstraction, between thinking and feeling. It is tragic and it is comic—only a few

degrees of separation away from the mainstream events of Jack's life. The extreme caricaturesque nature of the drawing—the shaved head and quasi-military appearance of the subject—bring to mind the figures George Grosz drew and painted of the decadent army officers and politicians he saw in Berlin between the world wars.

Jack has written the title of the pastel drawing at its bottom: *Le Roué,* a word which is generally translated as a lecherous person, debaucher, a rake; a name, too, that was first applied to the "profligate companions of the Duc d'Orléans."

In *Satori in Paris,* Jack describes his odyssey in France in search of his ancestry, of the origins of the Kerouac name, which family legend believed was derived from the French aristocracy. In a discussion about French pronunciation between Jack, using his full French-Canadian-American name, Jean-Louis Lebris de Kerouac, and a Paris art dealer, who he is seated near in a restaurant, and who actually knew André Breton, Jack makes his single literary reference to *Le Roué.*

. . . I finally warned him, concluding my charming lecture across the restaurant as people listened half amused and half attentive, Francois' name was pronounced Francois and not Françewe for the simple reason that he spelled it Francoy, like the King is spelled Roy, and this has nothing to do with "oi" and if the King ever heard it pronounced rouive (rive) he would not have invited you to the Versailles dance but given you a roué with a hood over his head to deal with your impertinent con, or coup, and couped it right off and recouped you nothing but loss.

A different version of the roué as hit-man. Apparently, along with all the debauchery, cunning,

and dissolute immoral activities apportioned to them in the various French histories, decapitation work for the monarchy may have been part of their oeuvre.

But in a letter to Lawrence Ferlinghetti, Jack has described himself as "an old roué with a drink in his hand before a good friend's fireplace," far more suitable an image of Jack then that of an assassin, and although it's not quite clear how Jack's French odyssey ends, it fantasizes at his having found his heritage among these "profligate companions of the Duc d'Orléans."

And too, there is a letter that Jack wrote to John Clellon Holmes on December 7, 1965, and signed it

"The old roué —Jack."

The drawing of *Le Roué* appears to have been executed with an uncommon degree of abandon. Long, blue-green, freely swirling lines create an energy field, out of which materializes the balloon-like head, in profile, hairless, diabolical. A small, slightly hooked nose curves outward from the sweep of a fiendishly angled brow. Its line continues down into a confusing series of folds that are at once a mustache, upper lip, lower lip, and chin, but it is difficult to miss the image of the male genitalia in their formation. A small, faded or scumbled-over shape that can resemble a tongue or the tip of a penis materializes from a formless gestural line to touch lightly against the puckered lips of the roué's mouth.

The head is filled in with pink flesh-colored pastel chalk applied liberally and with little concern for "staying in the lines" of the drawing. Blue-green, Naples yellow, sienna orange, and ultramarine blue comprise the color aesthetic of the work. They are used sparingly and drawn largely by dragging the chalk, on its broad side, across the paper. The effect is soft, uneven, somewhat sketchy, and nonlinear.

The ultramarine blue forms a frame along the bottom and right edges, and once more, very lightly, along the left edge. It is used again, in a blend with the pink and some yellow as a curved base for the head, and finally in the short dash with three verticals that form what could be the symbol of a mouth or a mustache. To the right of this enigmatic shape is a quick flourish of the color which does not conform to any feature of facial anatomy, but contributes to the leer of the roué's general demeanor.

Long lines were an important part of the Kerouac-Ginsberg literary explorations. Part of the Walt Whitman legacy to the young writers, Allen Ginsberg wrote about his use of them in *Howl*:

These long lines or Strophes as I call them came spontaneously as a result of the kind of feelings I was trying to put down and came as a surprise solution to a metrical problem that preoccupied me for a decade.

Jack carried the strophes over into his drawing of *Le Roué,* which can be deconstructed into two concentric, deliberate lines that outline the fiendish profile. Four long, rambling discursive lines energize the background and four quick, arrow-straight lines frame and encompass the various elements of the picture.

In 1905, a group of obscure French painters exhibited at the Paris *Salon d'Automne.* Their unofficial leader was Henri Matisse. Their inspiration came from the earlier breakthroughs of Impressionism, Seurat's pointillism, the radical expressionism of Van Gogh and the aesthetic theories of Paul Gauguin. The work of André Derain, Georges Roualt, Maurice de Vlaminck, and Raoul Dufy was segregated from the academically acceptable works of painters like Ingres and Manet. The young artists were viciously attacked by the

public and the critics, one of whom referred to them as *Les Fauves,* the wild beasts. And so the group was named and would continue to be known as a movement in modern art for another five years, practicing its bright, often arbitrary color, erratic configurations, vigorous gestural brushwork, and somewhat disorganized demeanor. It was trying hard to provoke pleasure and it was free and uninhibited.

About fifty years later, Kerouac, using felt-tip marking pens, drew a picture which he titled *Lilith* (**fig.79**), that would well have qualified him for a status as a *Fauve.* It is simplistic in its four-color palette, centralized composition, and joyous, light-hearted deformation.

But who is Lilith? Her name does not appear in Jack's books, letters, notebooks, or lists, and is unknown to his friends. She could have been familiar to Jack, however, not through the Duluoz legend, but from the popular film *Lilith,* in which Jean Seberg, in the title role, is obsessed with getting men to fall in love with her, after which she destroys them.

It became a cult film, far more popular than the novel by J.R. Salamanca on which it was based. The Jean Seberg character could possibly have served as the model for Jack's painting with her dark, hollow eyesockets; hypnotic, glowing pupils; amply lipsticked, sensual mouth; rouged cheeks; and long, romantic ringlets of curly red hair falling below her shoulders.

One other possibility, and perhaps Jack's first hearing of a Lilith, would have been at Catholic school. There is a story in the Apocrypha, the Greek term applied to a group of fourteen Jewish books believed to have been written between 200 B.C. and 200 A.D. that were excluded from the Bible but preserved by the Church. Among the historical writings, prophesies, poems, and proverbs is the legend of the first woman, who was the original wife that God created for Adam, but when she scoffed at the job, she was summarily eliminated and replaced by Eve. This first woman was named Lilith. Certainly a story that could move Jack to this depiction of the first mythic women's rights activist.

Among the other works in the Kerouac fine art legacy are those that extend the range of Jack's abilities and techniques, as well as continue the depiction of the Duluoz legend. An example of this extension is *Woman with Blue Book* (**fig.80**). The hazy, faded nature of the work led to closer examination of the medium, which resembles oil crayon but appears "printed" onto the paper. Other elements—the swirling, long hair and the green outline of the book—appear to be drawn with pastel or oil crayon.

The key is in the signature. Just beneath it, is another signature: "cauoreK." A mirror image, it is written in reverse: the work then is a print. It was transferred through a fine-arts printing process onto the paper, and since Jack signed his name on the original drawing, it printed in reverse in the final work. There are any number of techniques Jack could have used to make the print but most of the sophisticated methods, like etching, lithography, or woodcut would have logically led to an edition, with each print signed and numbered by the artist. We have here only one print with drawing on top of the printed surface. It is then, by definition, a monoprint: an old art device for capturing the surface qualities and textures of a print without the equipment, specialized materials, or tedious preparation.

Jack simply painted the image on a piece of glass, paper, wood, or any smooth surface, and while the

paint was still wet, placed a sheet of paper against the painted image and pressed them together. The result is a monoprint, an edition of one, a unique work of art.

It is in the many notebook sketches that we get really close to Jack, seeing him at his most uninhibited and spontaneous. Like his drawing on lined steno paper of a young woman with long hair, her head tilted in curiosity as she looks questioningly at one of Jack's personal little angels who delivers the typed message "I be at my house New Years Eve waiting for you, or not, as according, to whim" **(fig.81)**. Since the sketch is undated it is difficult to identify the subject; but the sketch does resemble Dody Muller.

In the time frame of 1956 to 1959, during which Jack's notes encompass the making of most of his artwork, the notebooks also detail no less than fifteen women with whom he had relationships on various levels. Many were fleeting sexual encounters, some romantic and inspirational, like Dody and like Joyce Glassman, who shared the critical 1957 period (*On the Road* was published) with Jack, Helen Elliot, who remained a close friend until his death in 1969.

There is a strange, psychodramatic sketch, hardly more than a brief notation "written" in curvilinear imagery, like a long unpunctuated Kerouac sentence, that makes its unqualified, emphatic statement in the clearest and simplest terms: *Mother and Child* **(fig.82)**. But this has none of the holy verve and spirit of Jack's Madonna and Child drawings. There is a sinister quality here that bespeaks the nightmare of the sudden appearance at the door of the woman and infant,

declaring that the shocked fellow with the doorknob in his hand is the father. If Jack is annotating his own legend here, then this is Joan Haverty with Jan in her arms. Jack and Joan were married in 1950. She became pregnant in 1952, and Jack left without seeing the child, insisting he was not the father. In a letter to Allen Ginsberg and William Burroughs from New York in May 1957 (Jack has just returned from the south of France and Paris), Jack rambles, touching briefly but sensitively on art:

> Be sure to dig the Cezanne country which looks (anyway in Spring) exactly like paintings, and Arles too, [Van Gogh home] the restless afternoon cypress, yellow tulips in windowboxes, amazing . . . Monmartre will call me back . . . and that was where Van Gogh, Cezanne, Rousseau, Lautrec, Seurat and Gauguin were, all together, wheeling their paintings upstreet in the wheelbarrows . . .

But the letter turns bitter:

> Bad news is that Joan is after me with the cops again already, they think I'm in Europe still and are about to clamp on my source of income at Sterling Lord's and attack it etc . . . what I'll do is order a blood test in a few months and settle it once and for all . . . that bitch, and I was feeling so good because no lushing and happy thoughts of concentrating all attention on Duluoz legend, damn her, she's like a snake snapping at my heels . . . this Joan shot has brought me down to utter gloom again . . . How can I ever make it as Bhikku? - - - - Even if I prove it aint my baby, the expense, the hassel, having to see her horrible, haughty face again, the judge might still make me support the kid because no one else will, then what do I do? Give

up writing and bhikkuhood and get a steady job? I'd rather jump off Golden Gate Bridge.

In the drawing *Mother and Child,* it's hard not to see that there was once beauty in the woman. Jack's flowing hand, in its initial pictorial statement, was quite likely projecting less ugliness than he had in mind, less hostility. It is the slashing of vertical pen strokes on the one half of the face, and the molting flesh on the other, that along with a further "slashing of the throat" turns what could have been a well done line drawing from Jack's Matissian mode into a terrifying image of Moloch and Child.

I'll go light candles to the Madonna. I'll paint the Madonna, and eat ice cream, benny and bread— "Dope and saltpork," as Bhikku Booboo said—I'll go to the south of Sicily in the winter and paint memories of Arles —I'll buy a piano and Mozart me that— I'll write long sad tales about people in the legend of my life —This part is my part of the movie, let's hear yours.

It was during the writing of *Tristessa* that Jack began to paint—October 1956 is the date he mentions in the letter to Ed White. There are two incidents in the novel that relate directly to his artwork. In one of them, he and Old Bull go down into the slums looking for a drug dealer:

. . . he's not in so we sit on the stone steps of the crazy courtyard full of screaming children and drunks and women with wash and banana peels you'd think, and wait there—Bull is so sick he has to go home—Tall,

humped, wizard cadaver-like he goes, leaving me sitting drunk on the stone drawing pictures of the children in my little notebook.

There is a drawing of Jack's that could be of these Mexico City street kids. The caption "PFUI" suggests a comment on the likelihood that these slum children bathed at infrequent intervals (**fig.83**).

A rather detailed description of the beginnings of Jack's life as an artist in Mexico in 1956 is found in *Tristessa*:

I've already swallowed a fifth of wine on the way down, its one of my drinking days, I've been bored + sad + lost too, for 3 days I've been painting + drawing with pencil, chalk + watercolors (my first formal try) + I'm exhausted I've sketched a little bearded Mexican artist in his roof hut + he tore the picture out of the big notebook to keep it—we drank tequila in the morning + drew each other—Of me he drew a kind of tourist sketch showing how young + handsome + American I am, I dont understand (he wants me to buy it?) - of him I draw a terrible apocalyptic black bearded face also his body tinily twisted on the edge of the couch, O heaven and posterity will judge all this art, whatever it is-so I'm drawing one particular little boy who wont stand still then I start drawing the Virgin Mary.

In that same month, Jack reflects upon love in a letter to Peter Orlovsky, who was going to make a speech on the subject to a poetry group in San Francisco. "I agree with you about love . . . say what comes in yr. heart" he begins and then warms to the subject:

. . . Yes, the girls have loosened up my belt but only the 3-minute whores

on Panama street, the girl I
love doesnt care one way or the
other, she offered herself part-time
but I want a lover not a whore
—The difference between love
and whoring is, love is a trance
of angels in heaven, while whoring
is a convenience of temporary
exchange of gyzm and money
and dresses and rent—Love
is the April row when feelers
reach for everything—
　　Love is loving lips and necks —-
　　Love is also God's infinite
compassion, his sad understanding
of suffering —-

Is Jack trying to say love is coming home, bag in hand, coat tossed over shoulder and being joyously welcomed from across the room by a naked woman who calls you "Honey"? This describes a notebook drawing of Jack's, and the illustrational nature of the work suggests that there was a specific rather than a general meaning to it (**fig.84**). It's a very sexual drawing. The fully dressed male, the naked female, an empty room, the endearing welcome. We can make reasonable assumptions as to what will happen next—and Jack provides a drawing for this, too. The couple has come together in what filmmakers call "a two-head shot," the breathless moment before the kiss. Jack adds a challenging touch to what would otherwise have been a work of far less profundity: they each have a question mark on their cheek (**fig.85**).

It is drafted with a light touch, honest and untrammeled. The woman's face is much larger than the man's. Both are of the quick-draw, instant-art variety: the profiles in one gesture, the eyes in two, and a dash here and there to complete the anatomy. One particularly serendipitous line delineates the man's hair, ear, and jaw, drawn with the ease and penmanship of one who goes through life with a pen in hand.

Another drawing, *Lover, Lover* (**fig.86**), takes us a step further in the romantic adventure. A woman is on the left, a man on the right, their lips are together, the woman's are puckered and there is even the hint of a tongue in that line that connects the mouths. Jack has physically integrated the bodies, with only the profiles and hair clearly defined; the arms and

shoulders are drawn more like the activity cycle of an energized field then of human anatomy. In case anyone looking at the work has somehow missed the point, Jack has written over each of their bodies the word "Lover."

Finally, Jack cuts to the quick, joins the ranks of the erotic artists and culminates his series of drawings on the art of making love with the most sexually explicit of his works. With the requisite foreplay accomplished, Jack draws *The Lay* (**fig.87**).

The two figures are outlined with the same spare rendering of the previous drawing: simple minimal lines, elegant curves paralleling and bisecting each other, the bodies virtually melding together with sensual rhythms. They are in the classic missionary position. The long bottom line in the drawing represents the sweep of the woman's back, waist, hips, and right thigh; her left leg is raised high at top center. The arch of the man's back and buttocks is accomplished with one fluid gesture as is his chest, groin, and the front of his thighs. The heads are vaguely detailed, the woman's face is tilted backwards, the man's, with what appears to be an exaggerated nose, looks down at her. A double semicircular arch surrounds the woman's head—a pillow or a halo. Two question-mark shapes once again raise the issue of identity—they are both superimposed on the man's head.

There is no easy explanation for the line of *X*'s that rises up from the point of the woman's groin, or the vaguely anthromorphic but very excited allegorical creature that dances orgasmically about above the couple. The maze of circles, swirling lines, and surrealistic "scribble" marks that form an energy bank at the area of direct sexual activity, on the other hand, is fraught with meaning. It is the focus of the event, all the complicated, entangled psychic emissions that Jack saw in the act of love. Little faces appear throughout the twisted labyrinthian convolutions—a cautionary note that as good as this feels, this, too, is how babies are made.

What remains somewhat disarming is Jack's labeling of the work *The Lay*, a term that reduces the lovemaking to a vulgar act. Yet the craftsmanship and sensitivity of the drawing contradict this feeling. The drawing itself is sensitive, emotional, even loving. There remains a provocative dichotomy between the inelegance of the painting's common caption and the graceful sense of intimacy of the coupled lovers.

girl in white, boy in red

By February of 1959, when Jack wrote in his note-book, "Painted Eagle and Girl in White, Boy in Red" (**fig.88**), he had been painting for three years. The two works stand as landmarks in denoting Jack's skills as an expressionist artist not of the American abstract school, of which Jack had minimal interest, but of the earlier style of European Figurative Expressionism.

Although the subjects of the two paintings *Eagle* (**fig.89**) and *Girl in White, Boy in Red* (**fig.90**) have little in common, it is easy to see their similarity in technique. The figures evolve out of the "negative space," by the paint of the background extending slightly into the body of the figures. The paint was laid on in long, loaded brush strokes which model the structurally solid foundations of the Girl, the Boy, and the Eagle. The figures are as much a product of the thickly painted cosmos surrounding them as of their own painterly mass. Like Franz Kline's explanation that he was not painting black forms against a white background, but independent black and white forms of equal significance.

In Jack's *Girl in White, Boy in Red,* the boy is shirt-less, arms reaching upward, torso leaning forward, a slight bulge at the midriff, a dash for the eyes, another for the mouth. He wears only skintight, high-gloss, bright red trousers. He is carrying a load on his head, which would account in part for his angled posture.

The girl wears a white floor length robe which resembles a toga. A white band circles her dark hair, and her face is a pasty, colorless pallor with a few touches of the same flesh-tone as used on the man's body. Her facial features are confusing—only the pro-filed nose and an elongated black teardrop shape of an eye are definable. One of her arms is raised parallel to the diagonal of the boy's bent back, the other relaxes at her midsection. The hand of the raised arm holds a long cylindrical gold-colored object.

Her left leg is planted on the ground, her right is bent at the knee, paralleling the angles created by the bent knees in the red pants. The resultant red, blue, and white curves formed by their bodies create a structural rhythm that bonds the two figures together in the synchronization of their movements.

Neo-Freudians could interpret the pose as sexually erotic: Jack's "boy" has pretty, female features and is

posed in the receiving position for heterosexual sex. The "girl" in white holds one hand between her legs, and in the other holds what can be viewed as a penis-shaped object, like a guiding light. In the chauvinistic terms of 1958, she is the leader; she has the penis.

On top of the boy's head is a curving purple horizontal that forms a base on which are piled high those biomorphic green and red objects that are scattered along the ground.

Jack has cloaked this dramatic moment in costume and myth: the woman as goddess, earth-mother—or just Jack's mother perhaps, standing behind her boy, her raised arm providing the necessary "push" to get him up the hill.

In whatever form the characters are related to Jack's legend, the woman as muse could be any of the many women in Jack's life, inspiring Jack to move the earth for them, and there are blue patches, too, among the red and green objects on the boy's head. Is Jack, then, moving Heaven and Earth; or merely demonstrating that he, like Hemingway's hero, can make the earth move, for the satisfaction of a woman who stands behind him.

THE EAGLE

Jan. 29, 1959 Notebook: "Tried unsuccessfully to paint an eagle, erased it."

Feb. 5, 1959 Notebook: "Painted eagle, and Girl in White Boy in Red"

Feb. (?) 1959 Notebook: "And so, walked 2 miles to liquor store, bought booze, painted THE EYE (in the Eagle) and completed
GIRL ———..."

Jack painted the eagle's eye exactly the same way as he painted the eyes of Cardinal Montini, with a penetrating stare that has an engaging, hypnotic grip. The stolid body of the bird itself bespeaks great strength and innate power. It seems to surge upright in a manner noted in Jack's painting of God and, like that earlier work, it exacts a similar, dramatic, heraldic, mood. The eagle is, after all, the bird of Zeus, the incarnation of the highest deity, and the image in which the god appears on earth. That is a pretty good mythological résumé.

One of the most striking things about the Eagle is the conservative use of color. Jack was seldom extravagant with color, and many of his best works were accomplished with a limited palette. Like the warm reds and cool blue-greens of *God,* the black and yellow of *Eagle* can be seen as "confrontational colors"; there is simply enough contrast and any more would seem excessive. The single red dot of an eye, as well, is maximally effective, in this less-is-more color framework.

But Jack was not conservative in his application of paint. The brushstrokes are masterful and responsive to the physical dynamics of the Eagle's imperial bearing: swift and vibratory, akin to the soaring of its powerful wings. The lemon-yellow of the background is painted right up and into the edges of the black body of the bird. There are yellow flickerings across the feathered surface as the blacks and whites mark their kinetic presence in the restless space around the eagle. Completing the work, at the top left, is a signatory mark that Jack must have been using on February 5, 1959: an unexplained rectangular dash of paint in the open space. A similar mark appears in the open space at the upper right of *Girl in White, Boy in Red,* which Jack painted that same day, cryptically connecting the two works.

BROWN MOTH PARLOR OF ETERNITY

In *On the Road:* "Dense, mothlike eternity brooded in the crazy brown parlor with the sad wallpaper, the pink lamp, the excited faces."

In *Doctor Sax:*

I'm sitting in my mother's arms in a brown aura of gloom sent up by her bathrobe—it has cords hanging, like the cords in movies, bellrope for Catherine Empress, but brown, hanging around the bathrobe belt —the bathrobe of the family . . . but the brown of the color of life, the color of the brain, the gray brown brain, and the first color I noticed after the rainy grays of my first views of the world in the spectrum from the crib so dumb . . . my mother's robe sends auras of warm brown (the brown of my family)—so now when I bundle my chin in a warm scarf in a wet gale—I think on that comfort in the brown bathrobe—. . . The brown that I saw in the bathrobe dream, and the gray in the shoeshop day, are connected with the browns and grays of Pawtucketville—the black of Doctor Sax came later.

There were two sides to the Surrealist movement. One practiced psychic automatism and experiments with chance effects and was associated with the surrealist poets; it produced artists like Joan Miró and André Masson. The other side was more directly linked to Sigmund Freud's theories of the unconscious mind and, most significantly for the artists, the imagery of dreams. This group included Salvador Dali, Yves Tanguy, René Magritte, and Paul Delvaux. There is also an indirect association with the group of Henri Rousseau, Marc Chagall, and Giorgio de Chirico.

Over the years, the classifications were less noticeable, as Picasso, Miró, Arp, and others evolved their own brands of fantasy-inspired imagery. Later, Dali's superreal and super-popular rendering of rational subjects in irrational dreamlike situations, along with his twelve-inch mustache and public displays of Dada-inspired, well-publicized buffoonery, contributed to a "mad-artist" popular view of the movement's painters.

Although the origin of Surrealism is generally attributed to Freud and Breton, the deeper roots of the aesthetic lie in the brilliant works of the sixteenth-century Flemish painters Hieronymus Bosch and Peter Bruegel, where hellish fantasies and mythic medieval creatures were portrayed with the magic touch and technical virtuosity of a Bellini.

Certainly neither Kerouac nor most of his contemporaries, save Dali, would ever approach or even attempt the technical precision of the early Venetian or Flemish masters. With the nineteenth- and twentieth-century

flexing of the rules of painterly order, this was not a requisite of the new, eclectic Surrealism and so it seems appropriate, despite the simple character of the drawing, to place Jack's *Brown Moth Parlor of Eternity* in the category of surrealist art (**fig.91**).

The work has no particular central focus; its strongest elements are positioned in opposite corners. At the lower left, a formidable figure with a large head sits comfortably in an armchair, its feet resting on a stool. The figure's hair is piled high on the head, there is a double chin, and the lines about the body describe a chest or bosom. The figure seems to be an integral part of the room. He or she anchors the composition in place and is the one solid entity in the work: Jack or Mamere perhaps.

Diametrically opposite, high in the corner, the outline of a human shape creates both a frame for the drawing and a cryptic symbol. Wide open to interpretation, its elongated arms wrap around the entire top length of the picture and down and around one side. From the hand at top, fingers reach out encompassing everything beneath it; the hand at bottom is cupped, supporting the weight of the work.

Four other people share the inner space, locked within the circumferential "cycle" of those long encircling arms, the endless life cycle, the "Eternity" of the Brown Moth Parlor. At left stands a very de Kooning-like figure, arms extended outwards. One hand touches a hanging electric light bulb and vibrates from either contact with the electricity or the heat. The face appears grotesque, contorted from shock or pain.

Just to the right of this figure, a woman wearing a pillbox hat, striped slacks and a sexy, tight-fitting top, sits a bit slumped on the edge of a sofa. Behind her is a window with the shade up; it is night.

In the right-hand corner is an open door or very large window; and through it, out of the dark, a very excited person waves their hands in the air. The image is rendered in tremulous, quivering lines and appears panicked, terror-struck. This figure suggests that Jack had recently been looking at *Guernica.* The position of the electric light and those quaking figures at the upper right are remarkably coincidental, but there is no armchair and no sofa in *Guernica,* and no long-armed eternal symbol of the cycle of life. Yet that head and mouth on the figure touching the light bulb has a Picasso ring to it, and that darkened person lying on the floor, whose left arm extends backward, is in the same position as the soldier in the foreground of *Guernica.* Possibly a coincidence, but certainly Jack had seen the great Picasso painting—it hung at the Museum of Modern Art in New York City in those years and left its mark on many who saw it.

cats

The little cat I had in my hands that had such a sweet sad little funnyface with gray eyes and finally spoke to me in a pitiful little voice, like Gerard's, "J'aime pas demain" and I said "Moi too mon ange!" and felt like crying . . .

The great affection Jack had for cats is well-documented in his books, poetry, drawings, and even a particularly endearing photograph. One of the most touching examples of the depth of these feelings is in a series of notebook entries made during 1959, when he was living in Northport with Mamere and his cats, Timmy and Tyke.

SATURDAY JAN 17—Dody drove me home with my heavy package of oils + canvasboards + a box of pastels, but Timmy ran away for the first time + I couldn't sleep + Tyke is sick with swollen leg—And Ma is sad — + all is sad because I am being torn in two by conflicting ideas—And, I'se go back to my Asvagosha—

—————which can transcend both arbitrary conceptions + rest in Holy Peace———————
—————————Timmy still gone———dusk———
I'm not excited about my paints now——————
——————————Ho! He came back + ate a ton of cat food!

Timmy's restless antics continued in the following weeks and Jack's notes vacillated between painting and anxiety.

THURSDAY JAN 29
Last night recited bitter poem into tape —————-
terrible, but good new technique for poems ———
Again walked at dusk for Timmy, say Mrs. Orlovsky
+ Laff was sleeping (5 PM) in his shroud blanket
————Oh Timmy vien's t'eu !
Going to NY with Aronowitz of NY Post tomorrow—
—for Knowles Holiday Nite——— + Dody ———-
Tried unsuccessfully to paint an eagle, erased it——
—Feel sick about Timmy—-O God Please Bring
Him Back

Another notebook page on February 5 makes mention of an ad in the paper for Timmy's return; and in the *Book of Blues*, two choruses of *Orlanda Blues* deal directly with Timmy's running off:

21ST CHORUS ORLANDA BLUES

That cat's in paradise
The noise of Automobile sigh
 don't interfere with the knowing
 of me or any paper party
 but what smat smeld red
Oh hey - now, Zulch!

Truth is, cry

Because the radar never was invented
could find paradise sound
or cat lost in the night
 radarless
 radar-less
 rad - arless
 radarle - ss
 r r r r t
Oranged suitcases as a kid
& sang to Glenn Miller's
 Moonlight Serenade
 & Laid
But O, Lord above,
 have pity on my
 missin kitty

And finally, we can rest easy:

29TH CHORUS

Timmy got back,
 soft Blakey lamb
Timmy got back
 & wrote rhymes
And we sat purring on the bed
 with Timmy

A few years earlier, in 1955, Jack had written a cat into his Mexican novel *Tristessa*.

The Kitty, la gata in Spanish, the little Tathagata of the night, Golden pink colored, 3 weeks old, crazy pink nose, crazy face, eyes of green, mustachio'd golden lion forceps and whiskers—-I run my finger over her little skull and she pops up purring and the little purring-machine is started for awhile and she looks around the room glad watching what we're all doing. "She's having golden thoughts," I'm thinking.

In a moment of reflection on Desolation Peak, Jack thinks of Lowell, and another cat:

Aw, and I remember sweet days of home that I didn't appreciate when I had them—afternoons then, when I was 15, 16 . . . as the orange sun of Lowell October'd slant through the porch and kitchen curtains and make a lazy dusty shaft and in it my cat'd be licking his forepaw laplap with Tiger tongue and cue tooth, all undergone and dust beticked. . . .

In haikus, too, Jack called upon the participation of the cats.

> How many cats they need
> around here
> for an orgy
>
> Every cat in Kyoto
> Can see through the fog
>
> In London—Town cats
> can sleep
> In the butcher's doorway

There are nine drawings of cats in the Kerouac art legacy. One is a quick sketch positioned above a Buddha eyes symbol and between two haikus **(fig.92)**:

> Fiddlydee! —
> Another day,
> Another something-or-other !
>
> and —
>
> Whatever it is, I quit
> —Now I'll let my
> breath out —

A drawing dated 1958 shows a man and a woman seated on a sofa and curled up between them, its front paws affectionately around the man's knee, is a furry cat. The two figures are drawn with a minimum of line and are a good example of Jack's skill at grasping the essence of body language with quick gestural penmanship. The feet of all three figures, the man's in slippers, one atop the other on the floor; the woman's, barefoot, curled up beneath her on the sofa; and the cats, holding on to that knee; show how well Jack deals with that difficult part of the anatomy **(fig.93)**.

The faces are depicted by a single curve of the eyebrow and bridge of nose; but subtle as this may be, it is sufficient to delineate the direction and general structure of the head. The man wears a slouch hat. He is reading something which he holds in his hand.

The most detailed and the only shaded part of the work is the face of the cat. Clearly this is intended as the focal point of the drawing. One ear is darkened and the dark portion continues through the lower left diagonal of the face, bypassing the nose. The effect is very much like Jack's Buddha head, where the division of light and dark recalled images of the Yin Yang symbol. Here, too, we find the white nose in the black space and the black eye in the white space; we are reminded of the line in *Tristessa*:

> . . . curled up under cat Buddha style, meditating
> among our mad endeavors

A matched pair of drawings depict a strange scene. The cats, in both pictures, fill the top left quarter of the space. One of the cats **(fig.94)** is drawn comic-cartoon style: round face, rounded body, legs, tail drawn to a point. It has pointy ears, oval eyes, and a brief dash of a mouth. Diagonally sketched lines stripe its head and body, and a scribbly gesture breaks up a too-perfectly striped symmetry and adds a sense of a body in motion. Its general appearance is that of a cute, happy, fat cat, without a trouble in the world.

The other cat, more austere, has a more muscular, anatomically correct body and features an angular, tiger-like demeanor. It is clearly running with purpose **(fig.95)**.

Behind each cat is a group of marching figures. In the happy cat picture they are drawn with a whimsical, comic sensibility. They could be taken for a group of kids playing "soldier" or "hunt-the-cat." Two of them carry sticks resting on their shoulders as one would a rifle. Another, a girl, carries a shaded rectangular object at the end of a long pole. One boy carries a trap-like device, a fifth pushes an unidentified object and the sixth, who seems quite a bit smaller than the others, is empty-handed. They wear a variety of hats: a crown on the girl, a hat with earflaps on the smallest child, and a helmet on the fellow with a "gun" on his shoulder.

The group changes character in the second drawing, much as the cat changed character. The figures are rendered as adults in a more sophisticated style of gesture-drawing; the lines suggest movement as well as shape. Although they are positioned exactly as on the other drawing, they are marching in step, in a precise military manner. The single feminine-looking figure again carries an object resembling a sign on a long pole, but it is blank, without the cross-hatch shading. The marcher at the rear rests what seems like a rifle on his shoulder. Their hats have a distinct military look.

Common to both drawings is a series of vertical and horizontal lines that demark the path of the marchers. The pattern they form could be seen as an aerial map of the city, the format of a board game, or a pattern loosely derived from the *I Ching*. There are four rows of two lines each in each of the drawings. The paths vary in length, and since there are the eight individual lines, one does give thought to the eight-fold path of Buddhism, which would then help shed some light on

the Bodhisattva-like figure in the lower right of the "serious cat" drawing.

If the pair of drawings are considered together, the kids in *Cat Hunt I* could be the kids who sat on the wrinkly tar of the sidewalk on Moody Street, Pawtucketville, Lowell, Mass.: Lousy, G.J., Gus, Jackie Duluoz, playing hunt the cat. Then the legend continues with their going off to war, as Jack did in World War II, when he served in the Coast Guard and during which he lost his best friend, Sammy Sampas, killed at Anzio. In *Cat Hunt II* the gang is all grown up and marching off to kill the cat, now grown from the alley cat of their childhood to a veritable tiger. But the eight-fold Buddhist path lies ahead, for those who are inclined to follow.

The Kerouac-alleged connection to the French aristocracy may have prompted Jack's drawing *Napoleon Looking at My Cat* **(fig.96)**. It is a vigorous, eclectic sketch with a combination of heavy-handed, freely applied scrawls, manifesting Napoleon, some carefully delineated, more sensitive lines economically structuring the cat, and the straight-edged diagonal and vertical lines that separate the two figures. The dynamic that is created by the positions of the regally posed, almost sphinx-like cat, and the restless, animated emperor, square-shouldered in his black cape, row of medals, and legendary hat, is in such extraordinary balance that they can be viewed as equals, even as one and the same; the likely common denominator: both alter egos of Jack.

Three little kitten faces grace a page of Jack's notebook **(fig.97)**. They are drawn as in a cartoonist's working sequence, striving to develop a character.

Each face is approached in a different manner. The one at left was likely drawn while Jack carefully studied the cat. It captures the subtlety of the features, particularly the eyes, and there is a general feeling of the essence of cat. The middle cat takes a step away from realism through a gestural drawing that includes a broad smile, small eyes, and a suggestion of front paws; but the third cat at the right culminates as a face of a de Kooning-like woman, with big eyes, flashing mouth, sweeping circle of a head, an arc of a forehead, and two little pointy ears.

Why Jack labeled a notebook sketch of a cat as "Phoney Cat" is anybody's guess. It could be that he drew it from a stuffed animal, in which case it was, in fact, just that: a phoney cat. Or it could be he was angry at some cat that just didn't know how to properly behave as a cat; or maybe he was just put off by the way the drawing just wasn't coming out right, and instead of tearing the page out of the book and starting over, Jack, frustrated, simply labeled it as a phoney for not

responding properly on its paper image, and then turned the page (**fig.98**).

There are two sensitive drawings that Jack did of sleeping cats (**figs.99, 100**). They both capture the very gentle essence of the curled-up feline at rest— kittenish, leonine, lovable. You can hear them purring as they breathe.

In these drawings and in Jack's sutra, *The Scripture of the Golden Eternity*, we find the best last word on his love of his cats.

Cats yawn because they realize
That there's nothing to do.

Everything's alright, form is emptiness and emptiness is form, and we're here forever, in one form or another, which is empty, Everything's Alright, we're not here, there, or anywhere. Everything's alright, cats sleep.

abstract expressionism and the beat generation at the whitney

It was a poet, André Breton, who set the pattern for Abstract Expressionism, the great mainstream art of the 1940s and 1950s when Jack began painting. Earlier in the century, the Italian poet Marinetti organized his country's painters into the Futurist movement; in France, poets Guillaume Apollinaire, Max Jacob, and the expatriate American Gertrude Stein supported the first generation of modern artists, explaining and elucidating the new work to a skeptical public; later Frank O'Hara, Clement Greenberg, and Harold Rosenberg did the same thing in America. Then there are the poets who paint, and the painters who write. These, too, appear with some regularity throughout art history—you can start counting with Michelangelo and go right up to the Beats—who all seemed to write and paint. In 1950, Picasso said to his friend and art dealer Daniel-Henry Kahnweiler, after reading from a sketch book which contained poems:

Poetry, but everything you find in these poems one can also find in my paintings. So many painters today have forgotten poetry in their paintings— and its the most important thing; Poetry.

William Blake was one painter-poet whom one would have difficulty categorizing into either discipline. His work is completely synthesized, often containing the written word and the drawn or painted image on the same page. His influence on the Beat Generation is immeasurable, having appeared to a young Allen Ginsberg in a dream and informed him that his life's work must be poetry.

America's sudden accession to the leadership of the international art world was a direct result of Abstract Expressionism: the painting of the New York School. It was in New York that the art form thrived and expanded—both in the concepts and dimensions of the individual works and, much more slowly, in its popular and even peer acceptance. It can be argued that it was in truth a European art form usurped by the energy, charisma, and media publicity that accompanied the New York group. For it was in 1910, in Munich, that the idea of abstract art first took root. It was here that the first nonobjective paintings were made by Wassily Kandinsky, who was obsessed with perceptually interpreting the visual

images of music: the works were labeled "Compositions" and "Improvisations."

World War I, the Russian Revolution, the Great Depression, and the rise of the Nazi party in Germany all shattered the status quo, rattled the European art community, and spurred its mass migration to the U.S. and to New York's Greenwich Village in particular. The Armory Show of 1913, in New York, had introduced the country to modern art and although the general response was largely one of ridicule—even anger—it did foment the beginnings of a modern art culture in America.

New York had been home to Marcel Duchamp since 1915, when he introduced the Dada consciousness to an esoteric group of intellectuals who still met regularly in the grand European salon tradition. In his Greenwich Village art school, German-born Hans Hofmann taught the theories and techniques of abstraction to a small band of dedicated followers. By the middle 1930s, the Whitney Museum held its first exhibition of abstract art. The arrival in New York of André Breton and the surrealists further intensified the modern movement, as did that of Mondrian, whose Neoplasticism was the clearcut and primary-color bridge between Cubism and Abstraction.

The 1939 New York World's Fair brought the movement to a wider public of visitors from across the country when it displayed the work of the American Abstract Artists group. The response was lukewarm. but by 1940 the movement had gathered sufficient momentum and resentment to picket the Museum of Modern Art for its neglect of American abstract painting.

The paintings proliferated during the agitated decade of the 1940s, which saw the demise of the economic depression and unemployment with the arrival of the war effort. The war ended in 1945 and the threat of communism soon became a condition of national paranoia. Ironically, while early in the era the American abstract artists and their supporters were considered suspect by the marauding Senator Joseph McCarthy and his House Un-American Activities Committee, the government would later sponsor an exhibit of abstract expressionist art to travel about the world and show off the unlimited freedom of expression that artists had in America. In retrospect, however, as heroic as the period and its painters seem today, in those early and middle years it was one of the least popular and quite likely the most hated movement in the entire history of art.

The big problem was its elitism, an extension of the old European tradition of aesthetic snobbishness and intellectual superiority that seemed to be characteristic of certain avant-garde, art-world circles. That Americans were not ready to welcome abstraction was further complicated by the fact that they were just getting comfortable with what did appear to be an American modern painting idiom, more in tune with the popular Impressionism of France—a regionalist landscape and portrait style, intellectually accessible, and just controversial enough to prompt cocktail party conversation. It took form in the work of Winslow Homer, John Singer Sargent, Edward Hopper, and the more urban-oriented Ashcan school disciples of Robert Henri: John Sloan, William Glackens, and George Luks.

Two critics rose in defense of the new art: Clement Greenberg, who saw American abstract art as a natural progression in the long-evolving metamorphosis of art history, and Harold Rosenberg who saw it as a clear break with the old-world aesthetic—a "frontierism" commensurate with the American Wild West character. He even compared Jackson Pollock to Daniel Boone.

We can, with some stretch of the imagination, position Kerouac into this analogy, in view of the evident parallels between his and Pollock's shared personas of the coonskin-capped All-American-boy turned hard-drinking, hard-living iconoclastic revolutionary. Poet Robert Creeley commented on the poet-painter relationship:

Possibly the attraction the artists had for people like myself—think of O'Hara, Ashbery, Koch, Duncan, McClure, Ginsberg; or Kerouac's wistful claim that he could probably paint better than Kline—has to do with that lovely, usefully uncluttered directness of perception and art we found in so many of them.

Despite Jack's involvement, intellectually and socially, with the painters, and despite the natural affinity that should have existed based on the common denominator of "spontaneity," or as Ginsberg saw Abstract Expressionism, "spontaneous bop prosody," the fact was that Jack was aligned with the unappreciative majority and not much of a fan of the work.

There are degrees of appreciation as there are degrees of abstraction. Herbert Marcuse had noted that the truth of art lies in its power to break the monopoly of established reality. To accomplish this, one need not entirely lose the object; unless, of course, one adheres to the observation of the scholarly art historian, Meyer Shapiro, that the *spontaneity* itself could be construed as the art object. De Kooning, one of the artists Jack admired, vacillated between several levels of objectivity, at times fragmenting anatomy into almost pure gesture, with other periods where recognizable figures of fierce women are painted of what seems to be pure energy.

It was into this arena of figure vs. abstract, human vs. the metaphysical, that Jack would briefly venture as an abstract artist, with a small group of paintings and a handful of drawings, all very close, but never quite taking that last step to complete abstraction.

One such painting, *Untitled Abstract #1* (**fig.101**), has an extraordinary reference to de Kooning in Jack's tempestuous painting of the two sweeping, fleshy phallic shapes at the center right side of the work, but Jack stays even closer to physical reality.

The scene is primeval, the brushwork convulsive, possessed with the power and lustiness of the forest. There is a sense of the last Van Gogh painting, with its cornfields and crows and sky, everything much too alive, struggling against itself. Jack's abstract, too, may well be an allegory of spring and rebirth—the spread legs, the deep space of the opening between, the upsweep of forestation, and, emanating from that point, unreadable symbols of ripe energy bursting into deep reds, yellows, oranges, and new greens. The large, black, sweeping shape festooning across the top; the shorter vertical black at bottom left; the twisting gold-on-black wedge. Positive and negative spaces swirl and rise into a spiritual sphere. Everything appears purposeful, every line and brushstroke intentional. A Dionysian rite. The dream is ended and we are being reborn into the golden eternity.

How to react to Jack's *Untitled Abstract #2* (**fig.102**) depends upon the context in which one views the painting. At first look, one is taken with the oval composition encircling the canvas and maintaining a fine balance from corner to corner, a small black dash at upper right, a large dash at lower right; a flash of red at upper left,

balanced by a burst of red and yellow that blends and integrates. Dark colors meld into amorphous shapes at the top, and a deep neon green explodes at lower left. Purple marks slash about the center, and emotion-charged dots, in various sizes, shapes, and colors, tumble about filling whatever voids are in the space.

It is the two sets of parallel dark brown and green-tinted dashes near the top of the oval that tip off the viewer that this otherwise abstract work indeed has a face. The purple slash marks become nose and mouth. The red and yellow become hair. Any meaning that can be attributed to the overall pattern of variegated dots and spots would be painterly rather than literal, perhaps a reflection of the overall compositions of Pollock, an attack on the rational order of things.

Robert Motherwell, a major New York School figure, confronted the figurative-vs.-abstract dilemma. In his painting *Ulysses,* we find diagonal slash marks across the face, as inexplicable as the white mark across Jack's painting. The slash marks in both works add a note of hostility, of cancellation, destruction. Leon Golub would take this self-censoring modality to a more physical level in the late sixties, when he painted mural-size Vietnam War scenes and then slashed the canvas with a bayonet. Considering then how the New York School evolved in the traumatic social and political climate of a world economic depression, followed by a mean and bitter war that embodied the unfathomable genocide of the Holocaust, it is no surprise that much of the art born to these years would reflect a significant degree of emotional anxiety and the kind of anger that would compel the artist to slash, with paint as the knife, destructively at the face on the canvas.

Although Jack occasionally ventured close to the abstract mark, often at the prompting of his good friend Twardowicz, whose own work is pure as the driven paint—not a sign or symbol of anything that vaguely resembles any thing—Jack would find meanings in Stanley's work, like "two black men fighting in a tunnel" for a completely black-on-black painting. Or he would see a clothesline blowing in the wind in a mass of shapes where Stanley intended only the play of integrated color and space. Certainly, there were times when the humor and sarcasm were intended, and when Jack did get close to abstract in his own work, as in the *Big Blue Oval* (**fig.103**), which could well have served as a viable abstract expressionist work in its nearly finished state, he could not resist the graffiti-like spotting-in of four dabs of white paint—two eyes, a nose, and mouth, to turn the blue oval into a face.

The most expressionistic of Jack's crucifix paintings, *Untitled (Crucifix)* (**fig.104**), clearly shows the influence of one of his favorite New York School painters, Franz Kline. Like Kline, Jack gave equal significance to the black-and-white elements of the work. There are some recognizable shapes. An inverted protractor shape at top left extends from a long, gray vertical along that edge—but most elements in the painting serve primarily to form the cross. It is possible to conceive human-like configuration in the swirls and blobs of paint (one particularly strange apparition is at the very base of the crucifix), but many of these defer more to each viewer's Rorshach-like self analysis than to the artist's intention.

There is a passage in *Big Sur* which one could associate with this painting and to a Rorschach test as well:

—For a moment I see blue heaven and the Virgin's white veil but suddenly a great evil blur like an ink spot spreads over it. "The devil!—the devil's come after me tonight! Tonight is the night! That's what!"—But angels are laughing and having a big barn dance in the rocks of the sea, nobody cares any more—Suddenly as clear as anything I ever saw in my life, I see the Cross.

Picasso expressed his nonelitist view of art with the statement, "I like all painting, I always look at the paintings — good or bad—in barbershops, furniture stores, provincial hotels . . . I'm like a drinker who needs wine. As long as it's wine, it doesn't matter what wine."

Red, White, and Blue Abstract (**fig.106**) is Kerouac's most nonobjective work. It is so confusingly different from Jack's general oeuvre that, in truth, there was a moment when it was considered an unfinished work in progress. Its inclusion in the Whitney Museum "Beat Culture and the New America" show in 1995 prompted its place in this book, as well as the determination of which end was up. It has neither signature nor markings in the rear nor anything to relate to other works— visual or literary—and the broad, sweeping brushstrokes of white paint even suggest the artist may have been in the process of obliterating the work.

Deep blue and turquoise angular shapes sweep along the bottom, up the right side, and seem to encircle and then soar toward the open space at the center of the painting. Although mostly obscured by the overlay of white dry brush marks, the three large oval shapes that dominate the body of the work appear to overlap each other, while the blue lingers as a shadow of the white, and the deep red, an austere, distant echo of the blue. Completing the puzzling composition are three small, egg-like ovals. One rests against the edge of the large half oval. It is in the scumbly blue shadow area and is pale yellow. Just beneath it, a second oval in the same pastel color hangs suspended in a void. The third, a transparent, lone pearl-white oval just barely visible in the rush of white brushstrokes, seems to lie in a hoarfrost and materialize from an overhead, radiating narrow turquoise beam.

Neither the ovals, the ladder shape formed by the horizontal lines, nor the wedge offer any suggestion as to the meaning of the work. In general, the mood seems to be one of struggle. The tension that may have existed at an earlier stage in the work between the flatness of the red background, the concentric dimensionality of the large ovals, and the lyrical dropping of the fragile egg shapes, has been shattered by the wild white paintmarks like a violent renunciation of the entire work—a sudden impulse to scribble all over it, as children so often do. But then, Joyce Johnson did say, at the conclusion of her book *Minor Characters,* the story of her life with Jack in the 1950s, that the Beat Generation was about their "right to remain children."

Tom Wolfe wrote of the "Great Artists of the Word." He also wrote that the less there was to see in a work of art, the more there was to *say* about it. Leonardo da Vinci likewise expressed the ultimate in simplification:

> Among the great things which
> are to be found among us,
> the Being of Nothingness is the
> Greatest.

And John Cage, who found his idiom in reductionism:

I have nothing to say, I am
Saying it, and that is poetry.

In the early decades of the twentieth century, two artists renounced Cubism. In Moscow, in 1913, Kasimir Malevich gave it up and made his first "Suprematist" painting: It was a black square on a white ground. He called it *The Void*. In Paris, in 1914, Marcel Duchamp also took the further step of renouncing the "uniqueness of the art object." His need to paint dissipated in light of this epiphany and he exhibited a commercially manufactured bottle rack, the first of his "ready-mades."

The course of art history was changing; three decades later the drip paintings of Jackson Pollock would again put a crimp in the mainstream, as it looked like the "zero" had been achieved in art, that this was the end of the line. Had the last painting been done? With this question came a re-evaluation of the limits and the advent of new radical ideas that would ultimately lead to Pop Art, Op Art, Earthworks, Happenings, Video Art, Conceptual Art, Photo Realism, and Minimalism, all among the eclecticism of the 1960s.

It was in this climate of experimentation and no-holds-barred creative freedom that Jack practiced his art. The breadth of his images range from near portrait realism, as in his *Weird Self Portrait at Sea,* through the expressionistic *Cardinal Montini* and all the way to his most extreme venture into modernity, *Untitled 185* (**fig.105**), another of the Kerouac paintings selected by the Whitney Museum to hang in their show of Beat art.

Clement Greenberg, in championing the Abstract Expressionism of Pollock and establishing what came to be known as the Washington School of Color-Field Painting, called for "aesthetic purity," the reduction of all to its very essence. This is certainly a good general

rule as a prerequisite of all good art and the very element that makes Picasso so extraordinary. (Look at the hands and feet in his work for the consummate essence of "handness" or "footness.")

Of course what Greenberg was talking about was the surface of the work, the paint or other media, and its two-dimensional flatness.

Jack's *Untitled 185* lends itself to anthropomorphism, in its representing any number of possible cleavages and bodily intersections; that very decisive angle at the top contradicts the human point of view. Jack, this one time, ventured as far as Pollock or Kline and others of the abstract expressionist persuasion into pure abstraction.

The bold, pronounced signature becomes an integral part of the composition and an emphatic statement of Jack's delight at the work itself. It is, after all, a fine arrangement of line and a testament to the idea that one can find the order one seeks in one's own life in a perfectly arranged work of art.

In the first days of his period of abstraction, Kandinsky was painting his responses to sound in visual interpretation of music, precipitating a tradition where generations of kindergarten students combined art and music appreciation by moving their crayons to the melody of Mendelssohn's "Spring Song." Rauschenberg built artworks with engineer Billy Kluver that reacted kinetically to sounds in the room, and poetry has long been a ready and reliable muse for painters. But Jack broke new ground with his drawing of laughter, and what is so extraordinary is that it looks like laughter. *Three Laughters* (**fig.107**) depicts a trio of biomorphic shapes that appear to be activated by the sounds of

three different levels of laughter: raucous laughter, deep bellowing laughter, and hysterical, shrieking laughter. The figures are drawn with one or two continuous, steady, contour outlines. There is almost no variation in line intensity or line quality. If the figures seem to interact it may not be intentional, merely the way they occupy the space.

In a similar linear aesthetic exercise, where the shapes are defined by contour gesture drawing, Jack titles the work *White Fighters with Black Referee* (**fig.108**). The shapes are clearly human, but muscles bulge in all the wrong places and limbs are placed rather arbitrarily. As what must have been an incurrence of whimsy, Jack has provided a few well-placed dots to represent eyes and suggest faces in the otherwise open space of the background.

The black referee is a huge, minotaur-like creature encompassing and bonding the entire work. Only his hind legs are clearly specified, the upper regions of its body are a morass of interchangeable positive and negative shapes that result in a coursing pattern of animated, ambiguous forms.

The theme of black and white, in its pure aesthetic modality, once again refers to the Franz Kline methodology:

The oriental idea of space is an infinite space; it is not painted space, and [mine] as . . . calligraphy is writing, and I'm not writing. People sometimes think this is not true. I paint the white as well as the black, and the white is just as important.

And there is a Pollock drawing that bears resemblance to these contour sketches of Jack's, *Untitled 1941–42.* Pollock leaves less to the imagination by the insertion of the detailed sketch of an embracing couple in an emphat-

ically sexual pose, and so the group of integrating and integrated shapes scattered about the page seem far from arbitrary in nature, once the theme of sexual intercourse has been established. The gestural forms seem to represent a veritable abstraction of the Kama Sutra in poses ranging from initial shyness and innocence through flirtation, courtship, kissing, cuddling, fondling, and coition in any number of inventive positions.

Although Jack's figures in *Three Laughters* and *White Fighters with Black Referee* resemble those in this Pollock work, we find a similar concurrence in the drawing that Jack titles *Figures* (**fig.109**). In his fashion, Jack enunciates the anthropoidal shapes by adding facial details and body parts to the otherwise freestyle gesture drawing. Here, a monkey holds center stage, standing tall amidst a medley of shapes ranging from methodical notation to automatic drawing. To the left of the monkey, and about the same size, is a figure drawn in contour but with interior detail resembling symbols of anatomical parts—eyes, nose, stomach, pelvis. To add to the conundrum, there are two objects atop its head that look like rabbit ears.

Four other figures inhabit the work. One seems to materialize from a scrawl and hovers to the right of the monkey. It faces left, its profile formed of somewhat jagged lines but with a defined nose, mouth, and chin. The hair is in gesticulating waves, the ear a heart-shaped flick, and a question-mark shape of an eye. The body never finds its form but appears to be in motion.

In the left corner is an angular, long-headed, androgynous person. Each mark that delineates the features of the face is hard and decisive, as in the *Y*-shaped eye. The pompadour at the top of the head and the irregularities in the rear remain a curiosity. There seems to be a brief symbolic statement spoken from the open

mouth; and a caricature-like neck, body, arms, and legs describe, in a few contiguous lines, a standing figure of a person, arms folded and an object in hand.

At the bottom right corner of the picture, just above Jack's "Jean Louis Kerouac" signature—garnishing what we could consider his favorite works—is one more whimsical, comic-like character in this page of "figures." Not unrelated to the other two that face left, it shares the elongation and unusual headdress, whether hair or hat, the simple shapes for eye and detail, and "stick-figure" arm and legs, and bears a striking resemblance to the hieroglyphic symbol of the Mayan corn god.

A final figure lies camouflaged at the bottom of the picture. The head is a virtual lightning bolt of concavitous jagged points. It seems convoluted and negative, but the eye, ear, smiling mouth, and cheek line are unmistakably cheery. A scriptorial rush of lines accounts for the body reclining amiably along the base edge of the work, and a number of cryptic symbols float about the person like random thoughts in the process of recapitulation.

The nonobjective jagged, craggy, angular shapes expand into a drawing of their own in Jack's *Abstraction with Two Stars* (**fig.110**). Here, the rough and ripply forms fill the entire space, save a vacant and restful respite in the top left corner. Although most of the elements in the composition seem, at first, to exist in the abstract, there are a number of clear exceptions. Most obvious are the stars, drawn with the elongation and tilt one tends to get when drawing a five-pointed star in one move of the pen. Jack then embellishes them with circles on their points, lending a circus whimsy to the shape.

At the bottom left edge are nine small, circular swirls.

Sandwiched between them and three larger swirls are three dragon-like shapes. None of these offer the slightest evidence of a meaning to the work, and indeed there is no reason to think there must be one. The pictographic symbol of a man at the lower right, decorated with circular flourishes at the ends of its arms and legs, seems a piece of the art-for-arts-sake, all-over composition, and not necessarily a part of an ongoing story.

Freudian symbols if one sets one's mind to it. Just below the wedge, two more dragons sporting erections seem bent on mounting the distended figure leaning parallel to the moon shape at the center of the work. There is the essence of buttocks, legs, arms, shoulders, all primed in sexual readiness. Many of the shapes begin to take the form of living creatures and many seem matched to mate. Yet, ironically, the only two that actually penetrate each other's space, the long, serrated shape with a broom-like base and the picket fence-like distended rectangle, have the least sexual identity.

Jack's serendipitous adventures in drawing often took the form of experiments: exercises in exploring the possibilities of perceptive spontaneity, as in *Three Dancers* (**fig.111**), where the gestures were drawn lightly, freely, with little thought to form and very likely in response to the syncopated rhythms of music. The figurative elements were then abstracted from the overall sketchy composition and outlined in the darker, more assertive, charcoal lines.

The focus is on essence and energy; a look at the hands, legs, and feet makes it clear that anatomical accuracy was of little consequence. Yet the experiment is successful: The drawing works. We can see dancers materialize out of the music.

Three Dancers begins as the personification of psychic automatism—it translates the music into linear form. And from the music evolved the dance. Jack didn't sign the drawing but he did date it with "57," and in another unusual notation, drew a zigzag pattern along the side of the drawing, perhaps honing up the point of his pencil as the dancer stretches on the bar or the sprinter (that Jack had been) readies for the run.

In a more abstruse arrangement of line, Jack again executes a few rhythmic swings of his pencil to establish the infrastructure of a complicated and psychically profound piece of work he titles *Looking Down on Death and Eternity in a Bed* (**fig.112**).

It has an inventory of pictorial elements, a bed, distorted figure, eccentric extensions, curving tubers, a phalanx of symbols, and the chain-like effect across the top establishes a cycle-of-life curve that may well be a link to the eerie title. At the bottom half of the drawing the sweeping lines form two figure eights, symbols of infinity—no beginning, no end—like the eternity of the title.

The larger figure eight oscillates about that cluster of what at first resemble abstract symbols, but when viewed vertically, evolves into a mass of dollar signs, numbers, pound signs, rectangles, circles, swastikas, dots, dashes, a small figure eight, and at its center, very lightly sketched, is a shape that looks a lot like a skull.

The mass of symbols is an example of textbook Jungian psychology. We even have a lively precedent for the motif in Jack's drawing *The Lay*, where a group of similar, tightly assembled abbreviatory elements jiggle about the joined genitalia of a copulating couple. One reads this quite differently from *The Lay* however,

as Jack has informed us that we are "looking down on death and eternity in a bed." If the reclining figure, then is death, and the figure eight image is eternity, then what is the visual cacophony of unrelated compendia? The detritus of life might be a ventured guess. All that knowledge and history that is left over at the end, hanging about like an old hairball next to the bed. A fast-forward of years of the daily grind: the final score in numbers and dollar signs, the periods and commas of the long life sentence, the swastika to remember it all wasn't what it should have been, and the pound sign to play the message back *ad infinitum*.

Among Jack's artworks are a handful of sketches of animals: horses, mostly with men on their backs; a mule from Big Sur; Agnus Dei, the lamb of God; and we have already seen a number of Jack's drawings of cats.

There is a drawing with "Waterloo" written in the upper right-hand corner, in which Jack sketches a horse and rider at a three-quarter front angle (**fig.113**). From the title of the blue and gold work, the tint of his jacket, and the epaulets on the shoulders, we make the assumption that it is Napoleon. Two figures wearing military hats sit on the ground. One has a spyglass, the other aims a rifle. A third squatting figure appears to be a civilian in a slouch hat, holding a pair of eyeglasses in his hands. Since Waterloo is the village in Belgium where Napoleon suffered his decisive defeat in 1815, the theme of the work is obvious, particularly in view of Kerouac's sense of connection to France and his eager pursuit of the family links to the aristocracy.

One should not overlook some very good drawing in the anatomy of the horse, modeled quite likely from one of the many existing history and portrait paintings

of Napoleon on horseback. The three-quarter view is difficult to draw, and Jack's structuring the horse's head, chest, and rump out of three progressive ovals works well right up to acknowledging the weight of the rider on the horse's back.

Jack drew four small pencil sketches of horses with riders, with a vigor appropriate to the potency of the subject and the unrestrained freedom that comes with doing a quick, idiographic sketch on the unintimidating ruled pages of a compact pocket notebook.

There's nothing in the Kerouac genealogy to connect the hell-bent raging configuration of the *Cossack* (**fig.114**) on his charging horse to the Duluoz legend, but Jack did have a dream about a Cossack:

I had the Tolstoyan dream, a great movie, with the Bolkousky-Boldieu hero officer, in the stress of events stomping out of a officer's milling ball and giving himself away thereby and they shout like Russians with toasts and arrest him on the spot and he indignant and meaningful—meanwhile I've been told to note the particular excellence of the performance of the "Peasant"—the old Fellaheen Hero—He is in Cossack soldier uniform, a soldier comes into his strange room to arrest him, the Peasant is just standing there,—with a sense that not only I but my father is watching this film, and its in the 42nd Apollo and it's like the great last lost Father chapter of now—naturally out of print Town and the City and I remember my pre-tea joys, strengths and knowings God bless the purity of the Martins, the Kerouacs of my soul, still unfulfilled—we are all to watch how the Peasant handles situations, he takes the gun from the soldier's hand, in a funny way, with an

enigmatic opaque remark, and points it floorward, makes a face, the soldier is non-plussed by this brother peasant,—the audience laughs with anticipatory tears in its eyes, it's the greatest Tolstoyan movie. The peasant has a big head and wears a huge hat & vast sadness in his face just as the officer has vast rage in his———

In Jack's drawing, the word "Cossack" is more than a title, it is drawn into the composition as an integral part of the work—straight from the horse's mouth, figuratively speaking. The "rage" of the Cossack can be read in the body language: the right arm drawn back to clutch a weapon, the left reaching forward to direct the horse, which appears to be veering toward the viewer with a distinct sense of menace. At the gallop, the pair, horse and rider, look this way and that in search of a target to attack, pillage, rape, burn . . . as was the way of many a grandfather's terrifying tale of the day the Cossacks rode into the village.

Continuing in a historical direction, and connected romantically to the Duluoz legend, and in consideration of Jean-Louis Lebris de Kerouac's certainty of his noble heritage, is a drawing of a knight with poised lance, seated upon a horse, on whose body the drawing suggests there is a coat of mail (**fig.115**). From the rider's headpiece and the bodily protrusions, he, too, appears to be suitably armored.

The horse is leaning back on its haunches, flexed to spring forward as is the knight's readied lance. It is the moment of high drama before the charge; the moment of baited breath, of the built-up tension of the drum roll. The gesticulations of Jack's pencil vary expressively in lines of alternating pressures and densities—a light

touch for the more volatile nature of the steed; a heavier hand describes the power and mettle of the rider.

In his enthusiasm and unbridled spontaneity, Jack goes right off the edge of the page so we never quite know what the rider's headdress looked like. The equally spirited convoluted lines that define the body merely hint at chest, stomach, arms, and shoulder, and the legs are left to a single swirl of the pencil delineating their range of motion in the stirrups, rather than any resemblance of physical shape. It is a drawing about energy, like the dynamic potential in the inherent kinetic energy of a coiled spring.

From the professional crouch of the rider, head down and rump up, and the little idiographic figure-eight of a cap, we take this to be a racehorse and jockey, as invoked by the work's title (**fig.116**). The horse, wearing blinders and possibly a blanket—note all those long folds in the front and back—would be out for a bit of exercise. All the gestural lines describing the legs in motion just follow the futurist doctrine of animation. As to why so much emphasis is placed on the saddle, and why that scrabble of line emanates from the rider's rear, they can be attributed to a bit of humor on Jack's part—an accenting of that part of the anatomy that smarts from the bounce and friction of the ride. The arrow, of course, makes sure that the viewer's attention is brought to Jack's whimsical notation of the occupational hazard.

"THISAWAY," Jack prints at the corner of another drawing of a horse and rider (**fig.117**). He really didn't have to do that; it's pretty obvious which way they are heading, but it certainly does animate the otherwise near-static scenario. The horse is captured in a few well-placed lines. It stands tall, proud, poised. The rider here is something else. It's a strong human presence, but if it has a face, it is more of a concept than a reality. The closest the figure comes to any appreciable anatomy is in its foot, which is solidly planted on a stirrup. All else is molten, protoplasmic mass or billowing folds of fabric.

In the fourth notebook drawing, we find a riderless horse (**fig.118**). It wears an ornamented harlequin-esque collar, and though it is a bit of a no-neck monster with a too square and clumsy torso and over-bulky haunches, it steps lightly and with a quiet gracefulness as though walking on air. This provides the perfect segue to a beautifully surrealistic dream Jack had about horses:

THE FLYING HORSES OF MIEN MO—I'm riding a bus thru Mexico with Cody sleeping at my side, at the dawn the bus stops in the countryside and I look out at the quiet warm fields & think: "Is this really Mexico? Why am I here?" . . . So I realize we're in "Coyocan" & this is the famous legendary place—I start telling 4 Mexicans in the seat in front of me the story of the Mountain of Coyocan & its Secret Horses but they laugh not only to hear a stranger talk about it but the ridiculousness of anybody even mentioning or noticing it—. . . We arrive at Coyocan town over which the hazy blue mountain rises and now I notice that the Flying Horses are constantly swirling over this town & around the cliff, swooping, flying, sometimes sweeping low, yet nobody looks up & bothers with them—I can't bring myself to believe that they are actually flying horses & I look & look but, thats what they have to be, even when I see them in moon profile: horses pawing thru air, slow, slow, eerie griffin horror men—horses but

**those flying horses are happy! how beautiful they claw
slow fore—hooves thru the blue void!—. . .**

Among Jack's contour drawings is *Horse and Rider*
(**fig.119**), a work which reaches for the purest essence
of horse, rider, and whatever symbolism one might
attribute to the combination.

The horse is drawn with one continuous line, with
Jack once again keeping more the aura than the anato-
my of a horse in mind, as the pen marks race across the
page. The leaner front and broader rear legs are rea-
sonably proportioned, as is the flare of the tail and
basic shape and relative size of the body. The head is
hard to comprehend and that, along with the scallop-
ing across its back, gives it an assuredly unintentional
dinosaur-like appearance.

The rider, as well, evolves from a single continuous
line and is drawn in that same style Jack employs to
capture essences rather than realities. Following the
contour of the arched-back figure, there is a tuft of hair,
or beret, atop the head, and a rather long, horsy, face.
The skinny neck rises out of a collar, and the lack of vis-
ibility of any arms suggests it is leaning back in the sad-
dle, on its elbows. The legs hug the horse's flanks in the
traditional riding position, but what is particularly
exorbitant in the work is the oversized phallus that pro-
jects unabashedly from the groin of the rider. There is
clearly some statement intended in so blatant an image,
whether it harks back to the sexual symbolism of a
horse-rider relationship or mocks or manifests macho
heroism. It may simply be a dimension of the Kerouac
oeuvre where we see what can happen when the artist
draws an irreversible, nonerasable, continuous line with
an idea, an essence, in mind: Automatic drawing at a
most Freudian level. It is clear that Jack was pleased
with the final results, as can be seen by the elaborate sig-
nature which he has affixed to the work.

A notebook drawing of a mule (**fig.120**) captures the
physical aspect of the animal, as well as a wry sense of its
notoriously stubborn character. As in many of the
Kerouac artworks, the absence of inhibiting rules leaves a
residual roadmap of the artist's process, and along with
that, a number of otherwise inexplicable elements which,
in a less idealistic aesthetic order, would likely have been
erased. The cape-like shape on the mule's back is one
such element, as is the lariat-like swirl hanging at the ani-
mal's rear, just beneath the tail. From the quickly noted
indication of the forelegs, we surmise that Jack was not
about to deal in detail with the mule's lower extremities,
and so we can disentangle, from this rear segment, the
two hind legs, and what appears to be an additional, for-
midable extension from which there is a suggestion that
Jack's mule is in fact, hung like one.

If one perceives a meditative, eyes-closed, somewhat
transfixed aspect to the animal, it may be that it is the
mule of *Big Sur*, Alf, who finds himself a place in the
Duluoz legend near the beginning of the story as Jack
explores his rugged environs:

**It was even frightening at the other peaceful end of
Raton Canyon, the east end, where Alf the pet mule of
local settlers slept at night such sleepfull sleeps under a
few weird trees and got up in the morning to graze in
the grass then negotiated the whole distance slowly to
the sea shore where you saw him standing by the waves
like an ancient sacred myth character motionless in the
sand——Alf the Sacred Burro I later called him——**

In this very same paragraph Jack writes about the flying horses dream (here he refers to it as a recurrent nightmare) and he describes "swarms of moony flying horses lyrically sweeping capes over their shoulders as they circle the peak . . ." We could find in this an explanation of that cape-like shape on the mule's back, but Jack never wrote of a flying mule. Better he remain as Alf the Sacred Burro.

One of the musical masterpieces of Johann Sebastian Bach, and the last of his great vocal compositions, is the *Mass in B minor.* Written when he was in failing health, he gathered into its being the musical experience of his entire life.

There is no known historical, political or societal event that is connected to or celebrated by the work, and it is believed that it was never performed in the composer's lifetime. What connects this to Jack Kerouac's work is that the last aria of the *Mass,* a moment highlighted by violins playing in unison to accompany the tenor vocal, called the *Agnus Dei,* the Lamb of God:

Agnus Dei,
qui tollis peccata mundi
miserere nobis!

Agnus Dei,
qui tollis peccata mundi
miserere nobis!

Agnus Dei,
qui tollis peccata mundi
dona nobis pacem!

Oh Lamb of God
that takest away the sins of the world,
have mercy upon us!

Oh Lamb of God,
that takest away the sins of the world,
have mercy upon us!

Oh Lamb of God!
that takest away the sins of the world,
grant us thy peace!

When Bach adapted the text of the *Agnus Dei* in the eighteenth century, it had already been in the liturgy of the Church for a thousand years and hundreds of melodies had been composed for it.

Jack knew it as a fixed element of his Catholic childhood, of his life, as the chant preceded the communion in the Mass. He sketched it with great vigor (**fig.121**), headlined its name and his byline across the top of the page, then placed his initials beneath a cross at the bottom left. (And there is even another set of his initials at bottom center that ran off the page—as Jack was often wont to do in his enthusiasm.) Jack's lamb received no special anatomical consideration. The work combines gesture and circumferentially emphasized contour drawing, with a few sketchy facial features and evidence of some presketching of the figure before the darker outlines were put in place. There are far too many limb-like extensions on the lamb's body, about eight, but in partial explanation it can be considered that the heavenly lamb has wings, defined by the triangulation on its back and belly, with which to fly through that dark and spiraling void in which Jack has envisioned it.

There is a flawless sense of timing in Jack's baseball drawing: the pursing of the lips, the crack of the bat against the ball, the breaking of the wrists, another

hero in action. Joe DiMaggio: batting average at the time of the drawing, a formidable .364 (**fig.122**).

Jack himself was a football and track star at Lowell High, played baseball at Horace Mann, and went to Columbia on a football scholarship. There was extended interest in baseball for Jack, both in the sport itself and in a baseball card game he invented as a child. He nostalgically looked back upon those teenage days at home on Moody Street as he sat alone at the top of Desolation Peak thinking about "Ritz Brothers crackers and peanut butter and milk, at the old round kitchen table, and my chess problems or self-invented baseball games, as the orange sun of Lowell October'd slant through the kitchen curtains. . . ."

Years later, Jack was still playing with his self-invented baseball game in February 1959, when he wrote an entry in his notebook that elaborates on the sophisticated nature of the game and the breadth of knowledge of Major League baseball necessary to play it (**fig.123**):

> **Played a game last night when Roland Lane of Browns belted a surprise homerun off pchr Carl Hands (1–6) to defeat those tragic Grays of mine again—I'll play em up to 39 games + start a new season with new rookies + Boston new "Orange" tag—maybe shift franchise to Brooklyn.**

Another notebook entry, in October, makes a more casual reference to the game, suggesting that it was Jack's form of an occasional relaxing game of solitaire (**fig.124**):

> **Quiet evening—played a game of baseball cards— walked a mile in the quiet streets—wrote letters earlier to Neal, Gary, Anson, a priest etc. . .**

The thrilling instant of the home run hit that Jack celebrates in his drawing, *.364* is likewise commemorated by him in *Visions of Cody*, where he conjures a metaphor between the "Take" of the filmmaker, the "moment of truth" of the matador, and the "loud clout" of the bat connecting with the ball.

> Just as in a bullfight, when the moment comes for the matador to stick his sword into the bull and kill it, and the matador makes use firmly of this allotted moment, you the American who never saw a bullfight realize this is what you came to see, the actual kill, and it surprises you that the actual kill is a distant, vague, almost dull flat happening like when Lou Gehrig actually did connect for a home run and the sharp flap of the bat on ball seems disappointing even though Gehrig hits another home run next time up. this one loud and clout in its sound, the actual moment, the central hill, the riddled middle idea, the thing, the Take, the actual juice suction of the camera catching a vastly planned action, the moment when we all know that the camera is germinating, a thing is being born whether we planned it right or not . . .

At the Whitney Museum Beat art show, in 1995, Larry Rivers exhibited a larger-than-lifesize portrait of Frank O'Hara. The male frontal nude was no longer a scandalous subject, as when it was first shown at the Whitney in the mid 1950s. Then a guard had to be posted in front of the painting to prevent anticipated physical attacks on the work. O'Hara, a poet, was Rivers's best friend and a close friend of many in the art world. He had worked his way up from bookstore clerk to curator at the Museum of Modern Art. But it all ended in tragedy when he was killed by a dune buggy in a freak accident on Fire Island in 1966. The

art world was stunned and saddened. Stunned because it happened on the beach at 3 A.M. in a crowd of about thirty people and the car, one of the few on the island, had its headlights on. Saddened because he was a beautiful, sensitive, beloved-by-all poet. John Ashbery positioned O'Hara as being, "Too hip for the squares and too square for the hips," but the "lunch poems," which he would write on his break, sitting in the Museum garden, endeared him to poet, artist, and art lover alike.

While O'Hara overlapped the Beat poets in time and place at New York's Cedar Tavern, the San Remo Bar, and the Artists' Club, there were few similarities between them in literary or life style. Most significantly, O'Hara had little interest in the prophetic zeal, revolutionary ardor, Zen Buddhism, or peripatetic wanderings of the Beats. He was perfectly happy to focus his writings on the isle of Manhattan. Although he enjoyed the jazz music that was a source of inspiration for many of the Beat writers, he preferred to seek his muse in the paintings of the New York School. He felt that the music intruded on the poetry and once wrote Gregory Corso, "Maybe I should try to give a reading somewhere in front of a Pollock or a de Kooning."

O'Hara did praise the work of Gary Snyder, Philip Whalen, and Michael McClure, and was allied to Ginsberg by "their dislike of the Academic Establishment, their allegiance to Rimbaud, Whitman, Pound, and Williams, their search for open forms, and their homosexuality," but was separated from him by "their very different sensibilities and poetic aims." In Ginsberg's elegy for O'Hara he describes him as "the poet who wanders down Fifth Avenue . . . with your tie / flopped over your shoulder in the wind . . . off to a date with martinis & a blonde."

In a letter to Jasper Johns on July 15, 1959, O'Hara wrote, "Kerouac's *Doctor Sax* is his best work, I think, and after that the first sections of *Old Angel Midnight* which are printed in the first issue of Big Table." Joe Le Sueur recalls an evening at the Cedar Tavern in 1960 when Kerouac, very drunk, came up to O'Hara and said: "I thought you liked me." O'Hara replied: "It's not you I like, it's your work," a remark that pleased Jack very much.

O'Hara is represented in the Kerouac pantheon of heroes by an unremarkable sketchbook rendering composed of a dozen fluid, intersecting, becalmed lines drawn with a soft-stroked elegance that seems reflective of O'Hara's erudite and eloquent persona (**fig.125**). As in other drawings in this series, Jack affixes the name of the subject on the face of the work, in this case, in neatly printed traditional lettering much as Larry Rivers used in his own portrait of the poet.

Jack draws O'Hara in profile, head bent slightly forward, holding something in his left hand that could symbolize a pointer indicating the distant rectangle of a painting. The subject's other hand points front and downward, fingers extended in a classic Buddhist position. But since O'Hara showed little interest in Buddhism, the position of the hand—particularly in view of the inconsistent sharp point among the fingers—could represent the right hand writing criticism of the painting being denoted by the pointer.

There is, too, the long, curving shape that sweeps down from the shoulders and bends to form the bottom edge of the drawing. If one were to stick with the idea that Jack imagines O'Hara as an art Buddha, this could denote the curving thigh of a lotus position. And then there is the phallic symbol possibility—which also deserves some credence here, as the most commonly

of acquaintances. Allen sometimes watched him work his restaurant coat-stealing operation, and Jack glorified him as a scholar, historian, and anthropologist. The line about him in *Howl* was deleted when Garver, having been shown a copy of the first draft, asked Kerouac to tell Allen that there were no coat hangers in Longchamps. (Garver had also suggested that there was too much homosexual material in *Howl*.)

When Jack was in Mexico in 1956, he shared the apartment with Garver while he wrote the 242 Choruses of *Mexico City Blues*. Legend has it that Garver would maintain a drug-induced, uninterrupted rambling discourse that functioned as background sound to Jack's writing, and as Jack wrote the verses he would include some of Garver's monologue. There are "Eleven Verses of Garver" in *Book of Blues* that are literal stories directly transcribed from Garver's ramblings in the Mexico City apartment. It was in this same period that Jack wrote *Tristessa,* the novel about his desperate and frustrating infatuation with the young Mexican girl who was Garver's morphine connection.

Ginsberg and Kerouac had been close since 1944, when they met as students at Columbia University. Allen, along with Gregory Corso and Peter and Lafcadio Orlovsky, joined Kerouac, Garver, and Burroughs in Mexico in October 1956.

It was in this same period, the autumn of 1956, that Jack drew his only known portrait of Allen Ginsberg, the person who is generally considered to be his best friend. He titled the work *Ginsberg in the Douche Bag* (**fig.129**). There is no date on the drawing, but the envelope in which it was mailed to Allen is postmarked October 1956. Just below Jack's formal "Jean-Louis" signature is written "commissioned + suggested by Bill Garver" and off to the right is written "P.S. Allen, try to sell this + we'll split."

Vigorously drawn on a standard 5" x 8" red-lined steno pad, the pencil lines are deliberate and carefully controlled. It is a good likeness; and it prophesizes a latter-day bearded Allen, for as we can see by the well-known photo taken in Mexico that year, Allen was clean-shaven in October of 1956. Beneath the dark-rimmed glasses there is a bit of the gleam of an eye, and in the shadow of the beard the full lips are a distinguishing Ginsberg feature. Why the single exaggerated ear is a mystery (Van Gogh?) as is the douche bag itself, which Jack drew well—just look at the fine draftsmanship in that rubber hose and metal clip. Whether Allen is rising up from the douche bag, like a vaginal Genie, or is wearing it as a shirt front, is anybody's guess, as are the various possibilities behind Garver's suggesting and commissioning the work. It may have been meant as a joke, a whimsical, Dada-derived work not unlike Marcel Duchamp's *Mona Lisa with Moustache,* but not as an insult. Jack's high regard for Allen and his work remains unquestioned and in a few lines at the end of the fourteenth chorus of *Orlanda Blues,* written in that same period, he pays the highest compliment to his friend when he writes:

& Read Competition Ginsberg
 the maddest brain
 in poetry

tangier

On February 15, 1957, Jack sailed on a freighter for Tangier to visit William Burroughs, who had been living in the Moroccan capital for three years. Three weeks later, when Ginsberg arrived with Corso and Orlovsky for a long-planned reunion, Jack was already burned out on Morocco, sick and depressed from some arsenic-laced hashish he had smoked, and ready to go home to America.

He had spent the three weeks in a marijuana-and-opium-induced euphoria heightened by the romance, adventure, uninhibiting mores, and colorful local ambiance that had made Tangier the haven-of-choice of expatriates like Burroughs, Paul Bowles, and the Swiss-Canadian painter Brion Gysin, owner of a local nightclub. A week after the arrival of Allen, Peter, and Gregory, Jack packed his rucksack and left. In the Kerouac oeuvre, there are six sketchpad pages that document the visit. One is a surrealist drawing and four sheets of poetry and art, each with its own strange aura that echoes the hazy decadence and intriguing offbeat social climate of Jack's month with Burroughs and company in the peculiar open city.

The work, *French Movie About Tangier* (**fig.130**), is titled by Jack on the face of the drawing, but there is no clue as to what movie it is, if in fact, it refers to an actual film. The central figure is a rabbit-eared, dog-faced Buddha-bodied eminence, who seems to rise on a cloud-like lotus bed from a straw basket–encased wine jug. It is genie like, as befits a drawing about a movie in the land of "1001 nights," which, by the way, was the name of Brion Gysin's Tangier nightclub and could well have been where Jack sat and "doodled" this work, since the club was a hangout for the expatriate crowd.

The funnel-shaped space that projects upward from the bottle into the floating figure is intercepted by a near perfect square which is formed by swirling circuitous scribble-scrabble lines. Its appearance is that of a mind wandering, a semi-consciously derived image. Then, in a similar, less-than-fully-conscious move, the square is extended laterally into a rectangle, but the attended area is left unfilled and the outline of it resembles a nonlinguistic, handwritten script.

This same unstructured, abstract, nonobjective penmanship portrays a face, in profile, at bottom left.

Formed predominantly of continuous line, the double outlining of the features destabilizes the image and lends an animated and extra ambiguous note to the facial expression. A double loop at the top of the head describes either a fifties pompadour hairstyle or a mythical set of horns: a satyr or devil perhaps. Yet, the elongated earlobes hint at the princely origins of the Buddha, a condition wrought by the weight of heavy earrings worn by royalty.

A border of convoluted wandering lines arches from the nape of the neck to the top of the head. Its abstruse pattern repeats little circular loops and peaks in a series of biomorphic shapes at the forehead. This sweep of hardly definable imagery can be interpreted as a visualization of the thinking process, a diagram of the juxtaposed brain patterns of a psychedelically stimulated mind.

Two other unidentified floating objects in the drawing fall from the back of the large figure hovering overhead. By "first thought, best thought" methodology, they could be wings dropping from the figure as angel. And Tangier in 1957, with its reputation for depravity, would have been just the place an angel could lose it wings.

Since the drawing, according to Jack, is about a French movie set in Tangier, one that would likely have been playing there in 1957, any analyses of Jack's intentions—other than to reflect his response to the film—would probably lead one astray. Since many of these old films are now suffering from celluloid deterioration one can only guess at the one elemental bit of symbology the drawing provides: that really big ideas come from the bottle.

In Ann Charters's biography *Kerouac,* there is a description of Jack's last week in Tangier:

. . . he stayed away from the parties, holing up in his room away from his friends and the hangers-on, drinking his own quart bottles of twenty-eight-cent wine. His favorite pastime was sitting cross-legged on his patio and reading the Diamond Sutra facing the Catholic priests at a nearby church who recited their rosaries facing the sea.

The mood was reflected in poetry and drawing in a page in Jack's Tangier sketch book (**fig.131**):

Star of Islam over roar of sea——
Dreaming Sleeping Arabs believe——
　Poor bone in a bunk carried here to market hands!
Poor Sherihan lustre the ruby cock prose crowing . . .
　Long for thick pocket thongs whip the khalib——

Holy Virgin wake me up, in your golden arms,
　in your arms of thread, in your arms of honey——
A light burns for the black sea
　Dogs bark by the black sea

Below the half page of handwritten poetry, Jack drew four figures. The boldest, most central, is the often drawn, familiar Kerouac head of Jesus: the face elongated, ascetic, dark, hollowed, deep-set eyes, long straight shoulder-length hair, ragged neckline at the collar, and, orbiting the head, an ellipse of lines form a kinetic halo.

To the right of this image, a smaller, less definitive human figure seems to emerge from one peripatetic, continuous line that begins at the shoulder of the central figure and rapidly ascends into shapes that suggest first bodily and then facial elements. Only the separate set of lines that encircle the head, in what must be a halo, identifies the figure as a tentative, just barely evolved angel.

To the left of the central figure is an elegantly drawn, very modern crucifixion image. This too appears to be made of one uninterrupted line that sweeps downward to form the cross and then up, always in curving streamlined gestures, to form the body on the cross. Although quickly sketched with a natural, rhythmic cadence, all the anatomical details are considered. The head, neck, arms, shoulders, hips, legs, and feet were duly notated in the few seconds that Jack's pen spanned the page.

A complicated, biomorphic, ecclesiastically suggestive image lies at the end of the last line of the poem. There are, in its arabesque Rococo display, an infinite number of possible conceptualizations suitable to the churchly scenario of the page: a cross, a heart, and the vivid impulse of a shape with dual identity, at once a human form and a dagger. The body or the blade, as it may be, comes to rest on the round object at bottom, presumably the world, which has poles established by two swords driven in to the hilt. It completes the poem, as in the words of the immortal Cyrano de Bergerac: "to end the refrain, thrust home!"

The Sighing of the Sea

Another page in Jack's Tangier sketch book **(fig.132)** begins with:

The sighing of the sea that I might listen
 Big sound howl man are not you for to be
 Gibber I mad (trails off in non readable doodle)
 Hashi is depressant—
 Sympatina is better all ares (trails off)
 (two lines of letters which dissolve into gibberish)

An arc separates the narrative from the drawings which occupy the bottom two thirds of the page; but the poetry, too, is partially composed of what are in reality "drawn" elements, as the handwriting breaks down into nondecipherable words that follow the format of cursive script, but relate more to childhood attempts at pretend-writing, before one has learned the letters of the alphabet.

It is as though Jack, high on hashish and wine, was contemplating the sounds of the sea and nodding off as he wrote, the words trailing into discursive gibberish, but with Jack still enough in control to keep the pen in motion. He wasn't asleep, he was just operating at another level of consciousness. The result: a hybrid of automatic drawing and automatic writing. If Jack was depicting the sounds of the sea, it would be conceptually like a John Cage composition. Through it all, it is clear that Jack was very much in control, as evidenced in the geometric accuracy of the arc and the clarity of line and image on the three drawings.

New and unique to the Kerouac ensemble is the inflated-looking figure with dinosaur ridges down its back, a minuscule head and a long pointed wing of an arm. It walks at a 45-degree angle, large-bodied and top-heavy, with a tiny pair of legs. It may reflect how Jack felt about himself that day: a dinosaur among the "new young people hanging around them" feeling poisoned and sick to his stomach on bad drugs, and with his chronically aching legs seeming inadequate to support his bloated body.

Sharing the center of the page is a character resembling a hieroglyph of a lord of the Mayan underworld. Part human, part five-eared rabbit, and part grotesque psychedelic monster, the end result is both abstruse and witty and is either walking on water (which Jack

said "wasn't built in a day") or perched precariously on the shaky ground of a hashish- and wine-derived terra not so firma. On the bottom edge of the page is the familiar Kerouac angel. This Tangier angel has an Arab headdress. The darkened eyes and the lines on the face and neck are very specific characteristics, suggesting that this may be a sketch of someone of Jack's acquaintance. The small *V* at the chin, a bit of a goatee, adds another element to the perfect symmetry of the image, a balance which is disturbed only by the asymmetrical drawing of the wings, which appear to be in animated motion, revving up for takeoff.

Lucien Midnight 1957, Tangier

A third page of poetry and sketches is titled *Lucien Midnight 1957 Tangier, March 7, 1957* (**fig.133**), and then after the number 25 appears in a triangle, begins a sketched-with-words transcription of the events of the moment:

Explosion in the window, sighing sea, talking motors
the razorhush of stars, boys ghosts on the sands in,
like a regular church . . .

Then a profile drawing, a possible self-portrait, with an afterthought in the outlining of a slouch hat and headlining a poetic segment: BOYS GOLDEN HOARD OF WORDS. And the hoard comes tumbling out (written with such urgency that some words are only partially legible):

The moonlight on Jeanare's thighs
Old shit-time stories about big pockmarks
Thighs in the moony pines
Mike stole the glow and stretch of his sister's

cunt & tits
Cary dangled his rod at his sister
in Oregon
Old B____ farted in a sheik
And gathered together his imaginary
Angels + his _____ to go forth
populace a world
for his editing
 to be saved
by lost
Running in the snowstorm in NY.
 looking for warm Lucien
the fireplace home
What's to write about now?
Sympatina no sympathy
Sunbeams bring
Message:
First light" —
 baby

Just below the poem, tucked away in the bottom right corner, is a little gem of a sketch, a rare Kerouac landscape which Jack has titled *Gods Empty Scene*.

It has the appearance of a quiet spot on a rocky coast: a tall, straight palm tree with boulders at its base. Another larger boulder lies at the foot of a sandcastle-shaped rocky massif that rises sculpturally like a great stone bear god looking out on the sea, which can be seen just off on the horizon.

God's empty scene is not entirely empty. A long slithering snake trails down from the craggy monolith and coils into a circle at center stage. Perhaps we are looking at Eden abandoned. Adam and Eve have eaten the apple, been evicted, and gone on the road. The serpent has inherited the empty scene.

The site of the biblical garden of Eden was in the Middle East, not that far from where Jack, in Tangier, sat looking out on the Mediterranean. On this same page, from another legendary moment in that part of the world, Jack draws a pyramid framed by a large cloud off on the horizon. Then, enigmatically, he writes just under it "Scene: Room in N.Y." and follows this with a poem written in a slurry, difficult to read script:

1 / he can when all
believe them in a world
to really worry about 10
upsidown in whisky
sir, held by gravity
whether Lord, for the
bottomless glass, they divers
with human moths the
search in Rites + galas
+ swap anecdotes about
Loving or married —
T is a ease for lunches
to consider in the human
money man or doctor

ZOCO CHICO

In *Allen Ginsberg's Journals 1954–1958,* there is a photograph of Zoco Chico, Tangier, dated 1957 and taken by Peter Orlovsky. It is of a wide street, half in sun and half in shade, the phalanx of signs in English and Arabic advertising hotels, *telegrapheos,* restaurants, and cafes along both sides of the street. Some tables line the narrow sidewalk. The architecture is Moorish, almost all the visible windows have the pointed arch.

It's a dramatic photograph with several figures silhouetted in the shaded foreground and others, including Allen, spotlighted in the shaft of sunlight that diagonally bisects the picture and illuminates the rear of the scene, like a theatrical set. A small Arab boy is approaching the cameraman to demand *baksheesh*, a posing fee. Jack describes this same scene in a sketchbook page, which begins "1957 ZOCO CHICO—TANGIERS— a weird Sunday in Fellaheen Arabland . . ." **(fig.134)** and as the page divides in two, the narrow column of writing continues:

. . . with you'd expect mystery white windows +
do see but is bad the broad up there in white
my veil is [sitling] + puny
by a Red cross, above a lil
sign says PRACTICANTES
 [SARIOU] Permanente
 TF NO + 9766
 The cross being red—this
is now a tobacco shop
with luggage + pictures
a little barelegged boy
leaning on Counter with a
family of
Spanish + Limey sailors
from the submarine
trying to get drunker + drunker
Yet great + lost in town
regret + true little Arab
[hyp . .] have a [brut] musical
contact (boys or 10) + then
part with a push of arms,
+ wheeling of arm, the cat
has a yellow skullcap +
a blue zoot suit—-

+ this is a pencil vision of it
by which Arabic may be seen

Here a pencil sketch of the "cat" (used here as the hip term for a "cool" guy) in the yellow skullcap and blue zoot suit (a forties term for a "Broadway" look: wide padded shoulders, long sweeping jacket collar with one button fastening about six inches below the waist and wide "peg" pants gathering tight around the ankles).

The sketch is a quick notation, likely made as Jack sat at a café table and caught the man as he walked by. There are few elements in it to merit much in the way of illustrational value, other than the skullcap and the swaggering angle at which it is worn. But it is the kind of shorthand sketch that can serve as a valuable mnemonic to the artist. Even the few circular and parallel lines in the background could have had some representational significance to Jack.

A narrow column written on the right side of the page is introduced with, "I am now hi on *Mahoun.*" Then:

MAHOUN

cakes or keer boiled with
spices + candies—
eaten with hot tea—
the black + white tiles
in the outdoor café
are sorted by lovely
Tangiers time—A
little bald cropped
boy walks by, goes
to man at table
says "yo" thon
the waiter throws

him out, "yig"—
A brown ragged robe
priest sits with me at
table, but looks
off with hands on
lab at brilliant
red hen + red girl
sweater + red boy
shirt green scene

MOMINU

In *The Poet Assassinated,* Guillaume Apollinaire, surrealist poet and friend and early champion of Picasso, presents a Dada map of Europe. The borders are in place, but where Paris should be it is marked "Constantinople," Seoul stands in for Pamplona, Melbourne for Naples, and Nazareth seems to be somewhere in the middle of Romania.

Apollinaire may have been commenting on the way Europe's borders were changing at the end of the First World War. As territories were won and lost, Austrians found themselves suddenly Polish, Hungarians turned Russian, and hatred proliferated between neighbors. It was like the Limelighter's folk song (circa 1950s):

> . . . the whole world is festering
> with unhappy souls
> the French hate the Germans
> the Germans hate the Poles,
> Italians hate Yugoslavs
> South Africans hate the Dutch
> and we don't like anybody very much
> tra la

About forty years after Apollinaire, Jack Kerouac

also drew a surrealistic map. It is of the fictitious island of Mominu, an invention of Jack's **(fig.135)**. It may even be a continent—if we are to consider its proportions in relation to the global indication on the drawing. The Marabuda River flows north and south on the island, with two major tributaries. Along the river are the cities, or towns, of River Village and Traucheck. Where the river flows into the (unnamed) ocean, is what appears to be Mominu's capital city, Cate. (It is written on the map in the boldest print and demarked by the largest circle.) A shore road from Cate leads to Port Town, at the southeast corner of the island.

There are two mountain ranges, one along the west coast and another to the north. They are unnamed and without markings as to the altitudes of their peaks, but from the drawing, the northern range appears to have at least one formidable summit.

Positioned between the western mountain range and the plains that border the Marabuda River, dominating the southwest region of the island, is the Mominuan Desert. Here and there on the map are small circles and squares that demark cities or towns; there are two on the peninsula at the south, one in the northeast mountains, another on the west coast, where the mountains go into the sea, and several along the river. There are none in the desert, in the mountains, or on the vast plains on either side of the river.

A ferry from Cate sails across the bay to Temple City on the smaller island of Cato, to the south of Mominu. It is on Cato that we find the first link to the Duluoz legend: the mountain of Mien Mo.

Mien Mo is recorded in Jack's *Book of Dreams* as "the name of the mountain in Burma they call the world." And consciously or not, Jack's dream was based in fact. There is a city in Burma called Myan Mar which is known as a "place of pagodas."

The only other name that turns up any reference is "Cato"—the offshore island. In the 1940s and '50s, Cato was the name of the sidekick of the superhero of radio serials the Green Hornet. Cato, an Asian, was also a houseboy and general right-hand man to the popular crimefighter, and, conveniently, an expert in the martial arts.

Looking a bit deeper into history there was another Cato who was a great Roman statesman, warrior, Stoic philosopher, and writer. While this Cato's legend remains intact, the Green Hornet's Cato has been largely forgotten by other than aficionados of old-time radio. With this in mind, it is not inconceivable that Jack, a great fan of *The Shadow* radio show, and radio serials in general, would commemorate the island to him.

rembrandt, vincent, and jack

Jack was enamored of the work of Rembrandt and van Gogh, and his admiration was for all the right reasons. They were painter's painters, and Jack appreciated their work as one who worked with paint should: as much for the adventure and daring of the creative process as for the amazing glory of the finished art. After studying their paintings at the Louvre, Jack wrote to his friend Ed White:

> So I went to Paris and in the Louvre stuck my nose up against Van Gogh and Rembrandt canvases and saw they are the same person

When Jack used Rembrandt as a point of departure, as in his drawing of *Tobias and the Angel*, it was the way van Gogh often used Rembrandt and others as a source of subject matter and inspiration. Jack's recognition of the subtle stylistic similarities between Rembrandt and van Gogh is expressed in his enthusiastic appraisal of their Louvre works, as he continues in the letter to White:

Then O Rembrandt! Dim Van Gogh like trees in the darkness of Crepuscule Chateau, the hanging beef completely modern with splash of blood paint . . . with Van Gogh swirls in face of Emmaeus Christ . . . the floor (in Sainte Famille) completely detailed in color of planks, and nails, and shafts of light on Virgin's tit. . . . St. Matthew being inspired by the angel is a MIRACLE, the rough strokes, so much so, the drip of red paint in the angel's lower lip making it so angelic and his own rough hands ready to write the gospel (as I will be visited). . . . Also miraculous is the veil (of) mistaken angel smoke on Tobias' departing angels left arm. Finally, not least, Van Gogh . . . his crazy blue Chinese Church, the hurrying woman, the spontaneous brush stroke, the secret, of it is Japanese, is what for instance makes the woman's back, white, because her back is unpainted canvas with a few black thick script strokes (so that I wasn't wrong when I started painting God last fall in doing everything fast like I write and thats it). . . . Then the madness of blue running in the roof of the church where he had a ball, I can see the joy red mad gladness he rioted in that Church heart. . . . I have a headache from

all this. . . . His maddest pic is of those gardens Les Somethings, with insane trees whirling in the blue swirl sky, one tree finally exploding into just black lines, almost silly but divine, the thick curls and butter burls of color paint, beautiful rusts, glubs, creams, greens, a master madman, Rembrandt reincarnated to do the same thing without pestiferous detail. . . .

The propensity for self-portraiture on the part of both Vincent and Rembrandt is another link between those most famous of Dutch painters. Two of the best-known self-portraits are of both artists wearing the hats that have become a part of their image: Rembrandt in his oversize beret, Vincent in the wide-brimmed straw hat with which he is often identified.

Jack's pen-and-ink sketch evinces the key elements of Vincent's self-portrait: after triangulating the head to block out the general form, he drew the broad-brimmed hat, intense eyes, pronounced ear, and beard. "Van Gogh" is written in the bottom corner; then, for no clear reason, "La Marde" is written just under the face (fig.136).

There is no easy explanation as to why Jack wrote the French (Canadian) word for "shit" on a sketch of a man whom he so admired, unless he was dissatisfied with his own drawing and thus critically commented upon it.

Rarely does one find scatology in Jack's writing; one of the infrequent usages of the term is in his description of a recurrent dream in which he is:

" . . . driving wrong way on the one way boulevard . . . in that miserable coat and muff hat, driving slow like an old man, sunk low at the seat—"La Marde"— and all on account of a pie.

As a title for the sketch of Vincent, it remains an unsolved mystery. But there are a number of direct references to van Gogh in Jack's writings. In *Maggie Cassidy:*

I seriously sat in the flagstone yard of little flowers and woodfence sometimes with a drink like ginger ale and read *Lust for Life* the life of van Gogh I'd found in a bin and watched the great buildings of Brooklyn in the afternoon . . .

And later, at the end of *Tristessa,* "I'll paint memories of Arles." Arles being the town in the south of France where much of Vincent's life as a painter is generally situated.

Worshipper of the Eternal Buddha

A provocative nexus to Jack and the Beat Generation is a van Gogh self-portrait done in September 1888 and dedicated to Paul Gauguin. It is titled *Worshipper of the Eternal Buddha* and depicts the artist as a Buddhist monk. Commentary in his letters asserts that he was out to make a "real impressionist" work, to feel like a "link in the chain of artists." Why as a Buddhist monk? He said he wanted to "enlarge himself."

To his sister, Willemien, he wrote that the work portrayed him as "a Japanese," and to Gauguin he talked of it exaggerating his personality and noted that it "aimed at the character of a simple Bonze worshipping the Eternal Buddha." The painting grips the viewer by the incredible sadness in the eyes, which well up in the same deep turquoise color of the overwhelming vortex of the background. The head is shaved and drawn with a clarity, strength, and meditative physical balance that decries a state of nirvana.

This relatively little-known aspect of Vincent's personality is soulfully expressed in a letter written during his days as a preacher and social worker; like the portrait, it is an image of Vincent's suffering, his own Ecce Homo:

To sum up, I want to arrive at that point where people say of my work: this man feels deeply, + this man feels with delicacy. In spite of my so-called boorishness, if you understand what I mean, or precisely on account of it. What I am in the eyes of most people—a nonentity, or an eccentric or disagreeable person—someone with no position in society, or who will never have any, someone who's less than nothing. Good, supposing then I am exactly that, then I would like to show through my work what the heart of such an eccentric, such a nonentity, may hold.

In Jack's *Pomes All Sizes* is a poem called "Running Through—Chinese Poem Song," in which he reflects Vincent's identity crisis.

O I today
sad as Chu Yuan
stumbled to the store
in broiling Florida October
morning heat cursing
for my wine, sweating
like rain, & came to my chair
weak & trembling
 wondering if I'm crazy at last . . .

& I'm a fool
 without a river and a boat
 & a flower suit—
 without a wineshop at dawn
 — without self respect—

—without the truth—
but I'm a better man
than all of you—
 that's what I
wanted to say

And then, on the very next page, in Jack's poem "SKEN 3," it all comes together. It begins:

Radiation of Akshobya
Blinding my eye in the
water in the claypot
pan-pot, the rainbow
of the sun's reflection
there causing painful
imaginary blossoms to
arise in my eyeball

and ends:

—Buddhalands without
number & Van Gogh swirl
agog rows of an endless
emptiness in that little
pot, & bug fires—

Van Gogh at Work

This pocket notebook drawing of Jack's portrays Vincent in profile, painting at his easel (**fig.137**). The van Gogh–like swirls are there in the formation of the cypress tree. The perceptual instability of the landscape is emphasized by the 45-degree angle of the horizon, as though bending to the mistral winds that so drove Vincent to fits in his last years. Everything in the work is in flux: his painting arm animated by multiple lines of

motion; the easel rattles from either the wind or the vigorous laying on of the paint; the artist's face is taut, concentrated, although there is a stirring in the wide-brimmed straw hat; the long, cape-like garment anchors the painter to the earth, as does the bend in his knee; angled pencil marks energize the background in a way that reflects Vincent's own landscapes of hyperactive skies and nervous wheat fields. The subject of the painting on the easel is unclear, just the sketchy beginnings perhaps; and the wraithlike form looming directly over the artist's head is that one perplexing note in the drawing that becomes almost signatory to Jack's work.

Van Gogh Through the Window

The words "Van Gogh" fill the empty space of a sketch that appears to be a window view, through which one looks down upon two walking figures and a sculptured pietà (**fig.138**). The larger of the walkers is bearded and wears a tall black hat. The smaller figure is so sketchily drawn it contains no details or hints as to its identity.

The pietà appears to be a modern icon of the Virgin Mary, a halo about her head, with the crumpled figure of Jesus across her lap. The figures are positioned on a pedestal and the strong, linear statement of the edges of the image and angularity of features define it as a sculpture.

The burst of small geometric shapes in the right windowpane is an enigmatic element in the work, as is the sweeping arc that creates the impression that the scene is being viewed through an arch or a segment of a round window. Jack adds a note of uncertainty to this logical resolution by placing a moon at the upper left, in an area which should be a solid wall, not a piece of sky.

Where the relationship with van Gogh comes in is perhaps the most perplexing issue of all, although van Gogh did paint a number of window pictures. One, *Window at the Restaurant Chez Bataille,* has two small figures walking outside; the other, *Window of Vincent's Studio at the Asylum,* has the rounded, arched top. They are both at the Rijksmuseum in Amsterdam, which Jack visited in his European travels.

There is another window view by Jack (**fig.139**), simply drawn with a bookcase at left and a single curtain to the right. It depicts a snowy, stormy day with trees bending in the wind. Outside the window is a cat, heading home through what may be snowdrifts or shrubbery, and the cat appears to be running and anxious to get indoors.

The great crosspiece of the window frame cannot be overlooked as a reference to the little crucifix Jack draws in his sad notebook plea for his own missing cat:

> Feel sick about Timmy
> O God Please Bring
> Him Back +

The window drawing itself could well be in celebration of Timmy's return home after one of his occasional nights "on the road" that so worried Jack, who never noticed that Timmy was just a chip off the old block.

Night Candle

I'll go light candles to the Madonna, and eat
ice cream, benny and bread—"Dope and saltpork"
as Bhikku Booboo said—I'll go to the South of Sicily
in the winter, and paint memories of Arles—I'll
buy a piano and Mozart me that—I'll write

long sad tales about people in the legend
of my life—This part is my part of the
movie, lets hear yours,
Solo 3

The above statement, which Jack made in *Tristessa*, could find no better illustration than the painting he did of his chair (**fig.140**). There are two of van Gogh's well-known works, done in Arles, which depict his own and Gauguin's chairs. Jack's painting, clearly related, is composed of long, parallel brush strokes that conform to the structure of the painting's elements: the slats across the seat, the wooden framework of the chair's carpentry, the boards of the floor, and the light radiating from the candle. Jack titled the picture *Night Candle.*

The Gauguin chair is elegantly curved, robust, graceful and firmly implanted on a richly colored, carpeted floor. Two books lie on its upholstered seat, and a candle burns brightly. At the upper left is a circular yellow light, emblematic of the sun, Vincent's symbol of love.

Vincent's chair, on the other hand, is an austere, straight-backed, crudely made peasant's model, with a rough cane seat. The colorful carpet beneath the Gauguin chair is gone and in its place are the cold bare tiles. But the most obvious symbolism lies in the contrast between the unlit empty pipe of Vincent and the erect burning candle of Gauguin—a sad expression of the libidinous inferiority Vincent experienced in the presence of the sexually aggressive and uninhibitedly macho Gauguin.

Jack's contribution to the series is a chair which is hard and straight, no frills, no design, built not for comfort but for utility. But on its seat, a candle burns brightly. Jack wrote of the candle: "He saw that existence was like the light of a candle; the light of the candle and the extinction of the light of the candle were the same thing."

And in "Long Island Chinese Poem Rain," he wrote of an empty chair:

Old Sad Boddhidharma you were right
Everything we loved disappeared
Nobody in the chair
Nobody in the books
Nobody in the rain.

And, in *On the Road,* Sal and Dean are at Birdland to see George Shearing. The great jazz pianist rose from his seat at the end of the performance and Dean, seated just behind him, pointed to where Shearing had been sitting and said:

God's empty chair . . . God was gone; it was the silence of his departure . . . the moment when you know all and everything is decided forever.

My Future Hermitage (**fig.141**)

Turns out that all my final favorite writers (Dickinson, Blake, Thoreau) ended up their lives in little hermitages . . . Emily in her cottage, Blake in his, with wife; and Thoreau his hut . . . This I think will be my truly final move . . . tho I don't know where yet. It depends on how much money I can get. If I had all the money in the world, I would still prefer a humble hut. I guess in Mexico. Al Sublette once said what I wanted was a thatched hut in Lowell.

Jack wrote this to Allen Ginsberg from Rocky Mount, North Carolina, on July 14, 1955. It is a recurring sentiment through Jack's writings, like the brief reference in

The Subterraneans where he reflects on the futility of his unrequited longing for the nonresponsive Mardou:

so hip, so cool, so beautiful, so modern so new, so unattainable to sad bagpants me in my shack in the middle of the woods—.

There were dreams, too: one of them, located in the Lowell City Hall Square, ricochets about with surreal images of driving a car, of a confirmation and of a new blue suit, it ends "—For me it's immortality in a hut—."

There is an entire dream that takes place in another hut, while sleeping in a "Lowell Skidrow Hotel, the Depot Chambers."

I'm at Thoreau's Walden Pond Hut in Concord, it's evening and I can barely see as I try to examine some of his momentoe'd remaining personals including a little box of his old smokes, the box made of tearable soft cardboard like that of egg crate layers—a hip chick in a new convertible pulls up and is yanking her emergency brake with headlamps illuminating Thoreau's wall as I yell "Keep your lights on, I gotta see this" because I dig her right away as receptive and cool and I can't see—As she watches over my shoulder I open the box and it's a little thimbleful of marijuana seeds—a little powdered marijuana tobacco, at least seems so and I think "Thoreau High"—(which is certainly TRUE)—and I tell the girl what it is—. . . she says "that stuff is hard to get"—"now no it isnt" I say with the authority of a great hipster "you can get it anywhere on the street (from any hustling girl)" I think to add, and in my mind the street is a great Chicago Drag glittering outside Concord and Lowell—Pretty Chick is awed by me—she tears the lilbox softly apart for a souvenir rolling it up into a little ball—

And an entire poem further defines the life style:

THE SHACK OF DESOLATION

The shack of Desolation is dirty, with broken boxes of wood
 gathered by me like a Japanese old woman gathers
 driftwood on the beach or on the mountainside,

Full of mice, fat drops, chips, ancient chewed up fragments
 of religious tracts, crap, dust, old letters of other lookouts
 and general unsweepable debris too infinitude to assemble
 and sweep

Paniaw Powder Olympic Pawmanow

And Mt Hozomeen—most beautiful mountain I ever seen—
 frights me acme out the morning coffee window,
 blue Chinese void of Friday morning,

And I have an old washtub covered with a wood door of sheds
 that when I saw it made me think of oldtime baths
 of bathnight New England when Pa was pink –

Patiat rock mounts snow spomona'd that I drew at ten for
 Kuku and Coco everywhere, hundreds a miles of and
 clouds pass thru my ink

And again, in the résumé of his life that Jack wrote as an author's introduction to *Lonesome Traveler,* he states:

Final plans: hermitage in the woods, quiet writing of old age, mellow hopes of Paradise (which comes to everybody anyway) . . .

One drawing and one painting comprise the visualized component of Jack's plans to live the hermetic life: "My Future Hermitage" is a notebook drawing on lined paper, an intimate little sketch, and we know from its title that it is not a recollection of Jack's summer on the

mountaintop, but a plan for tomorrow. The hut seems particularly small, but it is nicely sheltered by the pinnacles rising about it. There is a body of water, a pond or lake just off to the right, and a distant panorama of a snowcapped mountain and the valley below. The snug coziness of the hut is heightened by a thin wisp of smoke that trails straight up from the bent stovepipe chimney, and we can sense that Jack is inside, sitting on his straight-backed Catholic-Buddhist chair at the manual typewriter, while the beans are warming on the old wood stove.

Winter Evening, the painting of Jack's that relates to his life in the "little hermitage," his "humble hut," is among his most successful **(fig.142)**. It is a frozen winter landscape, typical of Lowell, which is located in the heart of the New England "snow belt." It looks like a scene from the film *It's a Wonderful Life:* an early winter evening, the ground, the rooftops, the large central tree are all in a deep frost. Snowflakes are in the air and someone has built a snowman just beneath the large tree. One of the small houses is dark, unlit, but from the window and door of the other shines a warm, incandescent yellow light that reflects on the blue-white tundra. A path has been cleared to the house, and footprints lead from it to the person walking in the foreground—a shadowy figure that appears to be male, dressed in dark clothing wearing a cap with earmuffs and carrying a newspaper or book.

The compositional format of a house with foreground figure is a popular one in art. Van Gogh often put people in front of his drawings and paintings of houses, such as the well-known *The Church at Auvers.*

The strong presence of the figure in Jack's scene is related in format as well to the Edvard Munch painting *Virginia Creeper.*

Another Kerouac literary scenario that seems to fit the mood of *Winter Evening* is in *Maggie Cassidy,* as Jack is on his way home from a night of bungled, confused teenage passion, idealistic avowals of eternal love, and promises of a settled domesticated life as a brakeman on the railroad, married to his high school sweetheart in a little house by the tracks:

I walked home in the dead of Lowell night—three miles, no buses—the dark ground, road, cemetaries, streets, construction ditches, millyards—The billion winter stars hugeing overhead like frozen beads frozen suns all packed and inter-allied in one rich united universe of showery light

In August of 1882, van Gogh began working in oils. He wrote to Theo:

For oil painting, I now have everything which is also necessary, and also a stock of paints . . . ochre, red-yellow, brown, cobalt and prussian blue, Naples yellow, Sienna, black and white, completed with some smaller tubes of carmine, sepia, vermillion, ultramarine, gambage . . .

Jack had mentioned drawing as early as 1953, when he wrote in *The Subterraneans:*

I had drawn my first pencil sketches of human figures reclining and they were greeted with amazement by Carmody and Adam and so I was proud.

Then, on October 10, 1956, in a not unprecedented coincidence with Vincent's letter to Theo, Jack wrote to Allen from Mexico City:

Only good thing is I started to paint—I use housepaint mixed with glue. I use brush and fingertip both, in a few years I can be topflight painter if I want—maybe then I can sell paintings and buy a piano and compose music too—for life is a bore.

Both Kerouac and van Gogh were aware of the ubiquitous intersection of writing and painting. Vincent looked to literature to describe the light in a favorite Rembrandt:

> Twighlight is falling—blessed twighlight,
> Dickens called it, and indeed he was right . . .

Cézanne composed poetry that identified strongly with his paintings. As a young man he wrote:

> A tree, shaken by raging winds
> waves in the air
> like a gigantic corpse,
> Its naked branches which
> the mistral sways

It was an image that remained with him. Years later he painted a scene which he called *Bare Trees in the Fury of the Wind.*

The problems of painters are the problems of poets and each look to the ways, the means, and the muses of the other for a broader view of the incredible magic of their domains. Common denominators seem to abound in both contemporary and historical time. As Zen Buddhism became a rediscovered wellspring for literature and art in the middle years of the twentieth century, so too did El Greco, 400 years earlier, venture beyond the then popular Neoplatonist doctrines to find inspiration in a form of Zen meditation. The connections are as long as the story of art and literature and as profound as the mystique of art itself. In the first ten years every child paints like a genius, but as they grow into adulthood chances of this artistic genius persisting are hundreds of thousands to one.

Perhaps Joyce Johnson's perspicacious observation in *Minor Characters,* that what the Beat Generation was really all about was "their right to remain children," offers some key to an understanding of why Jack and so many of the Beat writers extended their oeuvres to the less-definable ambiguities possible in the visual arts. It may, too, have been an endeavor to broaden their anthropological explorations and reportorial observations and venture out into the vast alternative sensual hemisphere beyond the limits of the dialectic, beyond verbiage and vocabulary, beyond the lexiconical limits of text, beyond words themselves, to a place where they could find that ineffable extra to flesh out and more fully evolve the totality of their lives.

As Jack says in *Big Sur:*

> The world is too old for us to talk about
> with our new words.

acknowledgments

Jack Kerouac dreamed of a big Beat convention. In 1994, New York University fulfilled the dream. It was a week of readings, seminars, jazz concerts, films, and an art exhibit. A "Writings of Jack Kerouac" conference followed in the spring of '95, and it was there that the idea for this book was born.

At NYU, the burden fell to Helen Kelly and Ron Janoff at the Office of Special Programs and to professors Marilynn Karp and Ruth Newman in the Department of Art and Art Professions. Bernie Mindich, an artist and photographer, must be credited with the recognition of the then-unknown category of Beat Art. Bernie and I were among the organizers of the Beat Conference and co-curated the exhibit of Beat Art at NYU's 80 Washington Square Gallery.

An enormous debt of gratitude is due John Sampas, Jack Kerouac's friend, brother-in-law, and literary executor of the Kerouac estate. John saw to the preservation of the paintings, drawings, and notebooks, and after hearing a lecture I gave at NYU, asked me to write this book. Sterling Lord, Jack's literary agent, and now mine, is one of the legendary figures of the Beat Generation. Among the pleasures of writing this book was working with John and Sterling.

Several graduate students at NYU who have now taken their places as colleagues in the academic world were

helpful and supportive. Thanks to Maria Borrelli for her assistance in research and final preparation of the manuscript; also to Heidi Wineman and Dr. Dawn Ward for their tireless work at the conferences; and to Dr. Richard Marranca who, on his Fulbright, brought the teaching of the Beats to Munich.

David Amram, world-renowned musician and composer, holds a special position in the Beat world; his recent book, *Offbeat: Collaborating with Kerouac,* provides the best behind-the-scenes view of Beat life in the '50s and '60s. It has been a privilege and a pleasure to become David's art teacher, occasional harmonica accompanist and, last spring, Left Bank drinking companion, when we represented the Beat culture in Paris at Sylvia Whitman's Shakespeare & Co. Literary and Art Festival. Christopher Felver, photographer, filmmaker, and one of the great documenters of the Beat Generation, was with us in Paris, as was Carolyn Cassady.

Allen Ginsberg was the first person I contacted when I began to write the book. I had been working with Allen on the NYU conferences and we found we had a lot in common in our origins and family dynamics. My friendship with Allen remains one of my most cherished relationships. Lunches with Gregory Corso were lively events and filled in a few gaps about Kerouac's interest in art, as well as Gregory's. James Grauerholz and George Condo rounded out details on William Burroughs as a painter. To Allen Pepper, impresario and owner of The Bottom Line in Greenwich Village, thanks for the introductions to Ed Sanders, Tuli Kupferberg, Michael McClure, Ray Manzarek, and Al Aronowitz.

The painter Dody Muller, at an al fresco lunch in SoHo, with her dog in her lap, spoke nostalgically and at great length about Jack's excitement about art and his eagerness to learn from his painter friends. I have participated with Douglas Brinkley, Ann Charters, Ann Douglas, Joyce Johnson, John Tytell, Anne Waldman, and Regina Weinreich in programs honoring Jack. Their colorful stories and insights establish a scenario from which one can better comprehend the nature of his work. For the Kerouac events at UMass-Lowell, many thanks to Professors Bill Roberts, Hillary Holiday, and Jim Coates. For her curating of Kerouac shows at UMass and at the Whistler House Museum of Art, thanks to Michele Gagnon.

Bob Rosenthal and Peter Hale of Allen Ginsberg's office were always there for information, as was Bill Morgan. Thanks to David Meyer and David Stanford for their early reading of the manuscript and enthusiasm for the project. For her editorial acumen and encyclopedic knowledge, Prudence Dorsey was most helpful. Many stories about Jack and the Beat era were learned from David Orr and Paul Marion on visits to Lowell, from Stanley Twardowicz in Northport, from Herbert Huncke one Christmas day over a fruitcake at Allen Ginsberg's kitchen table, from Morris Dickstein's books and lectures and participation on

my doctoral committee back in the 1970s, along with Marilynn Karp and Angiola Churchill, and from Lawrence Ferlinghetti, San Francisco's poet laureate and a painter with a degree in art history from the Sorbonne. Thanks to Molly Barnes for the opportunity to speak on Kerouac's art at her Roger Smith Brown Bag Series and her exhibition of Beat art at the Studio 18 Gallery. Appreciation to Doug Sheer, at Artists Talk on Art, for the two talks I gave there on the topic of this book.

When I read *On the Road* in 1957, it sounded remarkably like my college years in Lowell. A special thank-you to my pal who shared the road with me those four years, my hitch-hiking and mountain climbing buddy, still a mountain man, Len Goodman.

Much appreciation to Dan O'Connor of Avalon Publishing Group, for his guidance, confidence in the book, and his broad ranging knowledge of art and of the social and literary dynamics of the Beat Generation.

Finally, to a great, close and supportive family: my wife Phyllis and our two amazing kids, Barry and Gwen, who married Susan Schackman and David Meyer and along came Emily and Jake and Ethan and Layla. And my brother Bob, no two brothers were ever closer, and his wife Deanna, their kids Greg and Pam, who married Marilyn and Howard and then came Samantha, Melissa, Miranda, Caroline, and Mark. And Mom, who raised us with love and music, and Dad, who weaned us off comic books with Dumas and H.G. Wells and never got to write the great American novel, but lived it. And to Grandma and Grandpa, for love, compassion, good common sense, and interesting genes.

—ED ADLER

ED ADLER was born in the Bronx, and when he was seventeen he went off to school in Lowell, Massachusetts. Jack Kerouac was born in Lowell, Massachusetts, and when he was seventeen he went off to school in the Bronx.

They both were members of Lowell's Pawtucketville Social Club. Ed still is, but the man at the bar won't honor the key he got from Jack's father, who managed the club back in Adler's college days. Ten years apart, Ed and Jack went to dances at the Rex Ballroom, ate at the Dutch Tea Room, worked out at the Lowell "Y," and walked on the "wrinkly tar" sidewalk on the way to the Textile Lunch Diner for a fifteen-cent bean sandwich.

In 1943, Jack went to sea in the merchant marines; in 1953, Ed went to Germany and fought the Cold War. In the heyday of the Beat years, they both hung out at Greenwich Village's San Remo, the Gaslight, the Bizarre, and the Open Door.

As the sixties came to a close, Ed turned from political activism to painting, running marathons, and researching the decade for a Ph.D. thesis. Since 1975 he has been associated with New York University where, as an associate professor, he has taught classes on the Beat Generation and the sixties, and in 1994 was an organizer of the Beat Generation conference and co-curator of the first Beat Art exhibit. In 1995, he was instrumental in producing another conference, *The Writings of Jack Kerouac*, and there delivered the first lecture on Kerouac's art.

Ed is a painter who writes, Jack was a writer who painted. Somehow celebrating the many intersections in their lives is the Jack Kerouac street sign at the corner next to City Lights Bookstore in San Francisco. For reasons unclear to most, but not to Ed, under Jack's name is printed the name of the intersecting road, "Adler."

DEPARTED ANGELS

Text copyright © 2004 by Ed Adler

Paintings and drawings copyright © 2004 John Sampas, Literary Representative of the Estate
of Jack Kerouac.

Published by
THUNDER'S MOUTH PRESS
An Imprint of Avalon Publishing Group Incorporated
245 West 17th St., 11th Floor
New York, NY 10011

AVALON
publishing group incorporated

LIBRARY OF CONGRESS CATALOGING-IN-PUBLICATION DATA IS AVAILABLE.

ISBN: 1-56025-621-4

9 8 7 6 5 4 3 2 1

Designed by Lorie Pagnozzi
Printed in China
Distributed by Publishers Group West

FIGURES: 1, 3, 6, 7, 12, 13, 14, 15, 17, 41, 54, 66, 67, 70, 73, 84, 85, 86, 87, 88, 91, 92, 96,
97, 98, 109, 107, 108, 112, 114, 115, 116, 117, 118, 119, 120, 121, 122, 123, 124, 126, 127,
128, 130, 131, 132, 133, 134, 135, 137, 144, used courtesy of the Henry W. and Albert A.
Berg Collection of English and American Literature,
The New York Public Library, Astor, Lenox and Tilden Foundations.

Viking royalty check for
#2,142⁰⁰ came in —

Peanuts, only 14,000
copies of epoch-changing
ON THE ROAD They
sold — But pocketbook
sale coming up —

Just decided to accept
That $100 night with
Max Lerner at Brandeis
Univ. forum — With
That money I'll buy
my oil paints, canvases
& stand, & $30 worth
of Theragram Vitamins!
And starts being healthy
 painter!

Another sensational game,
13-inning Thriller decided
by C-pitcher's homerun —
(Bob Aagaard of Detroit)

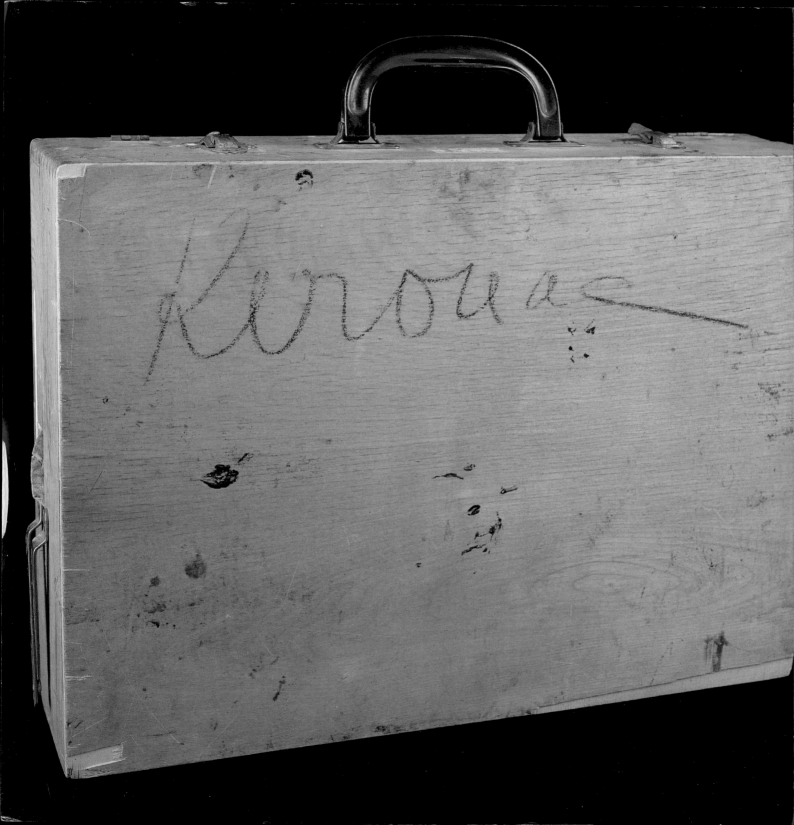